MANGA

THE MONSTER BOOK OF MANGA

GIRLS

MANGA

THE MONSTER BOOK OF MANGA

GIRLS

Edited by Ikari Studio

COLLINS | DESIGN

An Imprint of HarperCollinsPublishers

THE MONSTER BOOK OF MANGA: GIRLS
Copyright © 2008 by COLLINS DESIGN and **maomao** publications

HarperCollins books may be purchased for educational, business, or sales promotional use.
For information, please write: Special Markets Department, HarperCollins*Publishers*,
10 East 53rd Street, New York, NY 10022.

First Edition:
Published by **maomao** publications in 2008
Tallers, 22 bis, 3º 1ª
08001 Barcelona, Spain
Tel.: +34 93 481 57 22
Fax: +34 93 317 42 08
mao@maomaopublications.com
www.maomaopublications.com

English language edition first published in 2008 by:
Collins Design
An Imprint of HarperCollins*Publishers*,
10 East 53rd Street
New York, NY 10022
Tel.: (212) 207-7000
Fax: (212) 207-7654
collinsdesign@harpercollins.com
www.harpercollins.com

Distributed throughout the world by:
HarperCollins*Publishers*
10 East 53rd Street
New York, NY 10022
Fax: (212) 207-7654

Publisher:
Paco Asensio

Editorial Coordination:
Anja Llorella Oriol

Ilustrations and texts:
Ikari Studio (Santi Casas, Daniel Vendrell, David López),
with the collaboration of Jordi Riba

Translation:
Antonio Moreno

Art Direction:
Emma Termes Parera

Layout:
Gemma Gabarron Vicente

Library of Congress Control Number: 2008926856

ISBN: 978-0-06-153794-3

Printed in China

Third Printing, 2012

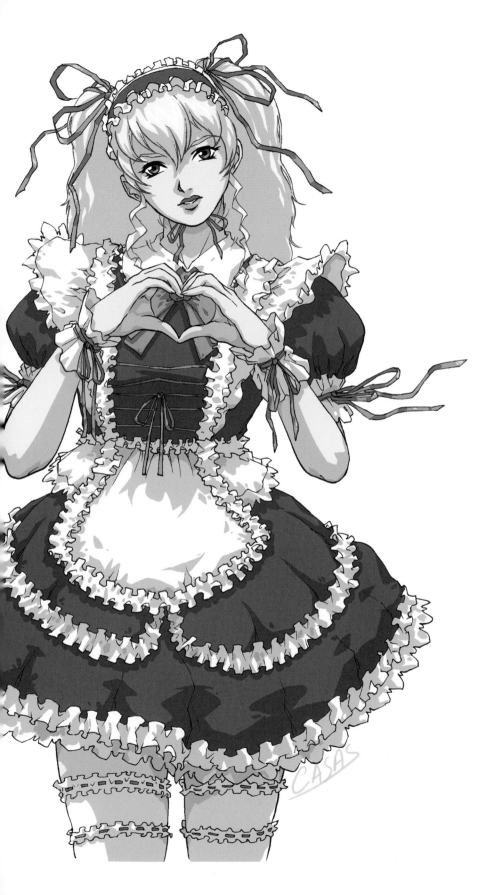

CONTENTS

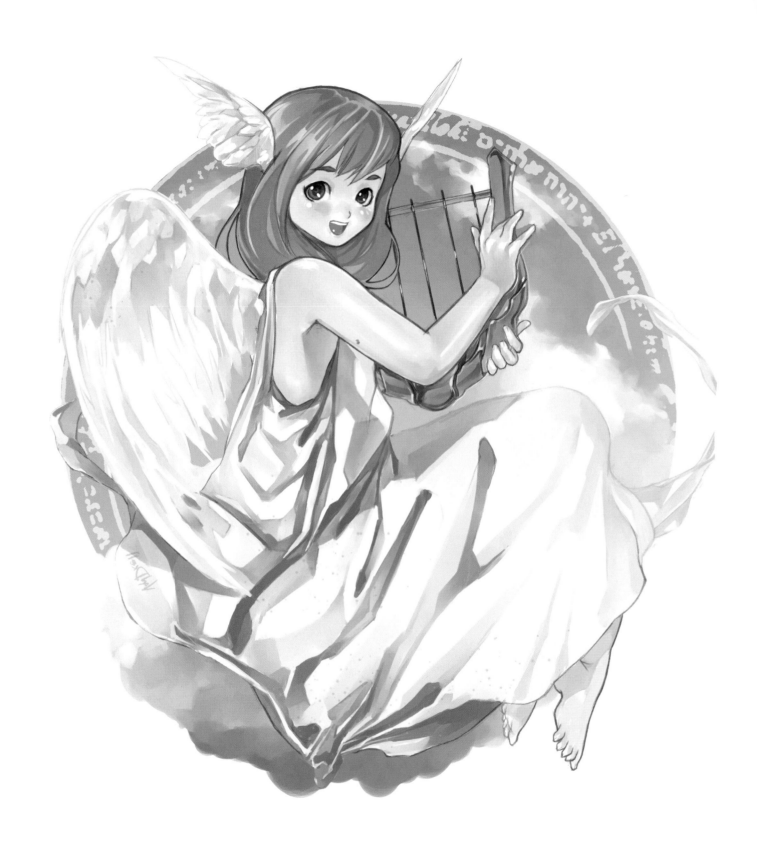

INTRODUCTION

If you've gotten this far you probably already know what manga is. Manga, or Japanese comics, is currently the biggest super-power in the modern comic industry. The secret ingredient that makes it such a universal graphic and narrative style is its use of the image as the primary means of expression. The story, dialogues and action are usually overpowered by the image and certain aesthetic resources, making for an incredibly simple and especially direct reading. One can read a page of manga in just a few seconds, and the graphic style is always striking, impressive and intense. But most of all, emotions and feelings are magnified to really stir the hearts of readers.

All this has turned manga into a true phenomenon of our time, one where girls play a decisive role on two separate levels. In the first place, more than in any other type of comic, female characters are extremely important in manga. The damsel in distress has been replaced by the independent and able heroine. Women full of passion, dreams and hopes, aggressive women who are free and adventurous, began to populate a new universe that connected with new generations of male and female readers. Manga encouraged the revision of the position women occupy in modern society, portraying them as new workers with new values and freedoms. And it went beyond this, suggesting a future in which women's roles had always been more decisive than the ones they had been given in previous narrative traditions. However, it's not only that, manga has also known how to bring out and exploit the most sexy and attractive sides of these heroines, to convert them into favorite characters for thousands of male readers.

Secondly, innovative proposals by mangakas have attracted an entire new generation of female readers. For over more than twenty years, women comic fans had practically disappeared in many parts of the world, especially on account of a lack of an attractive and interesting offer for them. But the emergence of manga, and especially shojo, the Japanese comic aimed at girls that enjoys such great success in its native country, has opened the door to this segment of fans who are now thirsty for new releases and titles and who today number as many or possibly more than the male audience. Publishing houses have been conscious of this for some time and have wagered on conquering the new female reading force that has driven the growth of the manga industry in the West.

So, we invite you to take a stroll through the extensive gallery of female characters who inhabit the world of manga. We hope you enjoy reading this book as much as we have making it.

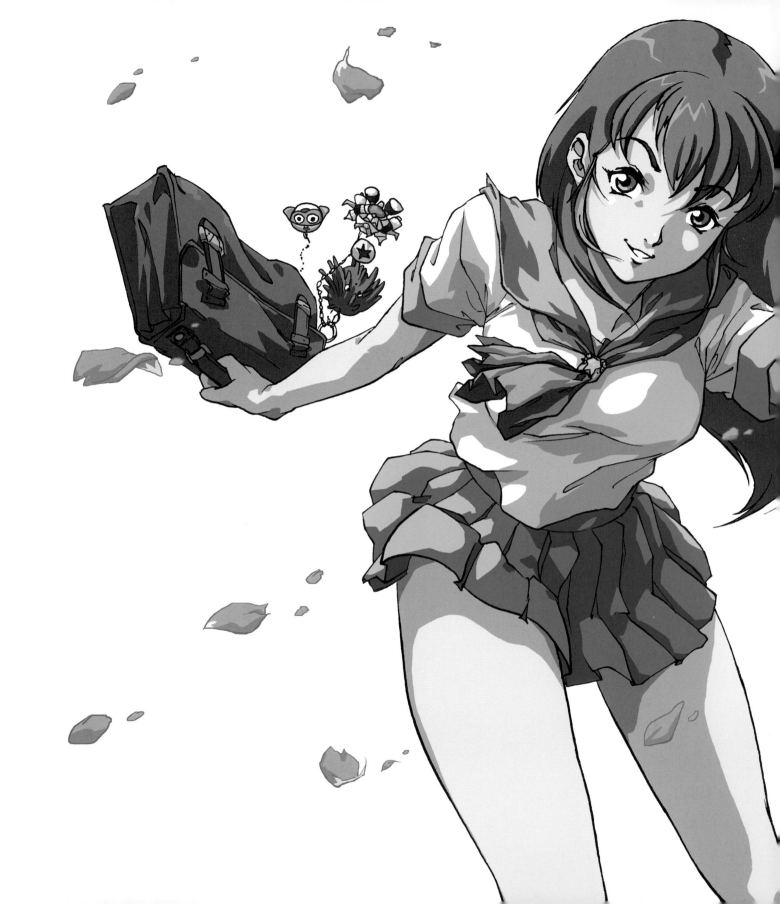

EVERYDAY

YOUNG GIRL

The roles played by female characters are usually relevant in manga. This also occurs with the youngest of them. The great number of genres aimed at all audiences explains why there are numerous series where little girls play the leading roles. While adolescence is a stage in life full of abrupt changes, childhood is all about rapid growth; so there isn't really just one system of proportions that is recommended for drawing young girls in general. It all depends on their age. In this exercise we'll be looking at a six-year-old girl and a pre-adolescent of about eleven in order to show the differences in their builds and the various attributes each of them might have.

1. Shape

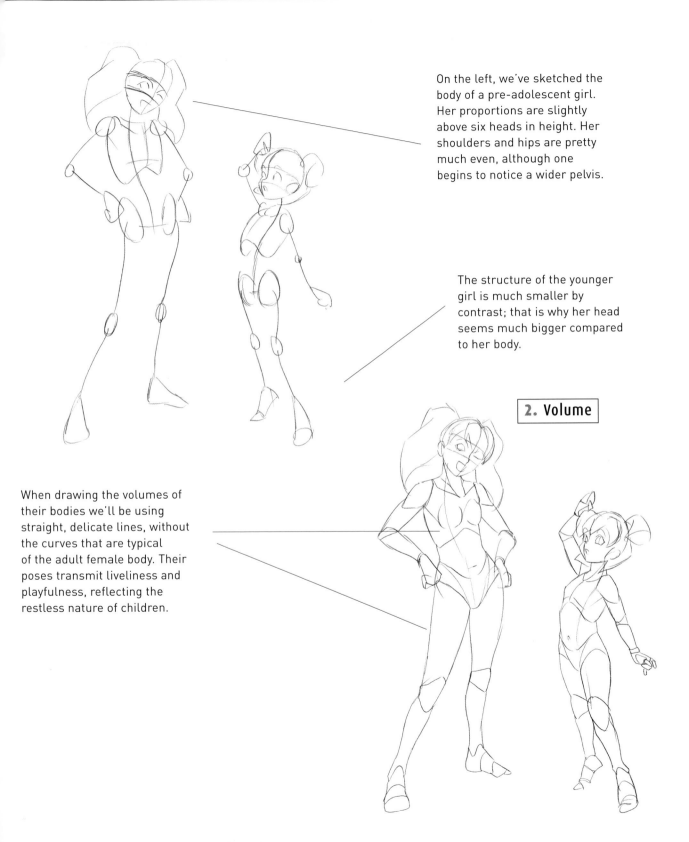

On the left, we've sketched the body of a pre-adolescent girl. Her proportions are slightly above six heads in height. Her shoulders and hips are pretty much even, although one begins to notice a wider pelvis.

The structure of the younger girl is much smaller by contrast; that is why her head seems much bigger compared to her body.

2. Volume

When drawing the volumes of their bodies we'll be using straight, delicate lines, without the curves that are typical of the adult female body. Their poses transmit liveliness and playfulness, reflecting the restless nature of children.

Looking at the bodies of these girls, we can observe the absence of characteristic female attributes such as wide hips and shapely breasts.

Their femininity is manifested by their faces, with soft and rounded features. We'll draw big eyes and shape their noses, mouths and little ears. Their hairstyle can accentuate their childish nature, and we can also add some freckles.

The older one shows she wants to grow up and look older than she is. If we give her some sporty accessories and casual clothes, along with some childish details, we'll have nailed it down pat.

Accessories serve to give some character and give information about their age. The littlest girls usually wear funnier clothes that may have childish patterns. Adding in a stuffed doll makes for a perfect combination.

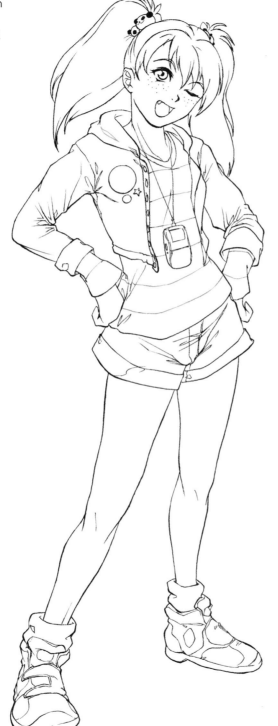

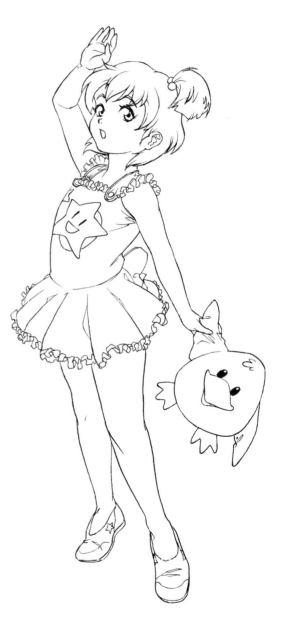

For this scene we'll be using an overhead, zenithal lighting. The volumes should be drawn making sure their shapes manage to express the different textures of each object.

Source of light

Their flesh will have smoother lines than the wrinkles on some of their clothing, especially the synthetic ones. We recommend you use softer lines on natural objects and harder ones on synthetic textures.

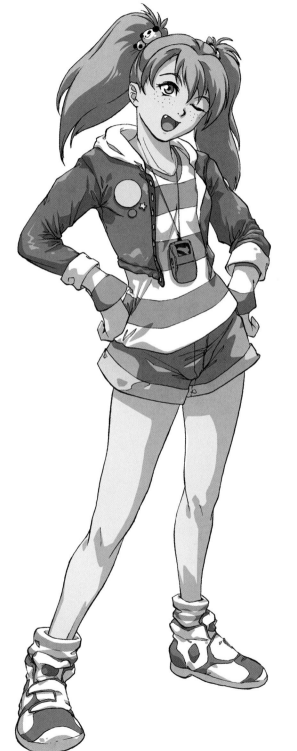

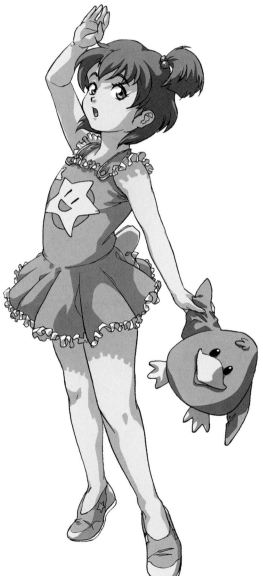

Colors serve to distinguish the girls' ages. Generally speaking, girls tend to look happy, which is why bright colors are more adequate for their attire. Bright colors also are used for the lead characters in children's series.

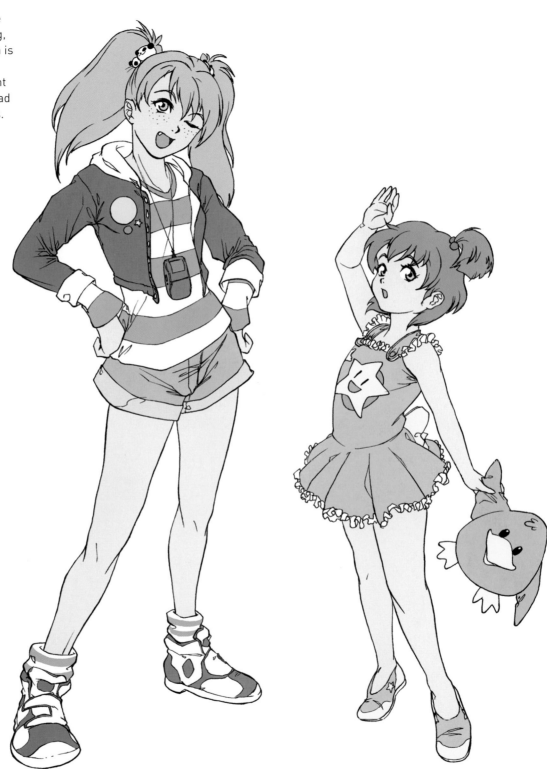

When using color to shape shadows, we'll apply a series of criteria that we'll be looking at little by little. First off, we'll follow the shapes we marked in our lighting exercise, where we defined the volumes of each object.

Our choice of color of shade depends on the scene's lighting. In this case we'll be using a slightly darker and more saturated color than our base color.

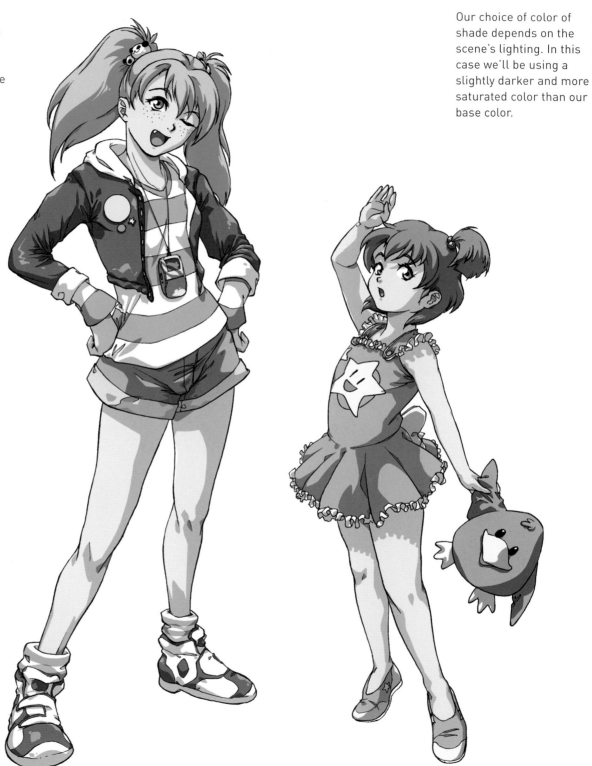

In the last steps we've added tones that complement the volumes of the shadows and the shiniest parts, such as their hair.

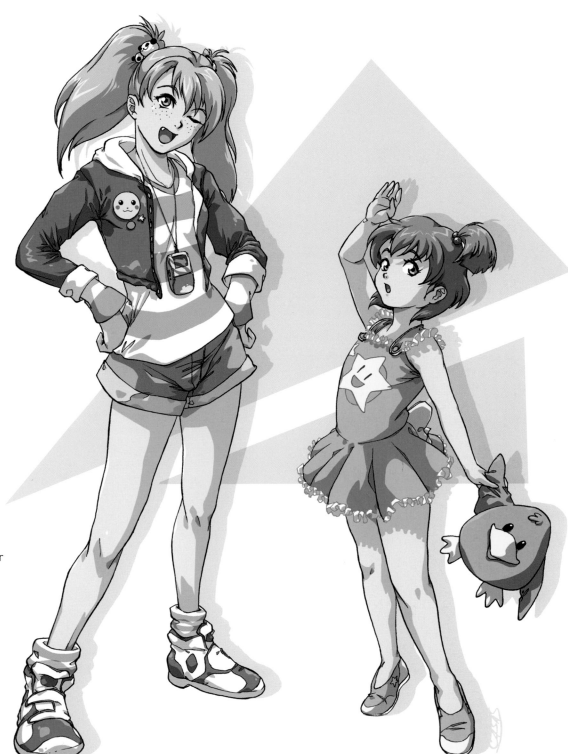

In addition, we've painted over the black lines of the striped shirt, and the sun on the pattern, to integrate them better with the clothing and separate them from the characters' contour lines.

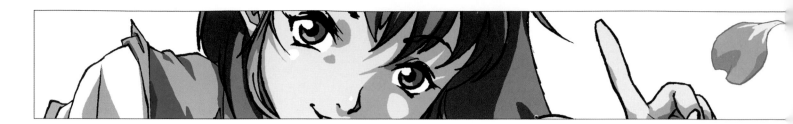

HIGH SCHOOL GIRL

In *shojo*, the main characters tend to be teenage high school students, because of the characters themselves and because of their great number of female readers. Within the traditionally masculine world of comics, manga has always believed in giving women important roles, and the increase in young adolescents is clear evidence of this. The stories draw inspiration from reality, and the reality of these kids involves school and their classes. The school girl character has evolved over time and gained strength, independence and protagonism. She wears the typical Japanese school girl uniform and is a reflection of the average student, so readers can identify with her more easily.

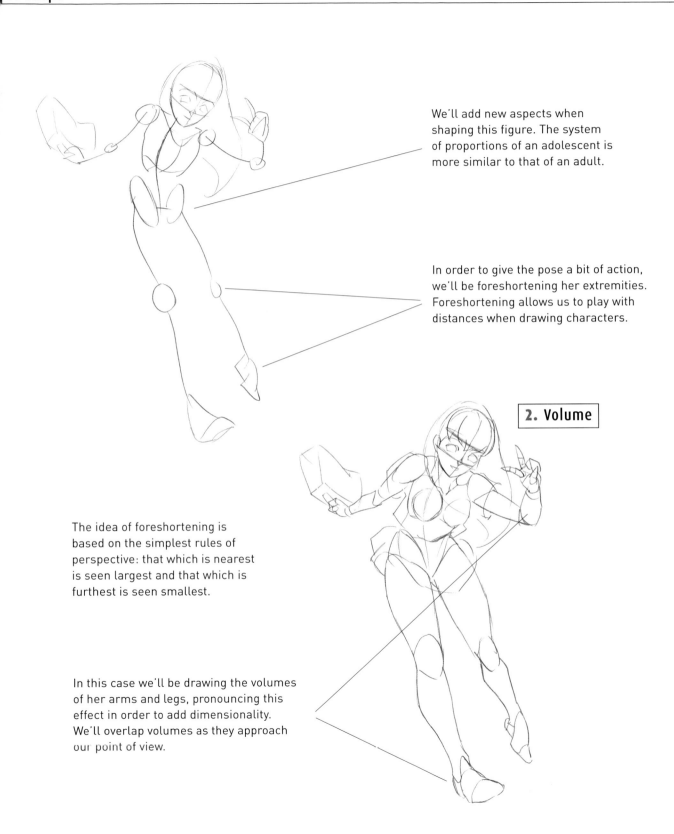

We'll add new aspects when shaping this figure. The system of proportions of an adolescent is more similar to that of an adult.

In order to give the pose a bit of action, we'll be foreshortening her extremities. Foreshortening allows us to play with distances when drawing characters.

2. Volume

The idea of foreshortening is based on the simplest rules of perspective: that which is nearest is seen largest and that which is furthest is seen smallest.

In this case we'll be drawing the volumes of her arms and legs, pronouncing this effect in order to add dimensionality. We'll overlap volumes as they approach our point of view.

On the adolescent body, feminine traits begin to become visible: her breasts grow and her hips become wider. The whole figure becomes stylized.

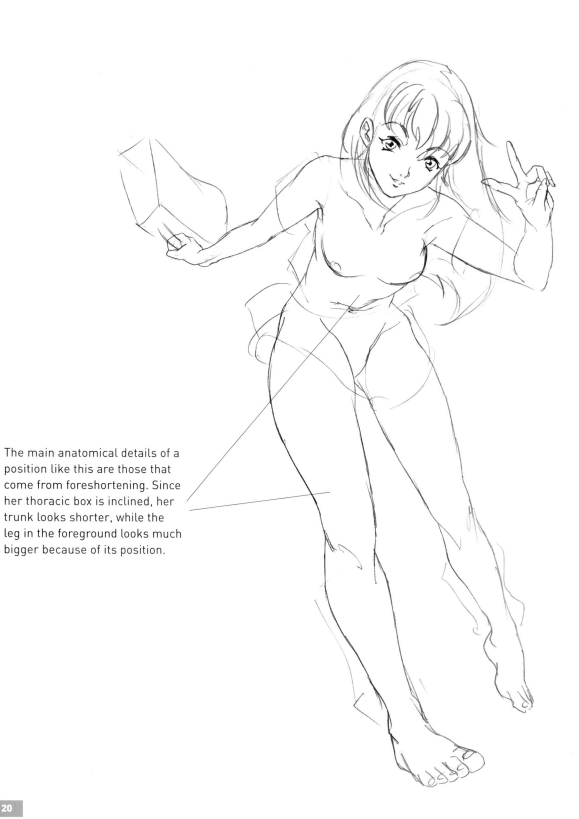

The main anatomical details of a position like this are those that come from foreshortening. Since her thoracic box is inclined, her trunk looks shorter, while the leg in the foreground looks much bigger because of its position.

These uniforms (*kon*) usually consist of a blouse with a sailor's neck, a handkerchief tied in front and a matching pleated skirt. *Loosers* are large, baggy socks that many girls wear as an accessory.

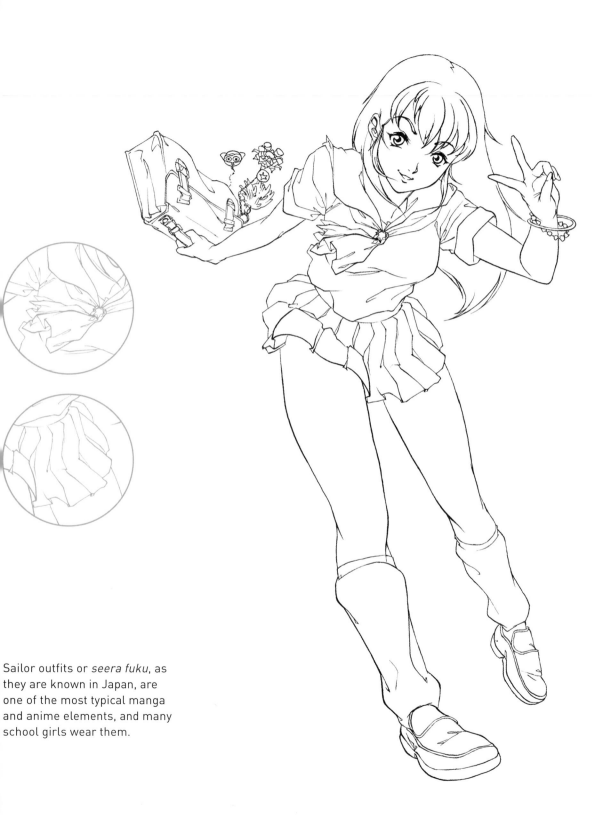

Sailor outfits or *seera fuku*, as they are known in Japan, are one of the most typical manga and anime elements, and many school girls wear them.

Source of light

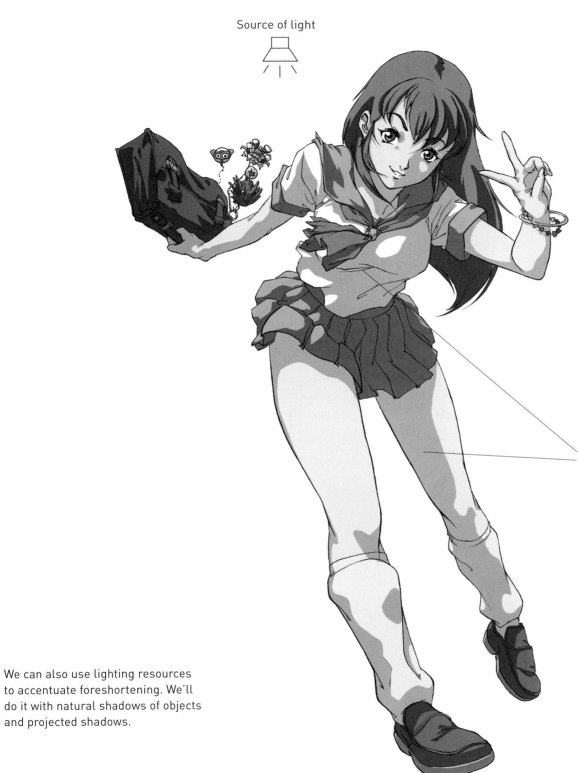

Her torso and rear leg are practically completely in shadow due to their position. This helps explain how light affects a tri-dimensional object and its position in space with respect to other objects.

We can also use lighting resources to accentuate foreshortening. We'll do it with natural shadows of objects and projected shadows.

In the case of this uniform, the handkerchief tied below the neck of her blouse and the figures adorning her pocketbook partially serve this purpose and also give an extra touch of color.

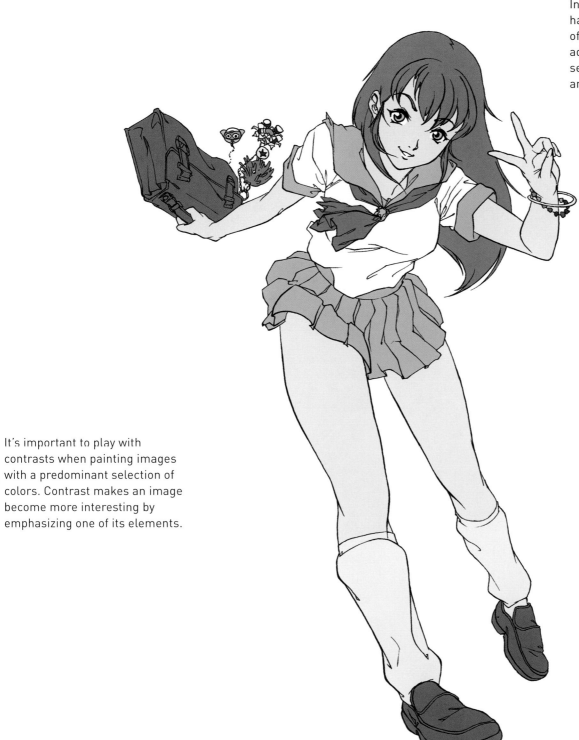

It's important to play with contrasts when painting images with a predominant selection of colors. Contrast makes an image become more interesting by emphasizing one of its elements.

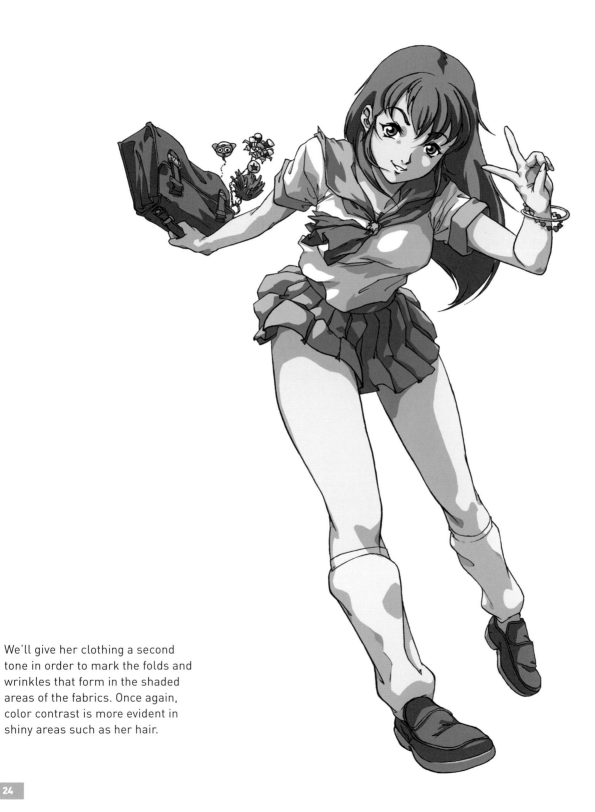

We'll give her clothing a second tone in order to mark the folds and wrinkles that form in the shaded areas of the fabrics. Once again, color contrast is more evident in shiny areas such as her hair.

To achieve the effect of gently falling petals, we'll use soft colors with little contrast, and soft and rounded shapes.

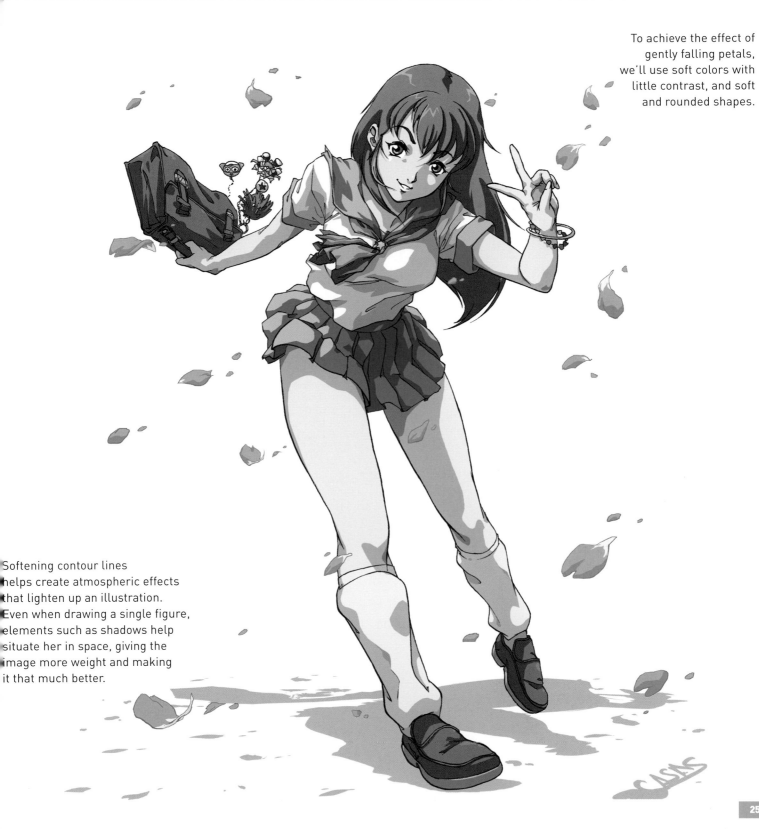

Softening contour lines helps create atmospheric effects that lighten up an illustration. Even when drawing a single figure, elements such as shadows help situate her in space, giving the image more weight and making it that much better.

TWENTYSOMETHING

What is a *gal*? Dressing up in the latest, being a prime example of fashion personified, setting trends, that's what real *gals* aspire to. They are Japanese girls; many of them still students, who love to be in fashion, wear platform shoes, mini-skirts, different color dyes for their hair, the latest in accessories, etc. They are passionate about fashion and spend all their time and money on clothes, make-up and accessories. Depending on their skin color and clothes, we can distinguish various types: *ganjiro*, whose skin is paler; *ganguro*, who are darker; *loko*, with more extreme colors; *hime,* with the modern princess look and many, many more.

1. Shape

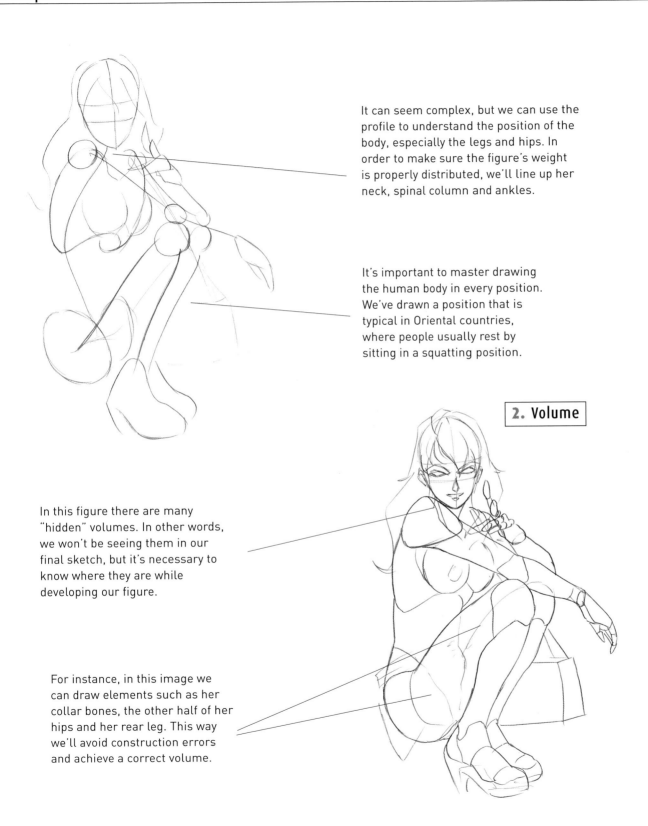

It can seem complex, but we can use the profile to understand the position of the body, especially the legs and hips. In order to make sure the figure's weight is properly distributed, we'll line up her neck, spinal column and ankles.

It's important to master drawing the human body in every position. We've drawn a position that is typical in Oriental countries, where people usually rest by sitting in a squatting position.

2. Volume

In this figure there are many "hidden" volumes. In other words, we won't be seeing them in our final sketch, but it's necessary to know where they are while developing our figure.

For instance, in this image we can draw elements such as her collar bones, the other half of her hips and her rear leg. This way we'll avoid construction errors and achieve a correct volume.

Stylization helps us make her hands and face more feminine, an important aspect to correctly typify our character.

We've drawn an adult female body and stylized her proportions. In manga, stylizing is one of the tools most often used to make a character more beautiful.

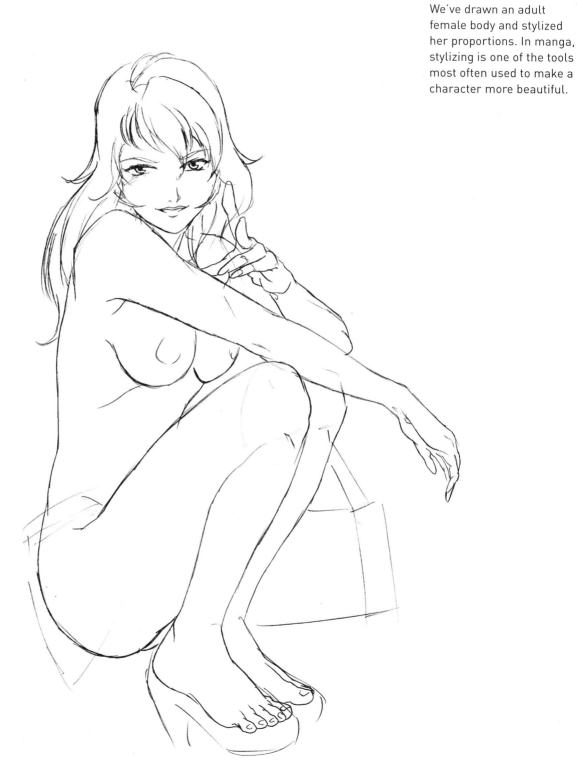

There are various tricks for drawing certain accessories. To correctly place her feet and shoe heels, we'll begin by combining them in the sketch, as we've done here.

Her bracelets and necklaces must not be drawn in alignment, but in random positions, as if gravity had moved them. Gravity must always be present, as in the tension of her pocketbook strap.

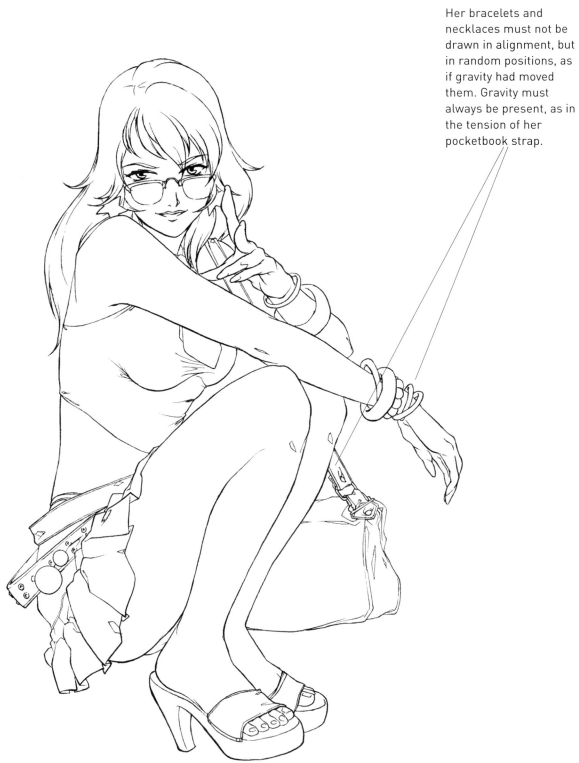

Source of light

Here we see different ways of applying lighting depending on the material we're working with. The harsh, angular lines of her skirt greatly contrast with the soft, ample curves of her legs.

In this case the projected shadows, such as that which her arm makes on her knee, accentuate the point of contact and give the illustration more volume.

In this illustration, color toning is also very important. Maintaining color coherence helps us transmit the character's taste for fashion. The aim is to compensate colors within the image in order to achieve the proper balance.

A useful trick for matching clothing items is to use colors from the same chromatic range or complementary colors.

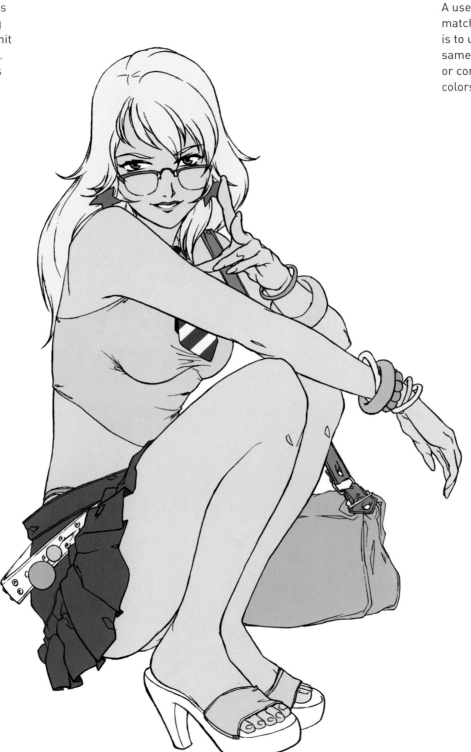

The process is the same as with the previous cases. We'll follow the outline in our ink and lighting exercise and use soft colors, without going overboard with contrasting shadows, thus achieving an image with almost pastel tones.

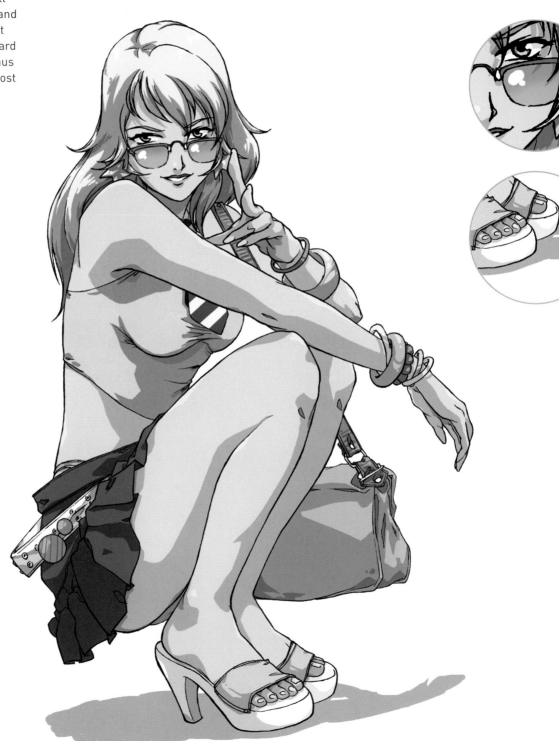

The greatest contrasts will always be on shiny surfaces, such as her glasses. By projecting the figure's shadow we situate her in the space and mark the location of the floor.

Her pink locks maintain the balance between light and shade and the rest of her hair. The pattern on her shirt is affected by the shadows we've marked and gets darker using the same criteria.

With a reference of direct color, we'll situate the scene in the perfect place for this character: in front of Shibuya's 109 building in the heart of Tokyo's fashion district.

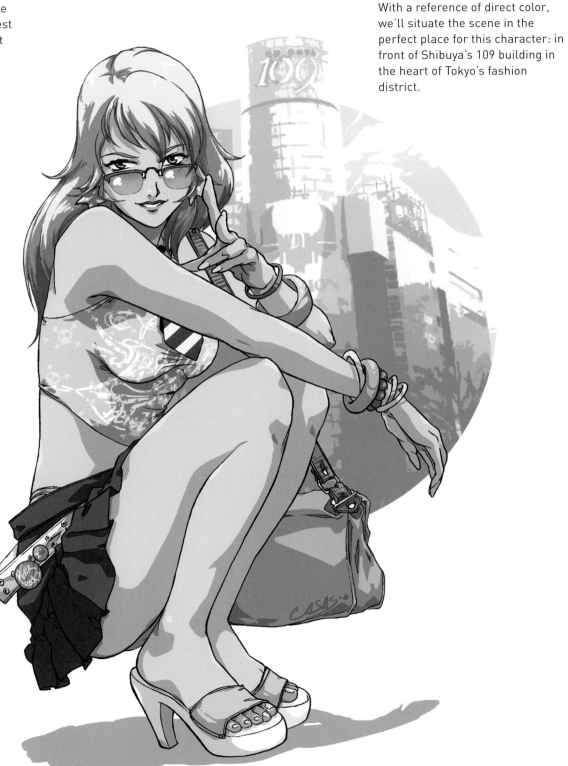

CAREER GIRL

For this character we've decided to take another step in maturity, thereby entering full thrust into the exuberant world of female anatomy. Our protagonist must meet the requisites of a real, explosive woman.

Manga exploits archetypes because of the ease with which readers connect with them. These are simplified characters, where their appearance is enough to inform the reader as to their temperament and what they are all about.

1. Shape

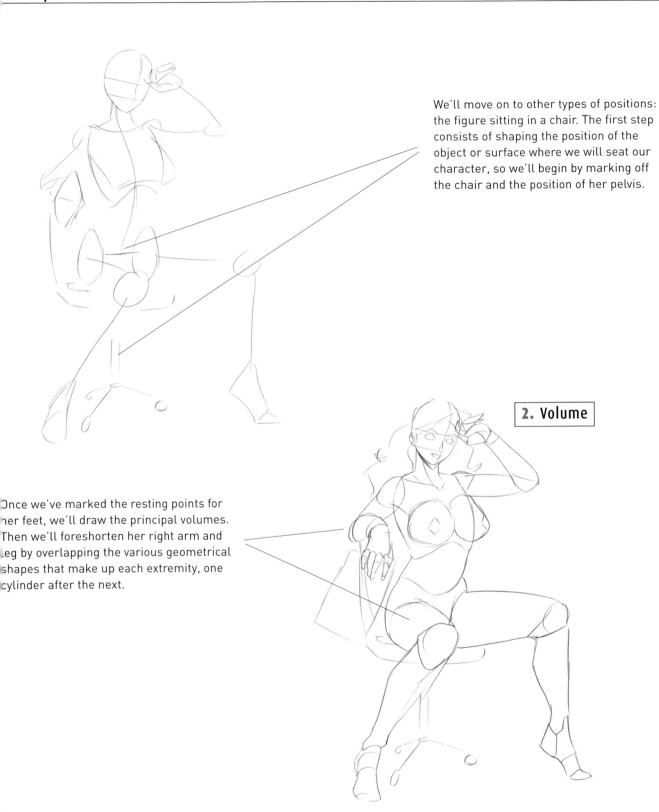

We'll move on to other types of positions: the figure sitting in a chair. The first step consists of shaping the position of the object or surface where we will seat our character, so we'll begin by marking off the chair and the position of her pelvis.

2. Volume

Once we've marked the resting points for her feet, we'll draw the principal volumes. Then we'll foreshorten her right arm and leg by overlapping the various geometrical shapes that make up each extremity, one cylinder after the next.

This figure is characterized by wide hips and generously proportioned breasts that bestow her with great femininity. We can narrow her waist to exaggerate the hourglass shape of her back. Her abundant, loose and disheveled hair makes her more attractive.

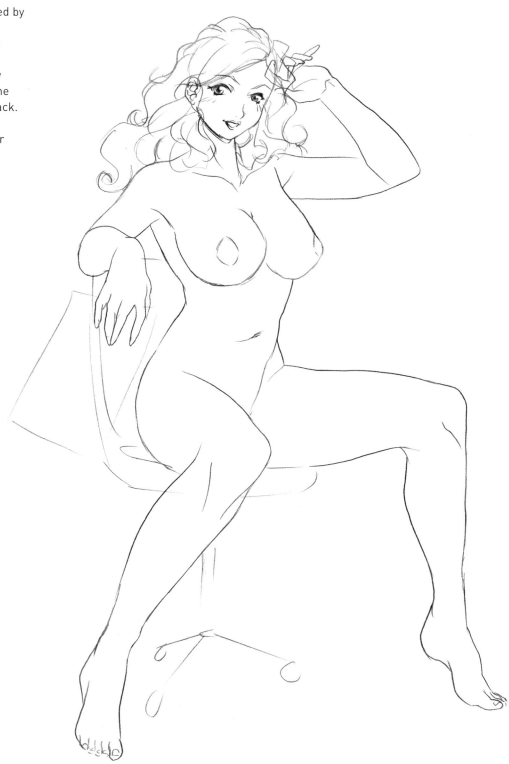

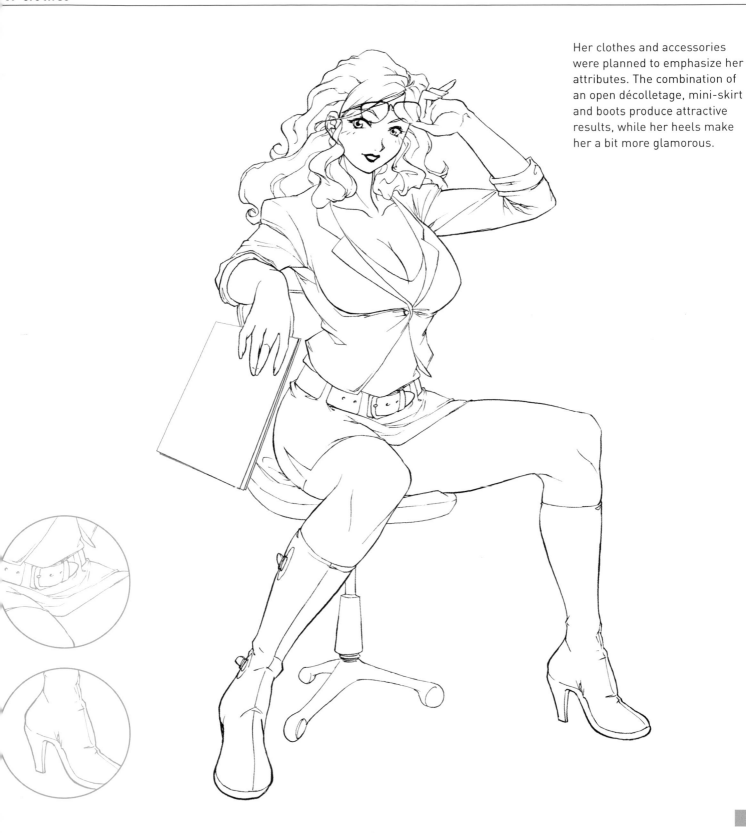

Her clothes and accessories were planned to emphasize her attributes. The combination of an open décolletage, mini-skirt and boots produce attractive results, while her heels make her a bit more glamorous.

Lighting plays in our favor to exaggerate our protagonist's attributes even further. It falls directly on her bosom and legs, highlighting her entire volume. The projected shadow helps make the surface the chair is resting on look more realistic.

Source of light

The selection of colors favors the character's role. White and black are elegant for clothes and help lend shape. Blonde hair is usually another symbol of femininity. The tiny highlights on her skin help make her anatomy stand out.

THIRTYSOMETHING

The psyche of a character is also very important, and there are certainly archetypes that cover this. It's common to find certain schemes that repeat themselves among female characters. Middle-age women, whether they are relatively young or mothers of a family, tend to display certain concerns, such as their personal relationships, their body weight, their body, their job, etc. A longing for childhood and its accompanying carefree life does well to encompass some of these aspects. They also tend to be slightly resentful of the younger generation. This explains why in this illustration we'll be comparing a young worker with a carefree girl.

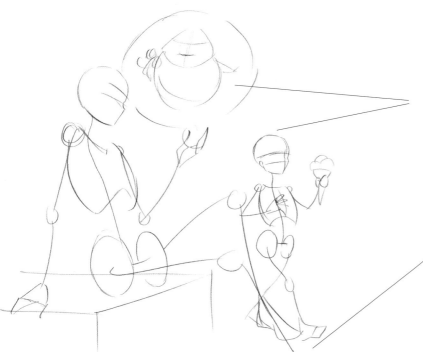

When the idea is to situate various figures in a single scene, the main thing is to choose our point of view in order to mark the correct location of the floor and the height of the characters.

Perspective can help us with this task. We'll put their feet on the same diagonal line of the floor and draw the resting point for the seated figure.

2. Volume

We'll mark off the volumes of each body while clearly differentiating the proportions of the adult woman and the child. The person who appears in the bubble completes the composition and will be an SD (superdeformed): small and chubby.

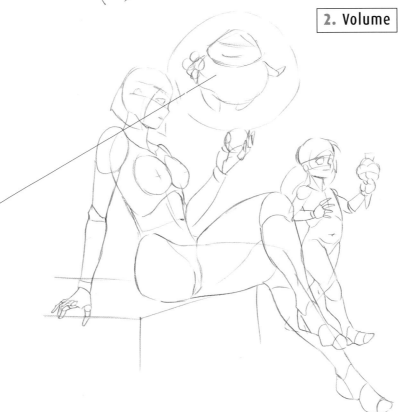

We can exaggerate the appearance of a middle-age woman by depicting her as worried about her figure despite her svelteness. This exaggeration makes the illustration more comical.

The proportions of their faces are quite different. The older one is, the smaller the eyes and the larger the nose and other elements of the face. Her gesture should be expressive and transmit the message without a need for words.

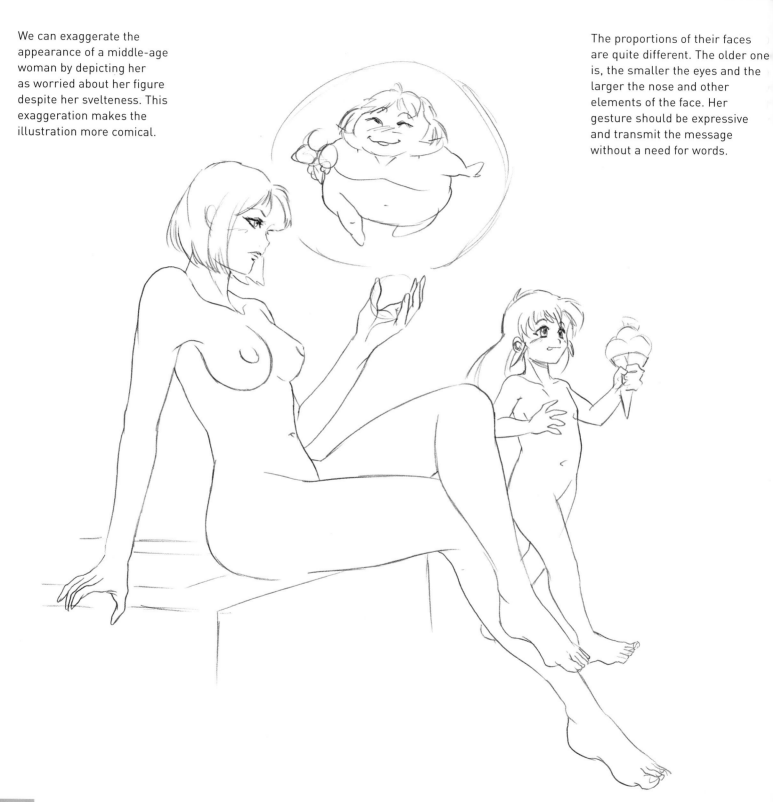

4. Clothes

Once again, their clothing helps us differentiate their roles. We'll give the working woman clothes that are typical of an office worker, or even a uniform.

We've given the girl a very masculine look, lending an ambiguous touch and making her that much more childish, which contrasts nicely with the adult's svelte, feminine figure.

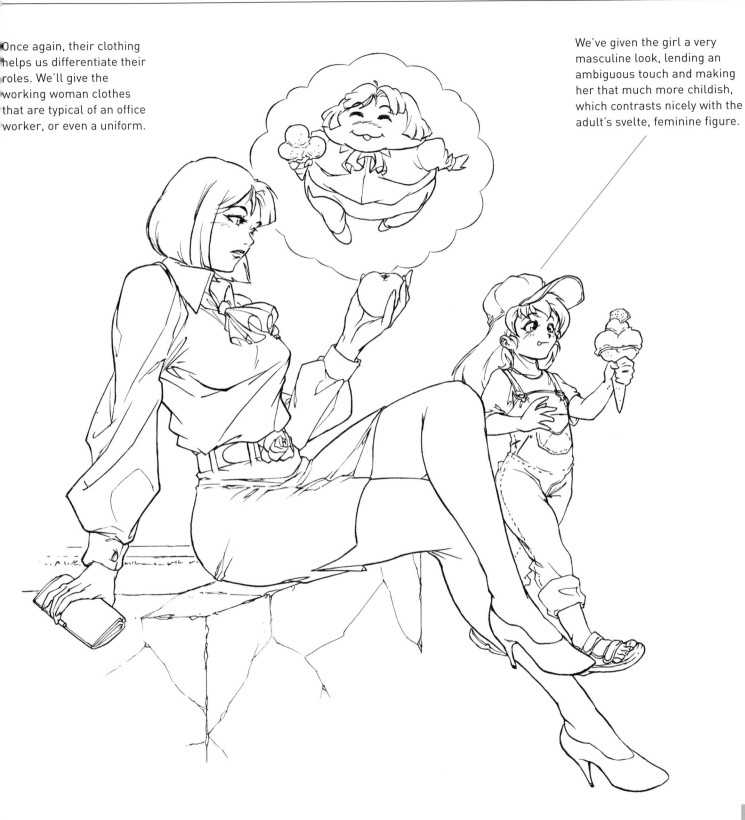

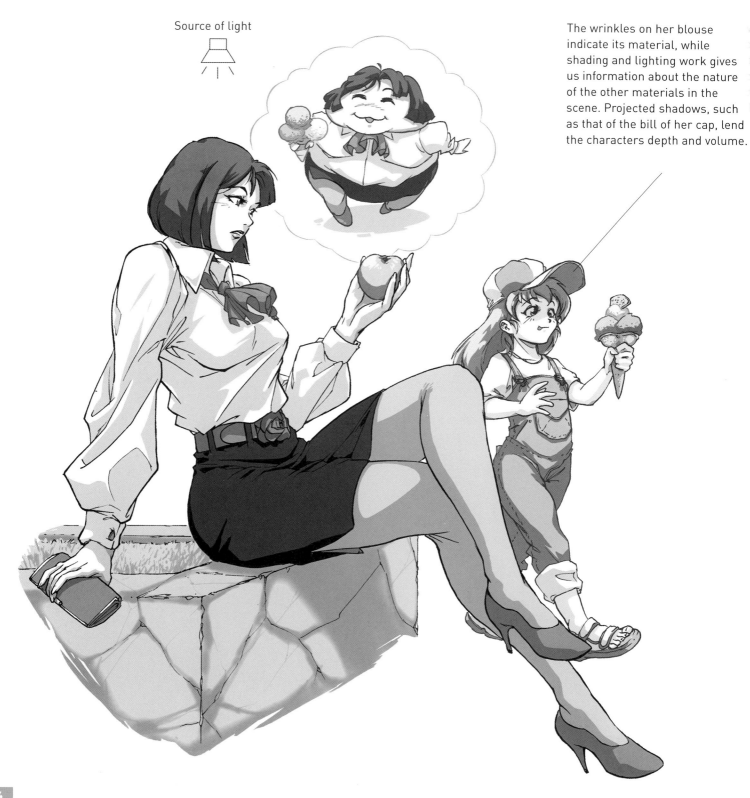

Source of light

The wrinkles on her blouse indicate its material, while shading and lighting work gives us information about the nature of the other materials in the scene. Projected shadows, such as that of the bill of her cap, lend the characters depth and volume.

We'll use color as yet another point of contrast between the two characters; selecting colder colors for the adult and brighter, more strident colors for the girl.

The more distinct the elements between the two figures, the more effective the contrast will be between them and the message. The girl's colored contour line helps put her into the scene's background.

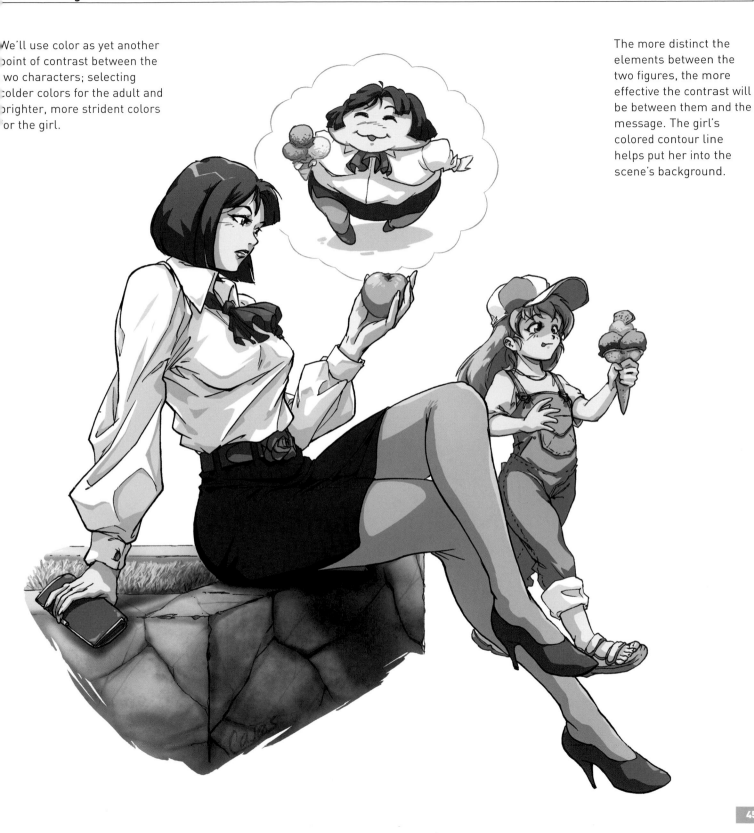

GRANDMOTHER

In manga, old folks are often keepers of knowledge. In many stories the grandfather or grandmother figure is used as a source of wisdom and advice. Time has given them the experience and patience necessary to use good judgment when reflecting upon the vicissitudes of life. What's more, they usually appear as an important counterpoint to young and impetuous heroes. Their fragile figure can be misleading since, even though they transmit calm and tranquility, they can be bottling up many years of hatred and bitterness. It's always enriching for a story to include an old person in it. We've opted for an innocent grandmother dressed in traditional clothing.

1. Shape

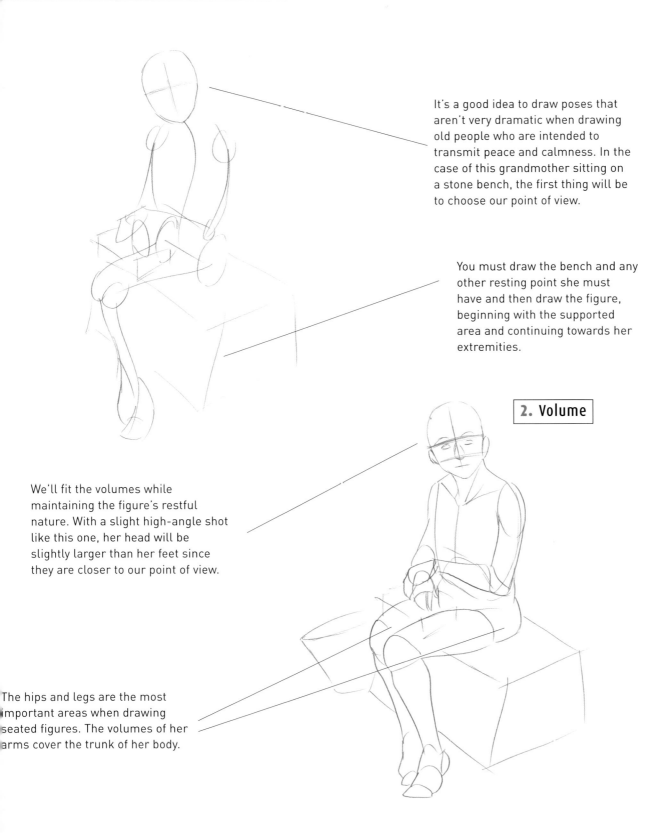

It's a good idea to draw poses that aren't very dramatic when drawing old people who are intended to transmit peace and calmness. In the case of this grandmother sitting on a stone bench, the first thing will be to choose our point of view.

You must draw the bench and any other resting point she must have and then draw the figure, beginning with the supported area and continuing towards her extremities.

2. Volume

We'll fit the volumes while maintaining the figure's restful nature. With a slight high-angle shot like this one, her head will be slightly larger than her feet since they are closer to our point of view.

The hips and legs are the most important areas when drawing seated figures. The volumes of her arms cover the trunk of her body.

Fundamental aspects when characterizing an old person are: their body, curved posture, flaccidity and wrinkles; as well as pronounced wrinkles in their face, smaller eyes and nose and larger ears. She may also be missing some teeth and hair.

Whatever a character's origin may be, choosing traditional clothing is always a good idea if we want them to look a little older. You can also choose old clothes that are out of style or dull colors.

We've added a couple of accessories that help us situate the action: a purse and a basket can tell us she's just come from shopping.

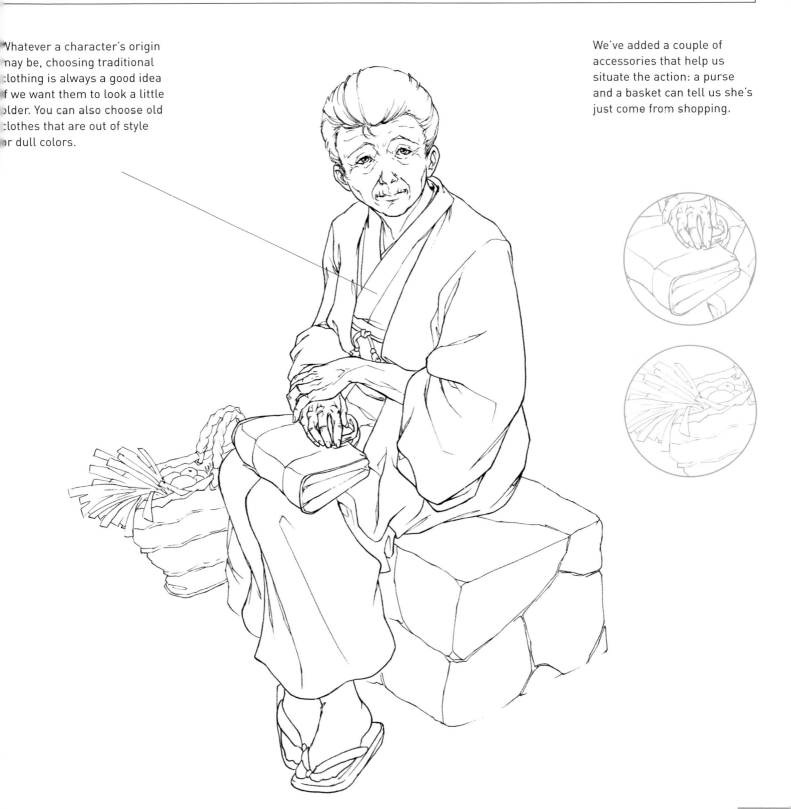

Once again, we'll use lighting as a way of treating different materials. Her hair, which is the brightest element, will have the greatest contrast.

Source of light

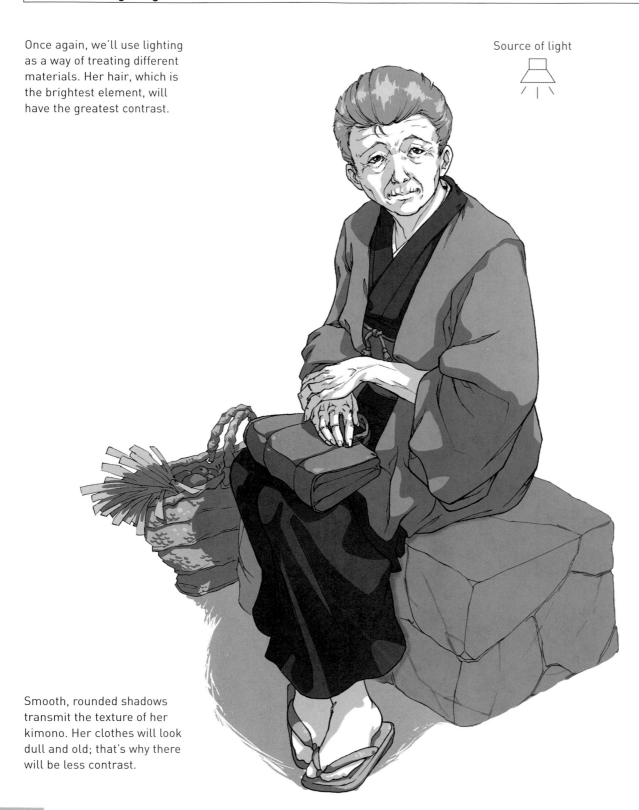

Smooth, rounded shadows transmit the texture of her kimono. Her clothes will look dull and old; that's why there will be less contrast.

Her skin color is light and soft and we've added some stains that suggest the imperfections of age. Sober colors are used for her clothes. The grass on the ground and the red and green of the vegetables in her shopping basket lend a touch of color.

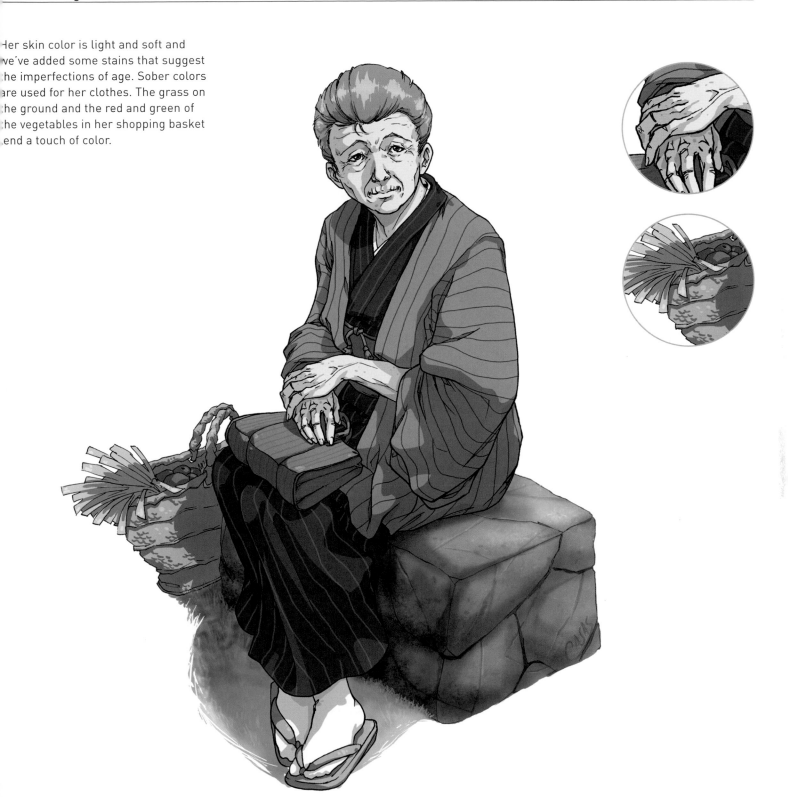

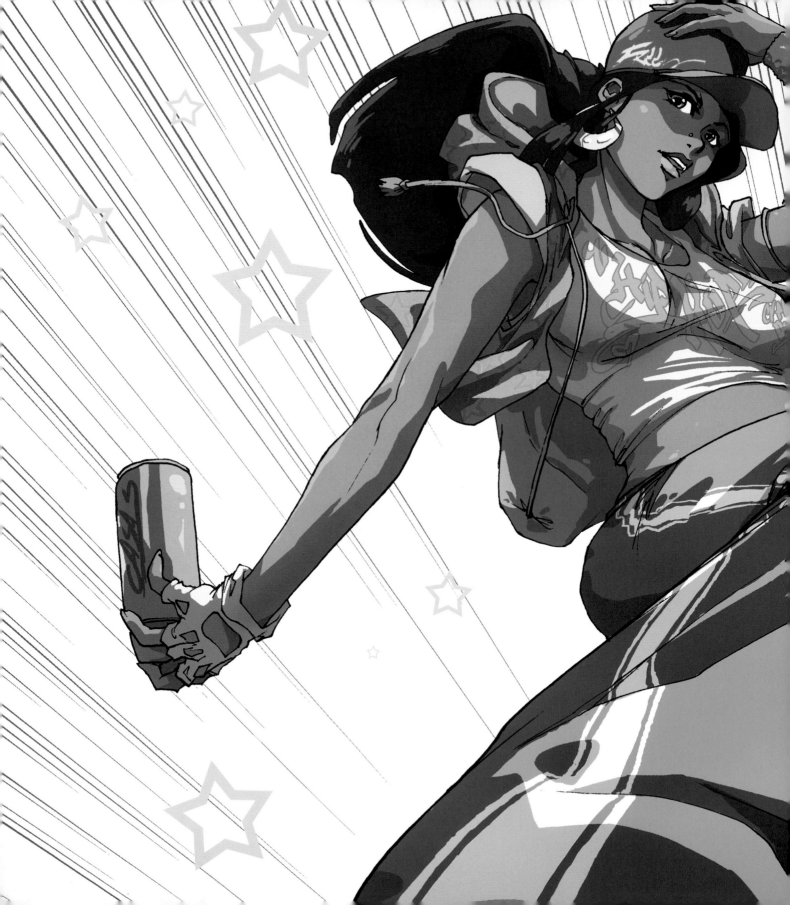

FASHION

KO-GAL

As we already said in the *gal* exercise, there exists an important subculture consisting of young Japanese girls that would be willing to die just to dress up in the latest styles and be on the cutting edge of fashion with their skin fully tanned and their hair dyed in a thousand colors.

Ko-gals tend to be Japanese schoolgirls who love to be in fashion, wear platform shoes, mini-skirts, use different color dyes for their hair, and follow the example set by important J-pop singers such as Namie Amuro. Nowadays this phenomenon has diversified so as to produce countless variations depending on their particular aesthetic references, as we already covered in the *gal* section.

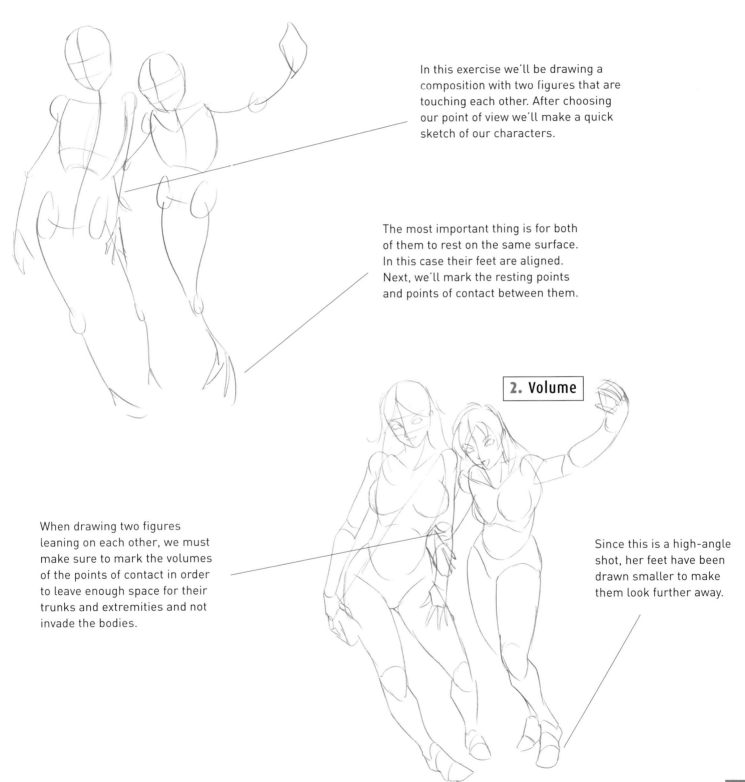

1. Shape

In this exercise we'll be drawing a composition with two figures that are touching each other. After choosing our point of view we'll make a quick sketch of our characters.

The most important thing is for both of them to rest on the same surface. In this case their feet are aligned. Next, we'll mark the resting points and points of contact between them.

2. Volume

When drawing two figures leaning on each other, we must make sure to mark the volumes of the points of contact in order to leave enough space for their trunks and extremities and not invade the bodies.

Since this is a high-angle shot, her feet have been drawn smaller to make them look further away.

Here we'll be drawing the bodies of two young adolescents who are very concerned about their appearance. Their attitude is usually ostentatious and provocative. They like to pose and show off.

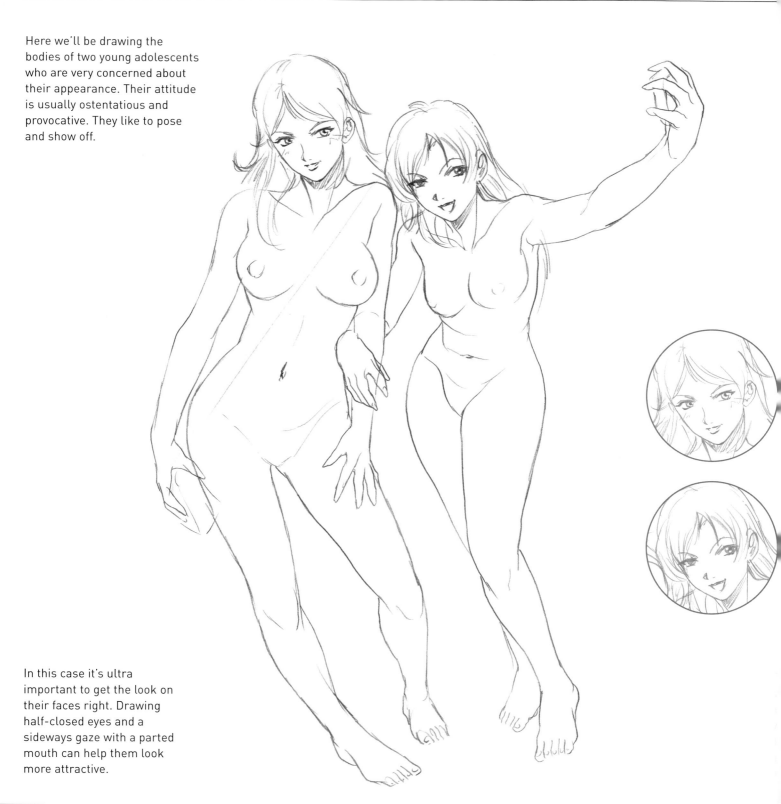

In this case it's ultra important to get the look on their faces right. Drawing half-closed eyes and a sideways gaze with a parted mouth can help them look more attractive.

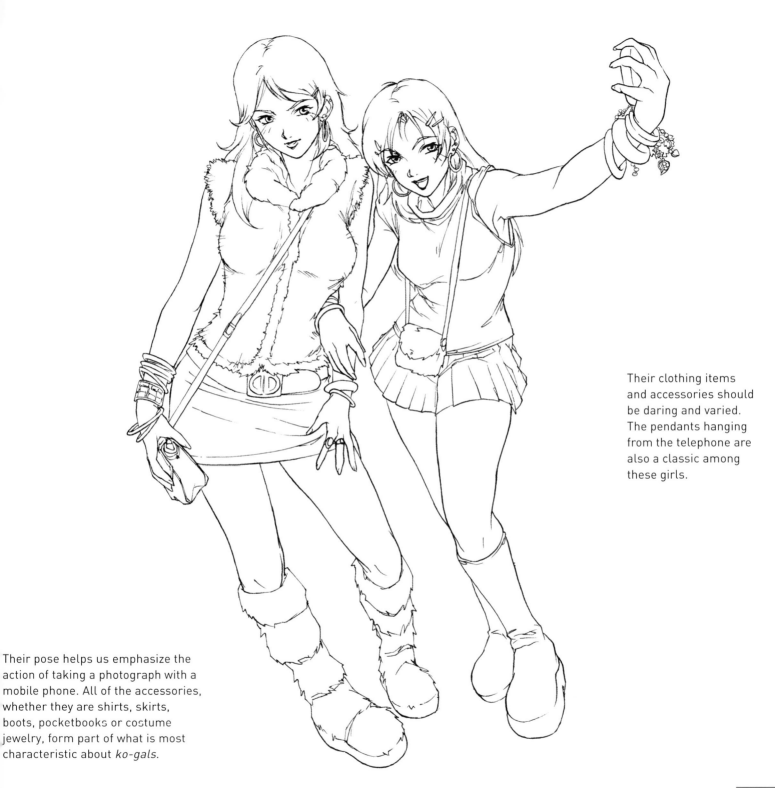

Their clothing items and accessories should be daring and varied. The pendants hanging from the telephone are also a classic among these girls.

Their pose helps us emphasize the action of taking a photograph with a mobile phone. All of the accessories, whether they are shirts, skirts, boots, pocketbooks or costume jewelry, form part of what is most characteristic about *ko-gals*.

Projecting our protagonists' shadows gives us a floor to place them on. The shadows give the figures weight and dimension. We can achieve the fur texture on the waistcoat and boots using short strokes that shape the articles of clothing.

Source of light

We've chosen a dark skin color that is characteristic of *ganguro*, emphasizing their tan skin and attractive make-up.

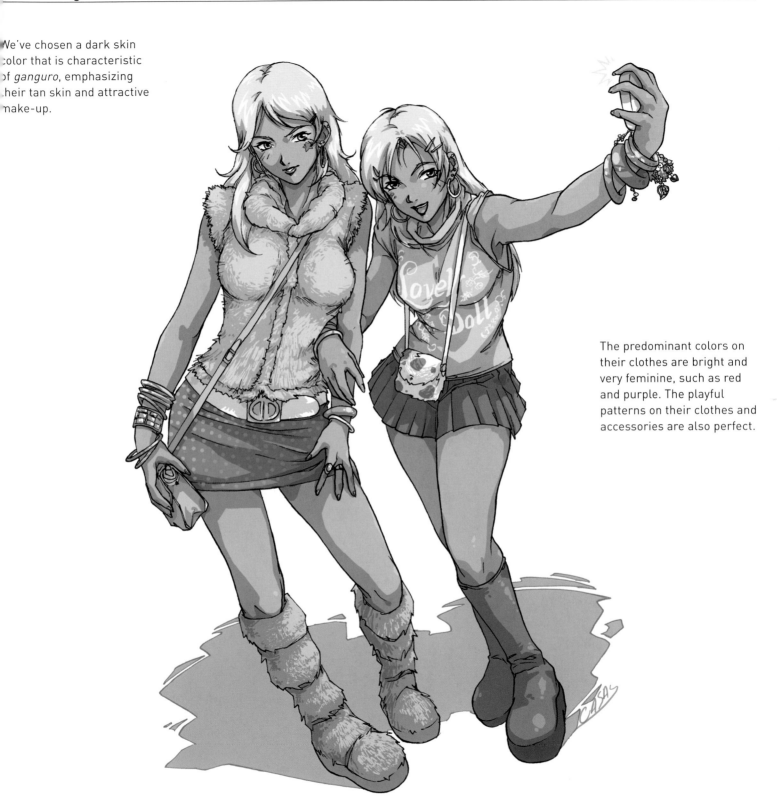

The predominant colors on their clothes are bright and very feminine, such as red and purple. The playful patterns on their clothes and accessories are also perfect.

VISUAL KEI

Visual kei is a movement with a strong aesthetic influence that began in the late eighties and early nineties. Musically, it combines rock, heavy metal, punk and even Japanese kabuki, represented by bands like Dir en Grey.

It's a movement that sets itself up against the deeply conservative traditional Japanese aesthetic, promoting a *radikal* look that oscillates between being beautiful, sinister and eclectic and, oftentimes, possesses a strong androgynous component so that we may find that even many boys play the parts of girls. Their make-up is extravagant, their hairdos exaggerated and their clothing is in keeping with their character.

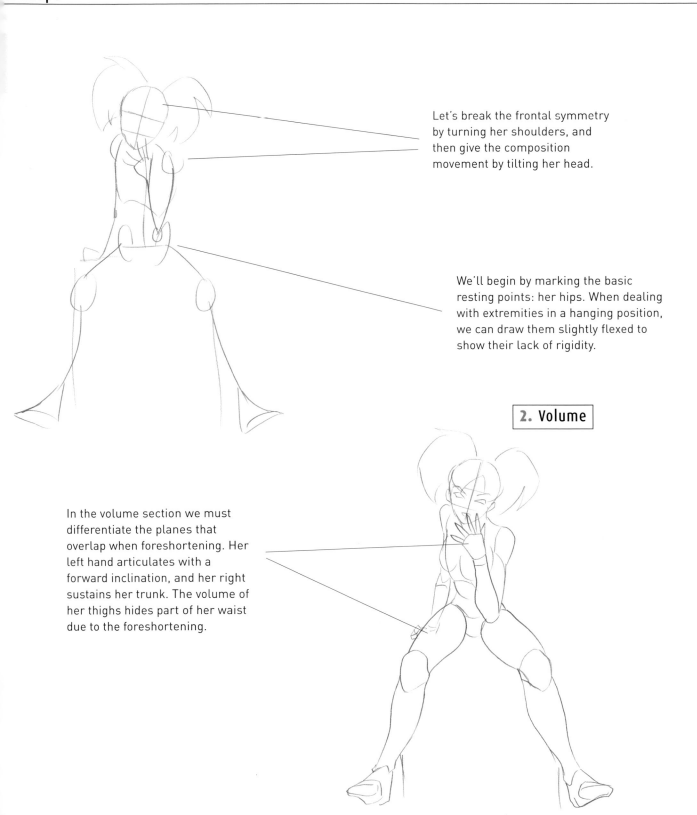

1. Shape

Let's break the frontal symmetry by turning her shoulders, and then give the composition movement by tilting her head.

We'll begin by marking the basic resting points: her hips. When dealing with extremities in a hanging position, we can draw them slightly flexed to show their lack of rigidity.

2. Volume

In the volume section we must differentiate the planes that overlap when foreshortening. Her left hand articulates with a forward inclination, and her right sustains her trunk. The volume of her thighs hides part of her waist due to the foreshortening.

Although it's common to find androgynous characters, we've chosen a real girl, although her feminine attributes are discreet: small breasts and a straighter body. Her thinness is befitting her role. Her hand gesture should be delicate and feminine.

Elements borrowed from the fantasy world, such as her crown, her wings and the horns on her boots, lend a more dramatic touch.

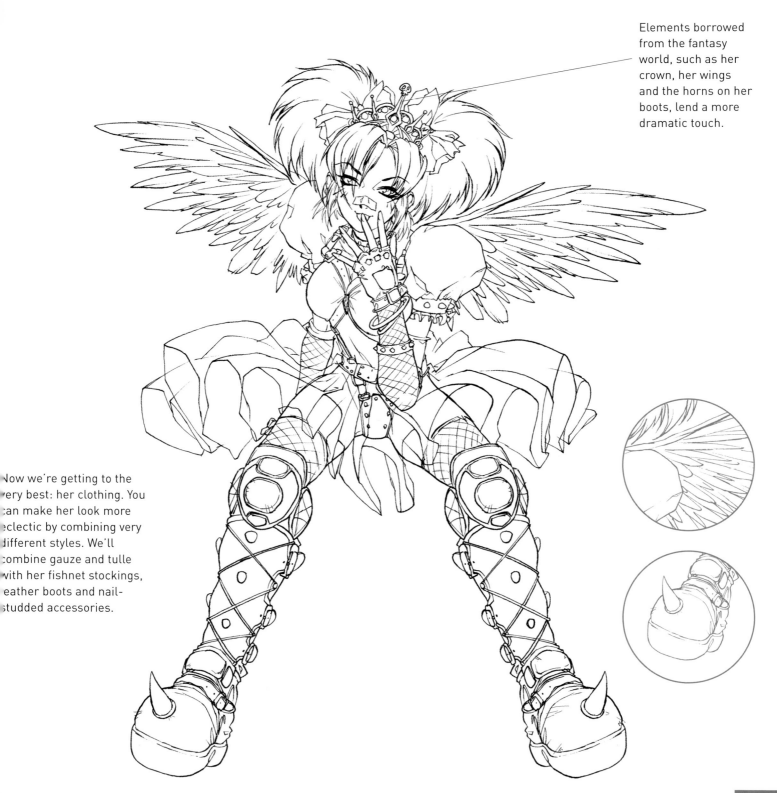

Now we're getting to the very best: her clothing. You can make her look more eclectic by combining very different styles. We'll combine gauze and tulle with her fishnet stockings, leather boots and nail-studded accessories.

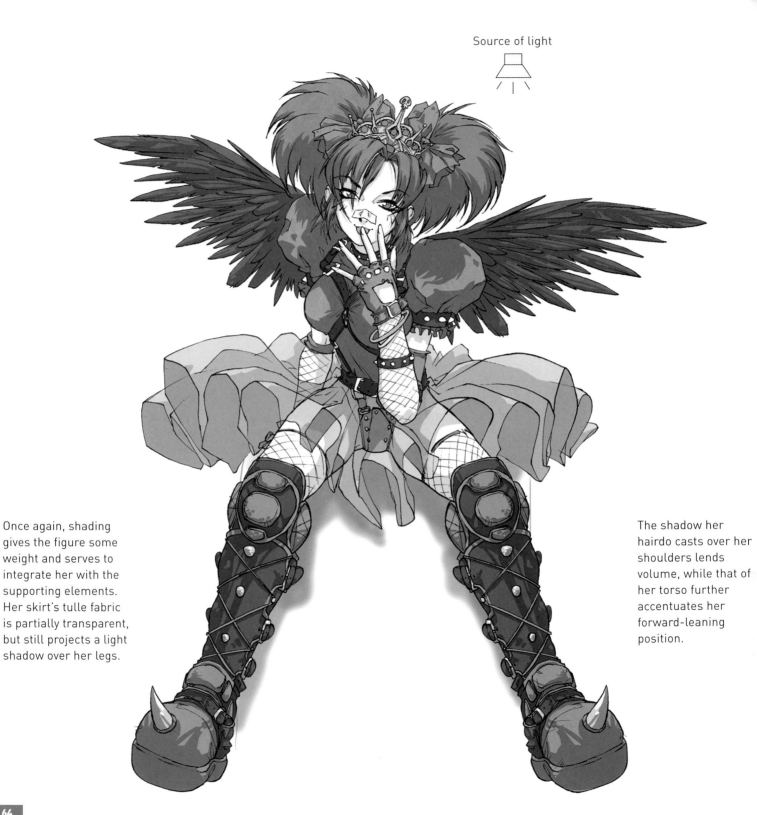

Source of light

Once again, shading gives the figure some weight and serves to integrate her with the supporting elements. Her skirt's tulle fabric is partially transparent, but still projects a light shadow over her legs.

The shadow her hairdo casts over her shoulders lends volume, while that of her torso further accentuates her forward-leaning position.

We'll break the black of her wings and leather with a tone that combines with ink. For her hair we'll use whatever colors we like while searching for a radical look. We'll finish by seating our protagonist on a gravestone.

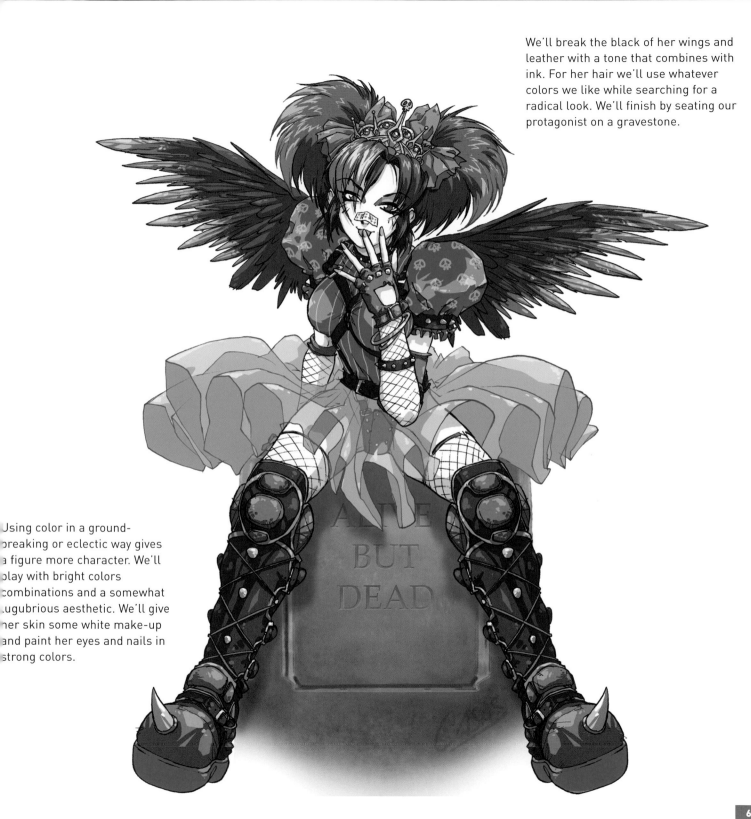

Using color in a ground-breaking or eclectic way gives a figure more character. We'll play with bright colors combinations and a somewhat lugubrious aesthetic. We'll give her skin some white make-up and paint her eyes and nails in strong colors.

GOTHIC LOLITA

One of the Japanese sub-cultures to have most surprised fans in the West is the Lolita style. In many ways, it's an answer to the idealized vision the Japanese have been given with respect to western history; in this case an aristocratic past. Although it can't be narrowed down to a single music style, groups like Malice Mizer, who mix pop-rock with punk and glam, kabuki and the gothic look helped promote this phenomenon. Mana, who had great success with Malice Mizer, was the designer who did the most to promote the gothic Lolita. Although the Victorian era combination of black and white prevails, we can also find a wide variety of styles and influences.

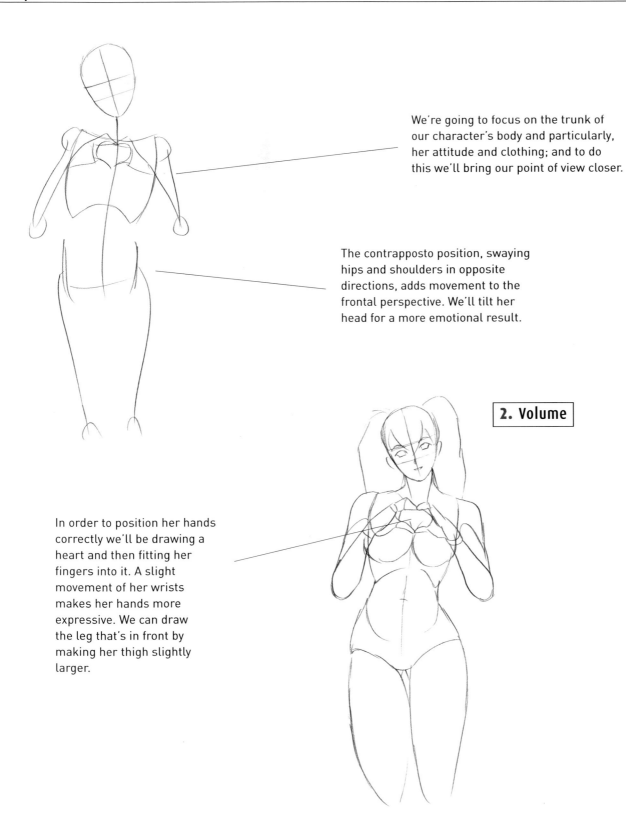

We're going to focus on the trunk of our character's body and particularly, her attitude and clothing; and to do this we'll bring our point of view closer.

The contrapposto position, swaying hips and shoulders in opposite directions, adds movement to the frontal perspective. We'll tilt her head for a more emotional result.

2. Volume

In order to position her hands correctly we'll be drawing a heart and then fitting her fingers into it. A slight movement of her wrists makes her hands more expressive. We can draw the leg that's in front by making her thigh slightly larger.

Her hands must be drawn correctly to center one's attention on the character's gesture. Her expression is a bit cold, imitating the rictus of a porcelain doll.

Lassitude is another characteristic of this illustration: her articulations are boney and reveal part of her skeleton, such as her shoulders and hips.

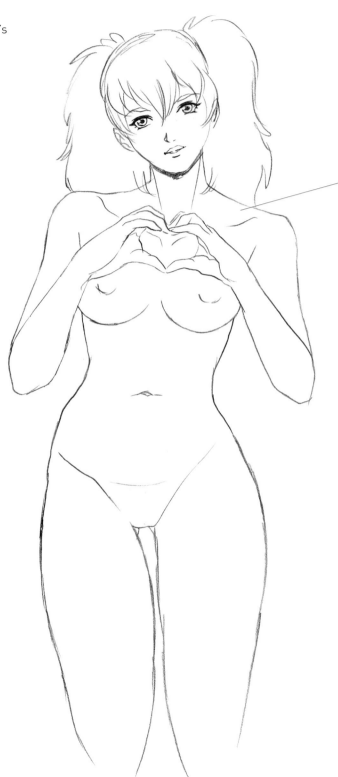

4. Clothes

The clothing articles on which the Lolita style is traditionally based have Rococo and Victorian influences that are then depicted from a modern and idealized perspective.

We'll use a black and white combination with lots of lace, bows and adornments. For more volume we'll be adding a petticoat to her skirt, which is usually worn at knee-level.

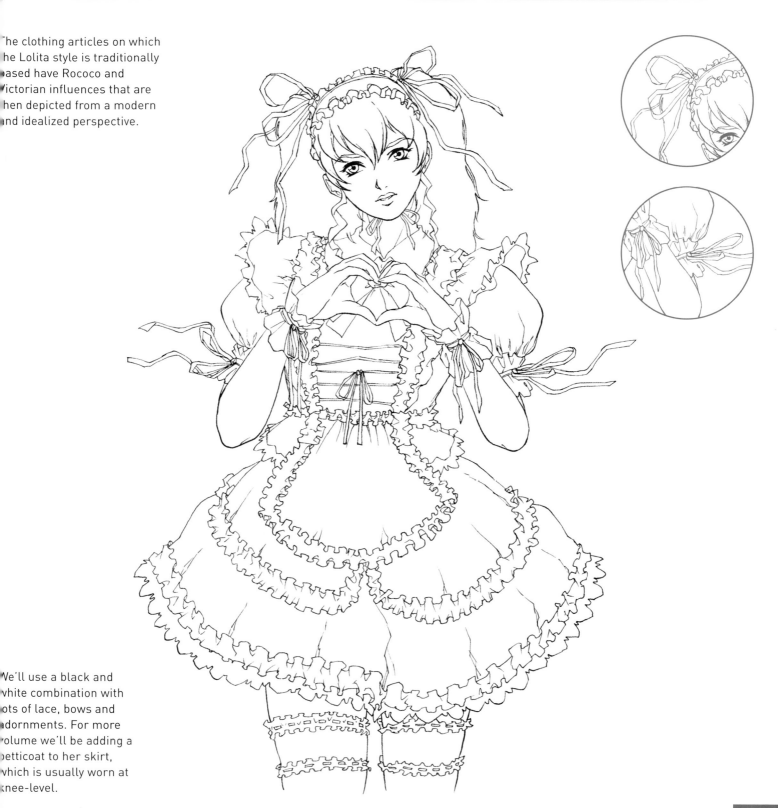

We'll use soft lighting to assist with the general tone of the image. Her hair projects a shadow over her face. And the shadow her skirt casts on her thighs lends volume to her clothing. The light falling on her right leg indicates that it is placed forward.

Source of light

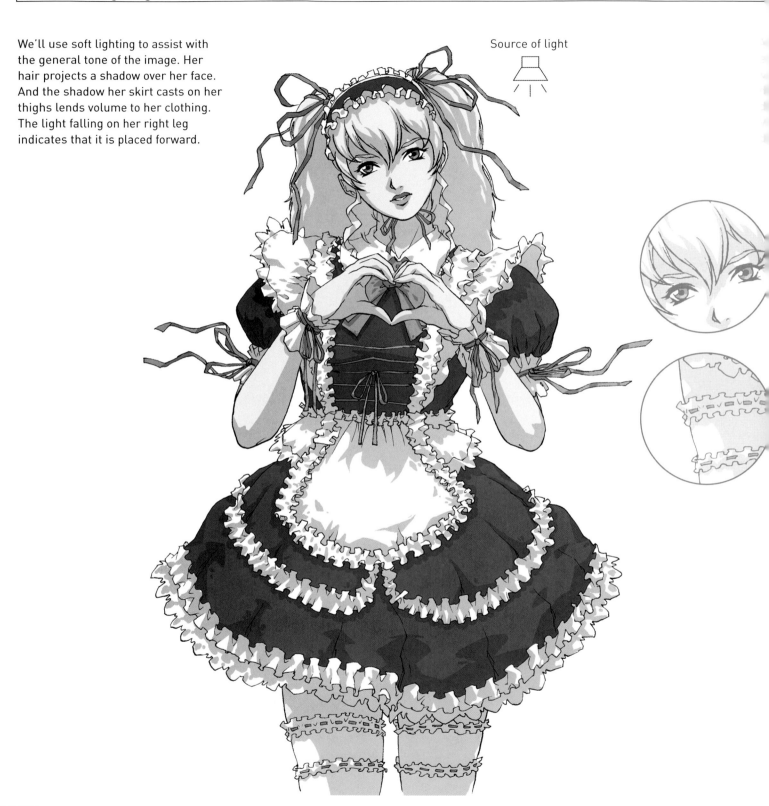

As we've already shown, we'll stick to the classic black and white color scheme when coloring her outfit. Her lace and silks will be appreciated better in white. We'll add a touch of color to the bows decorating her clothes.

Her eyes, which are of an intense color, resemble the contact lenses that kids sometimes wear. Her platinum blonde hair becomes just another token of her individuality.

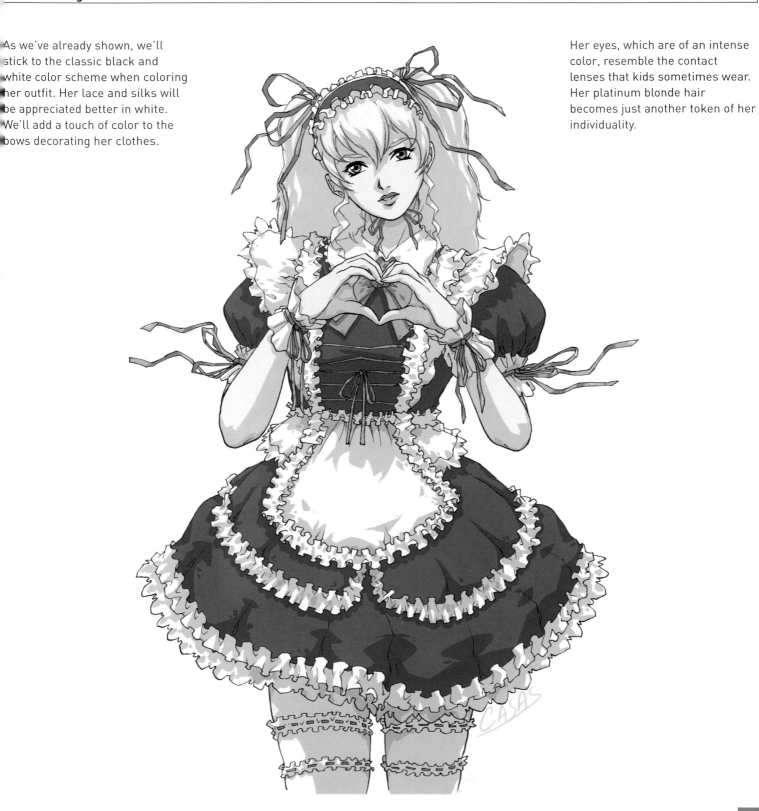

OTAKU

In Japan an *otaku* is a fanatic who spends too much time, money and effort on their hobbies. They are people who keep too much to themselves and pretty much live for their hobby: manga, computers, anime, models. In Japan the term is used in a derogatory sense, although some people wear the tag with pride. In the West its meaning changed considerably, becoming an umbrella word for manga enthusiasts, and has positive or negative connotations depending on who is using it.

Akiba-kei is the most famous of all *otakus*. His name derives from the Tokyo neighborhood Akihabara, where there are lots of specialized shops that are primarily obsessed with anime and videogames.

1. Shape

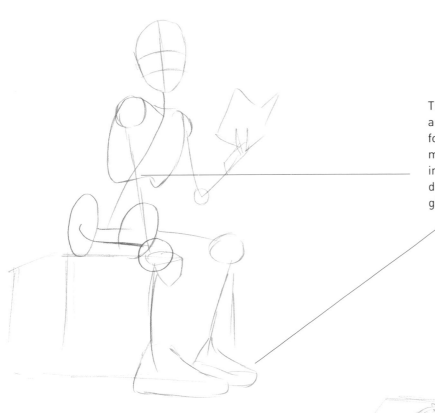

This time we've opted for a slightly low-angle perspective. Elements in the foreground, such as her feet, will appear much larger. We'll be drawing our character in a relaxed position since she is sitting down reading. We'll arch her back slightly to give her figure some movement.

2. Volume

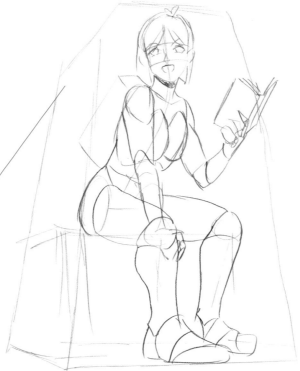

When drawing low- or high-angle perspectives we can draw boxes in perspective to help understand the volumes of bodies in an image. It's time to shape the other elements of the image: her knapsack, the book and the bench.

Otakus don't have an athletic build. They belong to a sub-culture that doesn't engage in much physical activity, so we can choose a very natural-looking body with wide hips.

Her face is childish and shows a puerile expression. Adding freckles can help achieve this look. Keeping in step with the character's personality, her hair is not very long and it's somewhat uncombed.

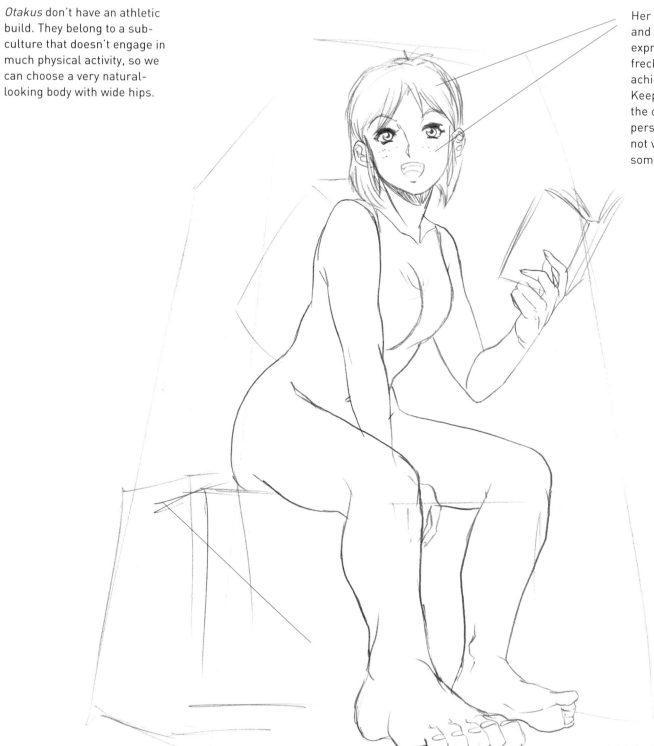

All of the details that characterize our *otaku* are related to her favorite leisure activities. We'll find references to anime series on her clothes and accessories.

In addition to the omnipresent knapsack, she also has a bag carrying her cosplay, the outfit of her favorite anime character. We can also see the kinds of shopping bags that are typical of great events such as Comiket.

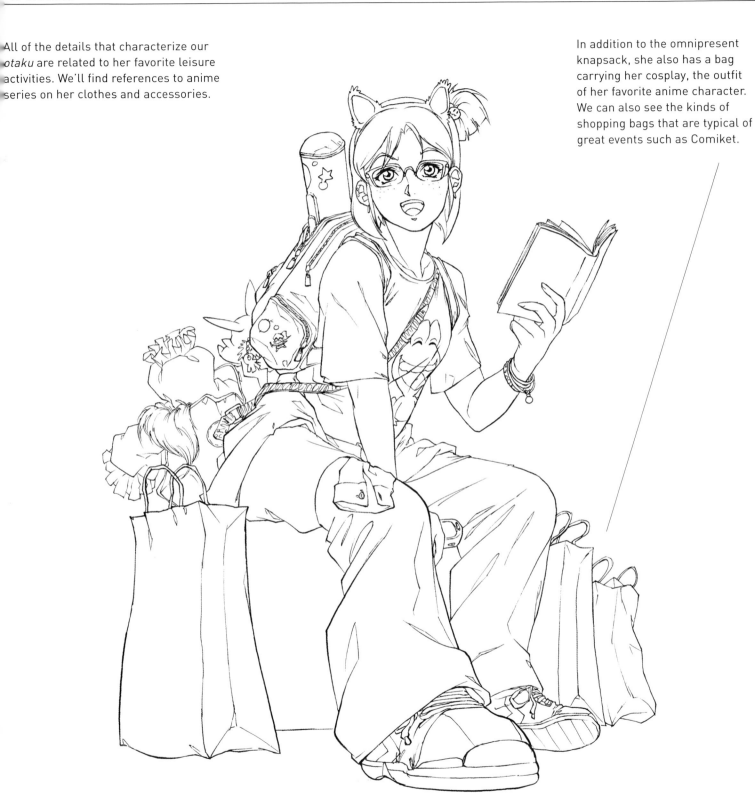

We'll use shading to give the stone bench some texture. The book cover and the arm holding it are also in shade on account of the position of the light source.

Source of light

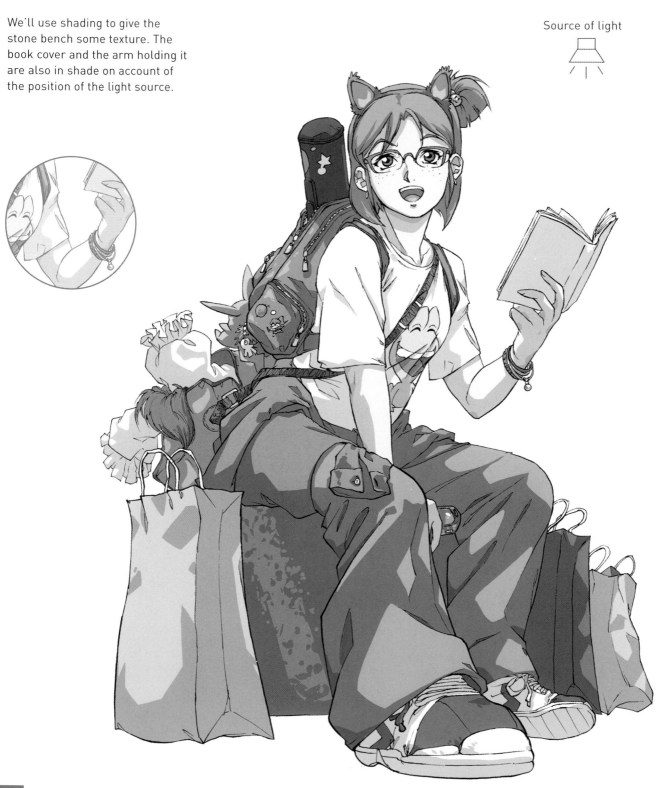

6. Finishing Touches

The selection of colors for her clothes indicate she doesn't match very much, is eclectic and not very feminine. So we're putting greater emphasis on her hobby than on her appearance. Next, we'll add some brand names on her shopping bags and patterns on her clothes.

We'll finish by drawing the cover of the manga that's in her hand, being mindful that people there read in the opposite direction than in the West.

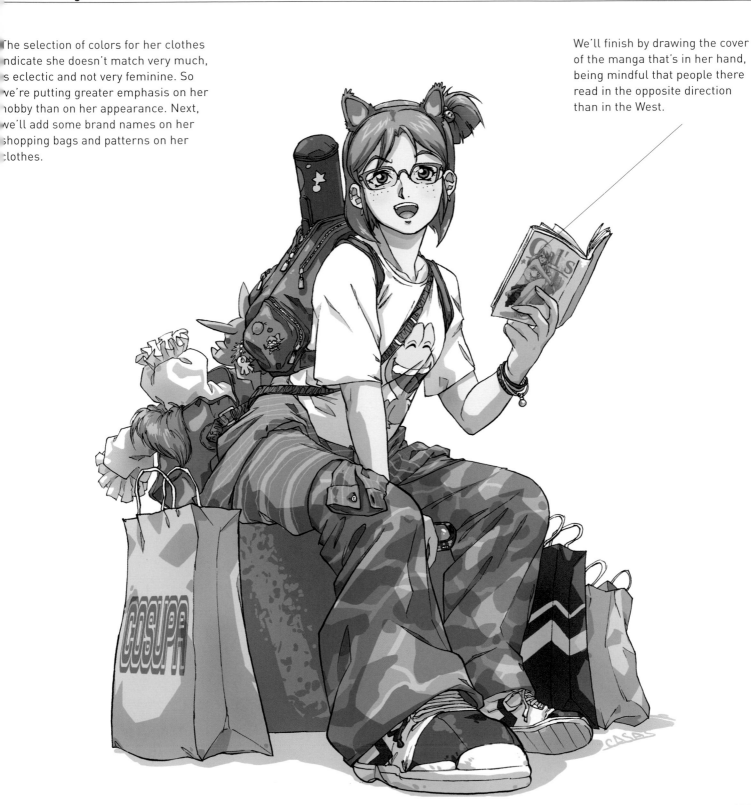

B-GIRL

B-boys and b-girls, or fly-girls, are all terms used for kids who are into hip-hop, and particularly the dance aspects of the genre. Hip-hop was born back in the seventies as a fundamentally urban movement among the Hispanic and Afro-American communities in the poorer New York neighborhoods. The style is primarily expressed in music (rap, funk or electro beat), dance, with break dancing being the key, and finally, the graffiti culture, but it also exerts influence on today's fashion and trends. We've sought out a dynamic pose for this character, one that encompasses the hip-hop spirit and reflects some of its characteristics.

1. Shape

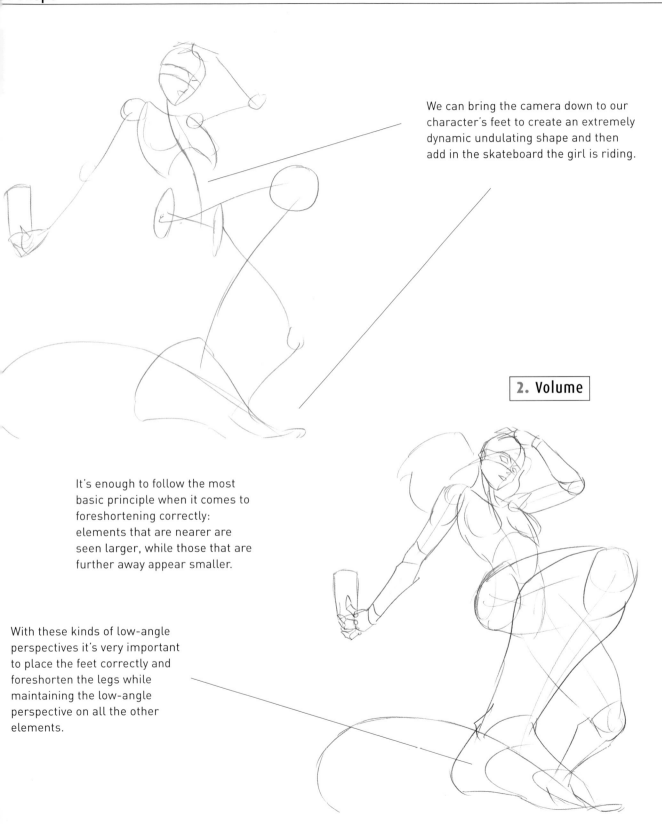

We can bring the camera down to our character's feet to create an extremely dynamic undulating shape and then add in the skateboard the girl is riding.

2. Volume

It's enough to follow the most basic principle when it comes to foreshortening correctly: elements that are nearer are seen larger, while those that are further away appear smaller.

With these kinds of low-angle perspectives it's very important to place the feet correctly and foreshorten the legs while maintaining the low-angle perspective on all the other elements.

Many hip-hop activities have a strong physical content, so it's not a bad idea to draw our b-girl with a strong and svelte body, riding her skateboard and holding her hat in a pose that seems straight out of a break dancing move.

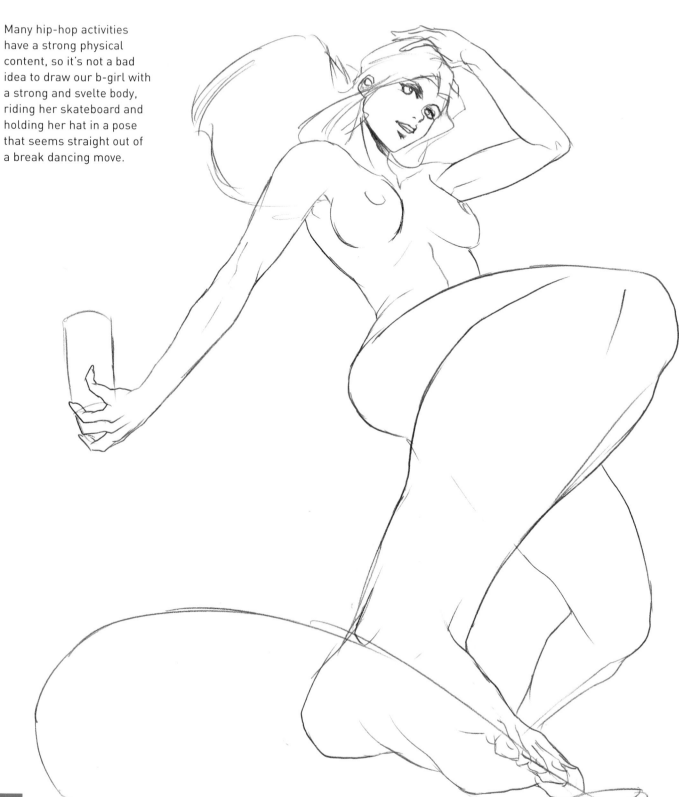

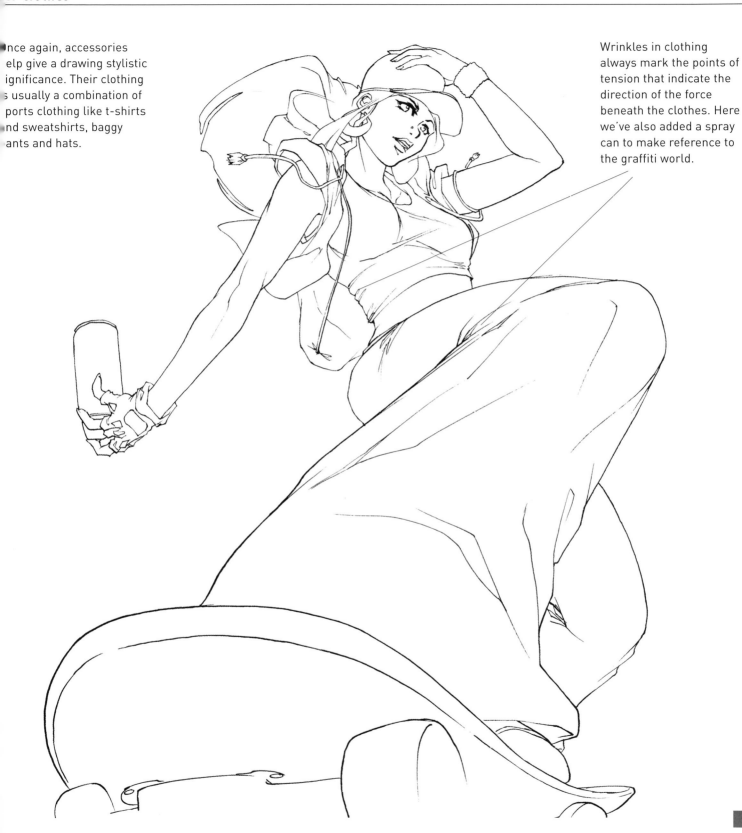

Once again, accessories help give a drawing stylistic significance. Their clothing is usually a combination of sports clothing like t-shirts and sweatshirts, baggy pants and hats.

Wrinkles in clothing always mark the points of tension that indicate the direction of the force beneath the clothes. Here we've also added a spray can to make reference to the graffiti world.

Shadows help accentuate the low-angle point of view. If we gather the greater mass of shadows down below, we'll be giving this part of her figure greater weight. The skateboard is almost completely in shadow, as we only see its lower part.

Source of light

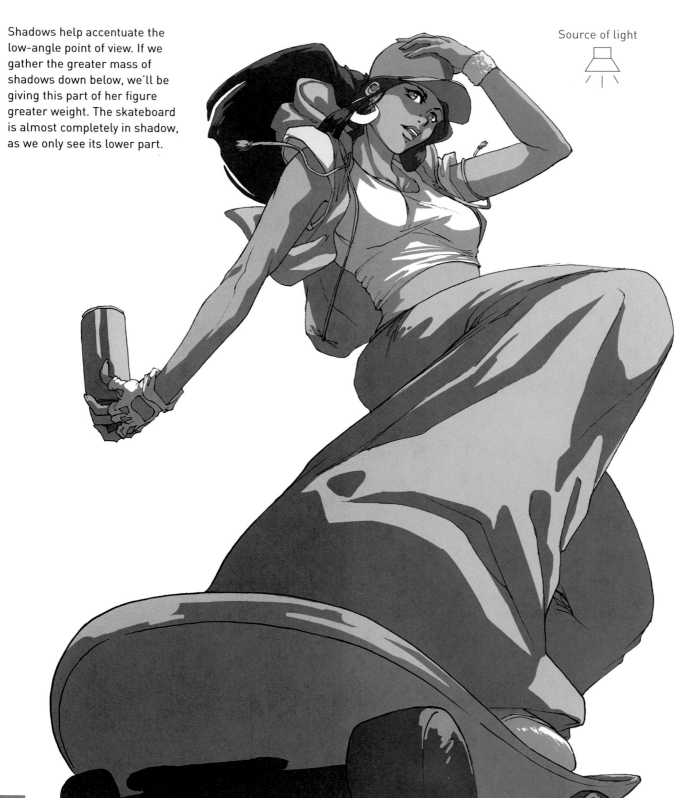

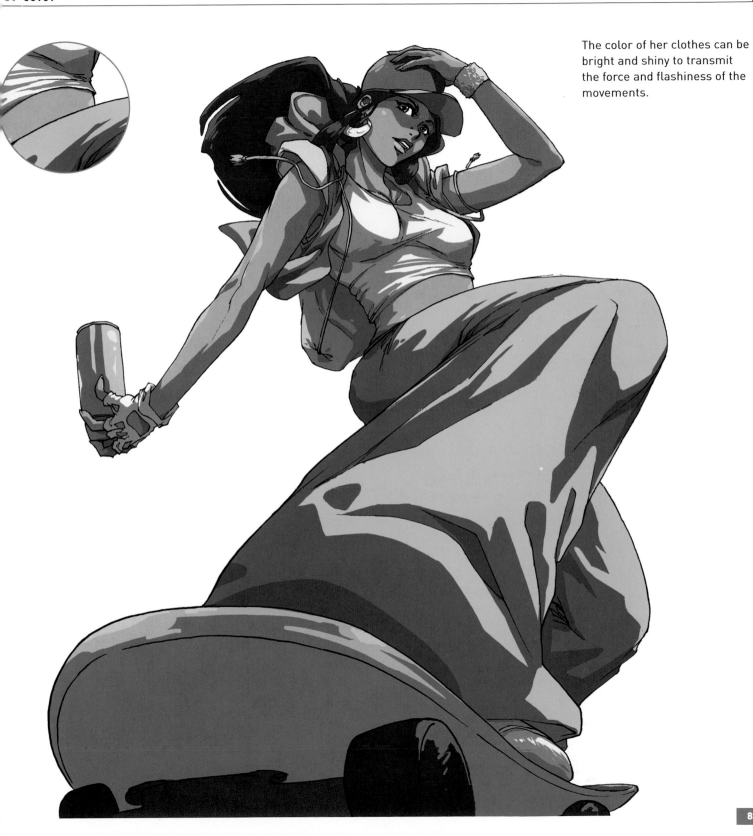

The color of her clothes can be bright and shiny to transmit the force and flashiness of the movements.

Adding texture is the way to increase an image's realism. We'll create motifs and patterns for her clothes, which should follow the shape and perspective of the objects they are drawn over.

We can draw logotypes with typographies that are typical of graffiti artists. And we should do the same with the stickers decorating her skateboard, which should also adjust the perspective on the stickers.

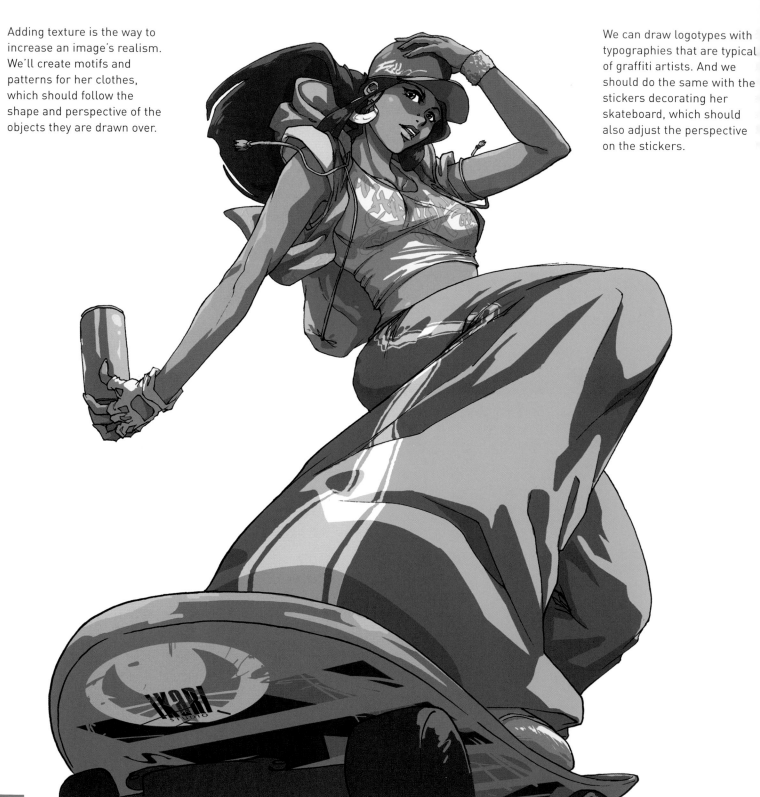

Secondly, there are the textures of the materials themselves such as the scraped wood of the skateboard, which we'll achieve by following the board's direction and foreshortening.

In manga kinetic lines are the effect most used to create a sense of movement. To draw them we need only take one point of origin as a reference.

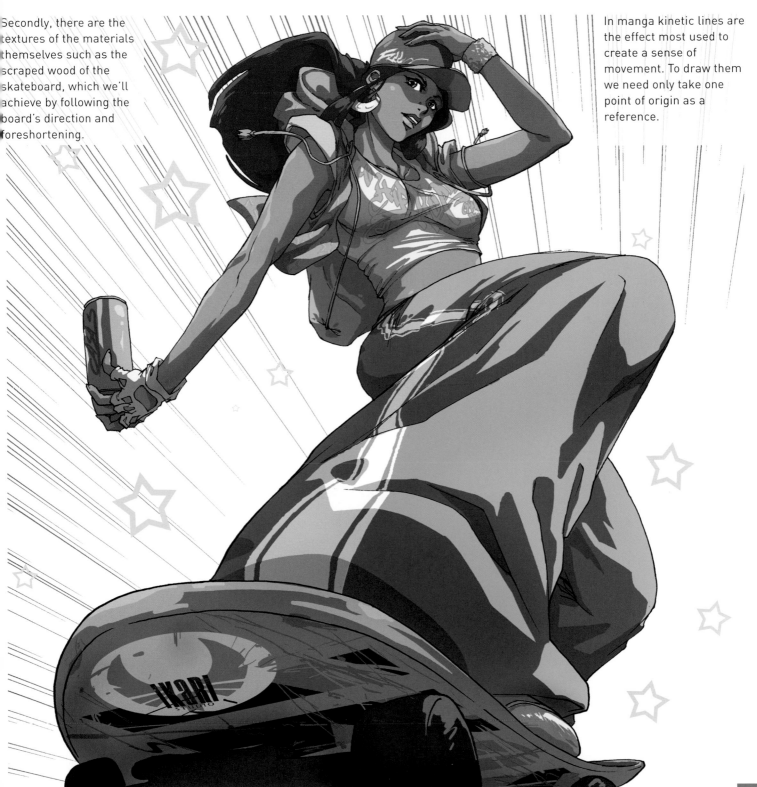

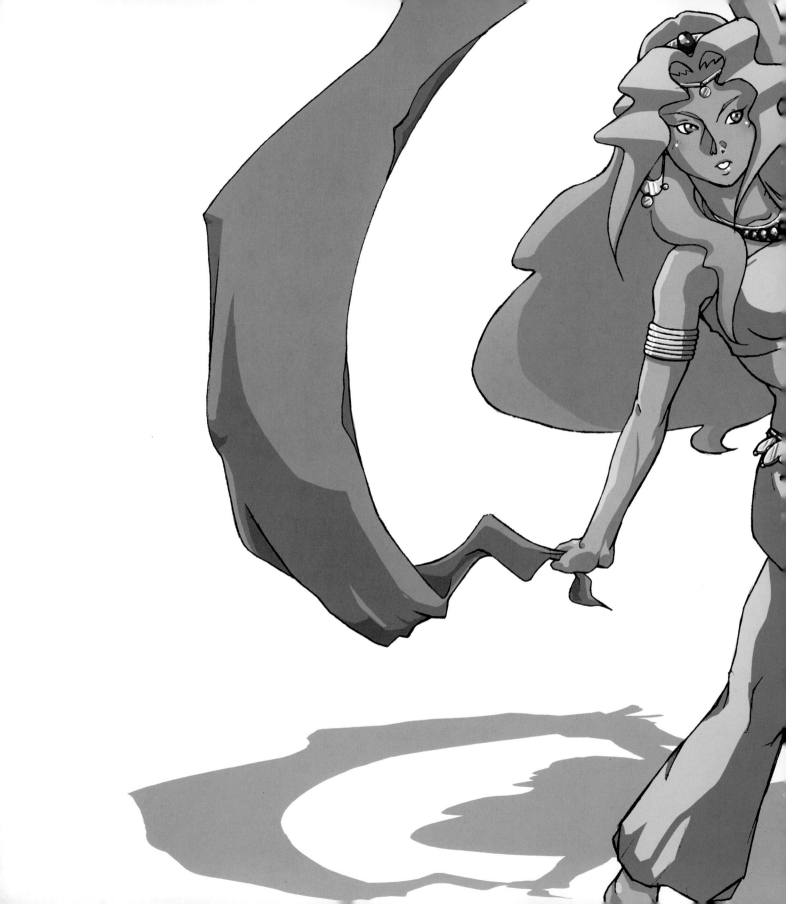

PRINCESSES OF THE WORLD

TRADITIONAL EUROPEAN PRINCESS

When we talk about the traditional European princess, we're talking about the princess in fairy tales, the one every prince tries to rescue from a haunted castle, or save from an evil character or from the jaws of a terrifying monster. We're talking about the kind of princess who wears a dress full of ruffles and a crown of precious stones.

Japanese authors tend to turn to these kinds of princesses when writing their stories, especially when adapting classical literature or European concepts such as the Princess Knight (*Ribbon no Kishi*). We'll be basing ourselves on this kind of model as we draw a princess with classical elements.

1. Shape

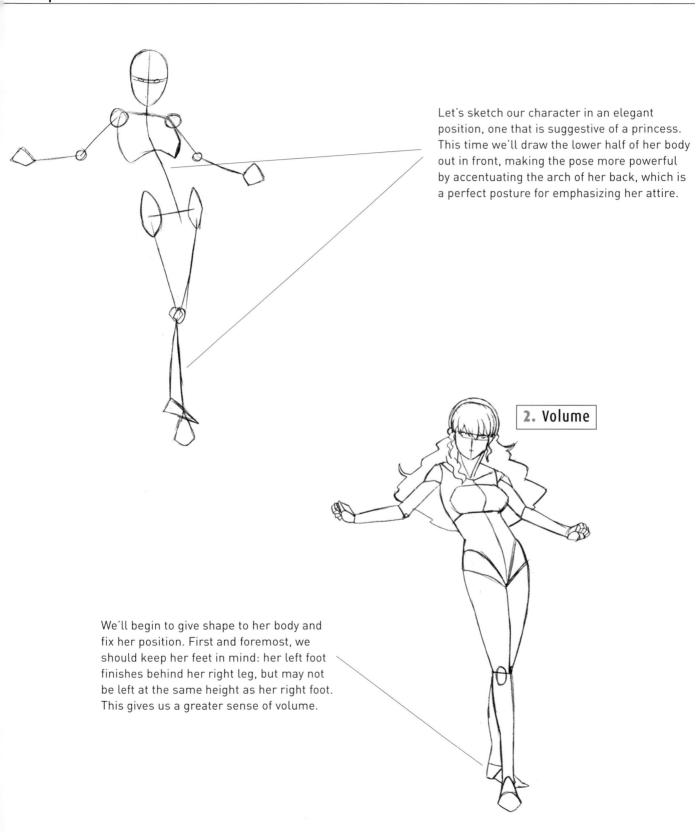

Let's sketch our character in an elegant position, one that is suggestive of a princess. This time we'll draw the lower half of her body out in front, making the pose more powerful by accentuating the arch of her back, which is a perfect posture for emphasizing her attire.

2. Volume

We'll begin to give shape to her body and fix her position. First and foremost, we should keep her feet in mind: her left foot finishes behind her right leg, but may not be left at the same height as her right foot. This gives us a greater sense of volume.

Princesses are not used to performing tasks that require a lot of physical strength, so her body will not be athletic, but rather frail instead.

We'll make her look fragile by drawing totally flat arms, without marking a single muscle; the same with her legs, where we'll just mark off the articulations.

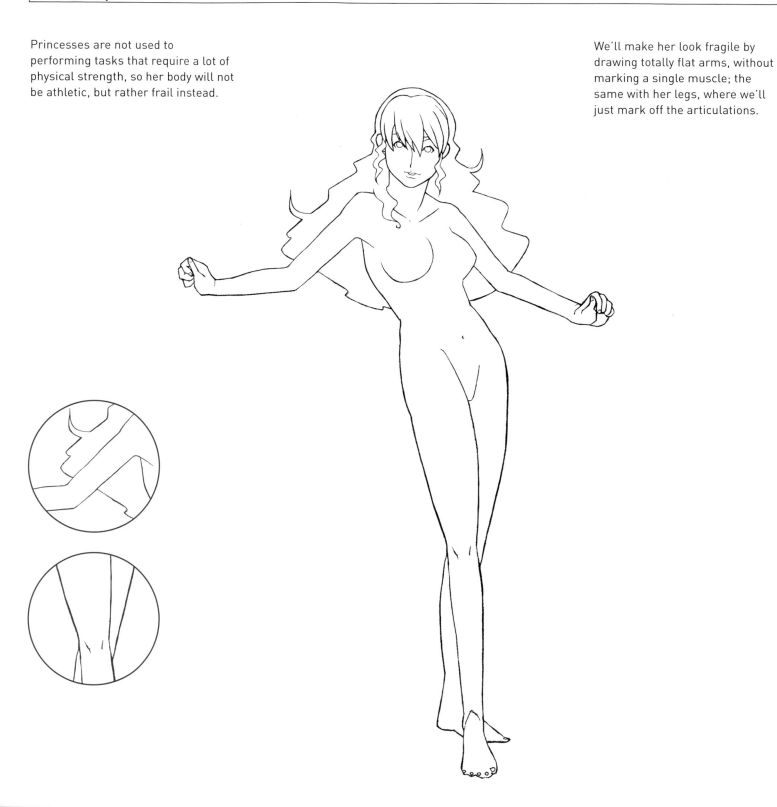

In this case we've chosen a dress with a simple but elegant cut, without many folds, which will make her brooch and crown stand out more in the end.

We can use our taste to draw her clothing: a dress with impossible ruffles and overloaded jewelry, or opt for a more sober tone instead.

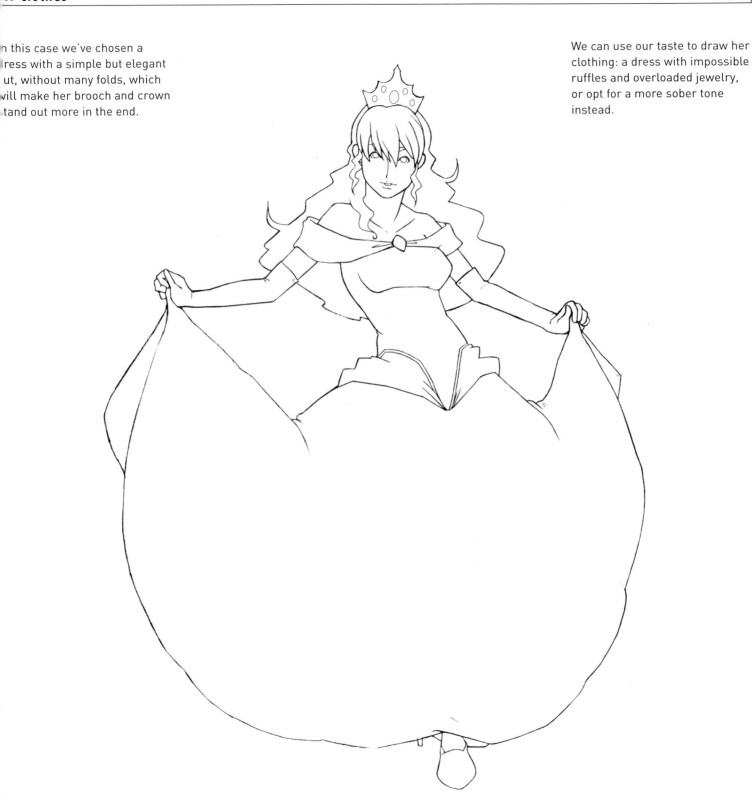

In this exercise we'll be using a zenithal lighting that will help us draw the folds in her dress as well as accentuating its volume and that of her body. We must bear in mind that light doesn't fall the same way on fabric as it does on a piece of jewelry.

Source of light

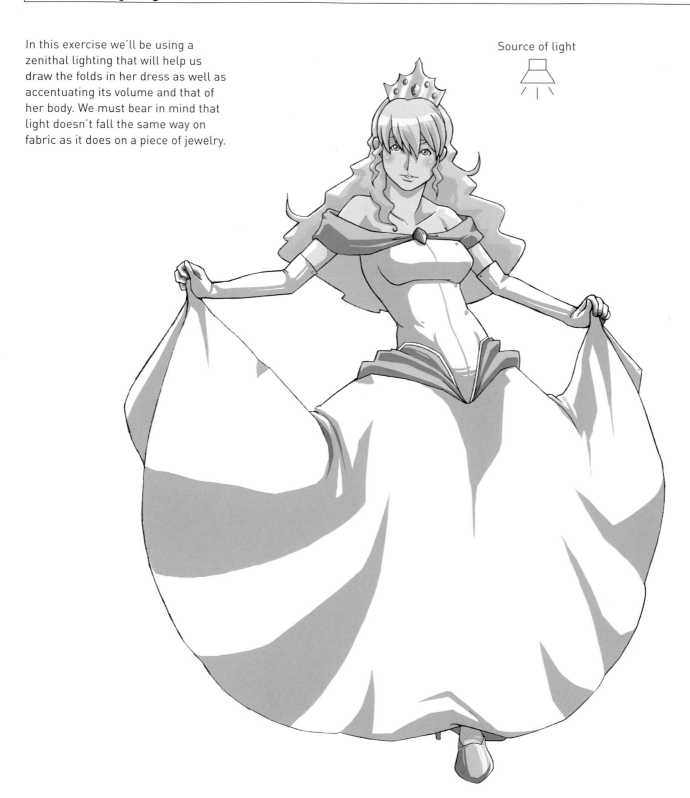

6. Finishing Touches

We'll use light color shading to create the kind of purity a princess is known for. We'll use blue for the shadows of her hair, thus sticking to a single color range for the entire drawing, which also makes it easier to draw contrasts if we need them.

When drawing shadows we should pay attention to the kind of material we are painting. It's not the same to paint clothing materials as it is jewelry, which allows us to play more with highlights, making them stand out more against her dress.

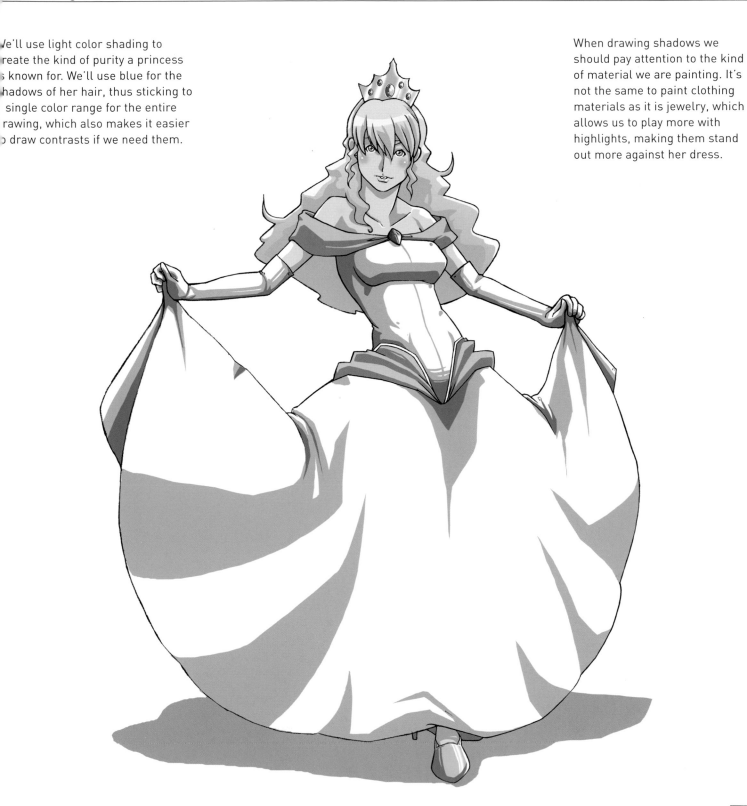

CHINESE PRINCESS

Today China is primarily known for its action films, martial arts and emerging economy. But the Red Giant owns a culture that goes back thousands of years, including everything from medicine to calligraphy and, of course, literature with hundreds of stories about princes and princesses. The enormous influence China has had on Japanese culture is not only reflected in their writing systems and in many of their traditions and legends, but also in the world of manga, as we can see in the famous *Fushigi yuugi*, by Yuu Watase. In this exercise we'll put a girl on top of a typical Chinese national symbol: the panda bear, which has often been used in manga as a link with the Sleeping Dragon.

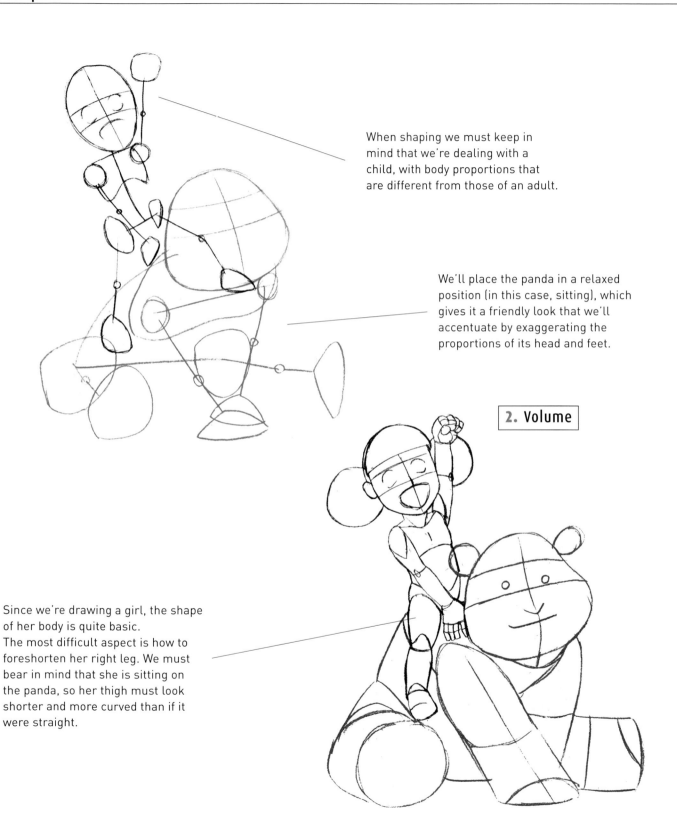

When shaping we must keep in mind that we're dealing with a child, with body proportions that are different from those of an adult.

We'll place the panda in a relaxed position (in this case, sitting), which gives it a friendly look that we'll accentuate by exaggerating the proportions of its head and feet.

2. Volume

Since we're drawing a girl, the shape of her body is quite basic.
The most difficult aspect is how to foreshorten her right leg. We must bear in mind that she is sitting on the panda, so her thigh must look shorter and more curved than if it were straight.

Let's finish defining her complexion and the shape of her body. Since her muscles are not fully developed, we'll just mark her articulations. Now is a good moment to define her expression: a happy child playing with her pet.

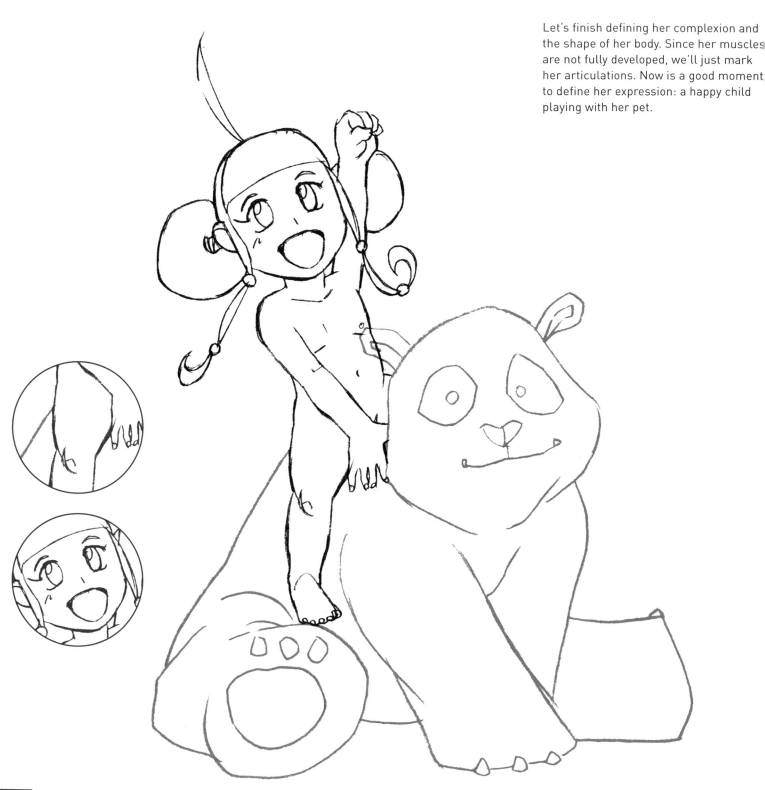

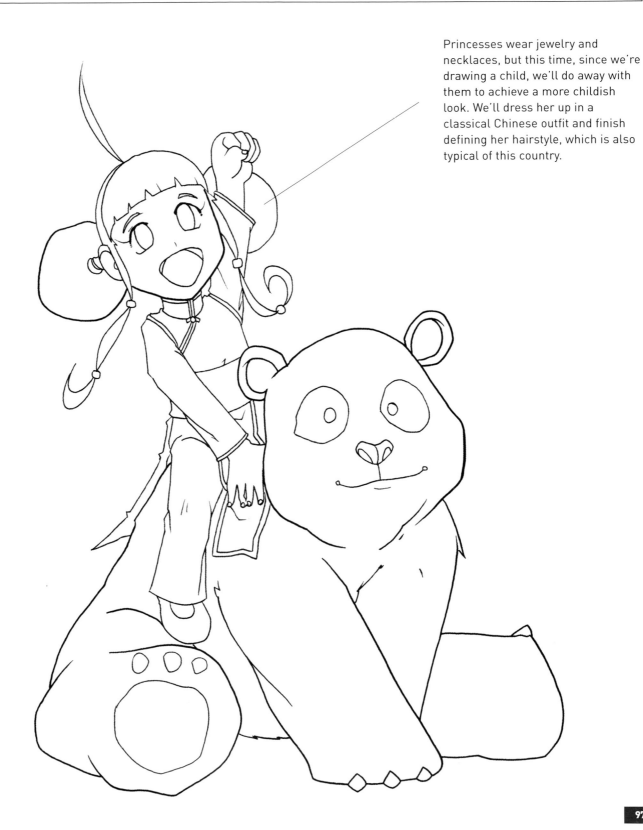

Princesses wear jewelry and necklaces, but this time, since we're drawing a child, we'll do away with them to achieve a more childish look. We'll dress her up in a classical Chinese outfit and finish defining her hairstyle, which is also typical of this country.

Source of light

The basic shapes of this drawing, such as her hair, which is practically spherical, will simplify our shading. The difficult thing is to define the folds in her dress. For this we'll have to pay attention to the parts that come into contact with her body.

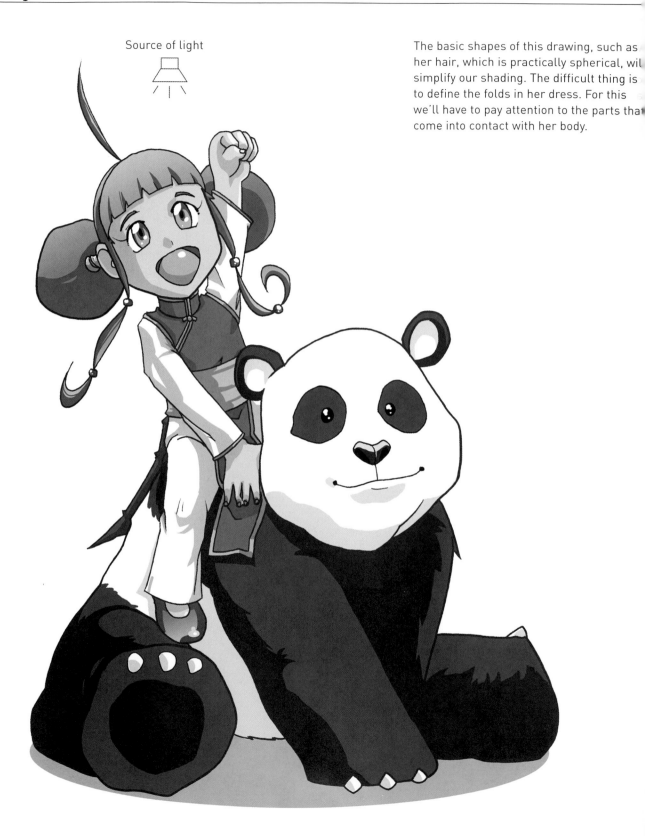

We'll paint the panda bear with its typical colors (black and white), and use shading to imitate its fur.

We'll apply blue shading to her clothes and thus have it match her hair. To create some contrast with the icy blue color, we'll paint part of her dress red and add some yellow details. We'll finish with a pattern on her belt and clothes.

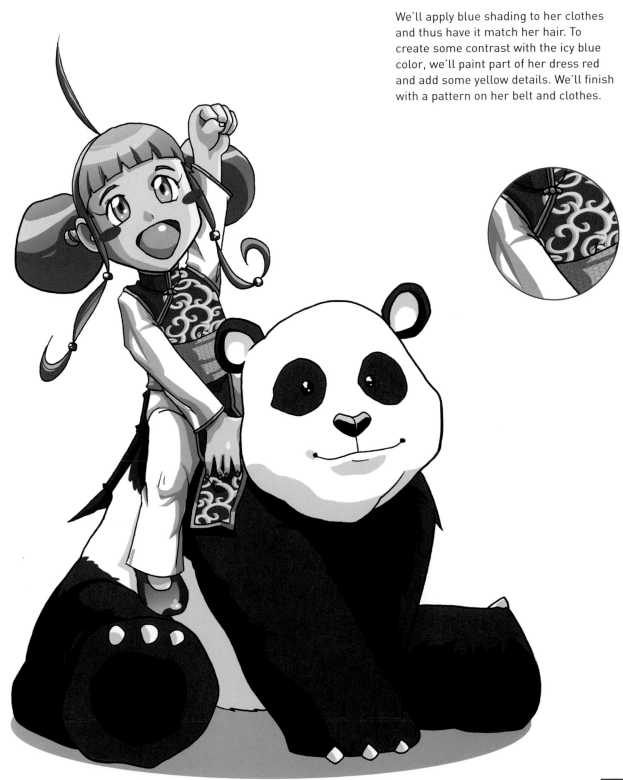

JAPANESE PRINCESS

Japan, the country that every manga fan knows or is intent on getting to know better, is a country with an incredibly rich culture with a wide array of artistic manifestations: from traditional ceramics and kabuki dance to cinema and manga, of course. Japanese comics are full of stories that blend mythology, history and epic tales. Among these we may find a wide variety of stories about princesses and adventures based on literature classics where *mangakas* let their imaginations run wild to help them create a story that is a bit different. In this exercise we'll be taking a closer look at the Japanese princess and traditional outfits from the Land of the Rising Sun.

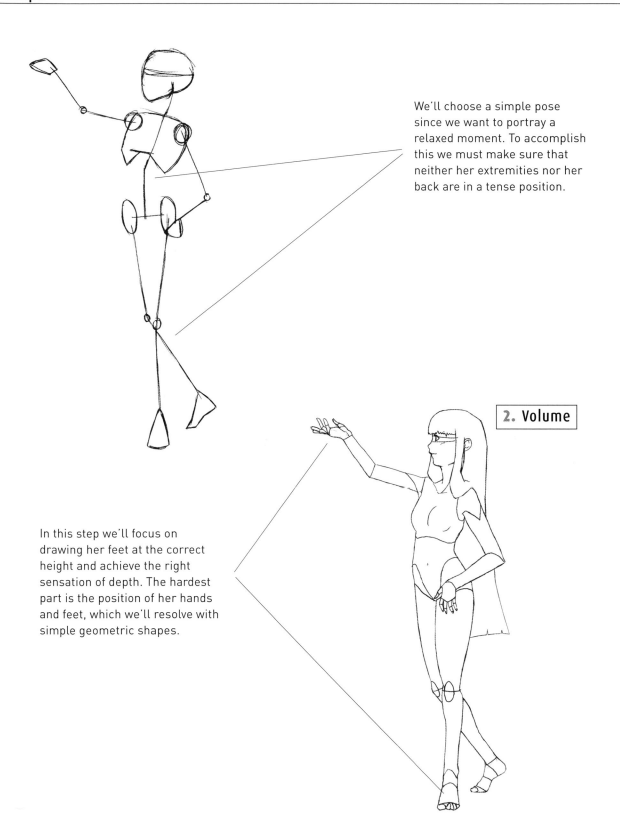

We'll choose a simple pose since we want to portray a relaxed moment. To accomplish this we must make sure that neither her extremities nor her back are in a tense position.

2. Volume

In this step we'll focus on drawing her feet at the correct height and achieve the right sensation of depth. The hardest part is the position of her hands and feet, which we'll resolve with simple geometric shapes.

We must make sure we reflect the narrow hips of typical Japanese women and not draw very large breasts to avoid problems when dressing up our character in a kimono, since it's more realistic to depict their breasts as flat as possible.

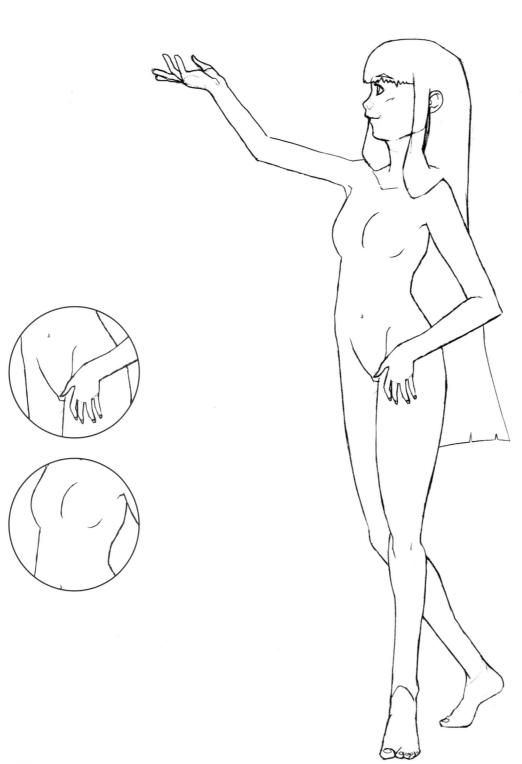

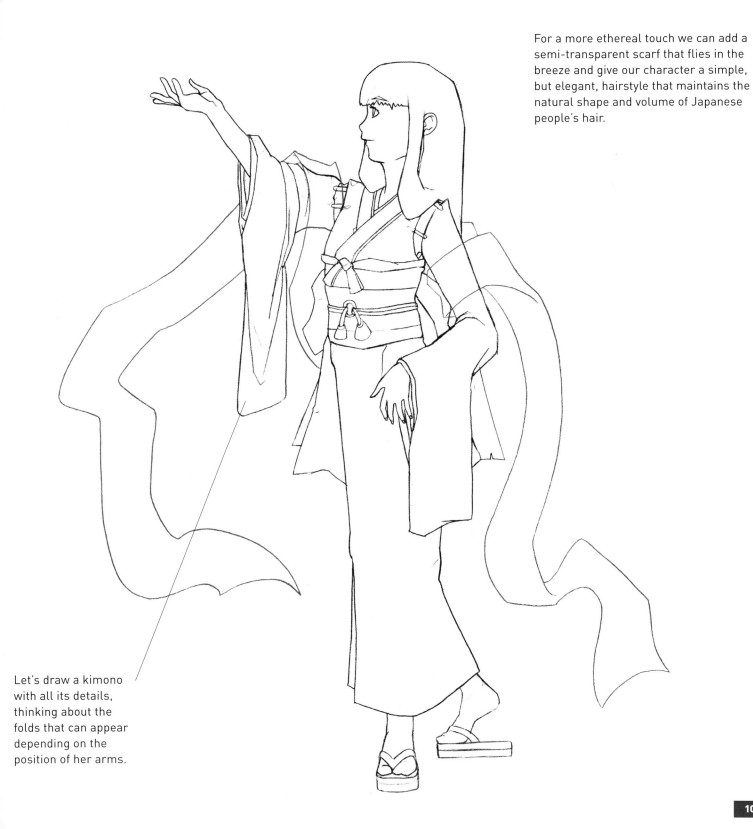

For a more ethereal touch we can add a semi-transparent scarf that flies in the breeze and give our character a simple, but elegant, hairstyle that maintains the natural shape and volume of Japanese people's hair.

Let's draw a kimono with all its details, thinking about the folds that can appear depending on the position of her arms.

Source of light

By placing the light source just above her raised hand we are creating a focus point in exactly that place. We'll give volume to the folds in her kimono and, at the same time, to our character. Since the scarf is semi-transparent it needs very light shading.

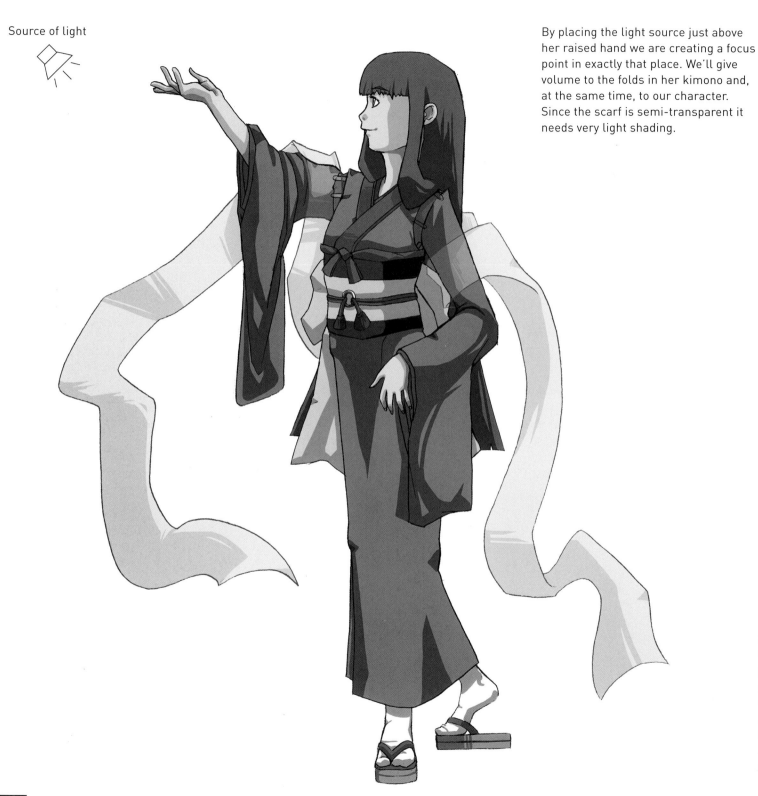

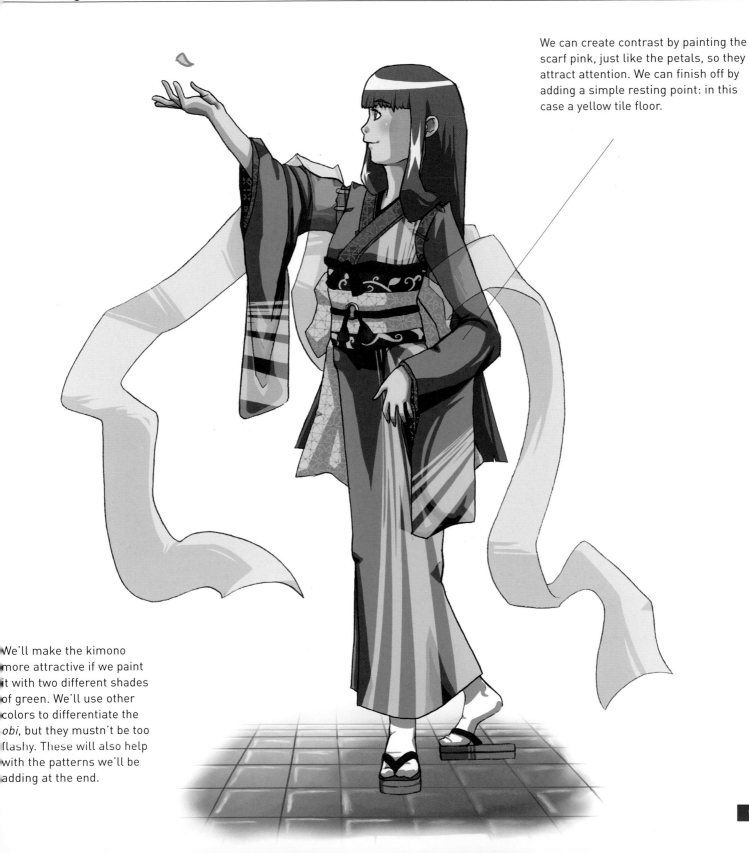

We can create contrast by painting the scarf pink, just like the petals, so they attract attention. We can finish off by adding a simple resting point: in this case a yellow tile floor.

We'll make the kimono more attractive if we paint it with two different shades of green. We'll use other colors to differentiate the *obi*, but they mustn't be too flashy. These will also help with the patterns we'll be adding at the end.

INDIAN PRINCESS

As surprising as it may seem, India is the largest film produc-
er in the world. The most famous and commercial films are
referred to as Bollywood, which is a fusion of the words
"Hollywood" and "Bombay," the city where they shoot the great
majority of these films. This genre features musical scenes and
mixes traditional Indian dance with western dance styles, while
usually depicting pure love stories between princes and
princesses.

We'll draw our Indian princess joined by one of the country's
symbols: the Indian tiger, better known as the Bengalese tiger.
We'll pay extra attention to her clothing, one of the basic ele-
ments for characterizing the country a person comes from.

1. Shape

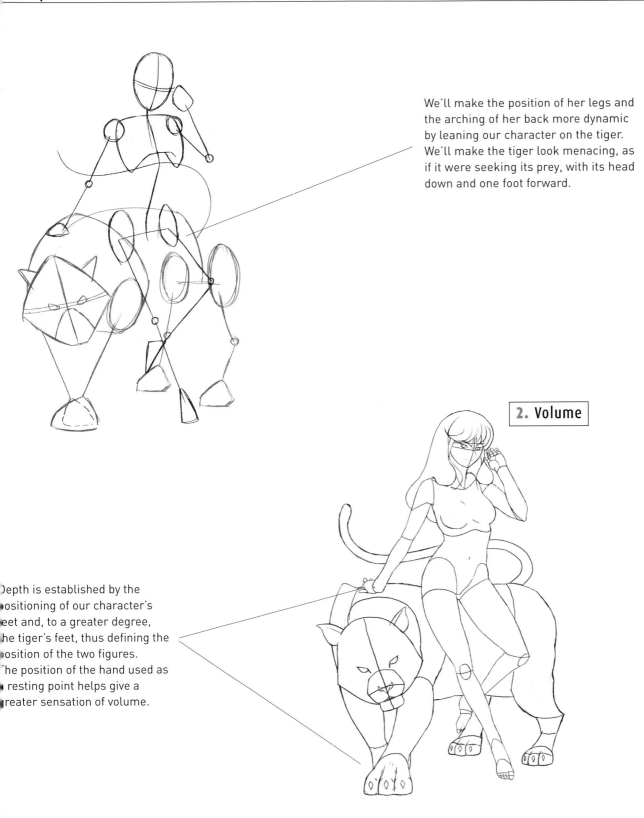

We'll make the position of her legs and the arching of her back more dynamic by leaning our character on the tiger. We'll make the tiger look menacing, as if it were seeking its prey, with its head down and one foot forward.

2. Volume

Depth is established by the positioning of our character's feet and, to a greater degree, the tiger's feet, thus defining the position of the two figures. The position of the hand used as a resting point helps give a greater sensation of volume.

We'll give our princess an athletic build, with shoulders a little wider than normal, but without marking the abdominals or the leg or arm muscles. We'll only insinuate them, which will give our figure more character.

astly, we'll draw a necklace
 encrusted jewelry hanging
om her neck and bracelets
nd ankle bracelets. We'll
so give the tiger the kinds
 stripes that are typical of
engalese tigers.

We'll finish our drawing with her
clothing, our version of a sari
along with a kerchief for her
head and a shawl for her chest.

In this exercise her outfit is quite basic, so we'll have to use shading in order to mark their volumes correctly, adding the kind of weight that makes them more realistic, especially where our character leans on the tiger.

Source of light

We should pay attention to how light falls on her necklace and bracelets to produce different shadows on her clothes.

6. Finishing Touches

We'll paint the sari with different shades of maroon and a pattern that makes it look more cheerful. We'll use light brown for her skin to make her look more realistic and we'll contrast the shades of red with her green hair and her jewelry.

We'll take advantage of those shades of red so that the Bengalese tiger, with its yellow eyes, is better integrated into the drawing.

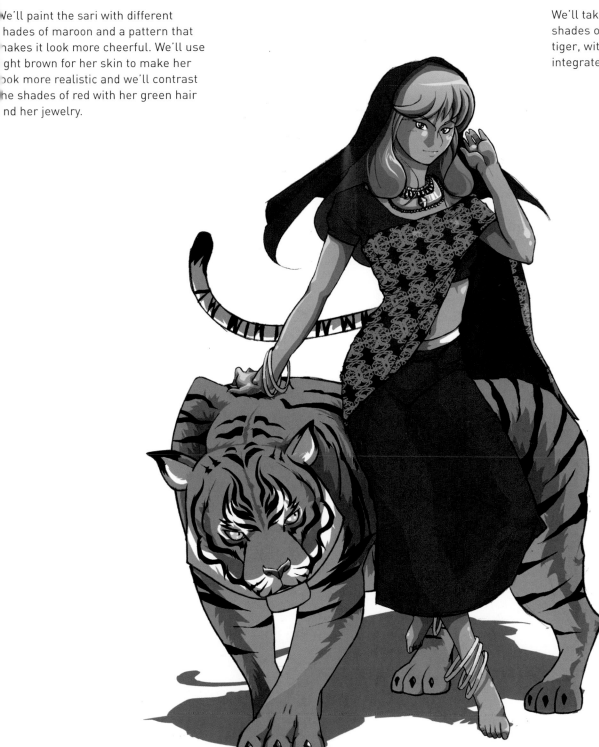

ARABIC PRINCESS

Arabia is known throughout the world for its oil-based economy and their sheiks, but also for their cultural wealth. A good example being what could be considered the most famous Oriental story: *One Thousand and One Nights*. In it the Princess Scheherazade avoids getting executed at daybreak, as the sultan had done with his previous wives, by telling her husband a story that is left unfinished at daybreak and continues the following night with tales about other princesses, such as Badroulbadour, in the famous Aladdin story.

Belly dancing also comes from Arabic culture, and we'll be making nice use of it in this exercise in creating a moving character.

1. Shape

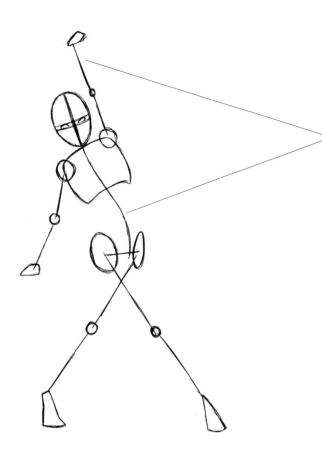

For this character we'll be focusing on movement, so the position of her body will be forced, with a complicated resting point. The position of her arms, the arching of her back and the flexing of her legs emphasize the sway of her body.

2. Volume

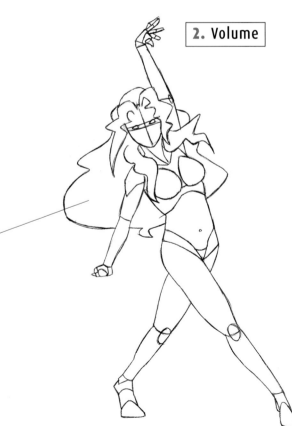

We'll make sure her feet are not left at the same height on paper so as to create a greater sense of depth than that which is achieved by body position alone. The volume of her hair also helps give her body more volume.

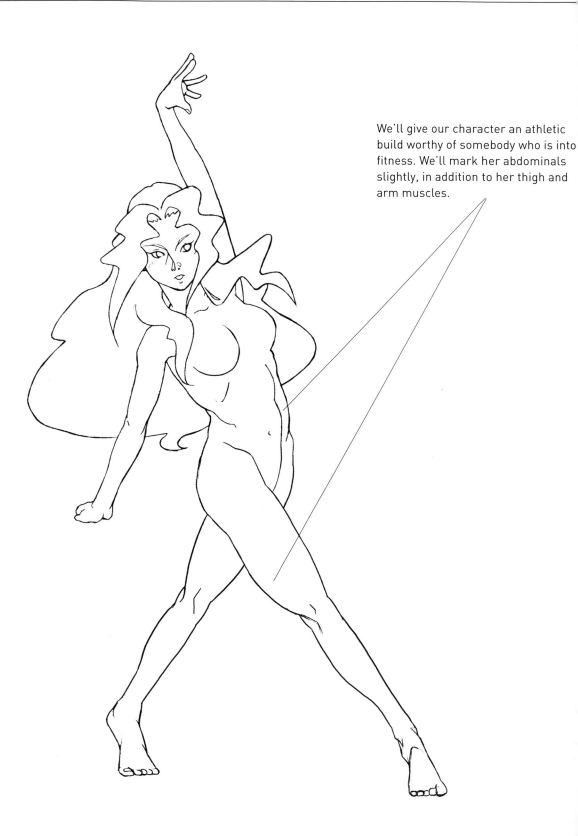

We'll give our character an athletic build worthy of somebody who is into fitness. We'll mark her abdominals slightly, in addition to her thigh and arm muscles.

We'll draw her with a metallic medallion belt, which together with the handkerchief in her right hand, help lend some movement.

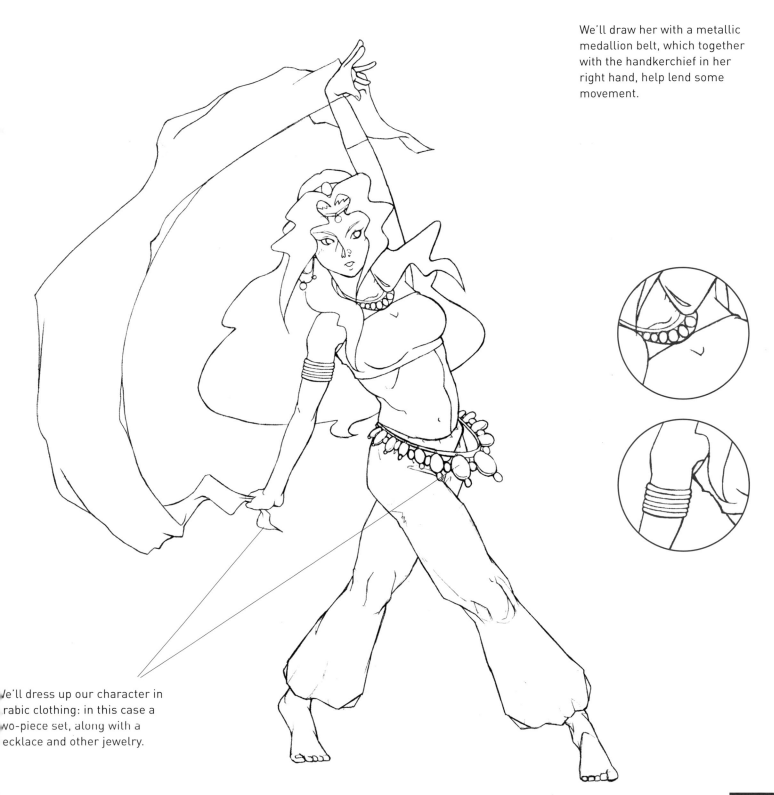

We'll dress up our character in rabic clothing: in this case a wo-piece set, along with a ecklace and other jewelry.

We'll finish shaping the abdominals and sketch the muscles of her arms. We'll also shape the folds in her clothes while bearing in mind the type of fabric we're drawing.

Lastly, we'll be careful when shaping our shadows and the highlights on her jewelry so that they stand out against the rest of the drawing.

Source of light

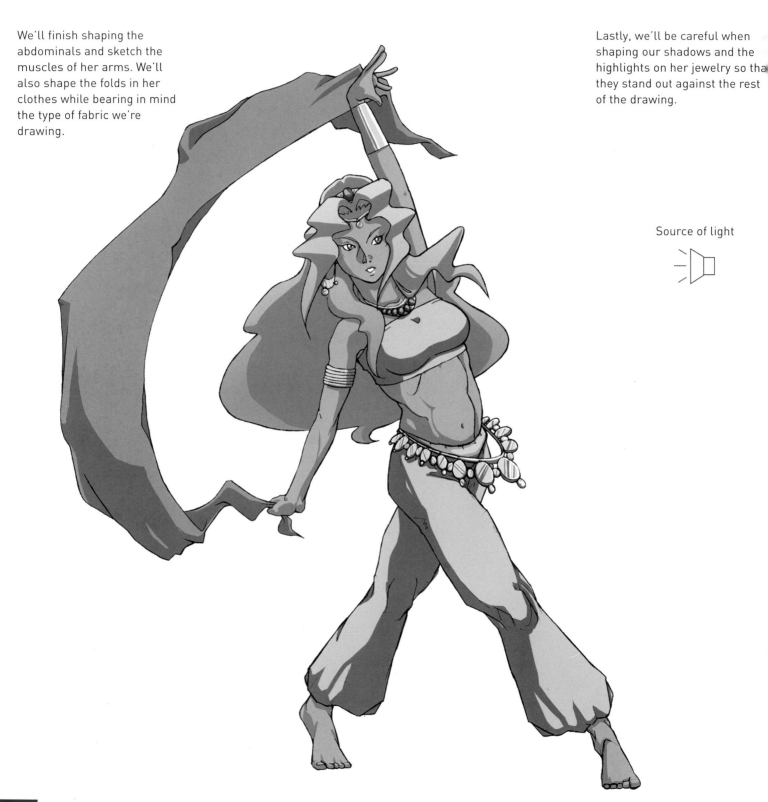

We'll go over the majority of the drawing with a slight touch of blue which helps create nice contrasts such as that between her purple hair, brownish skin and the intense yellow of her jewelry.

The fiery red stone in her crown and the beads of her necklace contrast with the cold colors predominating in the drawing.

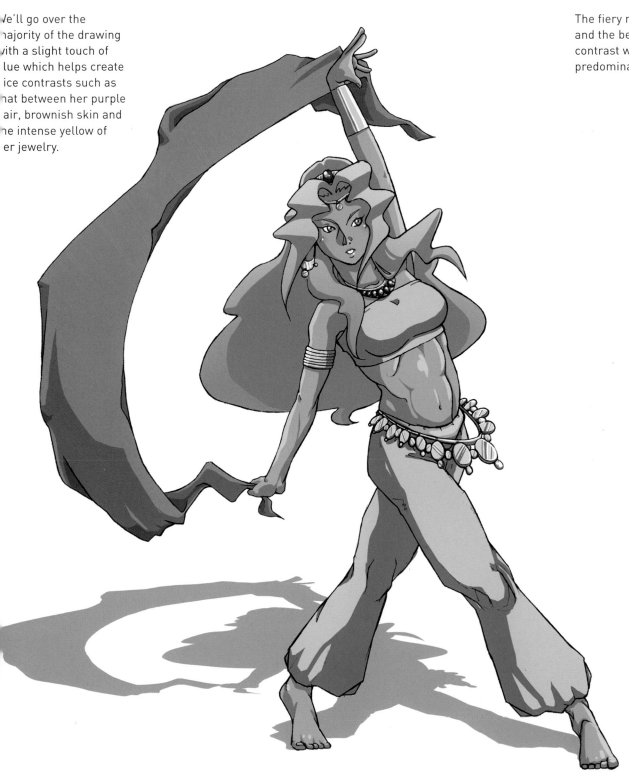

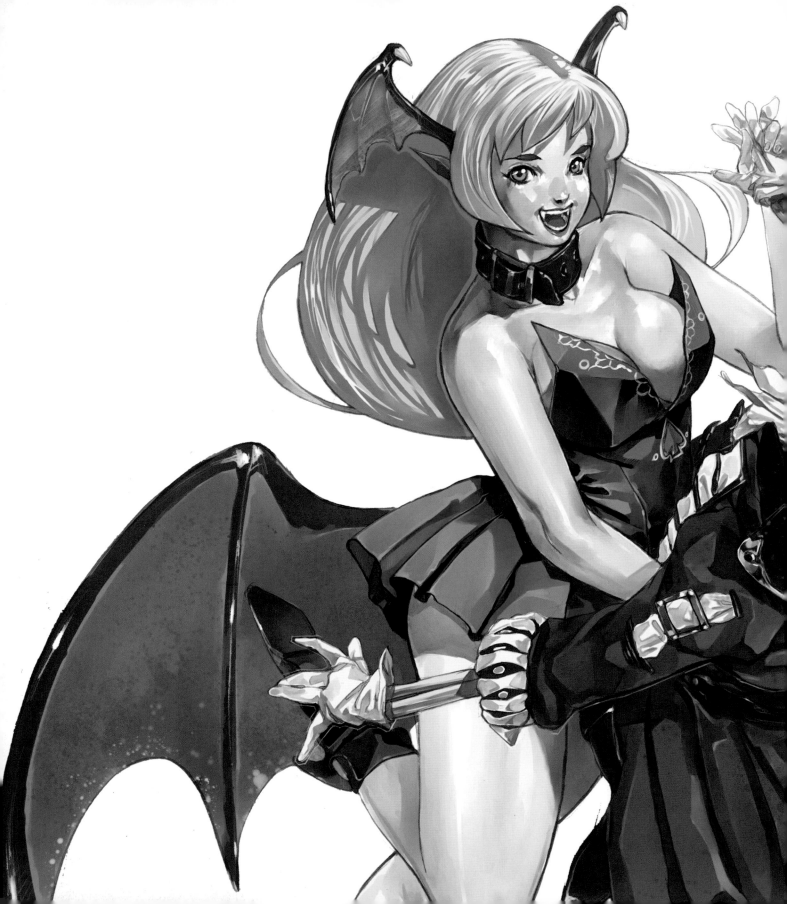

FANTASY

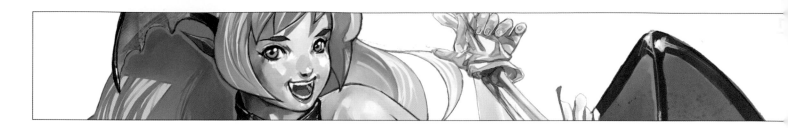

SUCCUBUS

If there's a single female character from the fantasy genre who warrants a place in this compilation, it would undoubtedly be the succubus. This lady of the night is capable of enrapturing any man in order to rob him of all his essence, to a degree that goes beyond the classical vampire rituals involving drinking one's blood, as this drains their prey of all their energy and even takes control of their souls. They are always depicted as beautiful women with splendid curves who do not hesitate to play with their victims in a macabre dance, even if they're already dead. Unlike vampires, you can recognize a succubus by the enormous wings on its back and the smaller ones on its head.

1. Shape

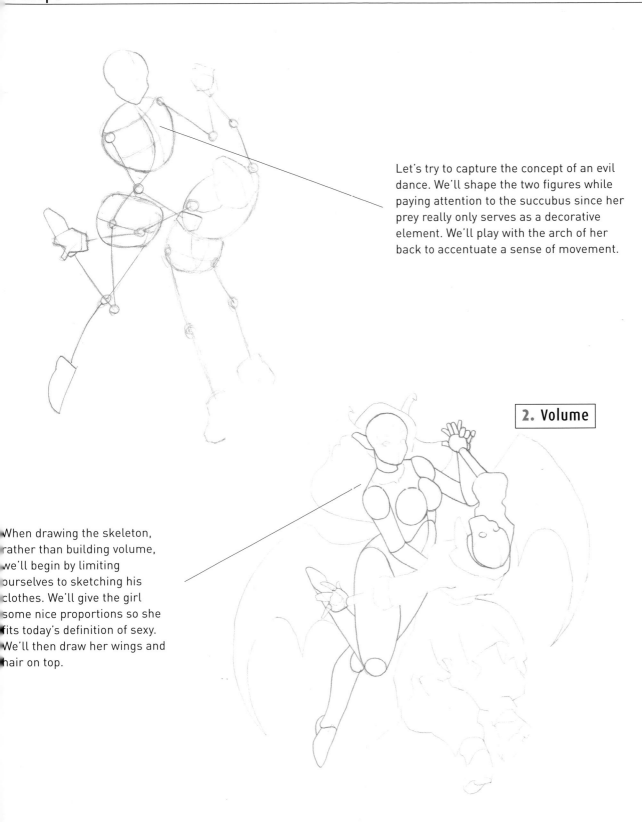

Let's try to capture the concept of an evil dance. We'll shape the two figures while paying attention to the succubus since her prey really only serves as a decorative element. We'll play with the arch of her back to accentuate a sense of movement.

2. Volume

When drawing the skeleton, rather than building volume, we'll begin by limiting ourselves to sketching his clothes. We'll give the girl some nice proportions so she fits today's definition of sexy. We'll then draw her wings and hair on top.

The most important part of the drawing is undoubtedly her shoulders and hips, since they define the movements of our protagonist. Now we'll add in her hair, as if it were swaying.

Her facial expression should be naughty and cheerful. We'll use a style that is closer to *shonen*, with features that are slightly more realistic.

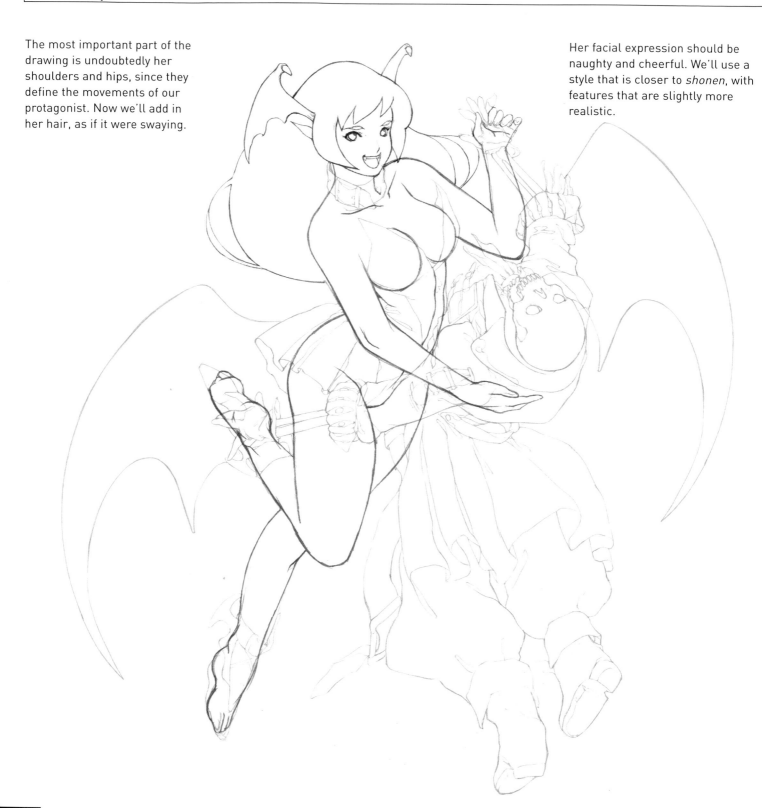

4. Clothes

Just as with other characters in this section, the succubus' outfit can be timeless, with some unique elements, such as her shoes.

Let's return to our succubus' victim. We'll pay close attention to the folds and wrinkles of his coat, which follows her movement. His arms, which are inert, will hang in the same way.

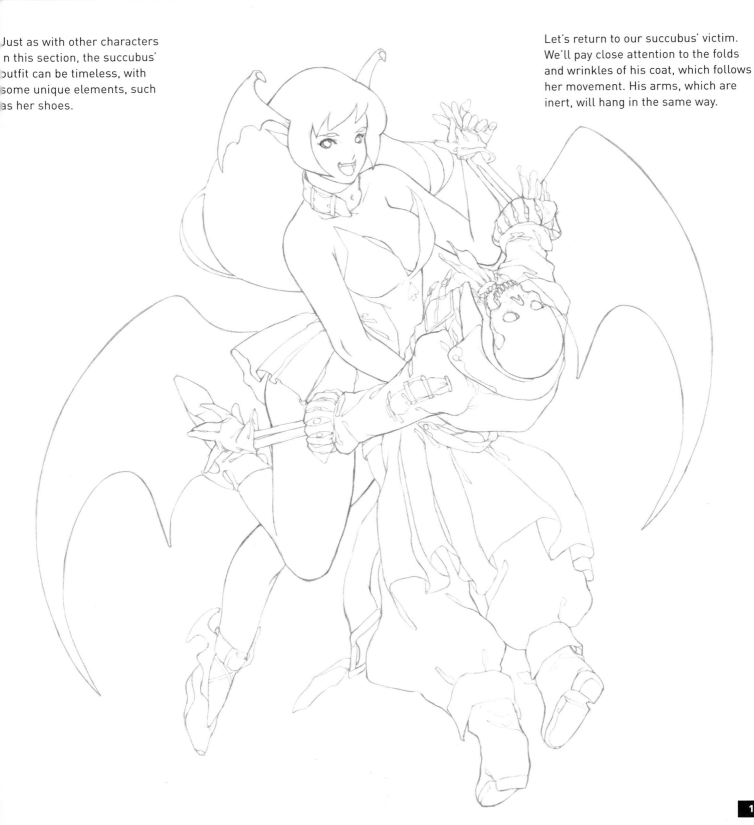

Although the final sketch lacks a background, we can imagine moonlight and the kind of sharp contrasts it produces. To achieve this effect we'll use darker tones to gently go over the shadow contours on her neck and hair.

Source of light

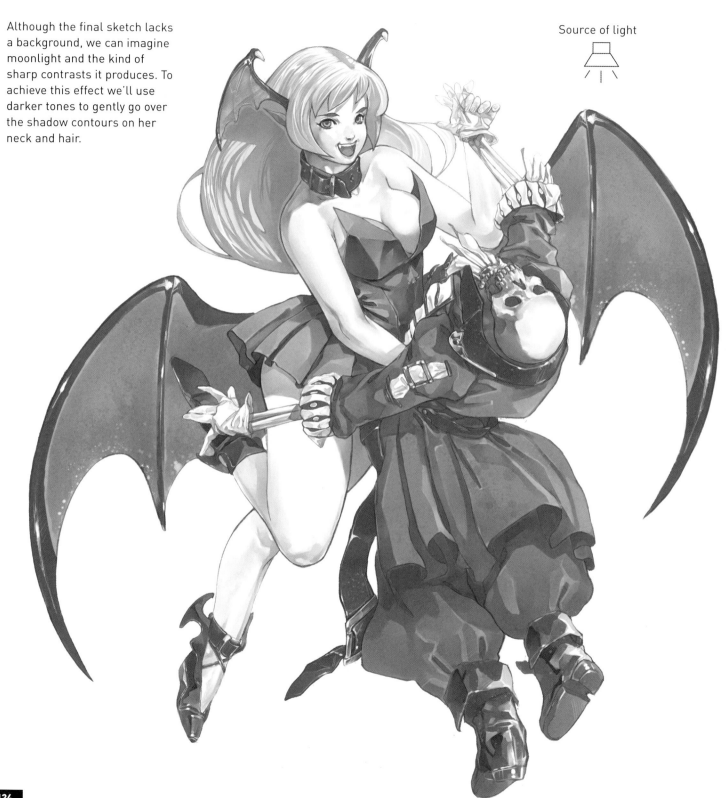

Since this is a drawing where we are looking for visible contrast, we'll paint the main shadows, especially on the succubus' skin. We'll also create that sensation on her wings by marking some points of light.

We can separate the two characters by using two different ranges of color although they should both be dim colors that take the lighting into account.

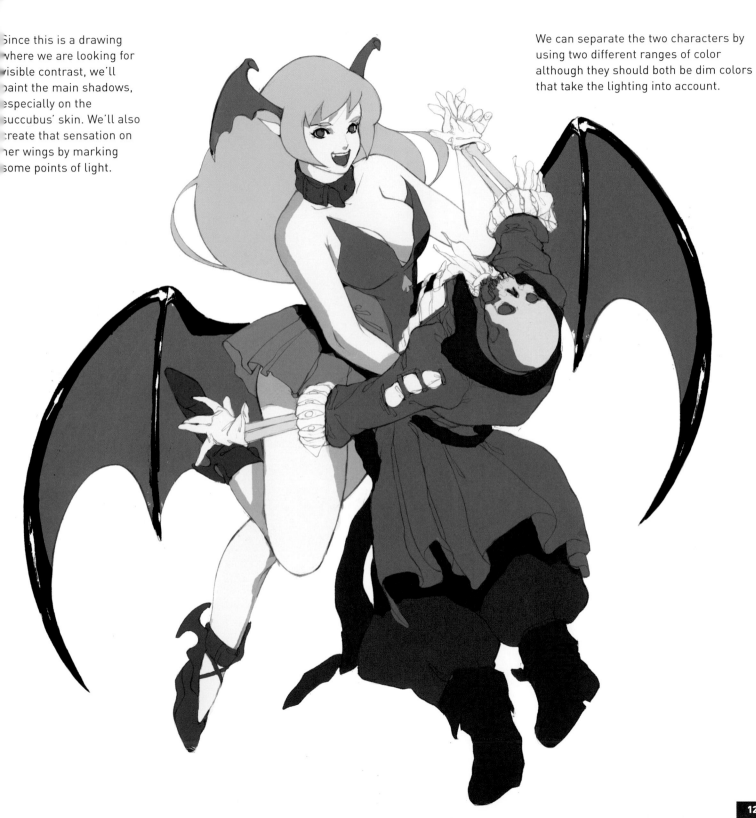

The lighting should offer a lot of contrast, so we'll add highlights in the spots where the most light falls (cheeks, breasts, etc.). When painting the wings on her head we must remember their transparency in order to create a membrane effect.

We'll add shades of color on all the shadows, especially on darker ones such as her wings, so they remain in the background. Then we'll add dapples to the skeleton's coat in order to convey neglect and carelessness.

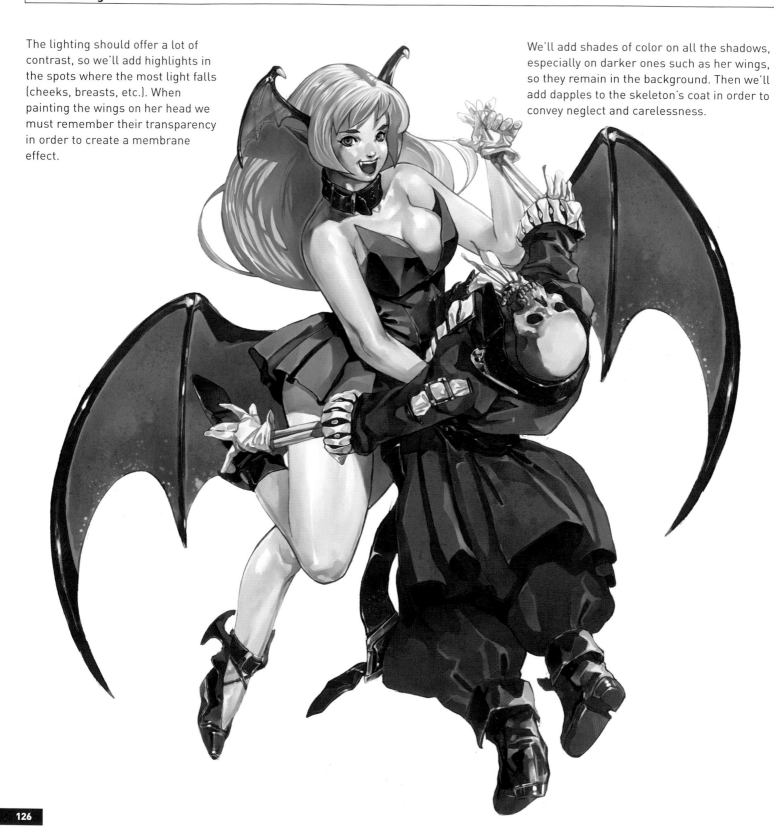

3. Finishing Touches

We'll complete the drawing of the succubus with some highlights in her eyes, defining her facial features with lighter tones, and drawing patterns on her clothes.

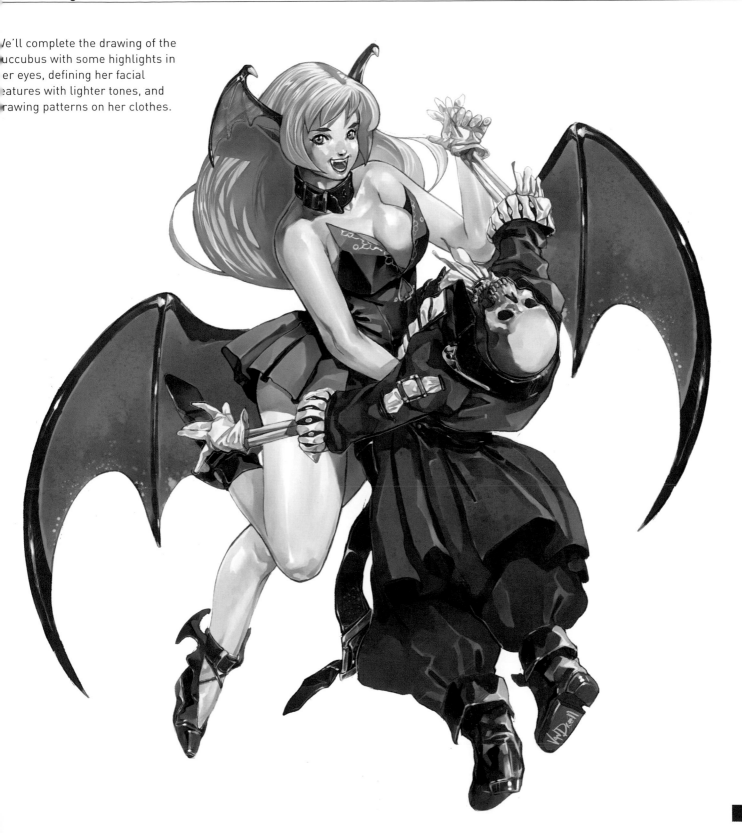

EARTH SPIRIT

The female incarnation of the earth element is always sur-
rounded by mysticism. In the heart of leafy forests every now
and then one can make out the figure of the little nymph
emerging from between the weeds she is camouflaged in to
surprise lost travelers walking about. She is not a very com-
mon character and her appearance varies from one work to the
next; however, it is usually connected to her surroundings, in
this case the vegetation she uses to go unnoticed by unobser-
vant eyes.

Relaxed and almost always cheerful, she is harsh, however,
with those that don't respect the environment she guards so
closely. Nevertheless, she is more a kind and peaceful charac-
ter than a violent and vindictive one.

1. Shape

Our sweet character rests among the weeds. We'll do a basic sketch of her shape and the base she is sitting on.

2. Volume

We'll draw simple volumes and prominent hips, especially on account of the character's pose, and sketch the basic elements of the illustration such as the base for her mushroom hat.

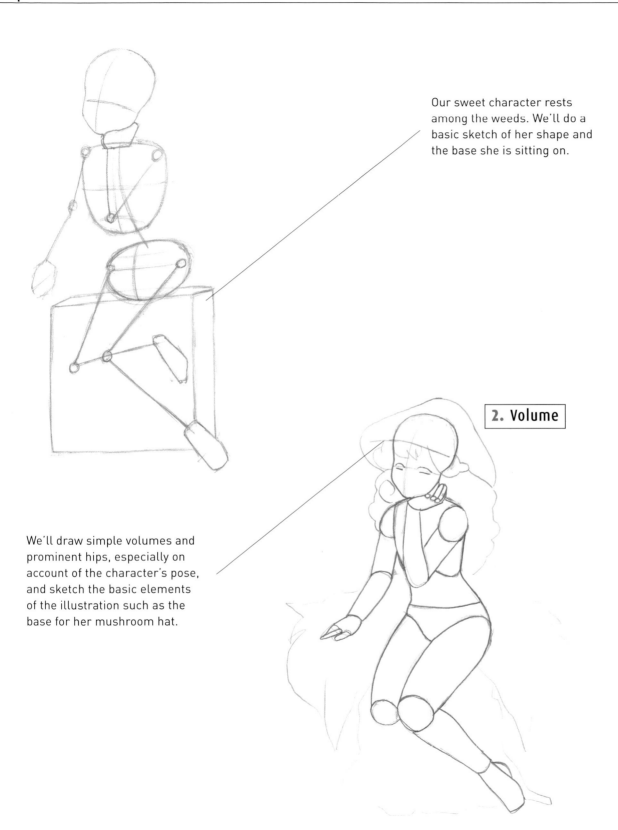

Her expression should be gentle, with a childish air, and we'll give her hair a different, more fantastic, look. These kinds of characters give us that freedom.

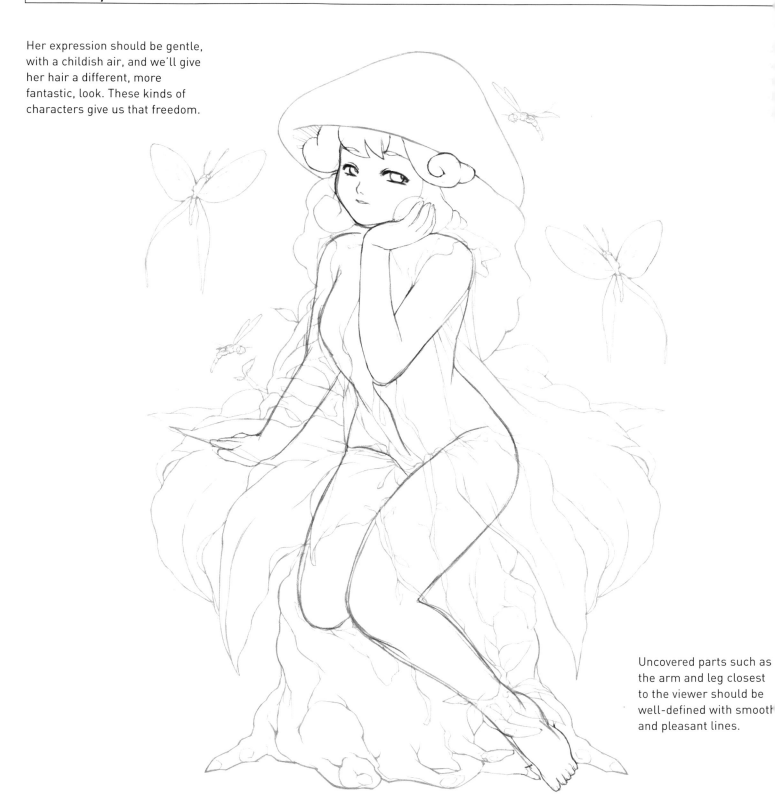

Uncovered parts such as the arm and leg closest to the viewer should be well-defined with smooth and pleasant lines.

4. Clothing

Using wild nature as our foundation, we'll draw an outfit that hangs like a nightgown with a skirt in the shape of leaves. The creases that gather on her lap should be clear and well-defined.

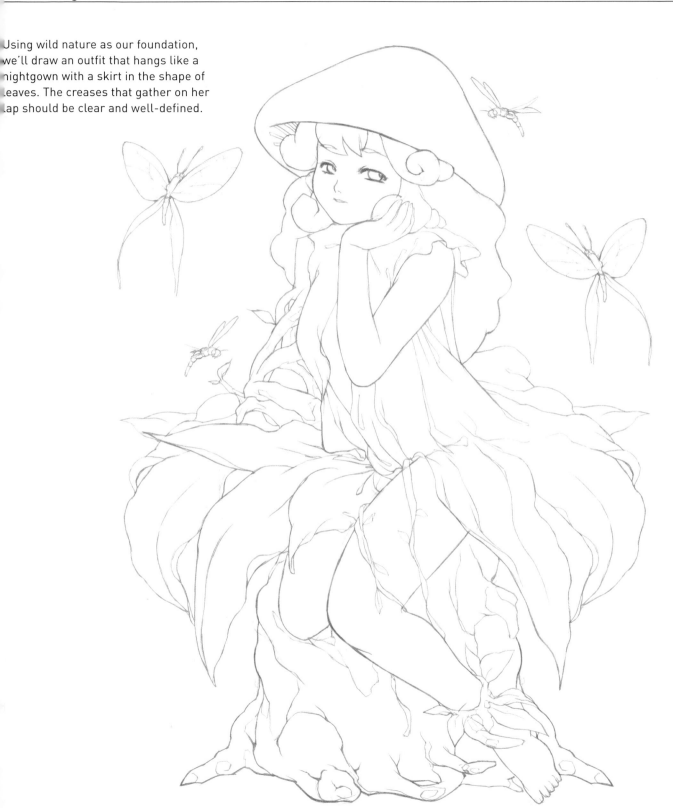

A natural light source conditions the lighting of the whole scene. We must pay attention to how the hat or the folds in her clothes project shadows.

Source of light

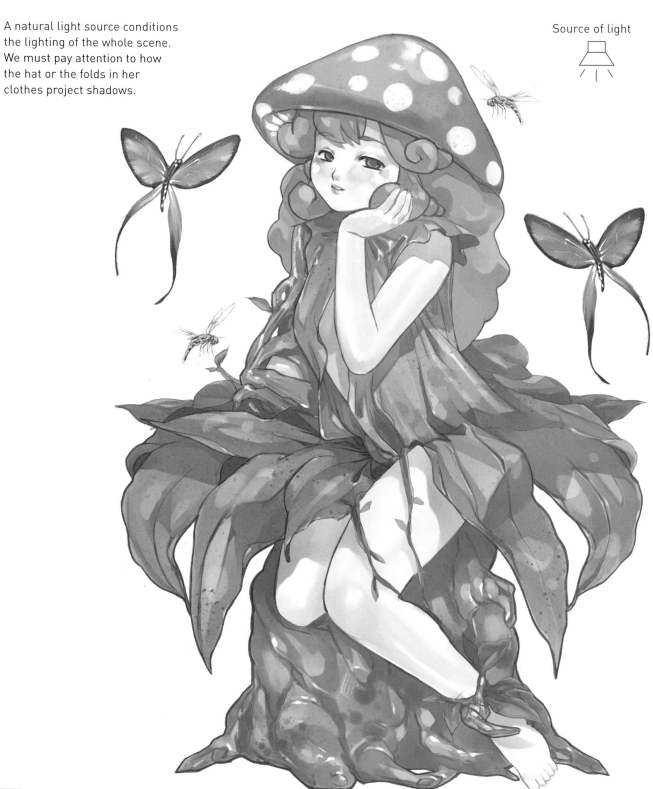

The base will have more neutral colors even if the colors themselves are bright. We'll paint out the character's skin with shades of green since her origin allows us to.

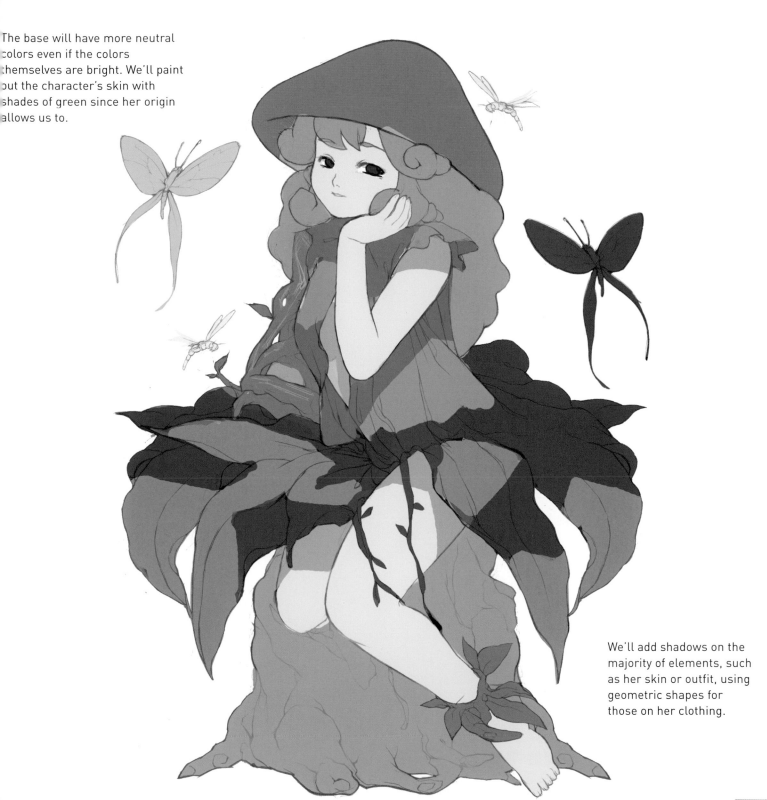

We'll add shadows on the majority of elements, such as her skin or outfit, using geometric shapes for those on her clothing.

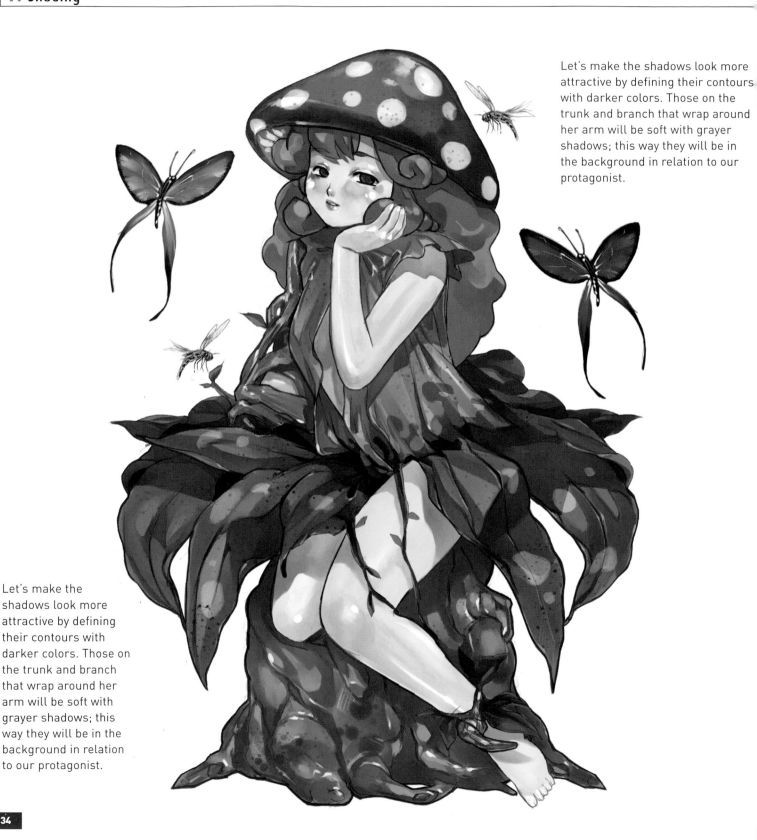

Let's make the shadows look more attractive by defining their contours with darker colors. Those on the trunk and branch that wrap around her arm will be soft with grayer shadows; this way they will be in the background in relation to our protagonist.

Let's make the shadows look more attractive by defining their contours with darker colors. Those on the trunk and branch that wrap around her arm will be soft with grayer shadows; this way they will be in the background in relation to our protagonist.

We'll finish by drawing a faded motif in the background. Make sure the colors aren't too bright so we don't lose the coherent field of depth in our illustration.

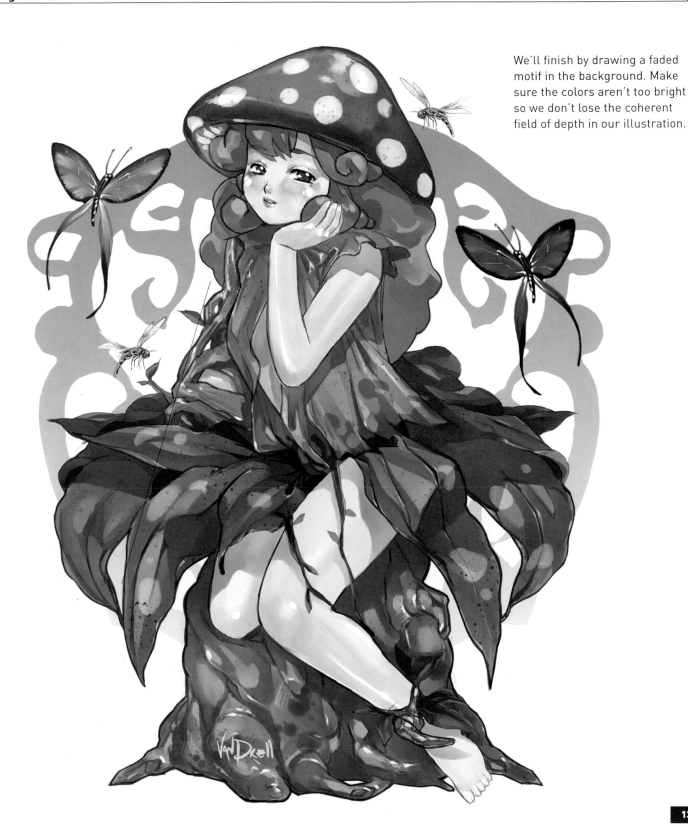

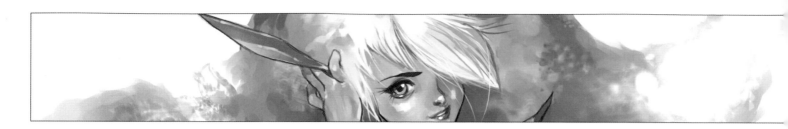

FIRE SPIRIT

Unlike the earth or air elements, whose appearance suggests pureness or innocence, the fire spirit is ruled by its own incandescent nature. A beautiful igneous character with a suggestive body emerges from the blazing flames and invites anyone who dares to step inside her circle. She's a rather typical element, with well-defined behavior and a naughty and playful nature that, while not going so far as being evil, can be responsible for more than just a few headaches to the people around her.

She is a recurring figure because of her impressive appearance (attractive for readers) and for her character, which instigates some crazy situations and spicy scenes.

1. Shape

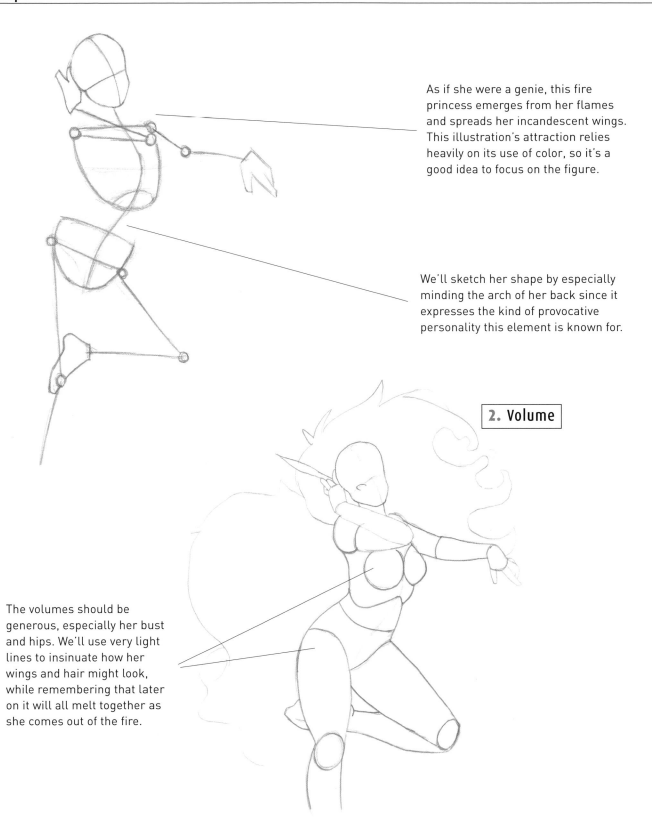

As if she were a genie, this fire princess emerges from her flames and spreads her incandescent wings. This illustration's attraction relies heavily on its use of color, so it's a good idea to focus on the figure.

We'll sketch her shape by especially minding the arch of her back since it expresses the kind of provocative personality this element is known for.

2. Volume

The volumes should be generous, especially her bust and hips. We'll use very light lines to insinuate how her wings and hair might look, while remembering that later on it will all melt together as she comes out of the fire.

As we already alluded to in the volume section, we'll top off the girl's voluptuousness with a look that is both provocative and mysterious, and then we'll define her features and the most visible parts of her hair.

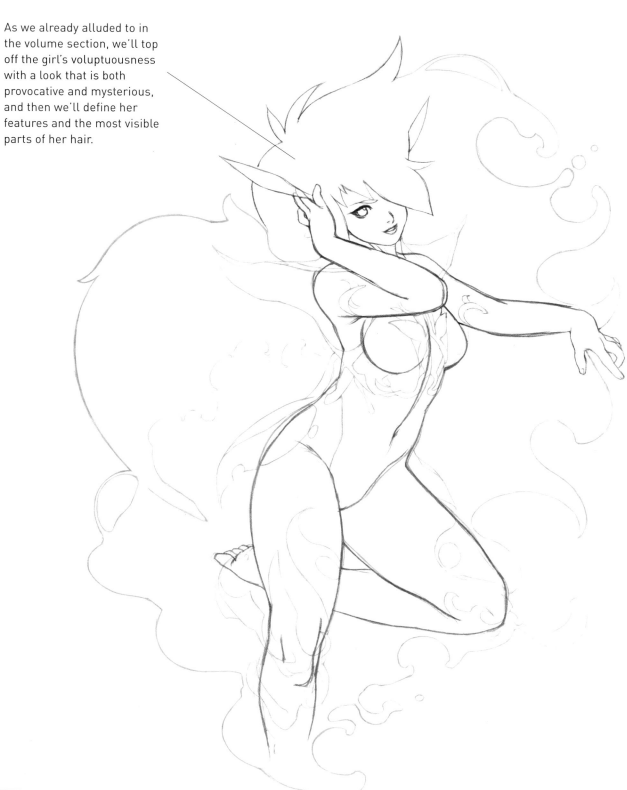

1. Clothes

The fun thing about these kinds of characters is their timelessness, with attire that would belong to the future as much as to the past.

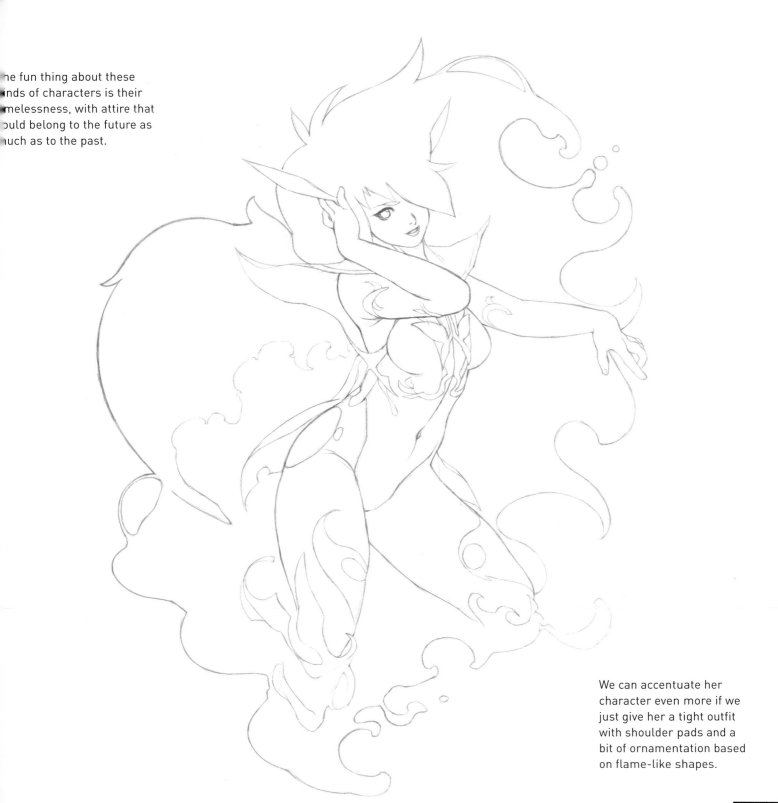

We can accentuate her character even more if we just give her a tight outfit with shoulder pads and a bit of ornamentation based on flame-like shapes.

Aside from the atmospheric light marked by the main shadows she projects over herself, we have the light her own body emits, especially her wings.

Source of light

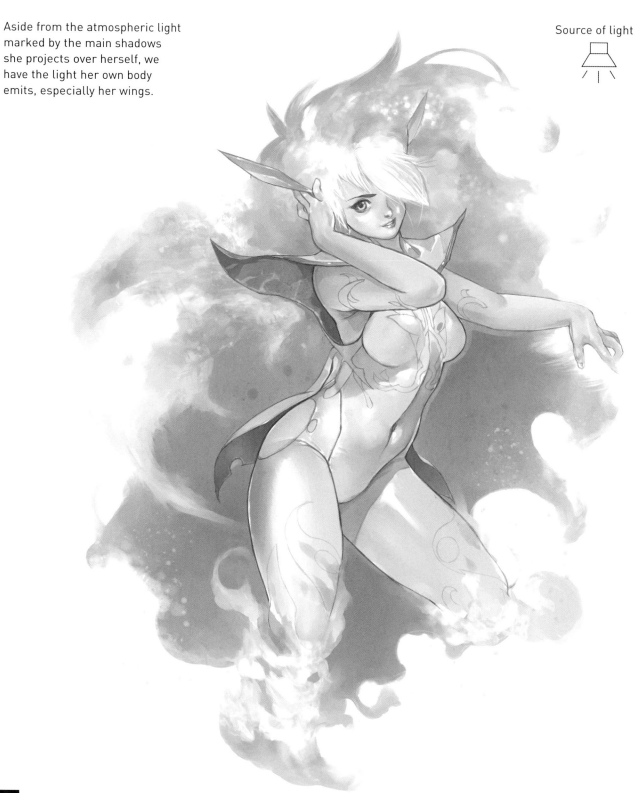

hen working flat colors we'll
ark the main color masses in
ght and in shade. For the
ames we'll use broken lines
addition to splashes and
atches of color, but without
sing too many different hues.

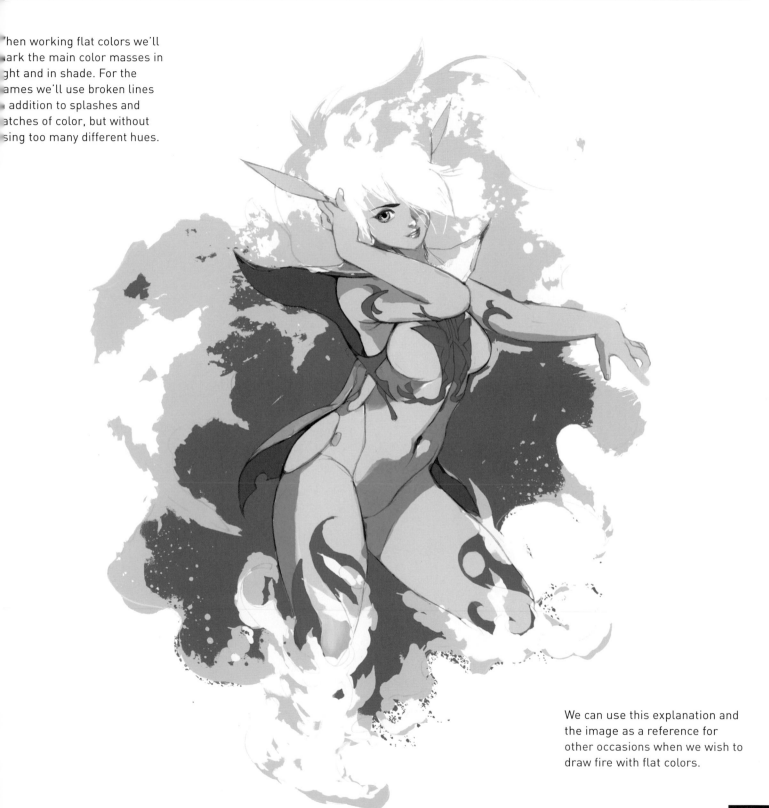

We can use this explanation and
the image as a reference for
other occasions when we wish to
draw fire with flat colors.

Let's use a chromatic hierarchy from dark to light coming from the back so the figure doesn't get lost in the flames surrounding her and we'll strengthen her silhouette to emphasize it further and make it more dynamic.

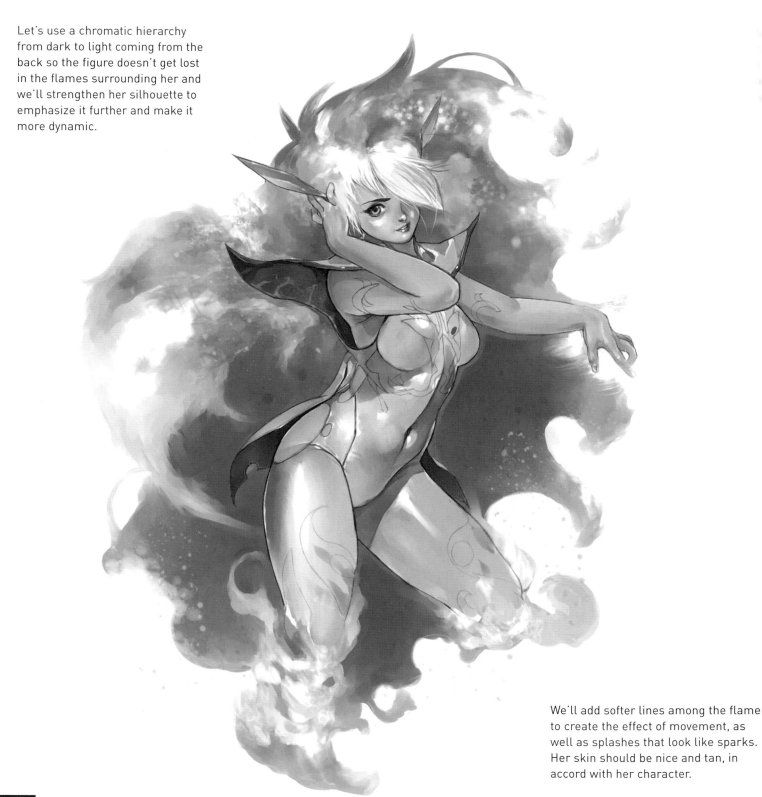

We'll add softer lines among the flame to create the effect of movement, as well as splashes that look like sparks. Her skin should be nice and tan, in accord with her character.

We'll paint her clothing while considering their proximity to the flames: those on her legs being lighter and those covering her chest being darker. Then we'll create greater movement by adding a flame that trails from her left hand.

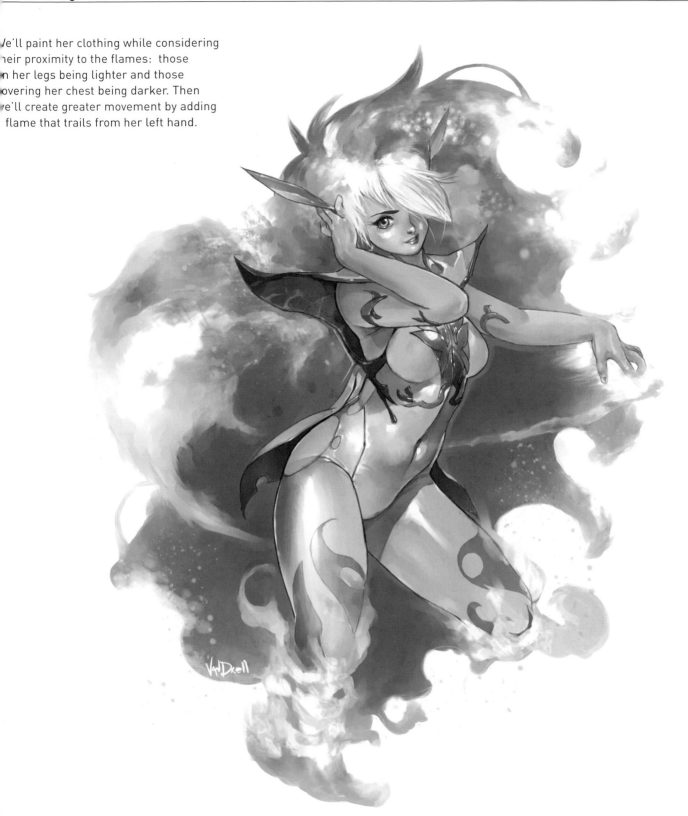

AIR SPIRIT

We've chosen the image of a kind angel to portray our air element. With childish features, she rests above the clouds watching how men travel through life and, if it's necessary, she won't hesitate to play some beautiful pieces on her lyre to enliven the steps of travelers embarking on long journeys. She is definitely a versatile character, especially within the world of children. Similar to an angel, she is a being who uses her appearance to transmit qualities associated with the color white, such as purity and innocence. Hence it's not strange to find tons of mangas full of these kinds of characters whether they are inhabitants of the skies, angels or air spirits like this one.

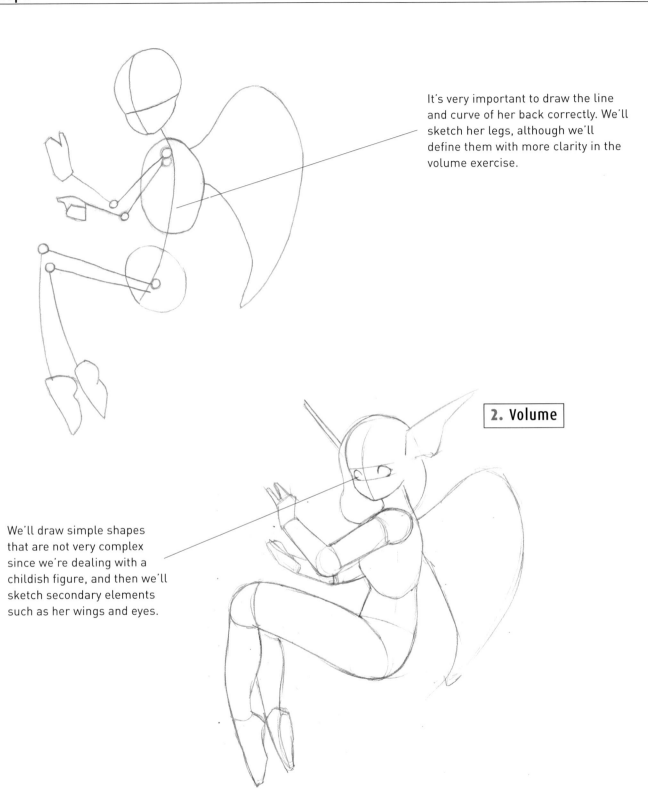

It's very important to draw the line and curve of her back correctly. We'll sketch her legs, although we'll define them with more clarity in the volume exercise.

2. Volume

We'll draw simple shapes that are not very complex since we're dealing with a childish figure, and then we'll sketch secondary elements such as her wings and eyes.

There are two big factors in this drawing: her hands and her face, which are the areas that best capture our character's personality.

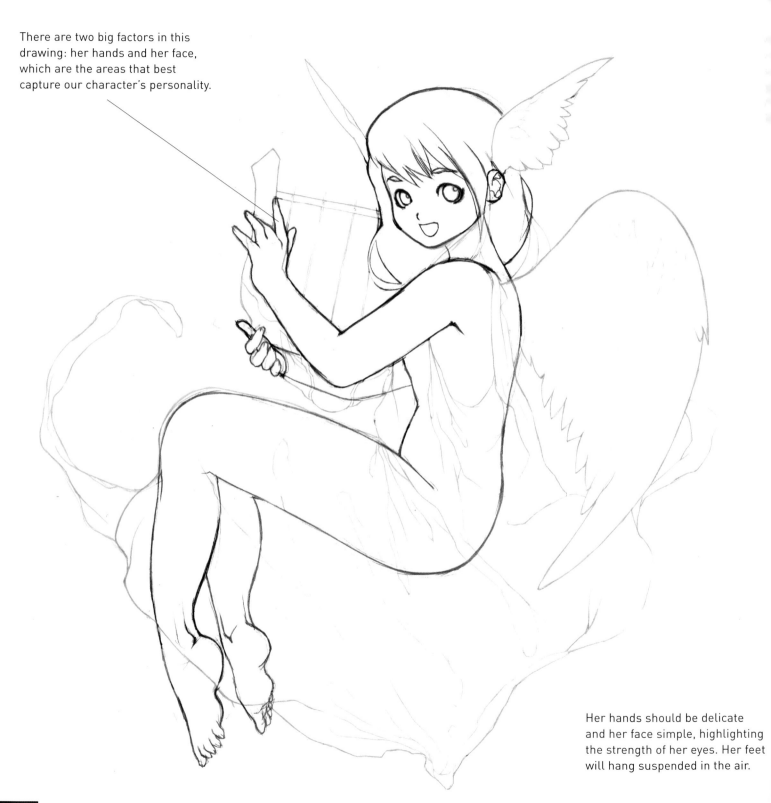

Her hands should be delicate and her face simple, highlighting the strength of her eyes. Her feet will hang suspended in the air.

We mustn't neglect the way her wrinkles form and how they accumulate at the base, apart from the lighter parts, of course, which sway in the air. We'll use soft lines for her clothing and, if we like, rougher lines for her wings.

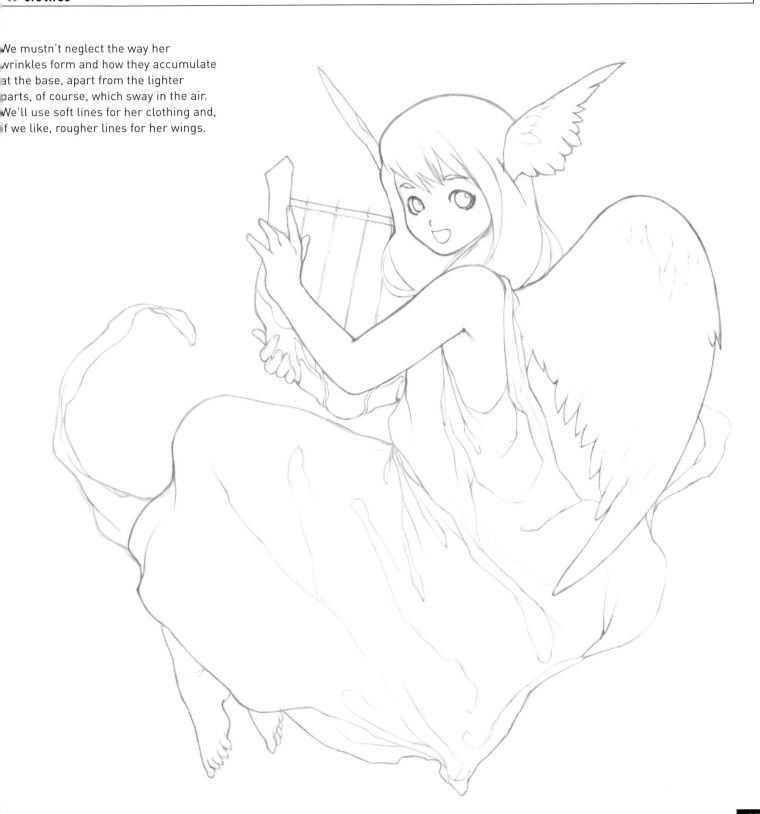

The illustration has a zenithal atmospheric light source. We'll pay attention to how her arms project a shadow over her clothing and how shadows accumulate in the lower part of her dress.

Source of light

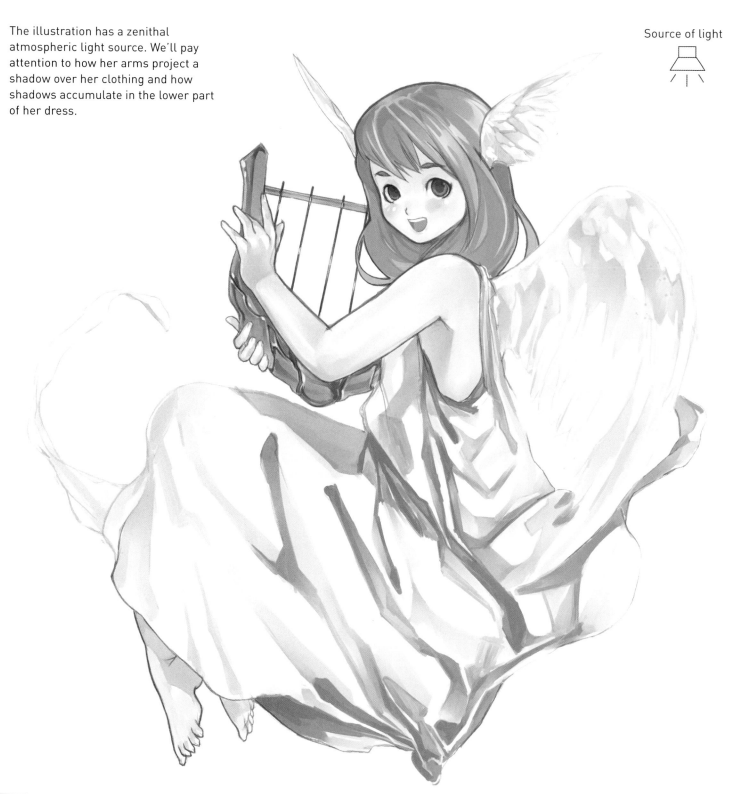

6. Color

Let's use warm and clean colors, especially for her clothing, which guides our attention directly towards our character's face. For her eyes we'll use a more intense flat color.

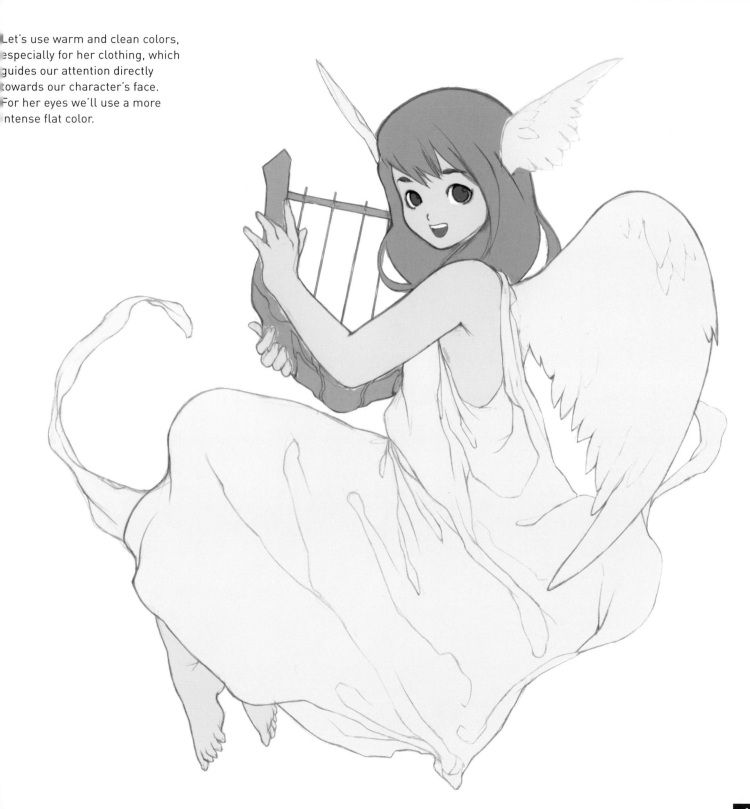

We'll use much heavier shadows on her clothing to make them more solid and contrast more with her wings, which are lighter. Her skin color should be bright to match with her lyre and hair.

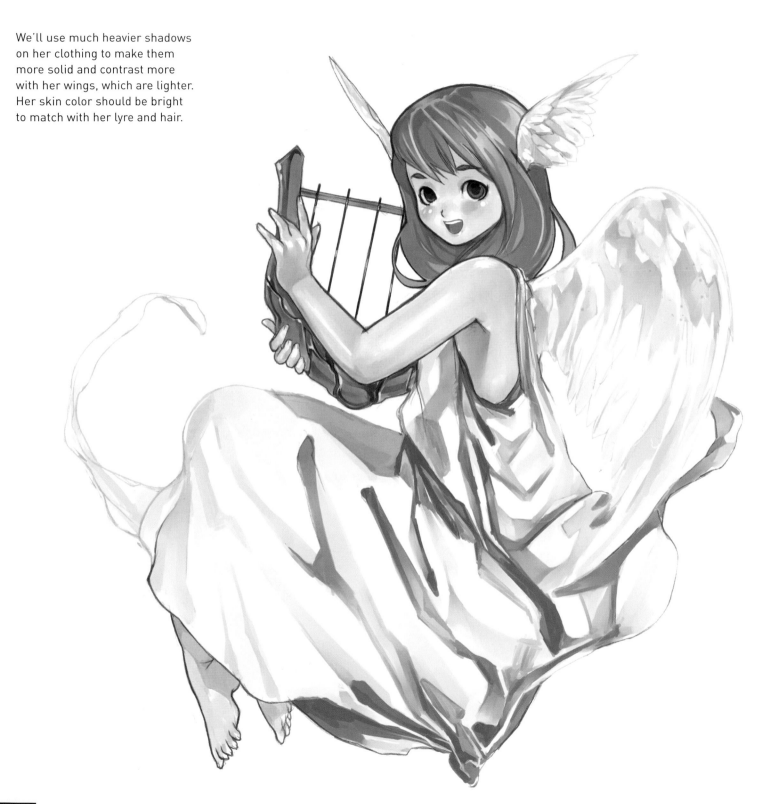

We'll create a background with clouds to situate our protagonist in the sky and we'll sit her atop one of them. The color of the clouds and background should be a little duller than the rest so as to not take importance away from our main character.

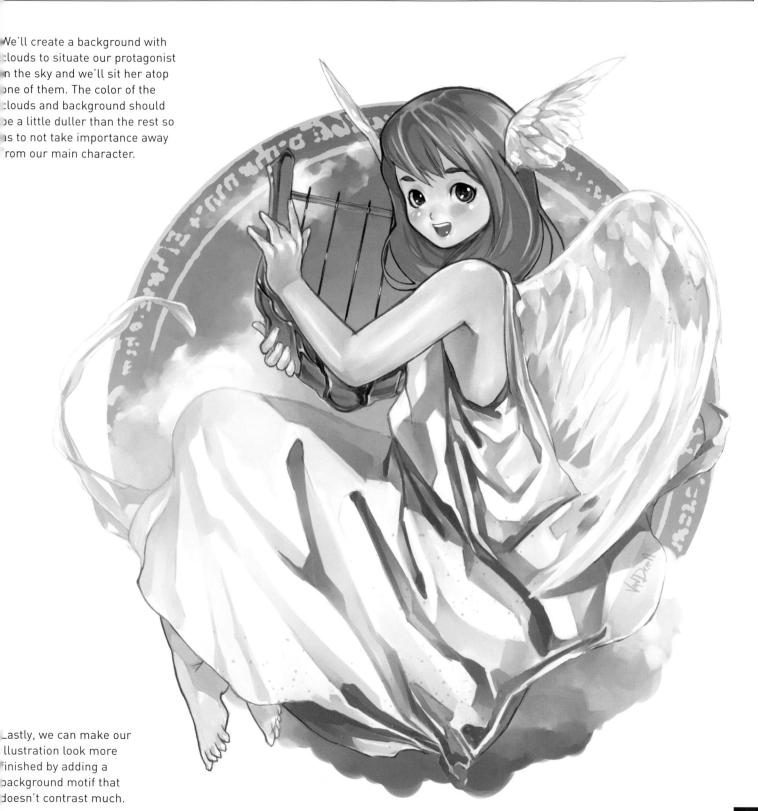

Lastly, we can make our illustration look more finished by adding a background motif that doesn't contrast much.

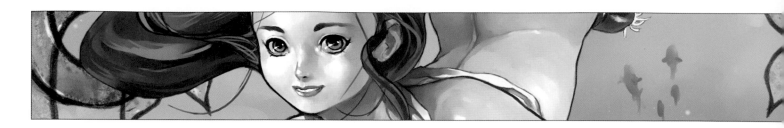

WATER SPIRIT

When drawing up a list of typical female fantasy characters in manga we must be sure not to forget about the wonderful siren figure, which in this case is represented by an aquatic being. Of incredible, unusual beauty, her song is said to attract seamen who try to navigate the inhospitable places where these Venuses of the sea live. Considering our intention is to depict the kind of idyllic image these beings typically represent within the context of manga culture, we've chosen to draw a sculptural lady cleaving through water to save poor shipwrecked sailors and then filling their memories with all that which is most beautiful in life.

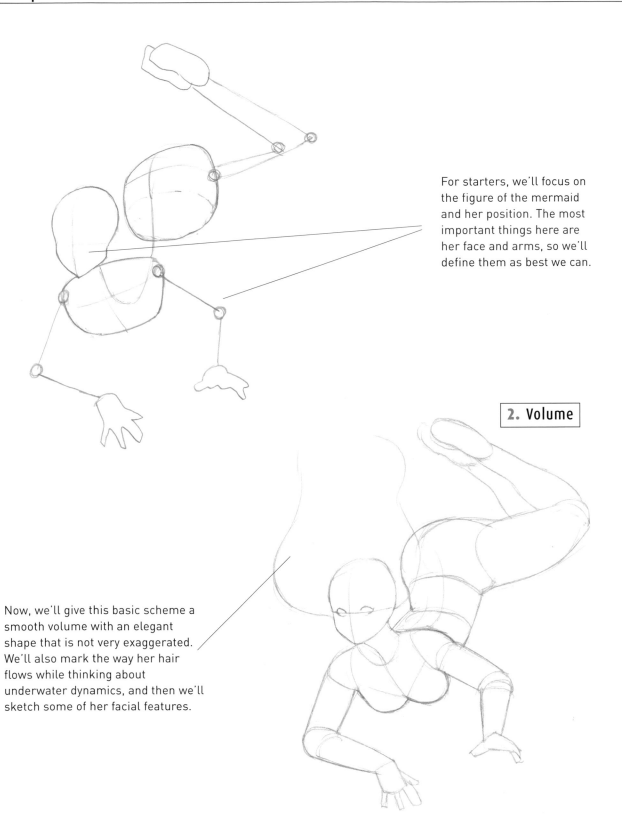

1. Shape

For starters, we'll focus on the figure of the mermaid and her position. The most important things here are her face and arms, so we'll define them as best we can.

2. Volume

Now, we'll give this basic scheme a smooth volume with an elegant shape that is not very exaggerated. We'll also mark the way her hair flows while thinking about underwater dynamics, and then we'll sketch some of her facial features.

We'll give this goddess of the seas a kind expression and a clear gaze, and we'll use the movement of her hands to try to capture the sensation she is underwater.

Although they won't be visible later on and they are somewhat small, we've drawn both her legs so we can see their position a little more clearly.

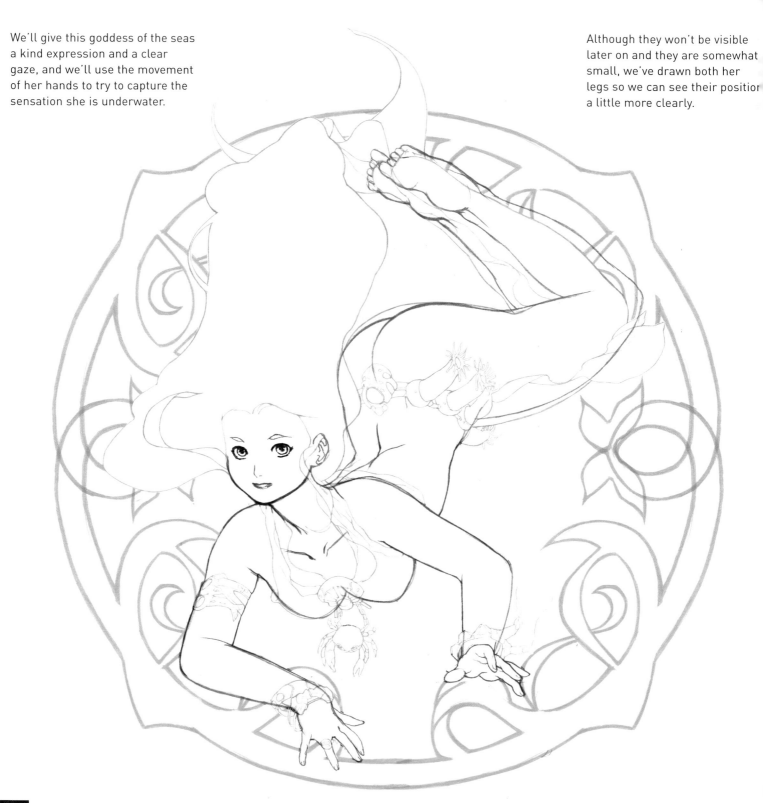

Clothes

The siren's clothing is conditioned by the sea environment, so we must seek elements such as shells or crustaceans to create jewelry, belts and all sorts of decoration.

We'll frame the illustration with a motif that will later serve as a fish eye come time for painting the background.

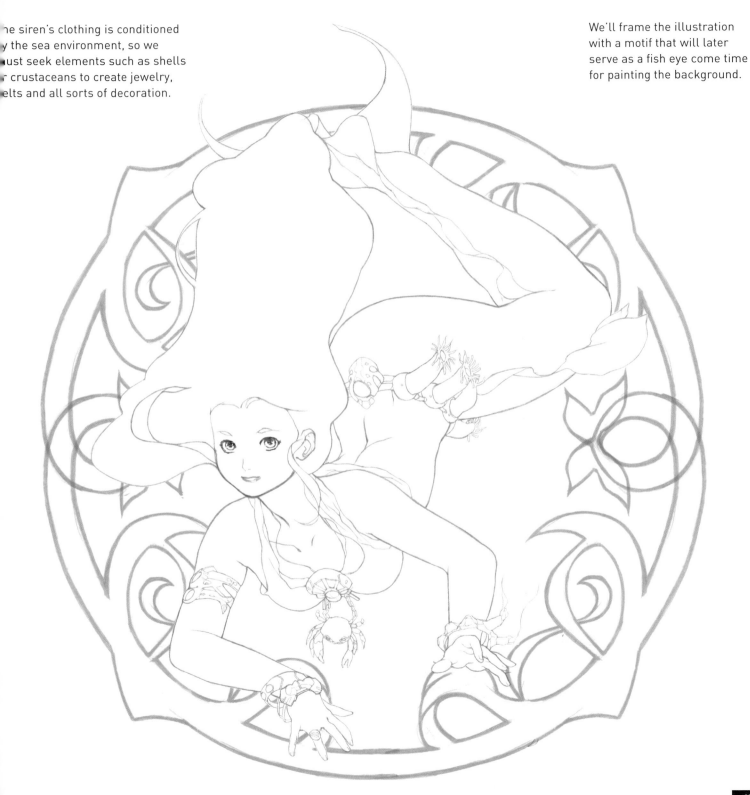

Source of light

The water spirit is not very far from the surface so the rays of light from above provide the lighting for this illustration. Her hair projects a light shadow over her shoulders, back and part of her tail.

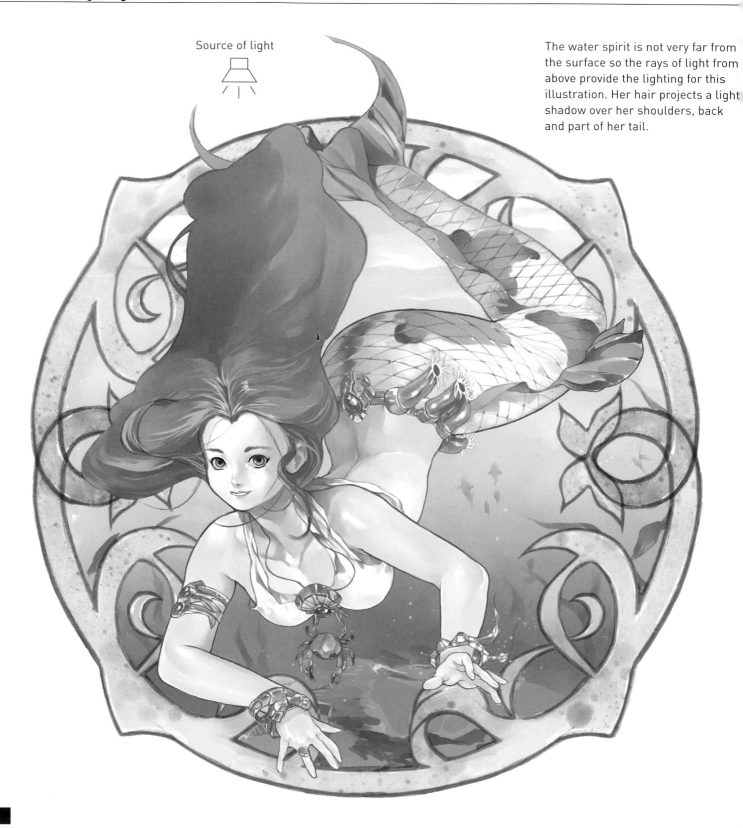

e'll paint our protagonist with
arm colors that help separate her
om the background, where we'll
e using colder colors.

We'll dapple and use highlights for
her tail and draw some organic
elements for her belt. We'll use
patches of color to paint rocks and
the various depths of the sea.

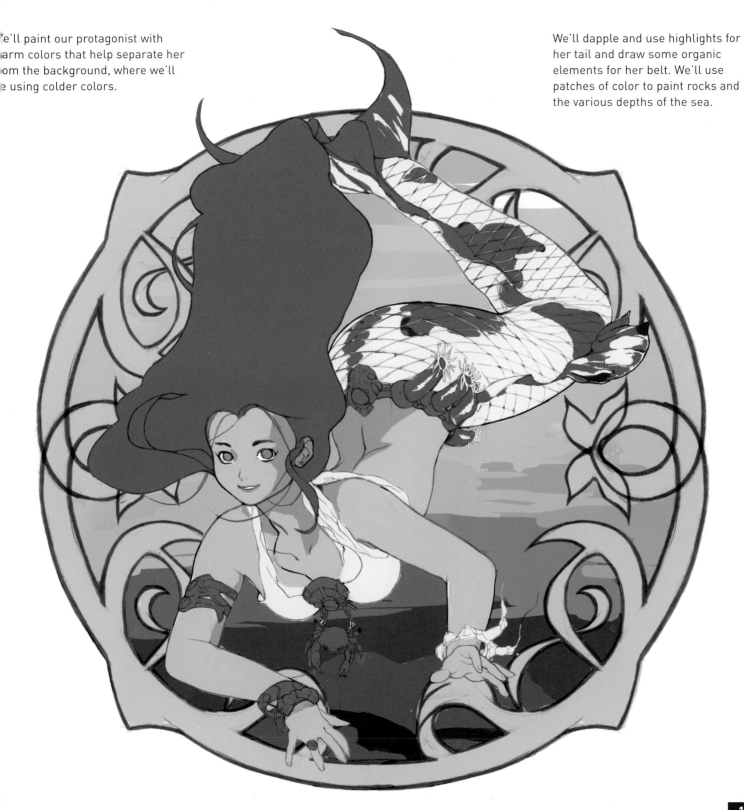

We'll color the water spirit's body according to the light source and the atmospheric light. Then we'll add shades of green to the shaded areas and add various other shades to integrate her with the background. We'll repeat the process with her tail, especially in more shaded areas.

We'll fade areas of her hair s as to give it more volume. Then we'll finish shaping elements we had only hinted at until now, such as seawee and fish, which can be simulated using shadows.

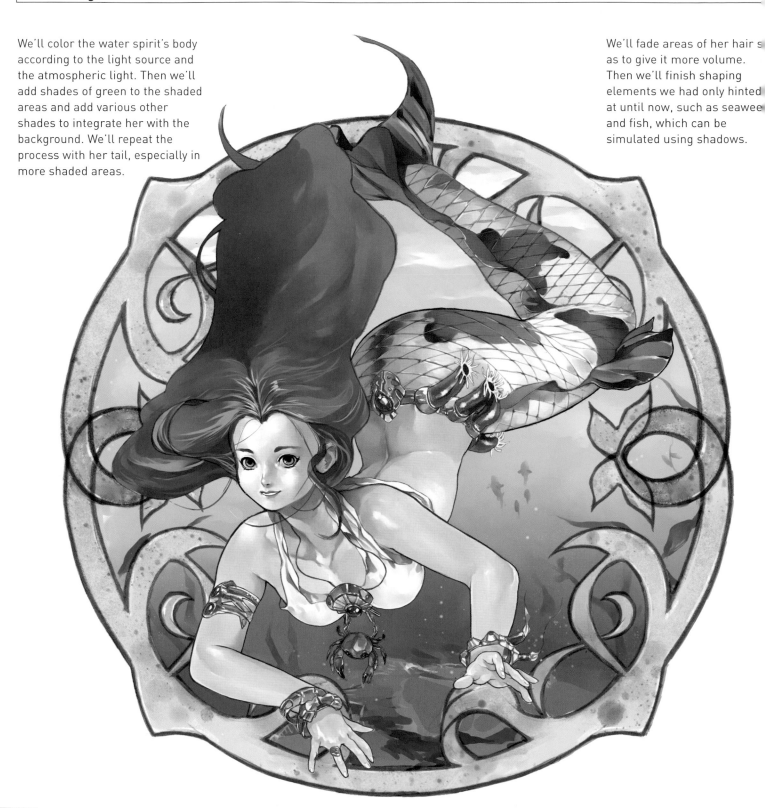

We can use patches of color and textures to create a more rocky look for the motif that surrounds the siren and the rocks on the sea bed.

We'll finish by giving final touches to elements such as her hair and tail and adding light contour lines on her arms to separate them from the rest of the drawing.

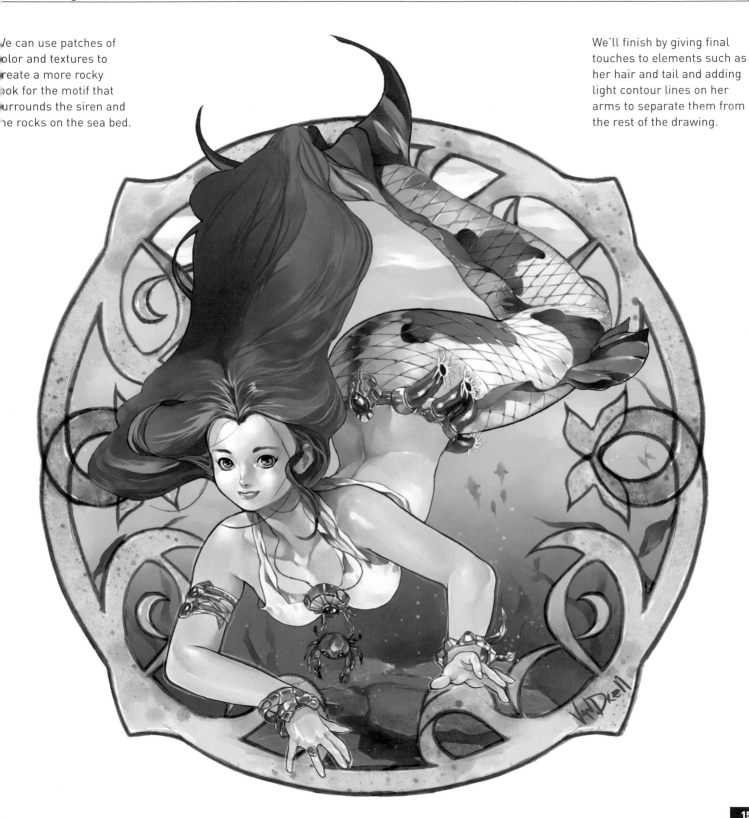

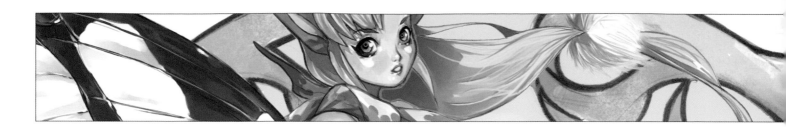

FAIRY

The fairy is possibly the most popular figure in the characteristic iconography of the genre. She is by far the being who appears in most works and with the widest variety of possibilities that range from pure heroic fantasy to the hardest *hentai*. It's not surprising since their cheerful and eternally youthful appearance suggests the kind of stranger to evil who fits perfectly with the stylistic canon of more classical manga. So, it's not hard to find hundreds of stories with these tiny nymphs with big eyes and their jolly nature wandering about, whether as protagonists (occasionally) or as a suffering hero's travel partner (almost always).

1. Shape

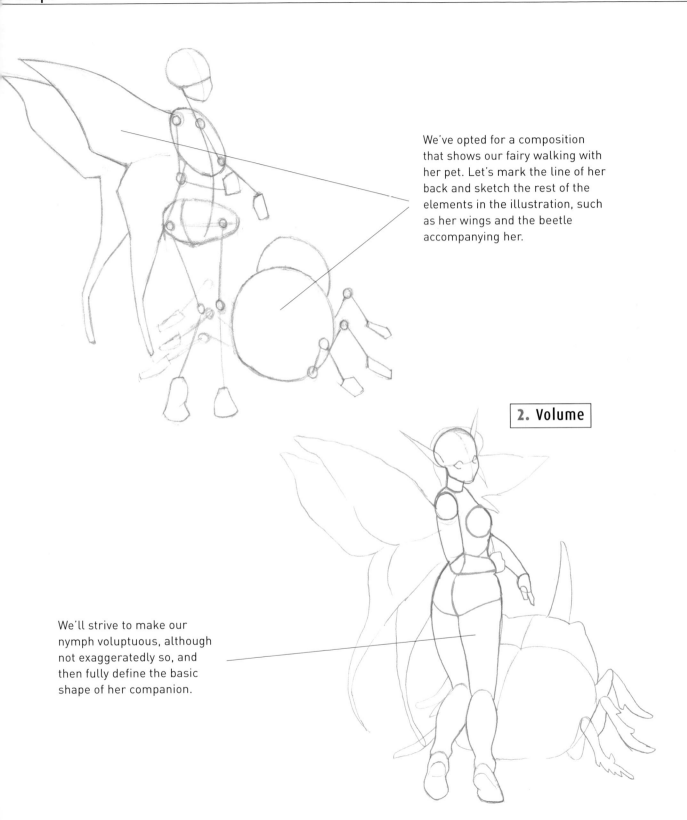

We've opted for a composition that shows our fairy walking with her pet. Let's mark the line of her back and sketch the rest of the elements in the illustration, such as her wings and the beetle accompanying her.

2. Volume

We'll strive to make our nymph voluptuous, although not exaggeratedly so, and then fully define the basic shape of her companion.

We'll need a body with an athleti
build, while preserving a certai
youthful flair which should also b
reflected on her face. We'll draw som
very large, expressive eyes and ha
blowing in the win

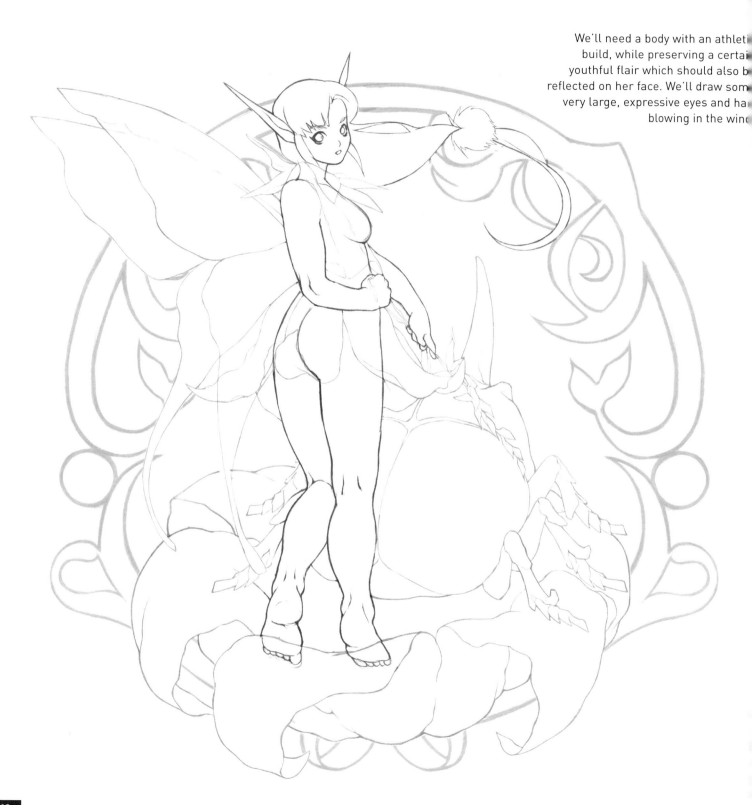

We'll fully define the beetle, as well as the more or less wilted flower both characters are resting on. Lastly, we'll add a decorative motif around them.

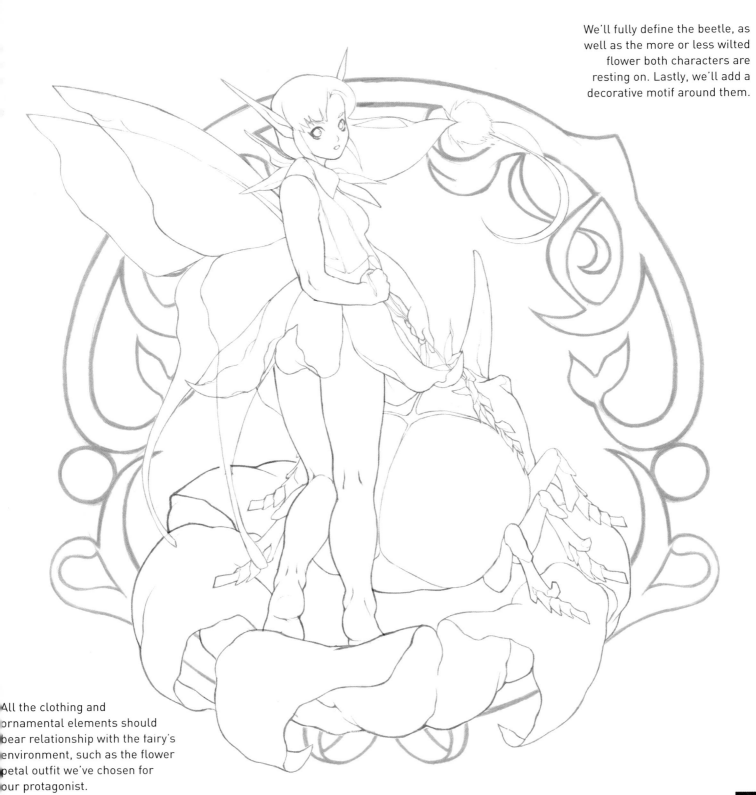

All the clothing and ornamental elements should bear relationship with the fairy's environment, such as the flower petal outfit we've chosen for our protagonist.

Source of light

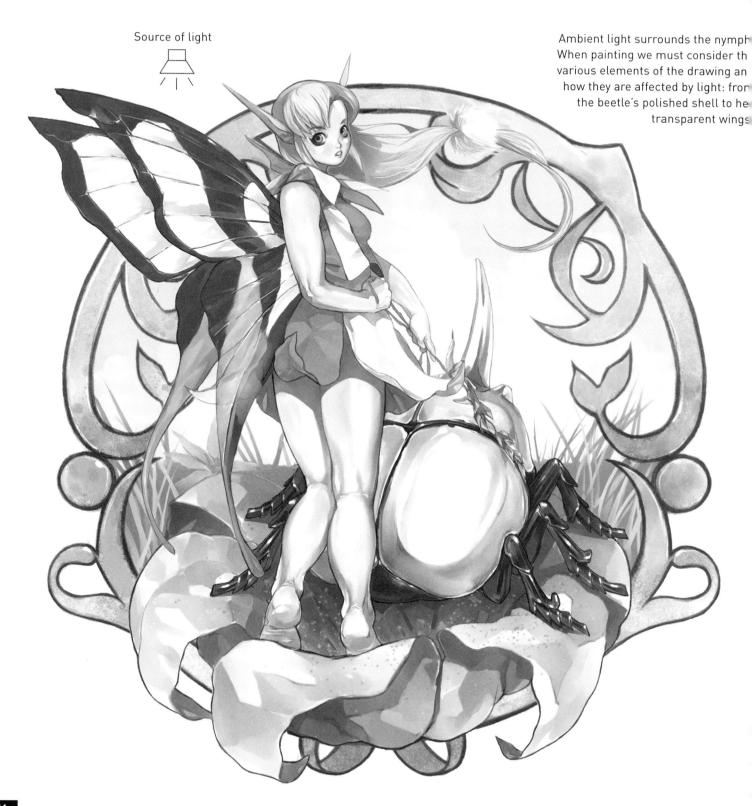

Ambient light surrounds the nymph
When painting we must consider th
various elements of the drawing an
how they are affected by light: fro
the beetle's polished shell to he
transparent wings

The design and color of her wings also make them stand out towards the viewer. Next we'll draw the main shadows on the flower and fairy.

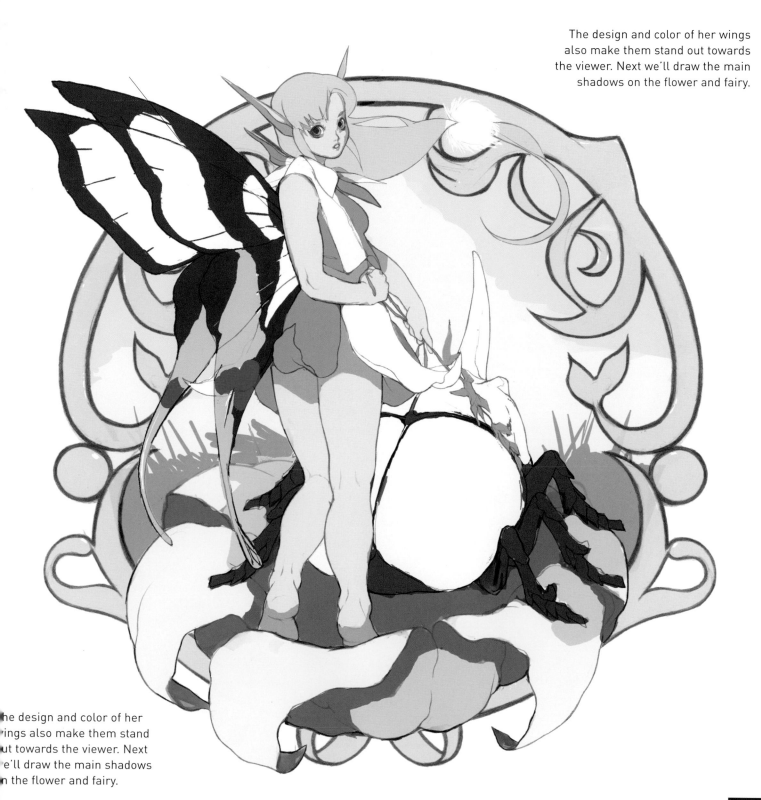

he design and color of her rings also make them stand ut towards the viewer. Next e'll draw the main shadows n the flower and fairy.

We must consider how th
surroundings are reflected o
the beetle, even if only in
subtle manner, and we'll mak
the wings look transparen
especially the one that i
nearest the viewe

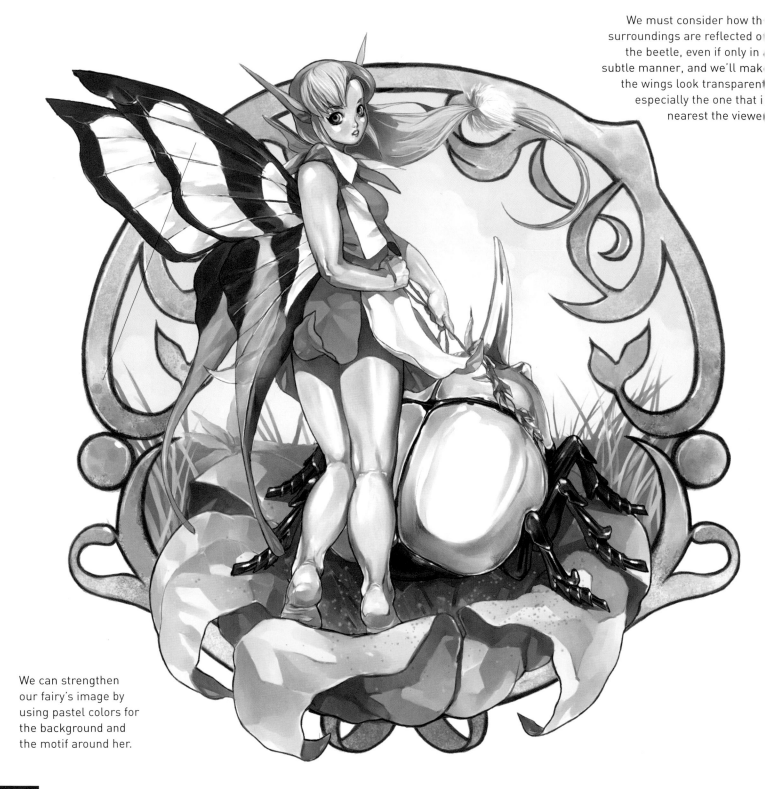

We can strengthen
our fairy's image by
using pastel colors for
the background and
the motif around her.

We'll paint patterns on the fairy's dress and on the beetle's shell so the image looks more natural, and then we'll dapple some pollen on the flower we've placed our characters on.

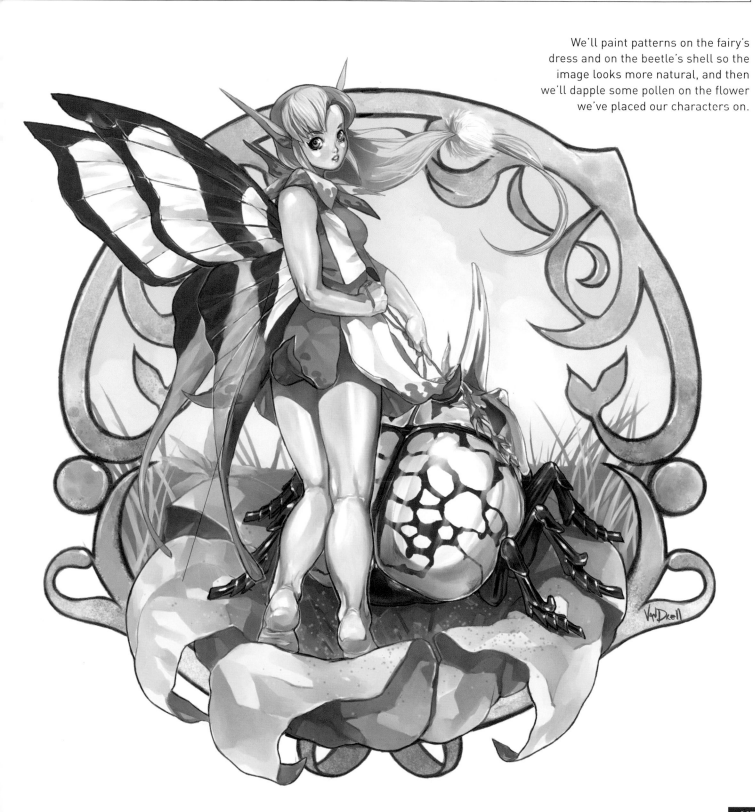

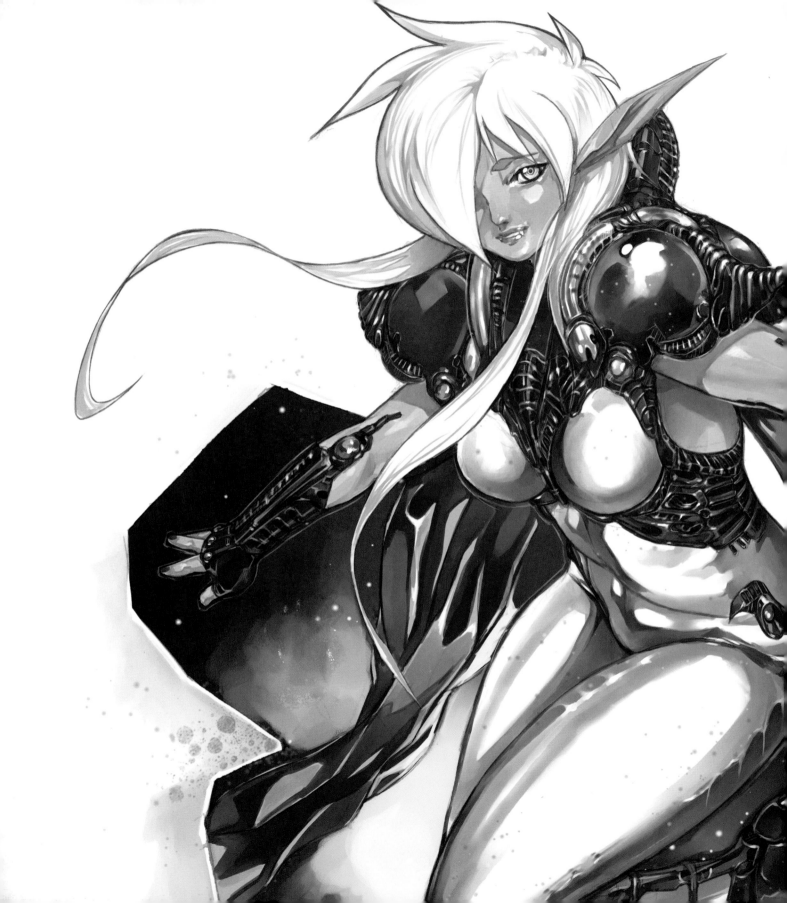

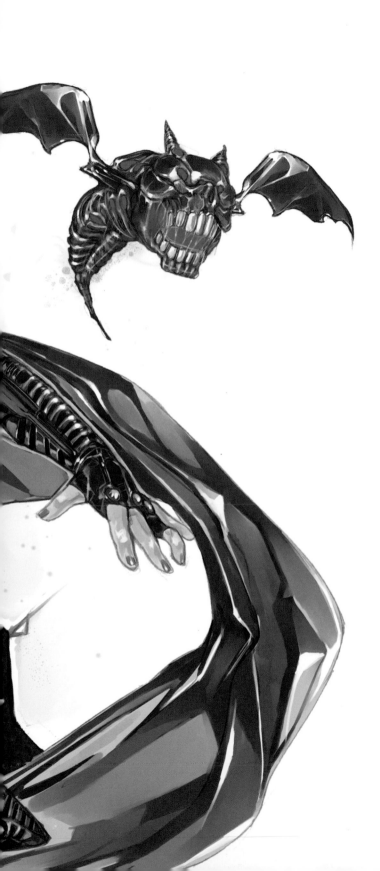

MAGICAL GIRLS

GIRL & PET

She and the love soldier are the most typical characters in the *maho shojo* genre. The easiest way to describe this cliché is to envision the kind of girl who accidentally discovers some object or element that suddenly gives her magical powers. Joined by her lively and faithful pet friend, who helps her and gives her smart advice, she is always dressed up in multi-colored outfits. She doesn't hesitate to distribute kindness and magic in equal parts, while at the same time finding a way to juggle all this into her daily life. In short, this type of character is a classic with an infinite number of representations who is well known by all good manga aficionados.

1. Shape

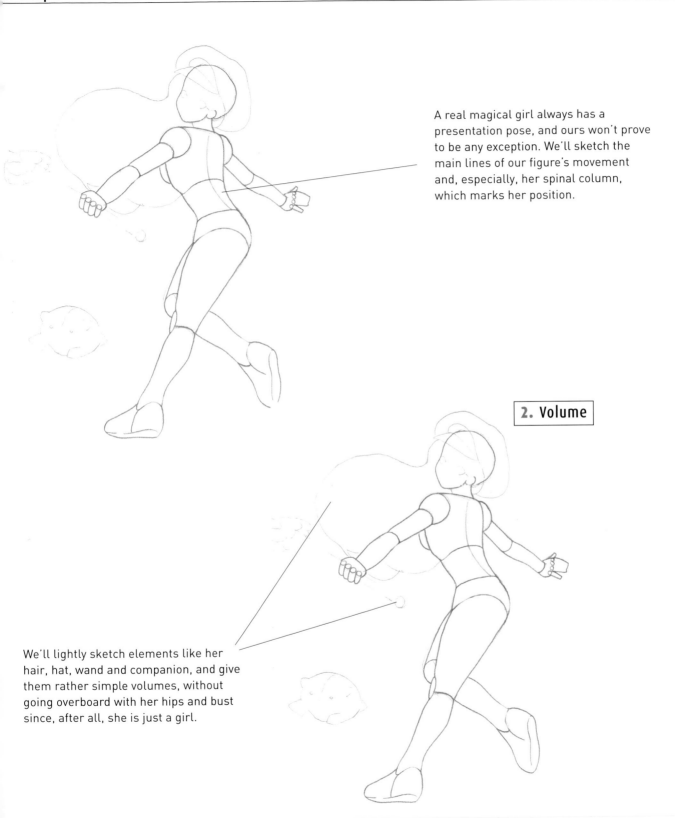

A real magical girl always has a presentation pose, and ours won't prove to be any exception. We'll sketch the main lines of our figure's movement and, especially, her spinal column, which marks her position.

2. Volume

We'll lightly sketch elements like her hair, hat, wand and companion, and give them rather simple volumes, without going overboard with her hips and bust since, after all, she is just a girl.

Her face is happy and
cheerful. We'll give her some
simple features, with big eyes
that radiate effusiveness.

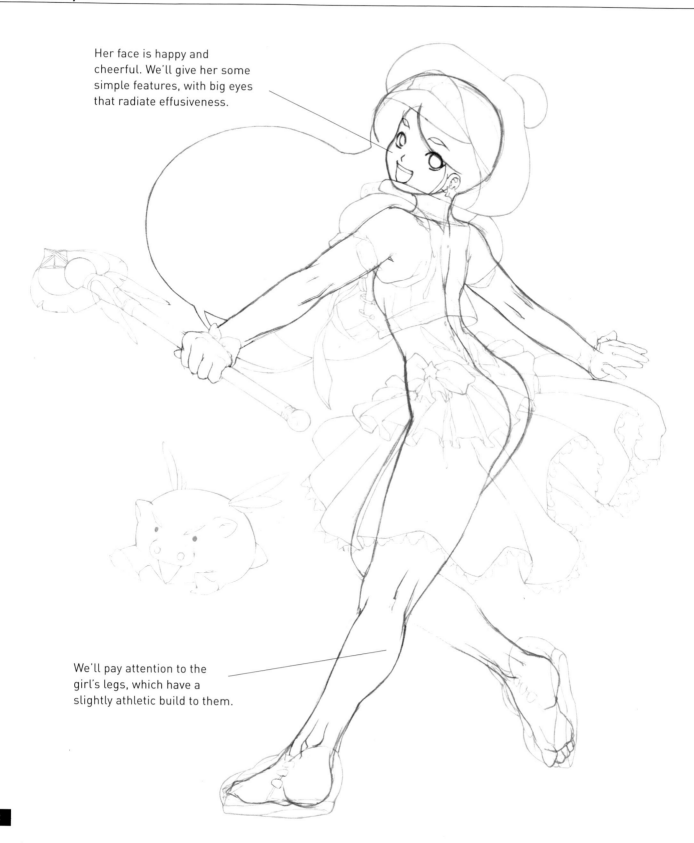

We'll pay attention to the
girl's legs, which have a
slightly athletic build to them.

his is the most interesting
art of this illustration, since,
s an exemplary magical girl,
he's wearing a dress that is
verloaded with lots of
ccessories.

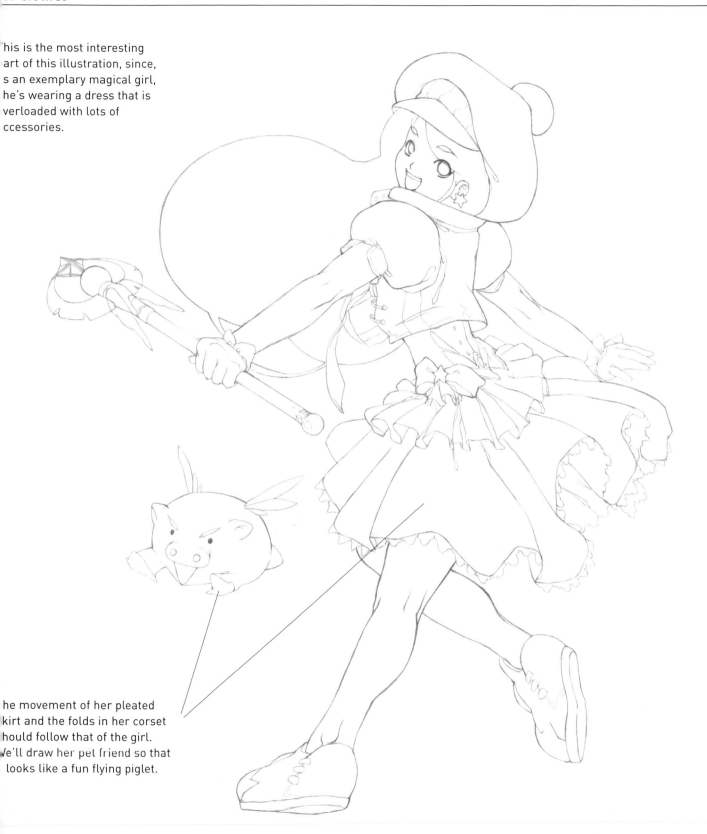

he movement of her pleated
kirt and the folds in her corset
hould follow that of the girl.
Ve'll draw her pet friend so that
 looks like a fun flying piglet.

The zenithal light falls on her hair and hat in a particular way. We must consider how light falls on chrome elements and how these reflect the other objects in the illustration.

Source of light

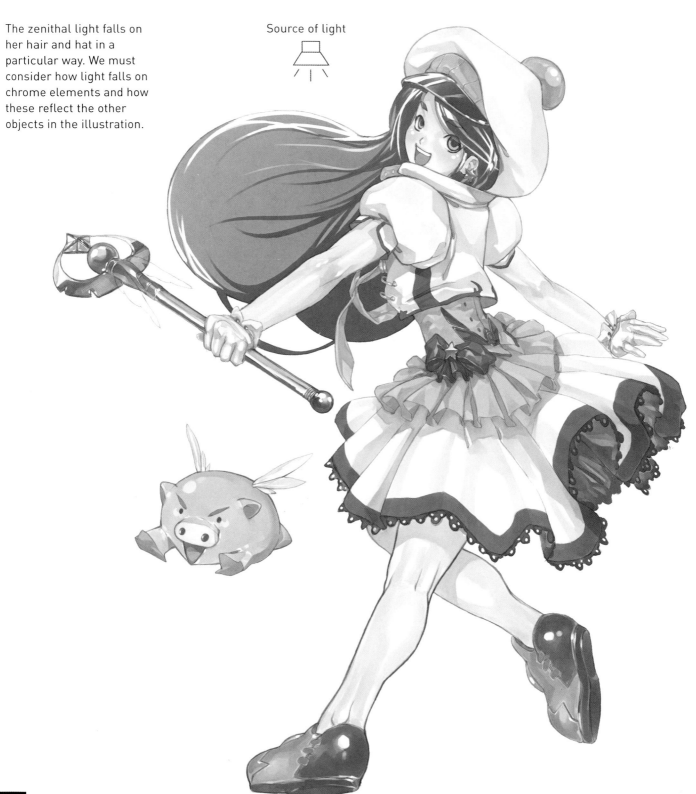

The flat colors should be pastels, which are befitting for our character. As a counterpoint we can use a darker complementary color on her clothes.

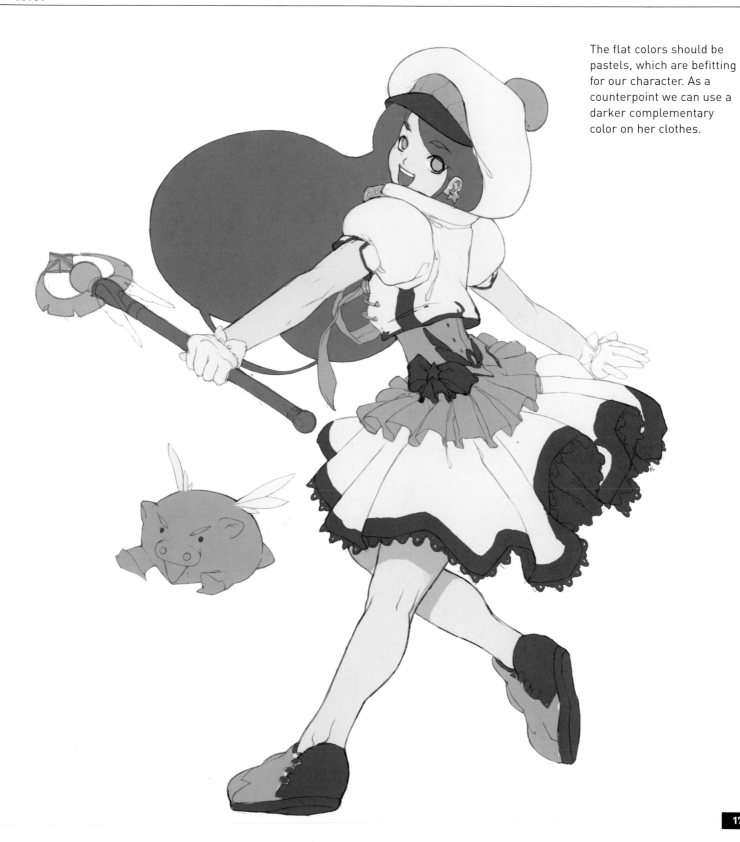

We can use lots of different shades of color to give volume to her outfit and make it look more believable.

Then we'll create the wrinkles on her jacket and the interior o her skirt using slightly geometric shapes and defining its narrow lace edging.

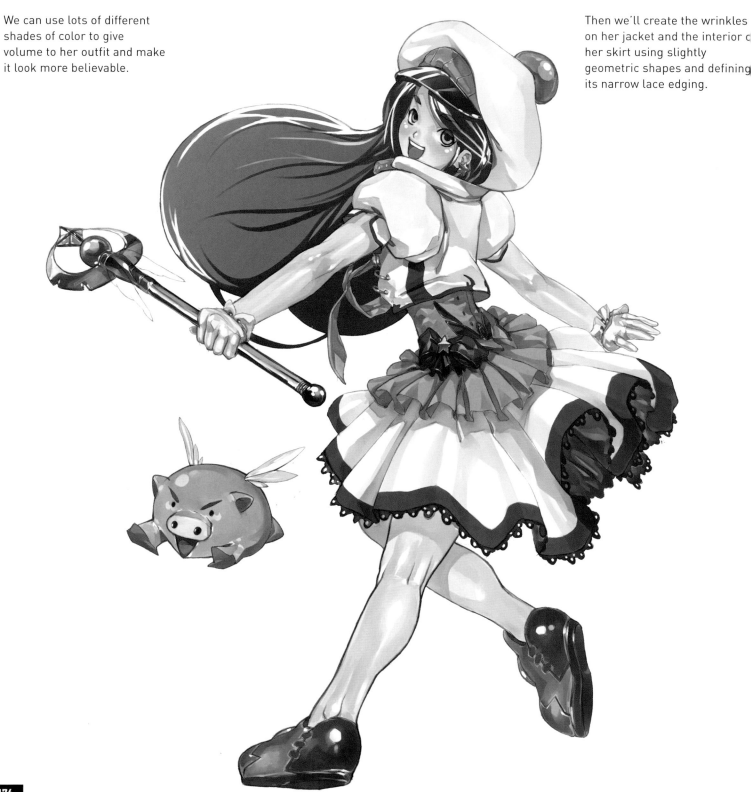

We can make the image more homogeneous by reproducing the star on her earrings and the bow on her corset in elements like her stockings, wand and the pig's forehead.

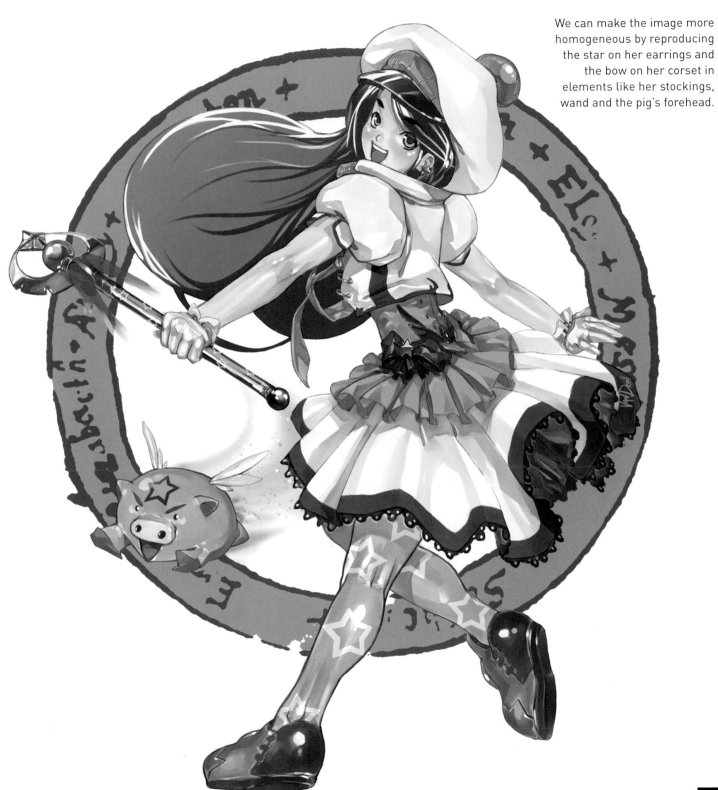

LITTLE WITCH

Far from being the stereotypical horrible, evil wart-ridden old witch that devours children, in the magical girls genre it's commonplace to find a healthy dose of witches and sorceresses who are much more childish and unique. Much closer to the typical *magical girl*, these witches are girls who combine their daily life with practicing the art of magic with the purpose of doing good and helping others without revealing their abilities. When it's time to use their powers they dress up in outfits that are clearly inspired by the classic iconography, but with a much more simplistic touch, and always make use of objects like magic hats and flying brooms.

1. Shape

The sweet girl flying her broom across the sky makes for an appropriate scene to illustrate this character.

We'll begin with the line of her back and hips, the most determining aspects of this drawing. We'll clearly mark the base for foreshortening her legs.

2. Volume

We'll look for simple shapes and give her hips some nice volume considering her pose above and beyond everything else, but without forgetting that she is a child while drawing the rest of the volumes. Let's sketch the remaining elements, such as her hat and broom.

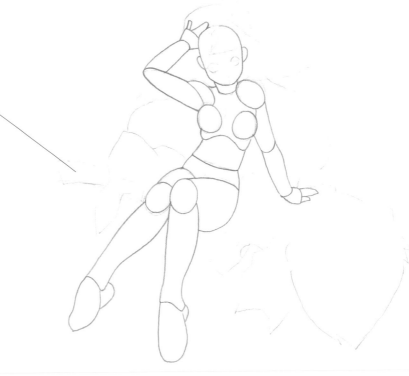

We'll fully define the girl's legs so they can be seen clearly, paying attention to how they should hang while suspended in air. Her face, which should display childish features and transmit happiness, will benefit from great big eyes.

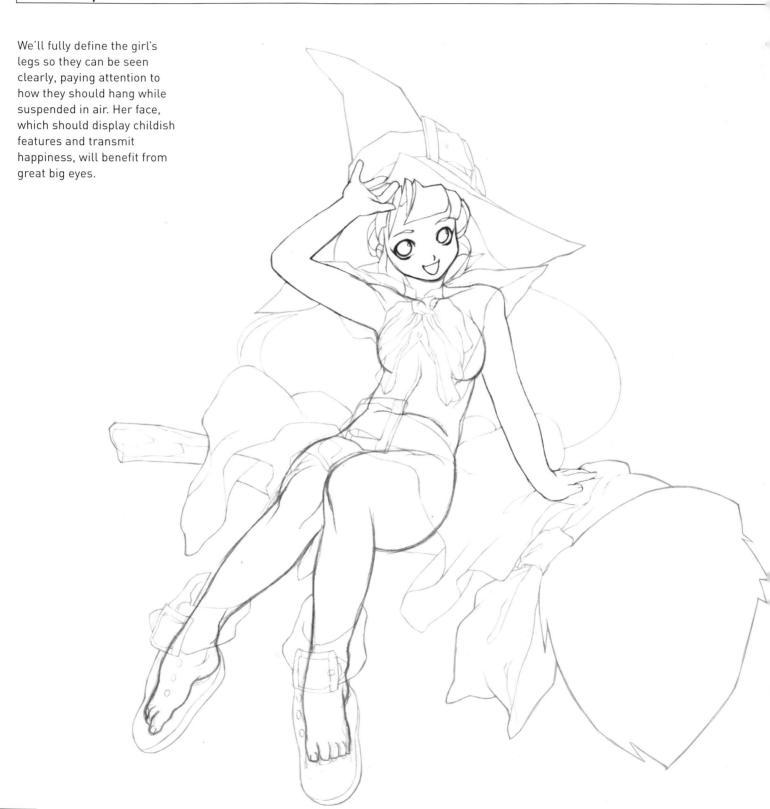

4. Clothes

We'll draw the volume of her hair and clothes, especially her skirt, considering the direction should fall in. We'll also define the basic shape of her broom, although we'll put off drawing the brush part until we begin working with color.

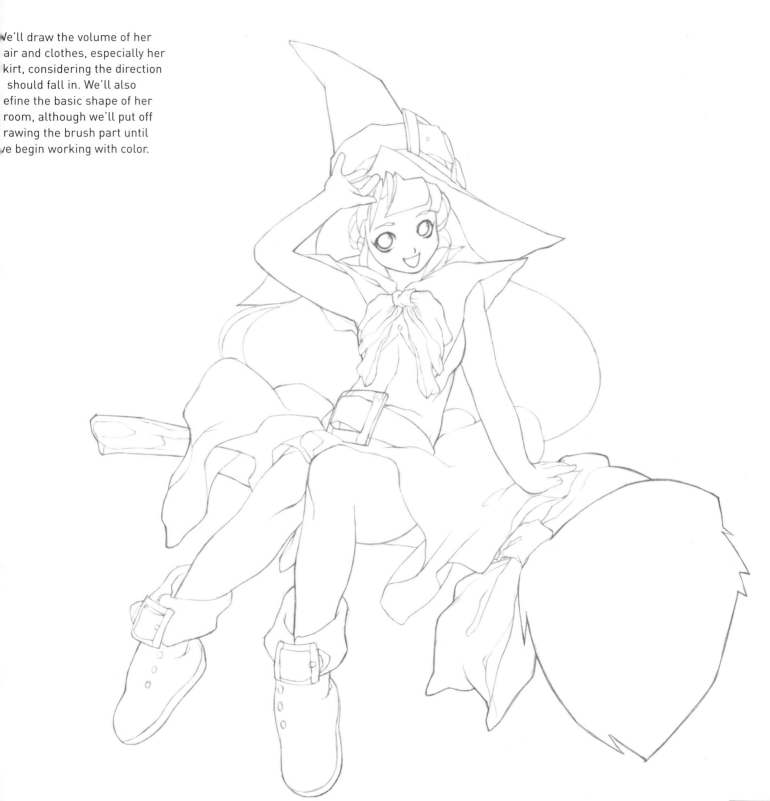

We have a zenithal light source, which projects shadows on the lower parts of all objects. The witch herself projects her shadow over the backside of her dress and the area touching the broom.

Source of light

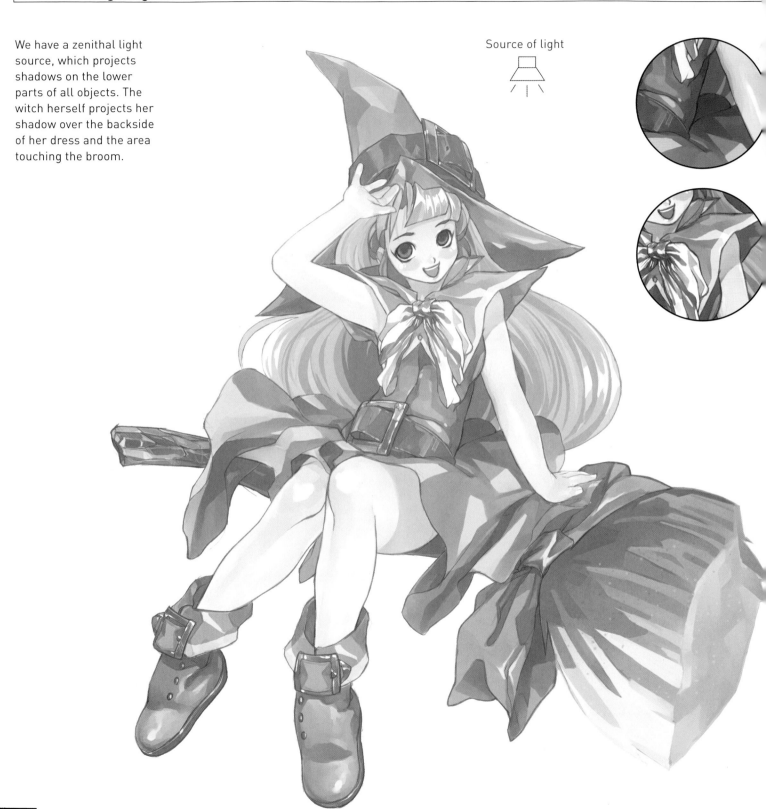

classical color selection will help
s easily identify our character. We'll
e using dull base colors and then
e'll mark her basic skin shading
nd outline her eyes.

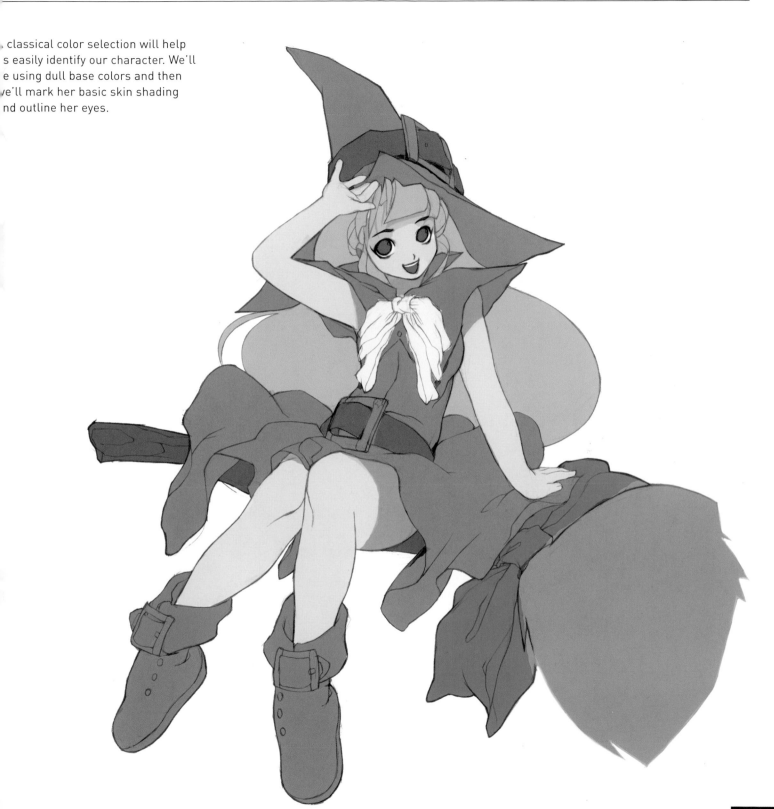

Let's give volume to all the elements in the illustration. We'll use geometrical patches of color for large objects such as the broom and hat, and use patches of various colors for her hair, making sure to follow the wave of her movement.

8. Finishing Touches

We'll finish her eyes by adding some lighting to give her some more personality. We'll complete the illustration by drawing a violet-colored magical motif for the background.

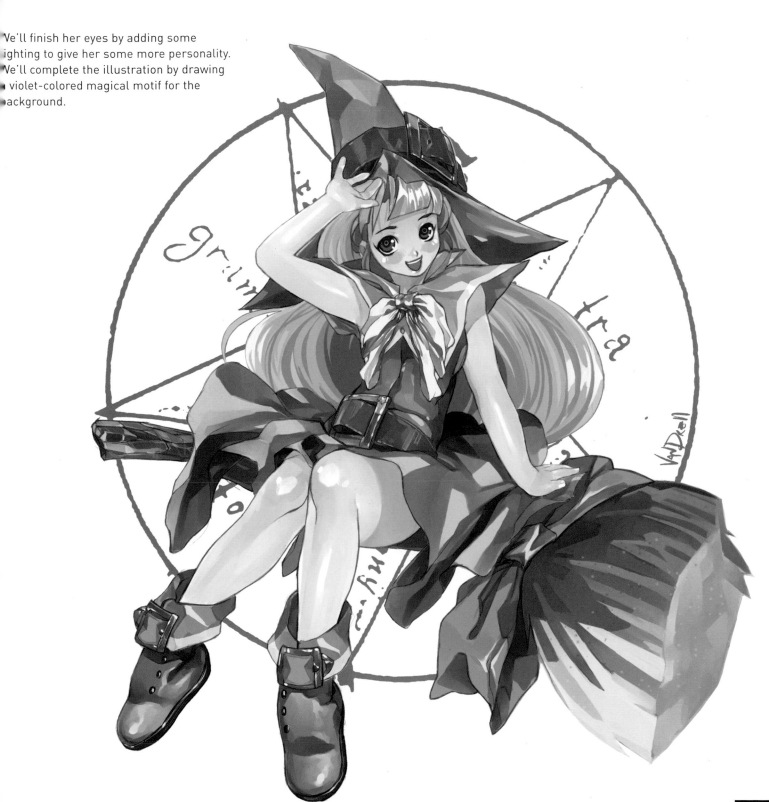

LOVE SOLDIER

One of the most well-known manga stereotypes is that of the girl in the schoolgirl outfit with the cosplay getup that is as *kitsch* as can be, with magical powers, wandering about the neighborhood in the name of love and justice. There are countless series that, based on this premise, have earned a spot in the hearts of true manga fans. With slight variations, such as using certain objects for their transformation or the issue they deal with (some find inspiration on the topic of marriage, while others recur to the elements). One thing is for sure, these characters, who are constantly looking to do away with evil wherever it lurks, won't leave anybody indifferent.

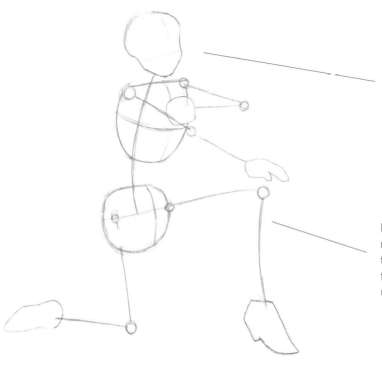

Any real love soldier must be characterized by some kind of special movement or magical attack with which they can defeat their dreadful enemies.

In this illustration we've opted for a relaxed pose that simulates one of these movements. The shape of the figure must be sketched while paying utmost respect to her proportions.

2. Volume

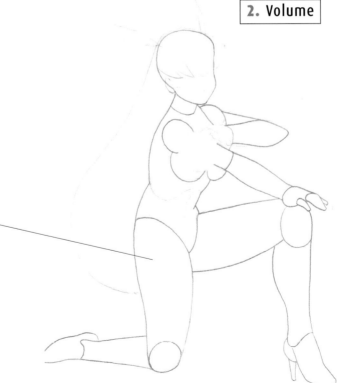

Next, we'll give the entire figure some volume while paying particular attention to her legs, which are key to this drawing.

It's a good idea to define the position of her shoulders in order to add her accessories later on. Following the same logic, the hand holding the magic wand must be drawn so that it looks realistic in the final illustration.

You should be very careful when drawing her legs, since they are definitive, and her face, which should look friendly and attractive. We've chosen a more polyvalent style, although it would also work if we chose to give her more extravagant features.

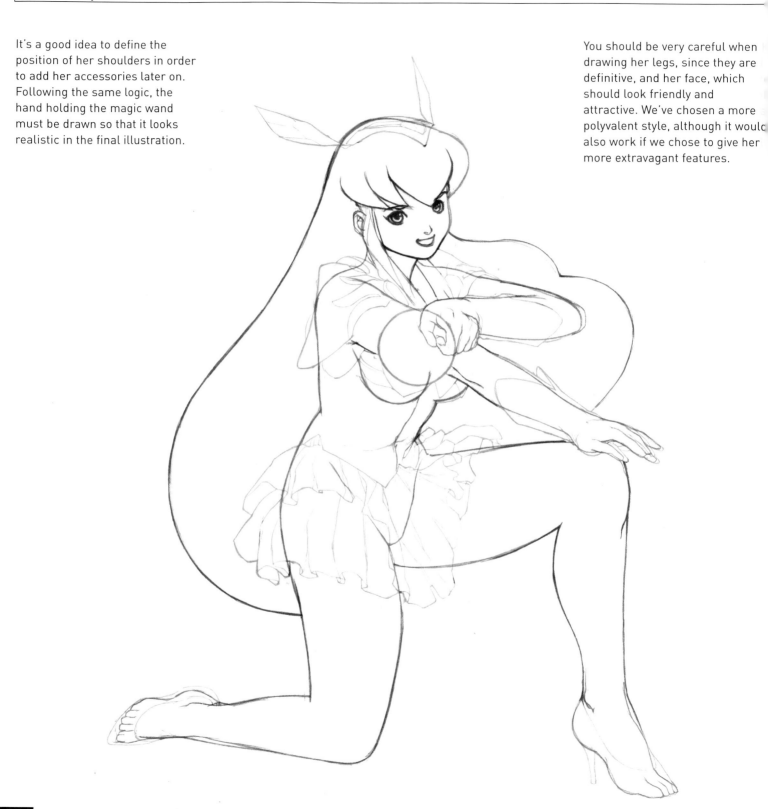

Her dress should be over-elaborate, but clear, with the pleats on the upper layer well differentiated from the lower layer. Using light lines for her shoes and cuirass will help give her better definition.

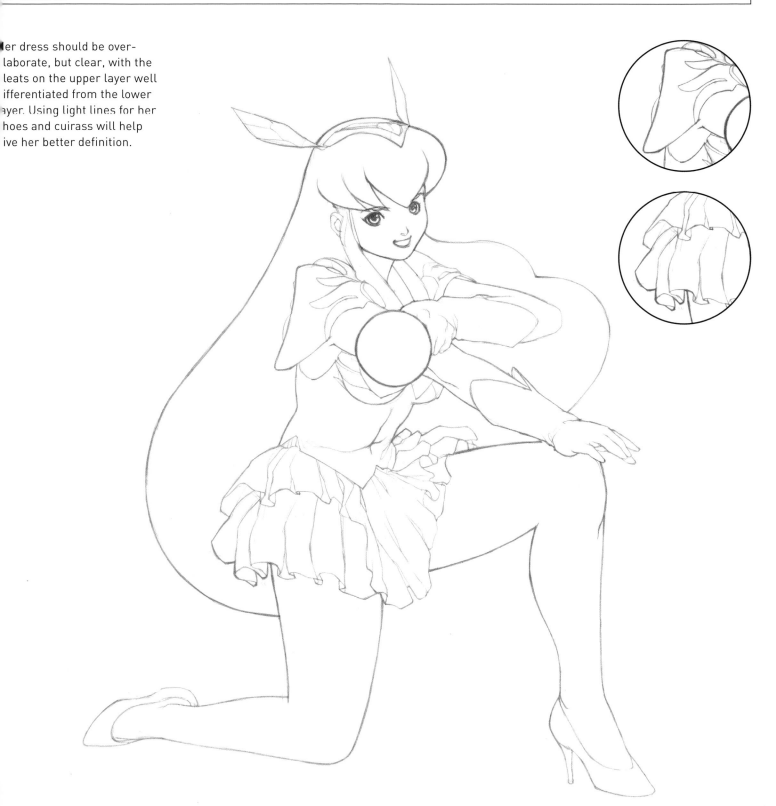

A light source on the upper right side allows for a nice range of shadows and shades of color to be projected on her neck and legs.

When drawing her cuirass and other elements we must not only bear in mind the light source itself but its reverberation.

Source of light

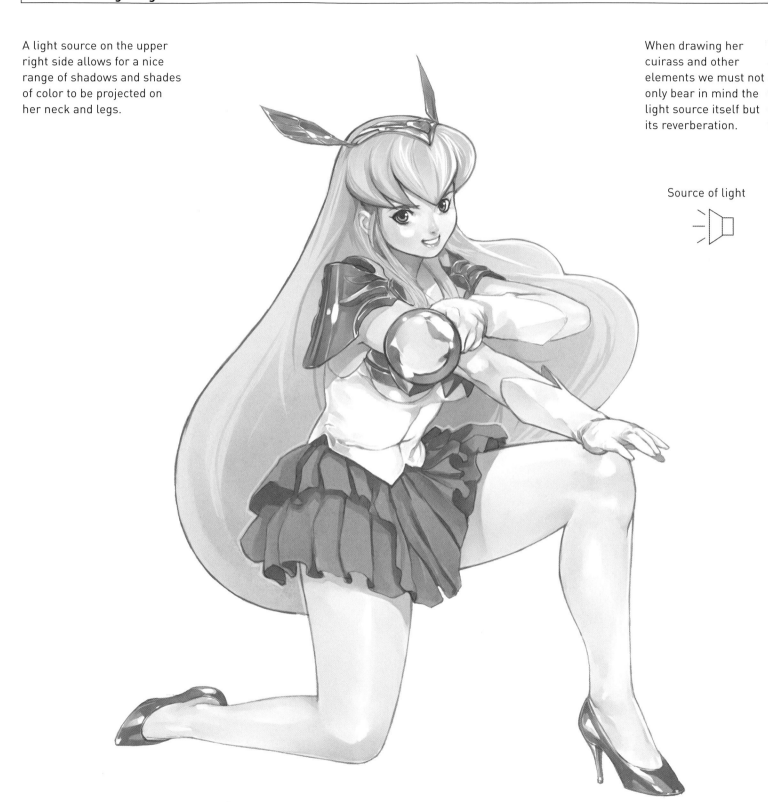

The flat colors for her dress will be rather bright, since we want them to attract attention. We'll use pastels for the other colors so that they remain in the background.

We'll use flat patches of shading on her skin and outfit in order to define them better.

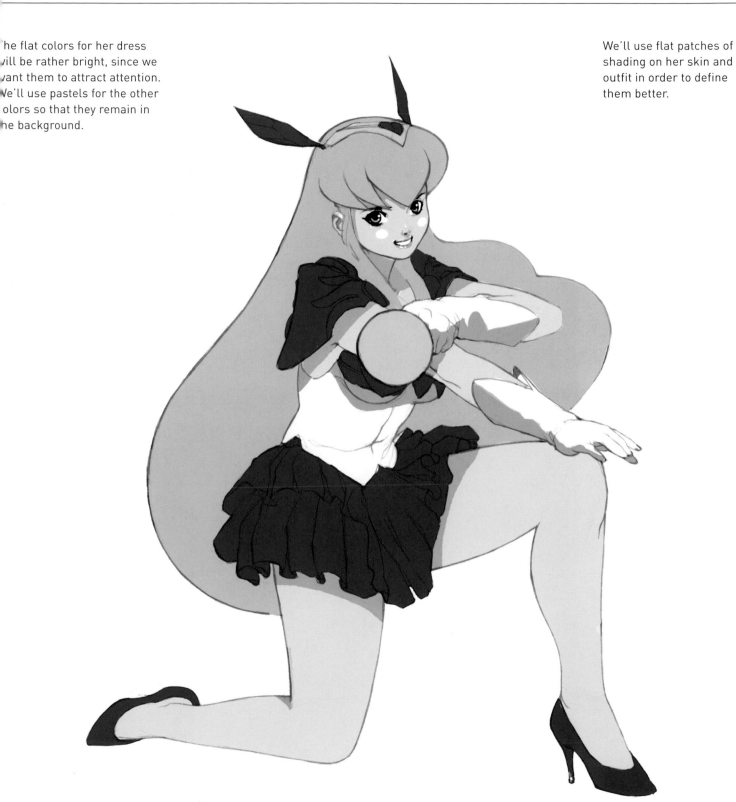

We'll use shades of pink for shading, thus giving the image better color balance that matches her outfit and hair, which require various different shades to give them volume.

Lastly, we'll add the lights. When drawing her armor and wand we must keep in mind the reflection created by all the other factors.

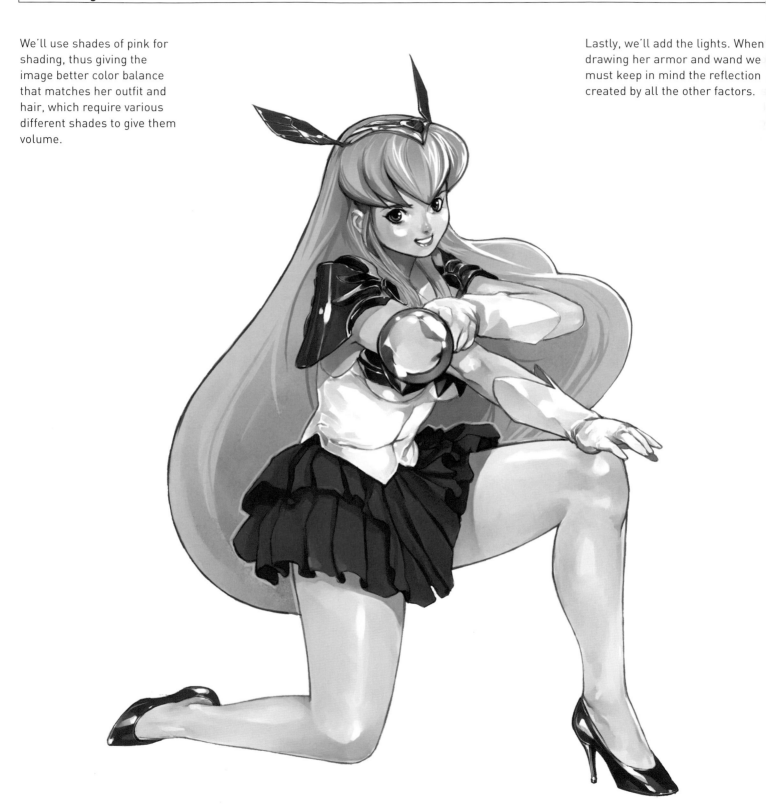

8. Finishing Touches

In this step we'll finish the wand by
adding a light around it that makes
it glow with maximum intensity. We
can use slight splashes of white to
place even more emphasis on the
light, and finish the illustration with
a light projection of her shadow.

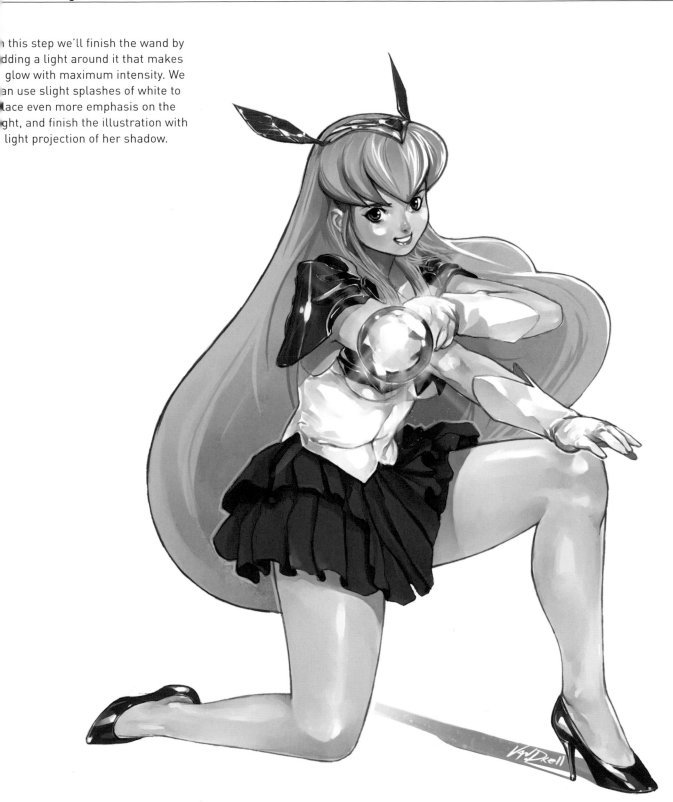

ASSASSIN COMMANDANT

While the love soldier receives her powers from a deity that belongs to the world of light and goodness, assassin commanders put blind faith in a dark force in exchange for incredible powers. Always accompanied by a creature of inferior rank, they walk among humans incognito, seeking victims to satiate the hunger of their master. When they reveal their true appearance they usually wear characteristic elements of the infernal world they come from, which almost always combine well with their lethal beauty. They are characters with boundless ambition who ultimately end up understanding the heroine's motives and yielding their place to another commander.

1. Shape

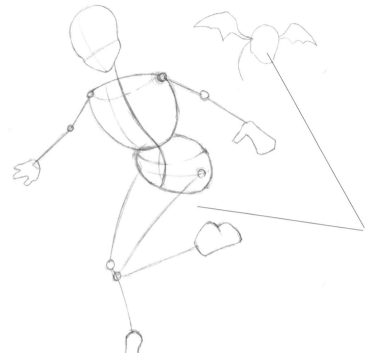

The focus of this illustration will be to capture the moment when one of these dangerous women enters our world. We should show her leaving her dimension as if she were coming out of the paper.

Her pose should have depth, so we'll mark the difference between the various foreshortened areas. We'll also sketch the commander's infernal companion to give us a reference of its position.

2. Volume

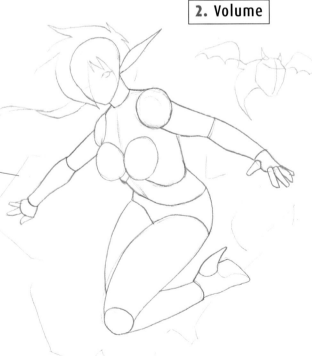

For her body we'll seek shapes that are as suggestive as possible. We'll mark the hole our character is coming out of and sketch elements such as her hair.

We'll use boney elements, such as skulls and vertebrae, when drawing the little devil and his rather charmless wings.

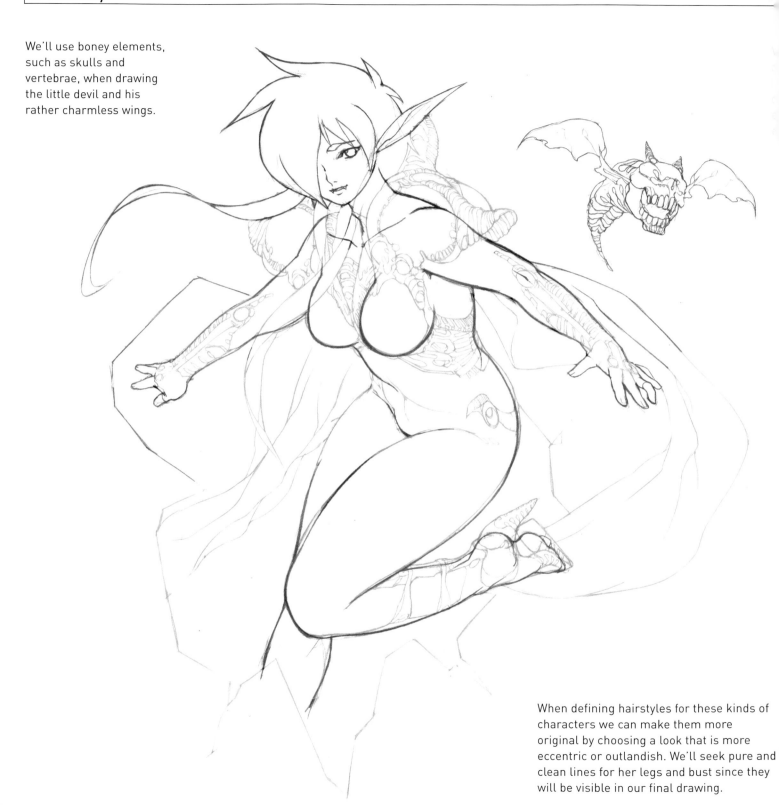

When defining hairstyles for these kinds of characters we can make them more original by choosing a look that is more eccentric or outlandish. We'll seek pure and clean lines for her legs and bust since they will be visible in our final drawing.

4. Clothes

We'll follow the same premise as when drawing the little devil and seek a balance between metallic armor and an organic shell as if she were an insect.

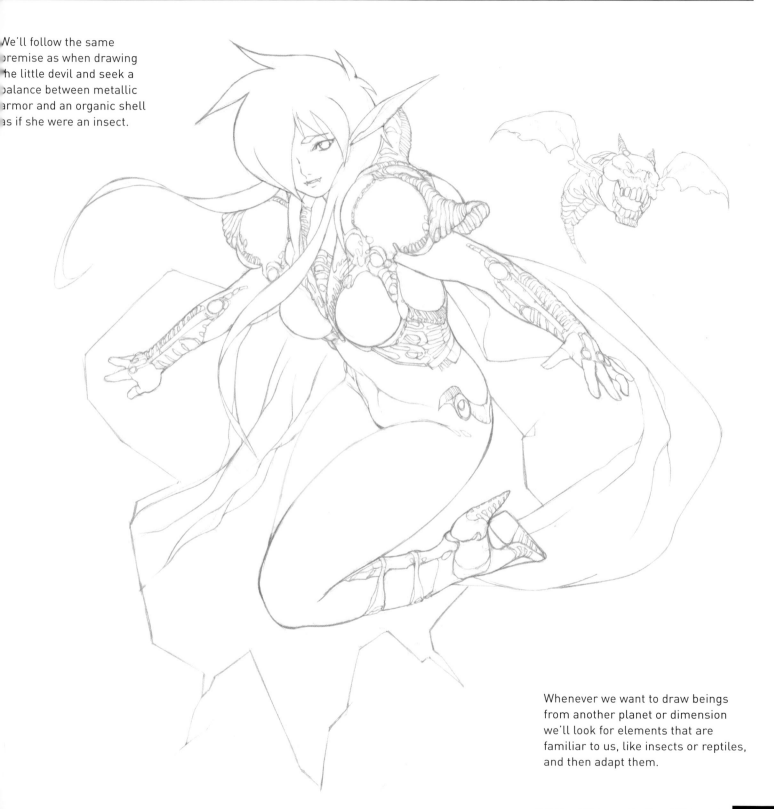

Whenever we want to draw beings from another planet or dimension we'll look for elements that are familiar to us, like insects or reptiles, and then adapt them.

The frontal light source provides the light necessary for the armor and outfit, and allows us to experiment while painting and to create materials that are different from the usual ones.

Source of light

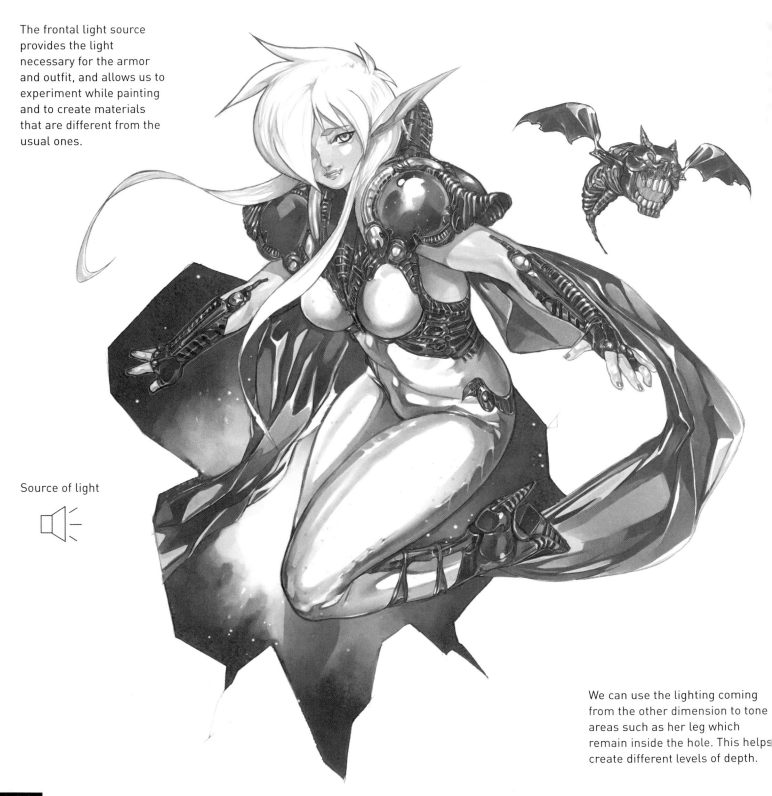

We can use the lighting coming from the other dimension to tone areas such as her leg which remain inside the hole. This helps create different levels of depth.

6. Color

We'll use off colors for the background because a dark color would blend in with the character and we'd lose the sensation of volume we've created. We'll use patches of color to paint the mist that covers part of the commander's silhouette.

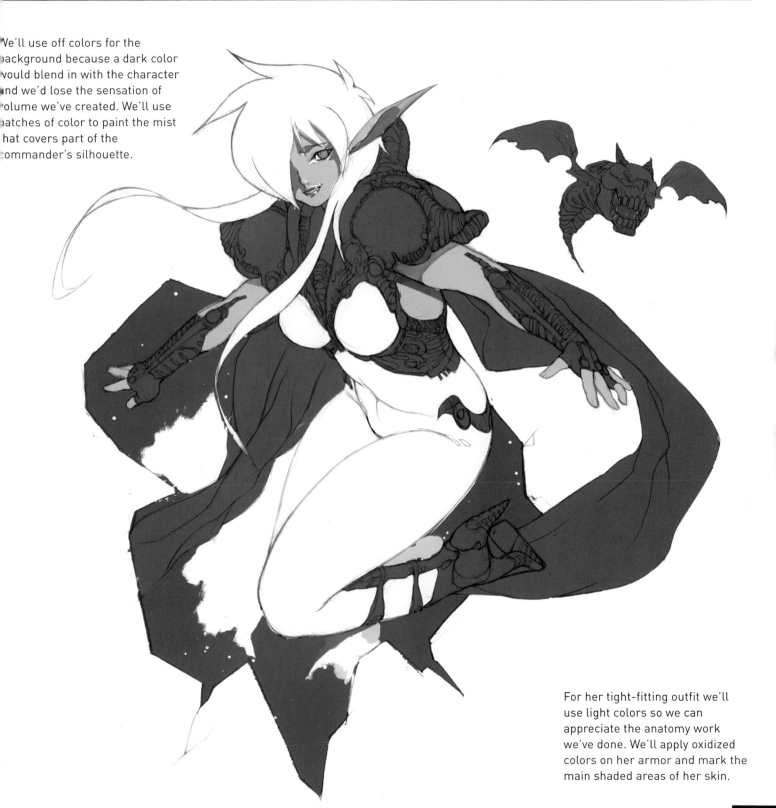

For her tight-fitting outfit we'll use light colors so we can appreciate the anatomy work we've done. We'll apply oxidized colors on her armor and mark the main shaded areas of her skin.

We'll go over her hair and part of the girl to trim her some more. We'll use patches of color when tooling around with oxidized colors and chiaroscuro hues and then give her outfit a chrome look by going over the shaded areas with darker contrast.

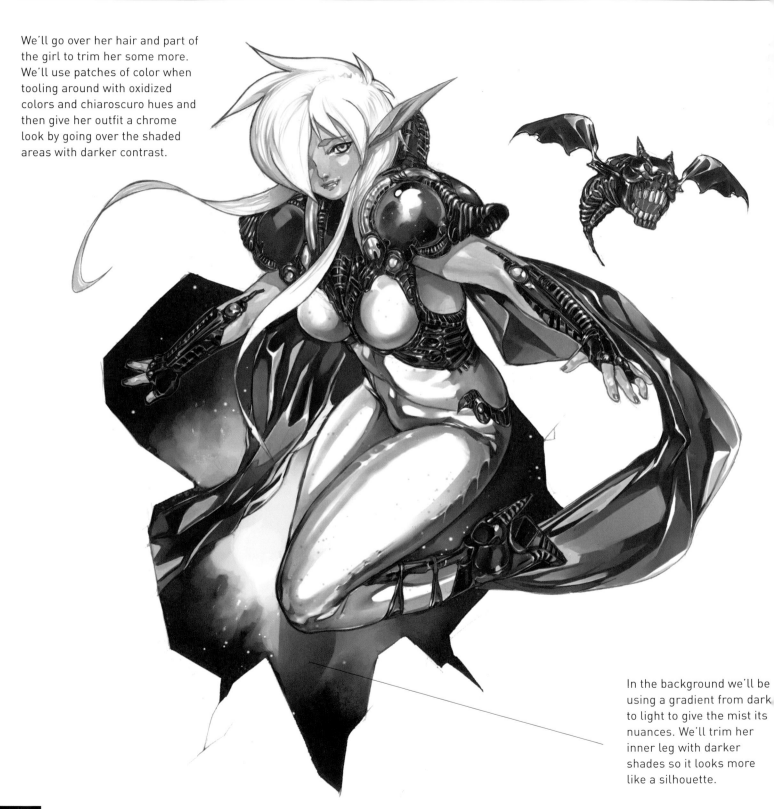

In the background we'll be using a gradient from dark to light to give the mist its nuances. We'll trim her inner leg with darker shades so it looks more like a silhouette.

Let's add effects around the hole as if it were a broken window. The white lines outlining her back hand and front leg help make the image more dynamic and tri-dimensional.

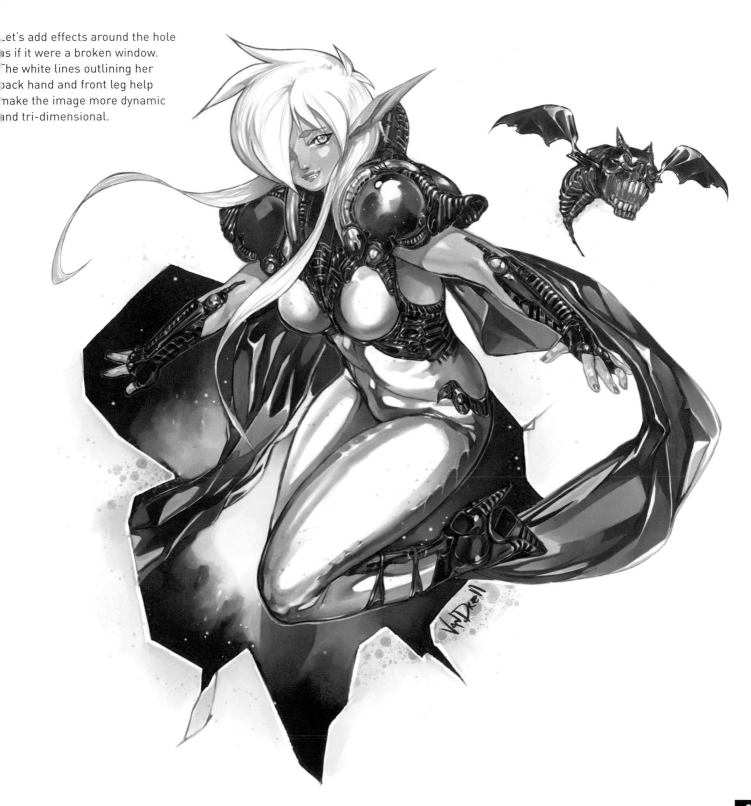

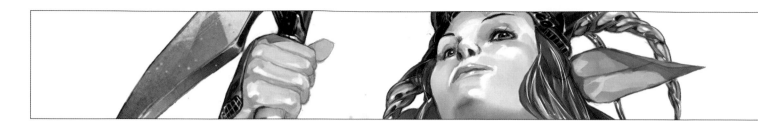

QUEEN OF EVIL

In any real magical girls story worthy of the title we can be sure to find the figure of the evil queen: the mega-powerful antagonist who is out to conquer the world of man with the help of her faithful demons, assassins and followers. In the great majority of cases, she will feed off the souls of her faithful in order to boost her evil powers and let them be manifested well beyond the dimensions she is living in, eagerly awaiting the day when her victory over the powers of good will be complete. She almost always hides her horrible physical appearance behind the figure of a beautiful lady, although her colossal proportions make her easily recognizable.

1. Shape

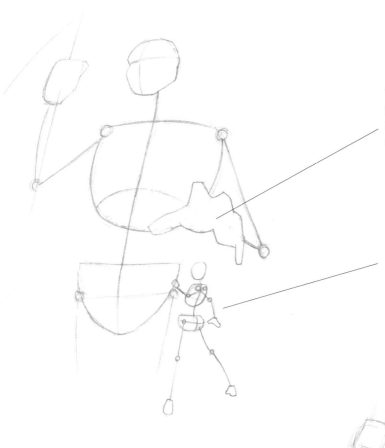

To depict this evil divinity, we've chosen to show a beautiful titan emerge from her dimension while one of her assassins awaits her.

We should pay great attention on each of the drawing steps so that we correctly portray the sharp low-angle and sketch the two characters while respecting the perspective of the scene.

2. Volume

We'll sketch the basic shapes of the bodies of the two characters. For the goddess we'll begin by detailing her features so that we have a clear idea when we move on to her anatomy.

In the same way, we should consider how the perspective of the proportions of her hands varies depending on their proximity to the viewer.

We'll give shape to all of the elements we marked previously. In this case, superimposing the armor on top of the body helps us see the exact position of her shoulders and how they are affected by the low-angle shot.

The assassin is also subjected to the same sharp perspective, which we'll accentuate by drawing its left leg as close as possible. The evil queen requires maximum detail, so it's a good idea to draw her face with a more realistic expression.

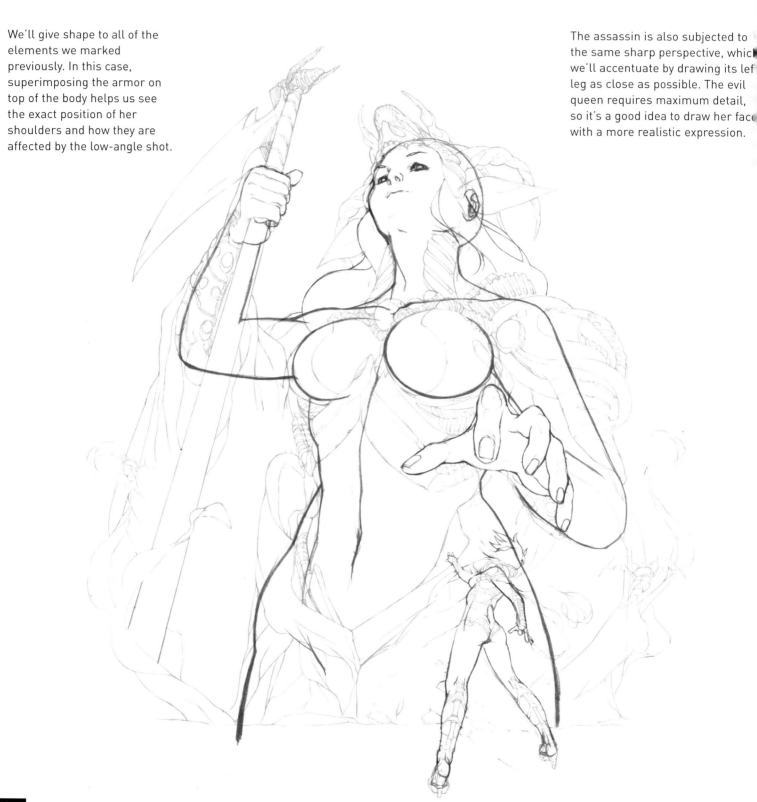

Clothes

We'll draw the veils and clothes of the queen and her helper while considering that they are subjected to the titan's emerging movement. As we did in the commandant exercise, we'll create the goddess' armor using organic and macabre elements.

In order to differentiate her further from her helper and demonstrate that she is not only a larger figure but a more important one, we'll add elements such as her crown or the greater detail on her shoulder pads and, finally, tiny demons flying around her.

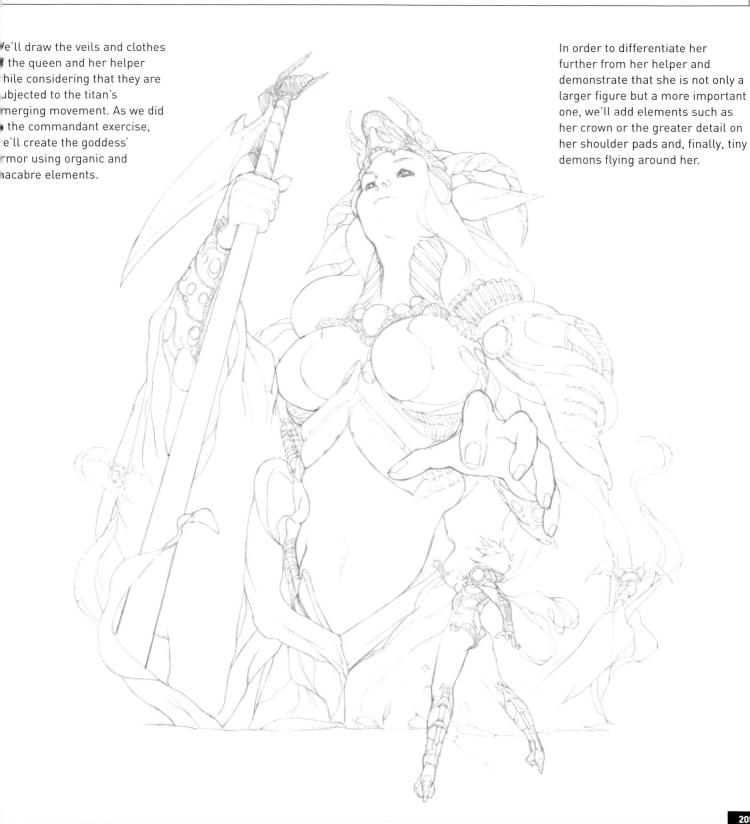

There are three main light sources. The first is the ambient light above the queen. Then we have another light source coming from below the queen, which we'll give a color of its own, as we did with the commandant.

Source of light

Lastly, between the palm of her hand and her emissary's arm there's a powerful light source that could be bolts of lightning which reverberate throughout the area surrounding the two characters.

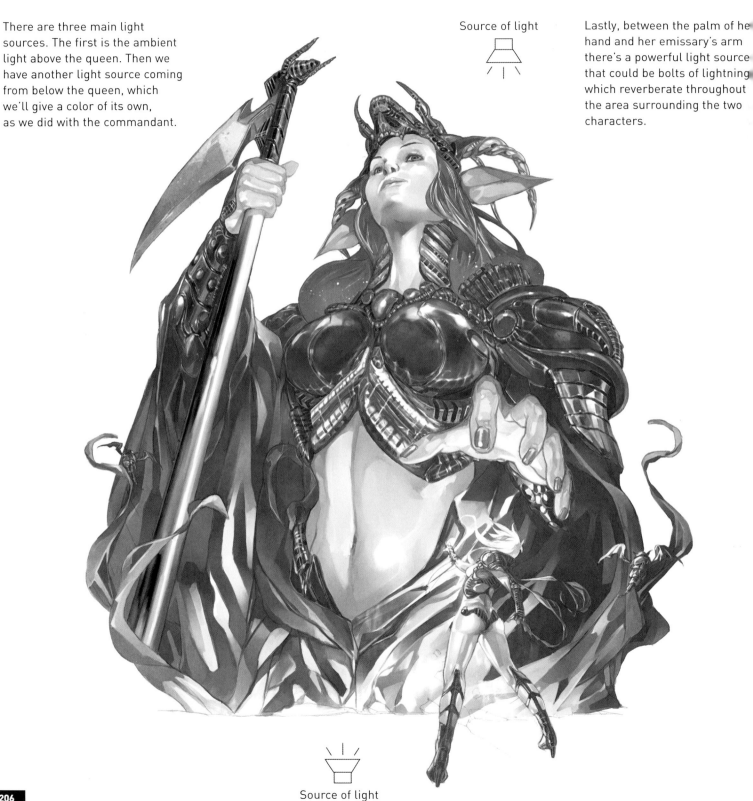

Source of light

We'll use a similar color palette as we did on the commandant in order to show that both characters come from the same place. Then we'll add the main lighting, which falls on the inner part of her clothes and on top of her follower.

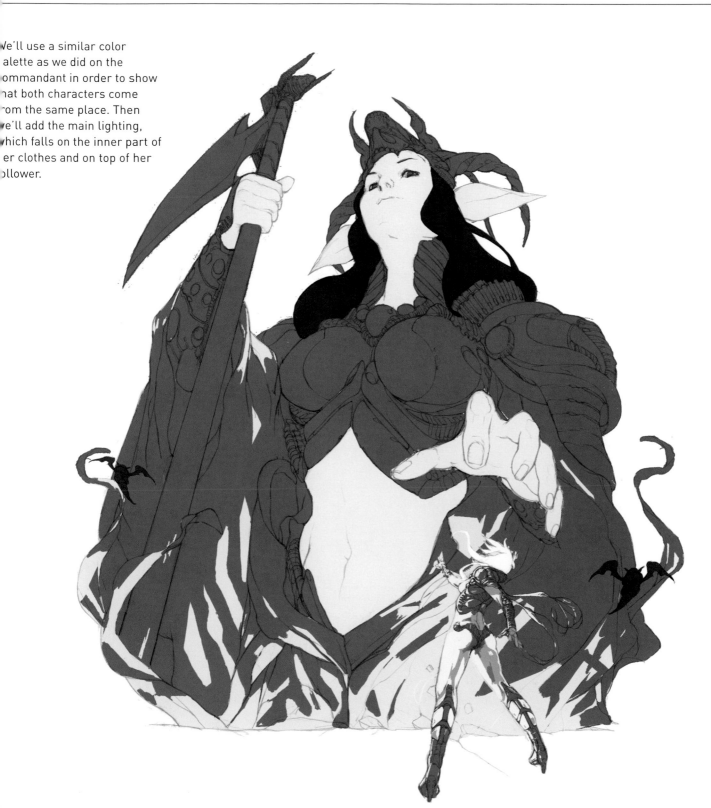

When painting her armor we'll seek a middle ground between metal and bone in some areas, and the shell of an insect in others. This will give it an organic, mechanical look.

We can differentiate the light sources further by using a range of greens to represent the light that is coming from another dimension.

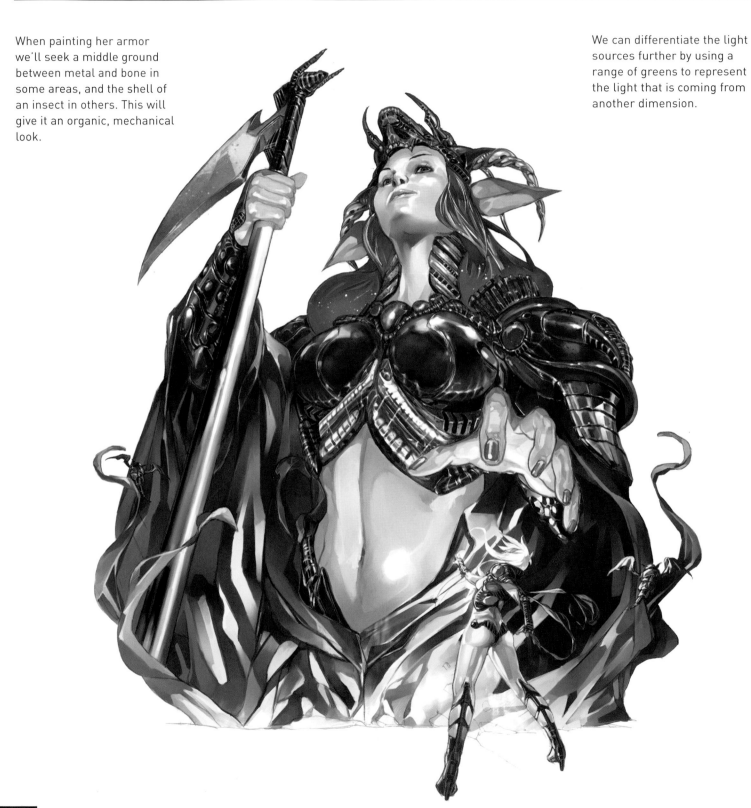

We'll paint the lightning bolt that comes from the hands of our characters and a green halo to make it more impressive. The flying demons will become more dynamic we draw a trail behind them.

The final step will be to paint a light aura around the evil queen, and use patches of color and texture for the abyss she is emerging from.

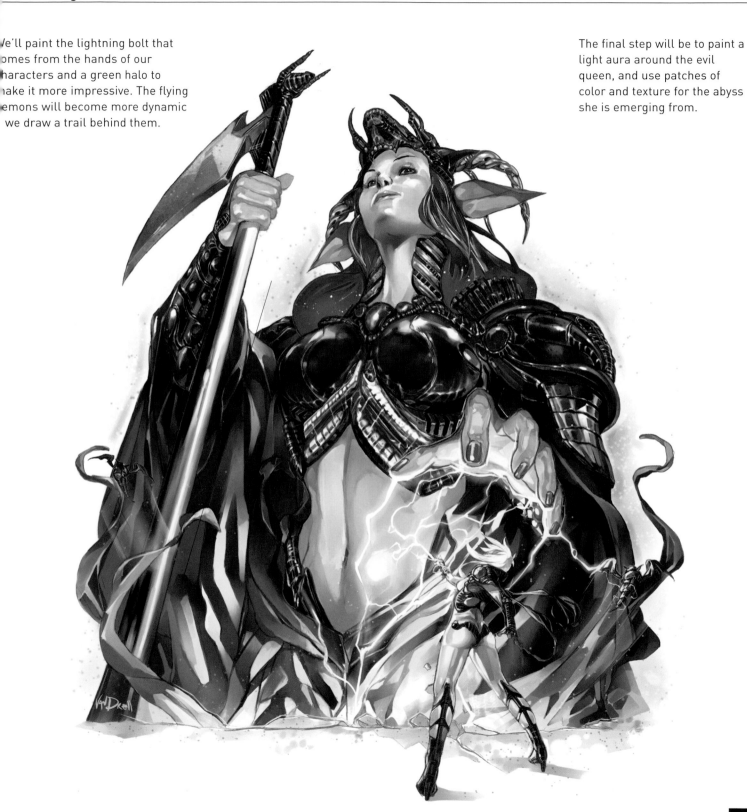

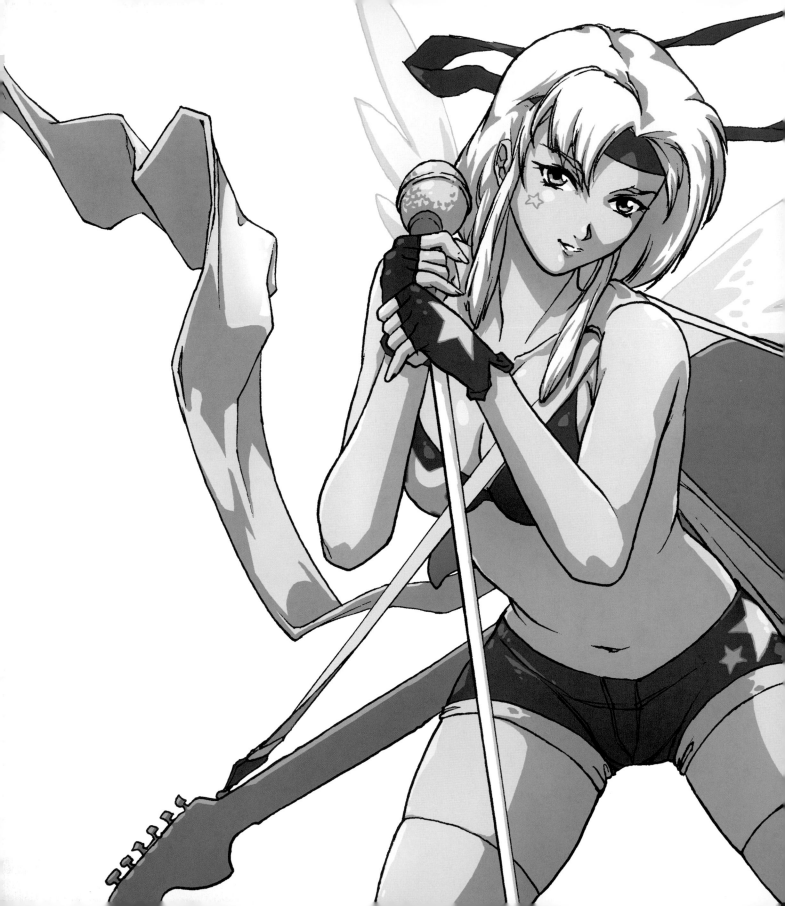

PROFESSIONS

WAITRESS

POLICEWOMAN

NURSE

IDOL SINGER

F1 RACE QUEEN

WAITRESS

Here we have the delight of any animation series. Waitresses appear in countless manga and anime series. They dazzle lots of characters who are attracted by the obliging attitude that is implied by their profession. Simultaneously serving as a reflection of contemporary society, many heroines spend some time dressed up in a waitress uniform; an example being Madoka, the famous protagonist of *Kimagure Orange Road*. We also find games like *Variable Geo*, where a considerable number of beautiful waitresses fight among themselves in the purest classic fighter tradition which originated in an *ova* saga.

Original, daring, colorful uniforms are preferred when dressing these kinds of characters.

1. Shape

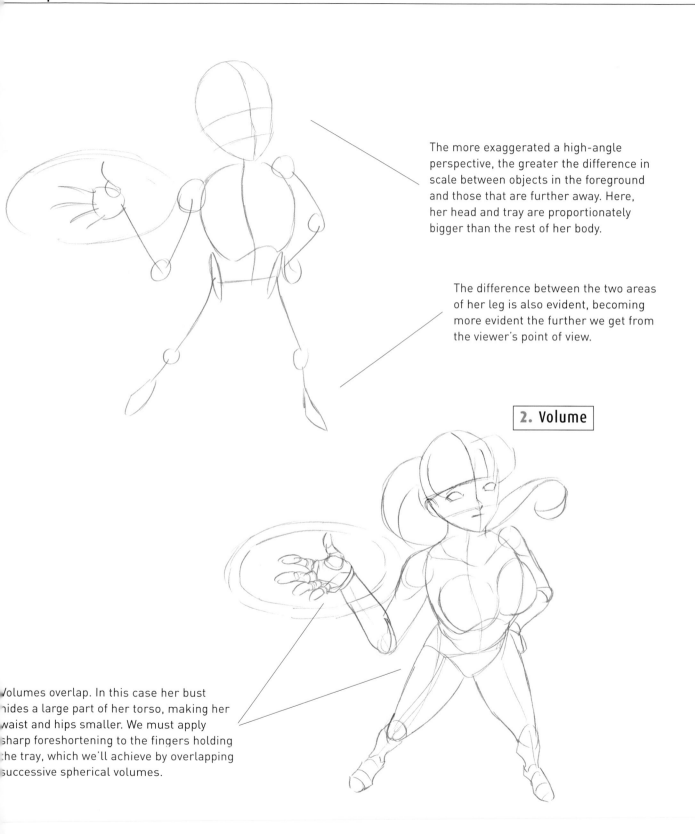

The more exaggerated a high-angle perspective, the greater the difference in scale between objects in the foreground and those that are further away. Here, her head and tray are proportionately bigger than the rest of her body.

The difference between the two areas of her leg is also evident, becoming more evident the further we get from the viewer's point of view.

2. Volume

Volumes overlap. In this case her bust hides a large part of her torso, making her waist and hips smaller. We must apply sharp foreshortening to the fingers holding the tray, which we'll achieve by overlapping successive spherical volumes.

These characters usually have a friendly and attentive demeanor. To achieve this, it's a good idea to draw large eyes and a sweet smile, as well as a youthful hairstyle that is comfortable for waiting tables.

We've drawn an attractive girl stereotype that matches the kind of audacious outfit we'll be preparing in the next step.

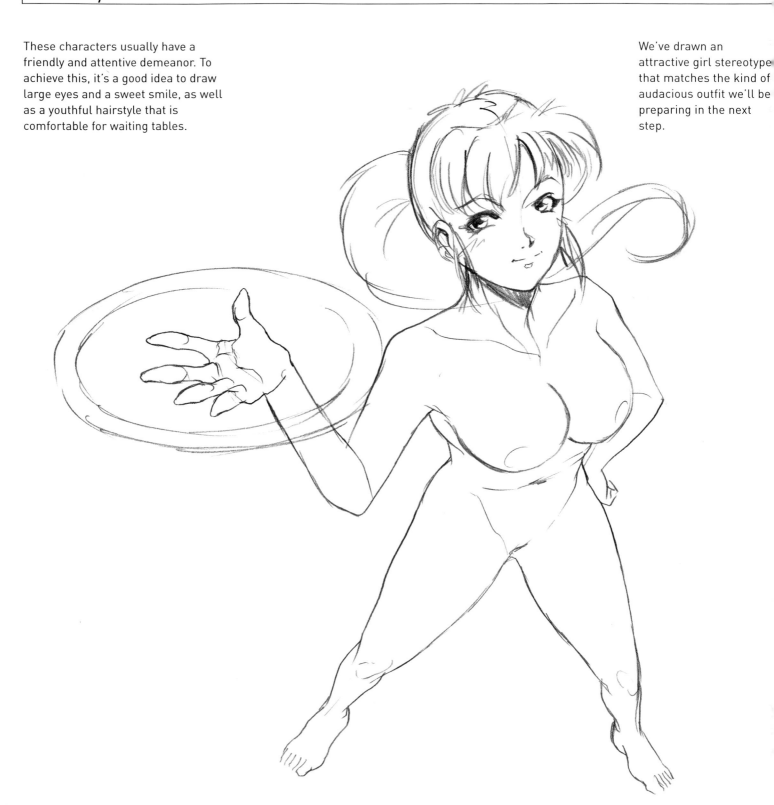

For the waitress's uniform we've based ourselves on the traditional American diner aesthetic where waitresses work on skates. The plunging neckline blouse and mini-skirt don't leave much to the imagination.

We'll fill the tray with the classic food you'll find at these establishments, being careful to draw all of the elements following the same perspective as the figure.

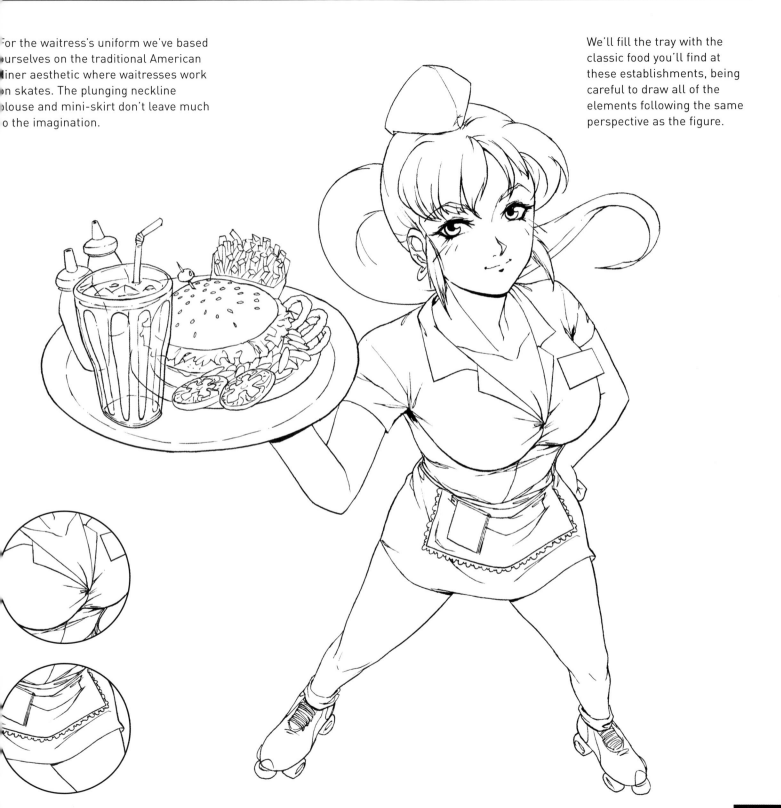

We'll bathe the image in a strong zenithal light and contrast tones to achieve the effect of a strong natural light. This helps make the character look like she is working outdoors. The tray projects a shadow over the arm holding it.

Source of light

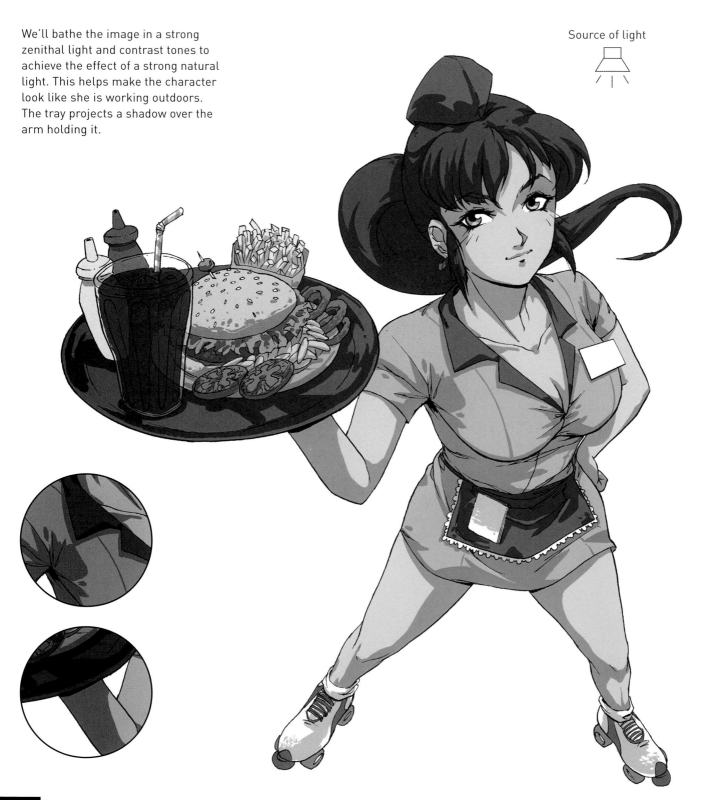

The tone of the illustration is determined by the colors of the waitress's uniform. We've chosen colors that can be easily related with fast-food establishments.

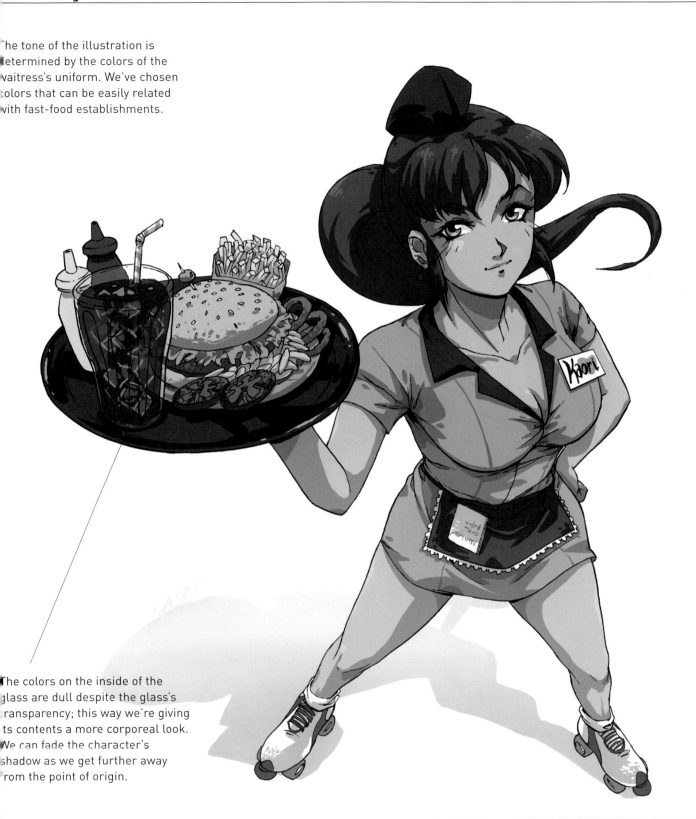

The colors on the inside of the glass are dull despite the glass's transparency; this way we're giving its contents a more corporeal look. We can fade the character's shadow as we get further away from the point of origin.

POLICEWOMAN

Like other professions involving risk and action, the police force has also been a target for mangakas. There are scores of series that center around the police, the most famous of which are: Kochikame, by Osamu Akimoto, which narrates the adventures of Kankichi Ryotsu and his partners at the Kameari Park Police Department, and is the longest manga saga with over 157 published since 1976; You're Under Arrest, by Kosuke Fujishima, which features the adventures of traffic cops Miyuki and Natsumi, that are full of humor, wacky stories and chases; and Dominion Tank Police, by the great master Shirow, which is set in a violence-ridden future where the police drive tanks to combat crime.

1. Shape

We'll use a low-angle perspective to play with her position of authority and the respect she commands as a cop. This positions the viewer so that he's looking up to the character.

To give the police woman's static pose some more movement we'll draw a slight contrapposto that raises one shoulder and the opposite hip.

2. Volume

In this position, the foreshortening of her head makes her facial elements bunch together; her chin becomes more prominent and we can't see the top of her cranium. Her thighs, which are the nearest part of her body, look bigger than the rest.

In manga, a simple, recurring and almost mandatory way to draw an exuberant female figure is to exaggerate her breasts. Another way of making a figure interesting is to have it look directly at us, irrespective of the action they are engaged in.

. Clothes

Many manga authors take certain liberties when adapting certain daily activities in order to make them look more interesting. We can obtain some originality by making outfits that are more attractive than those in reality.

Tilting her hat produces a sexy effect. We can obtain references in order to draw accessories like her badge and police utility belt.

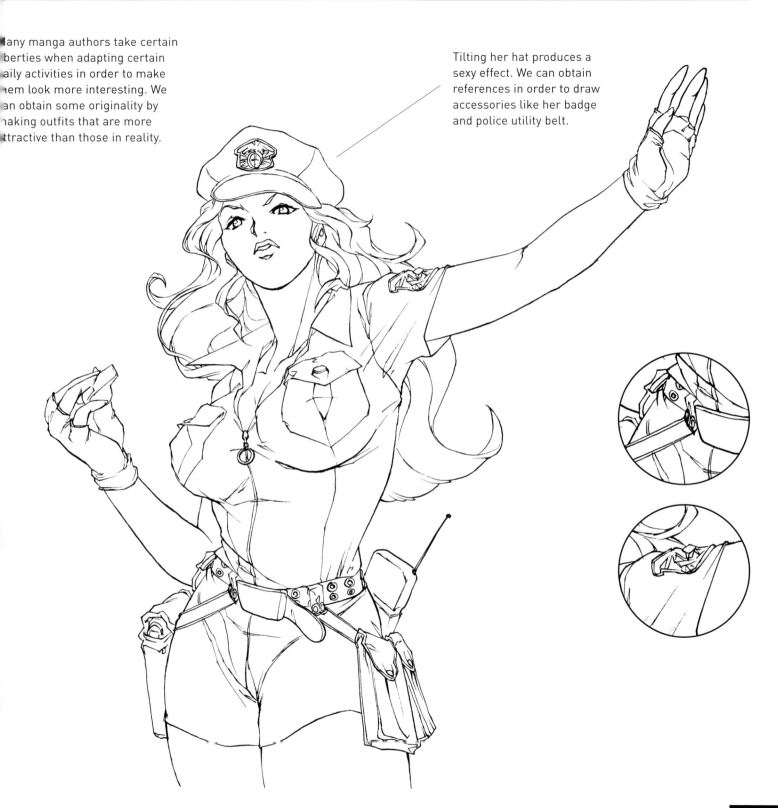

Our protagonist is directing traffic outside and, to transmit this kind of strong natural light, we'll contrast our lighting and shading. Projecting shadows will make her breasts more impactful. The shadow over her eyes produces an interesting effect.

Source of light

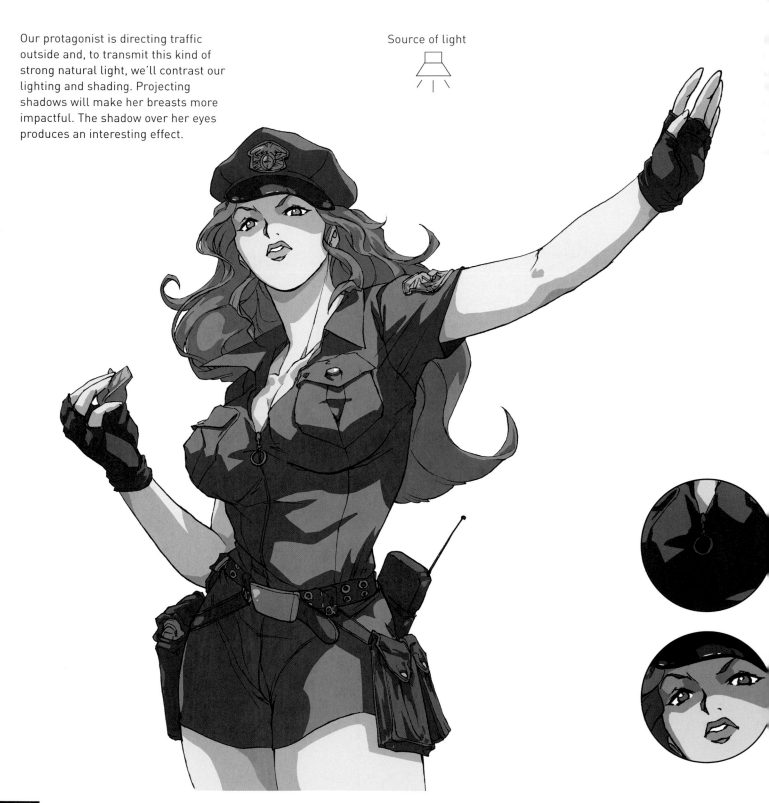

Dark blue is the predominant color in this scene, a color which we instantly relate with the police uniform. This way, even if we grant ourselves some drawing freedom, it will still be easy to recognize our heroine's profession.

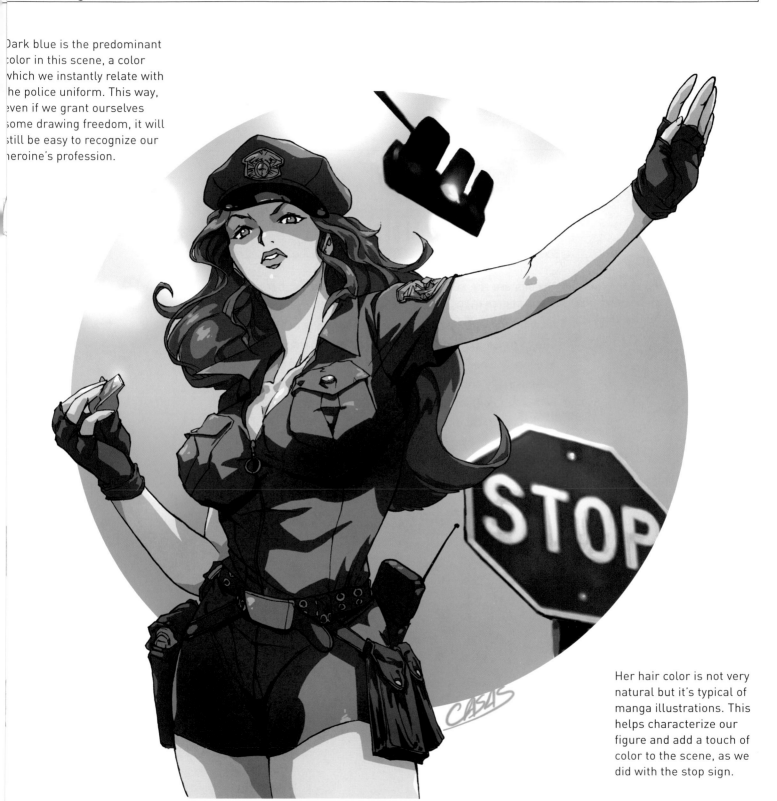

Her hair color is not very natural but it's typical of manga illustrations. This helps characterize our figure and add a touch of color to the scene, as we did with the stop sign.

Once again we'll use idealization and stylization to create an attractive body. Voluminous breasts and wide hips are what we need to create a very feminine figure.

The hands holding the nurse's tools must be drawn without aggressive or angular lines so that they look more feminine.

As with all uniforms, we can give ourselves artistic license to create an attractive and suggestive design. The most important thing is to use relevant elements such as the red cross, nurse's cap, stethoscope and needle.

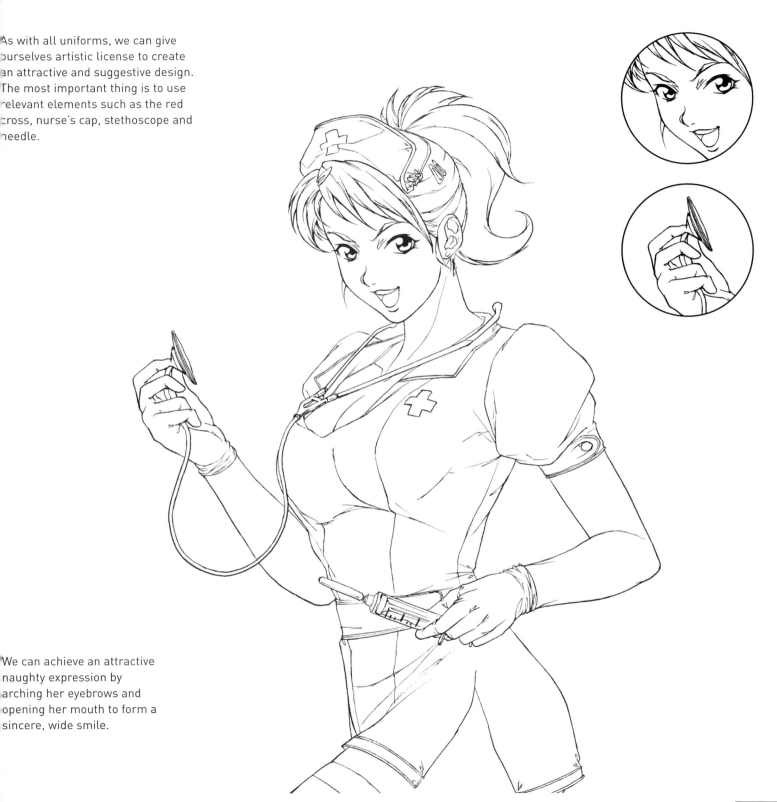

We can achieve an attractive naughty expression by arching her eyebrows and opening her mouth to form a sincere, wide smile.

In manga it is typical to synthesize the shapes of shadows and smooth them, especially when drawing faces, to achieve softer, brighter, and more candid expressions. The shadow her dress projects over her leg makes her clothing look a bit looser.

Source of light

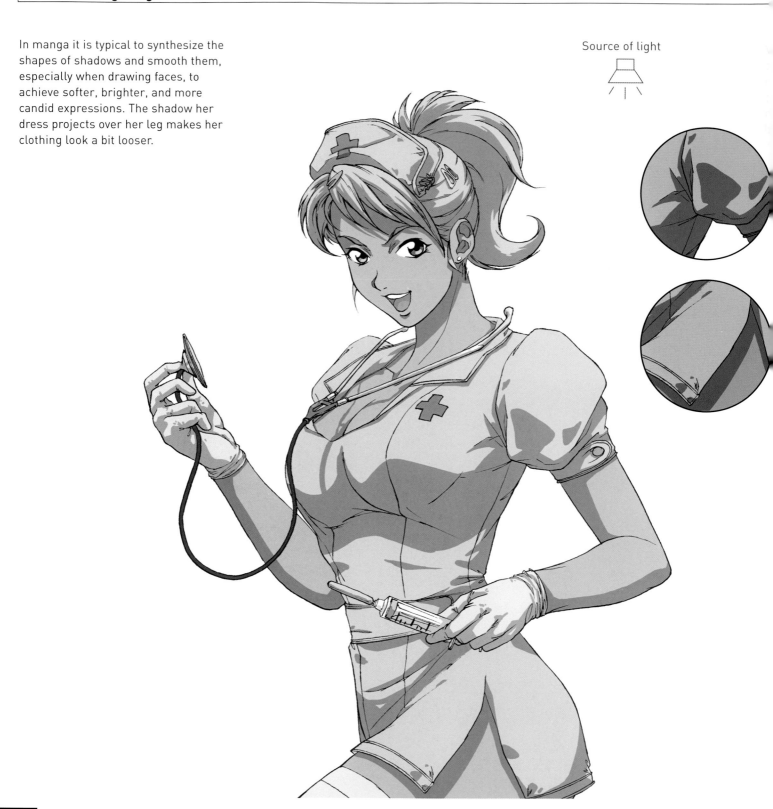

We can stick to the classic nurse uniform colors: white and green, which will contrast nicely with her tanned skin and the color of her hair. The ornamental element behind her looks less saturated so as to keep it in the background.

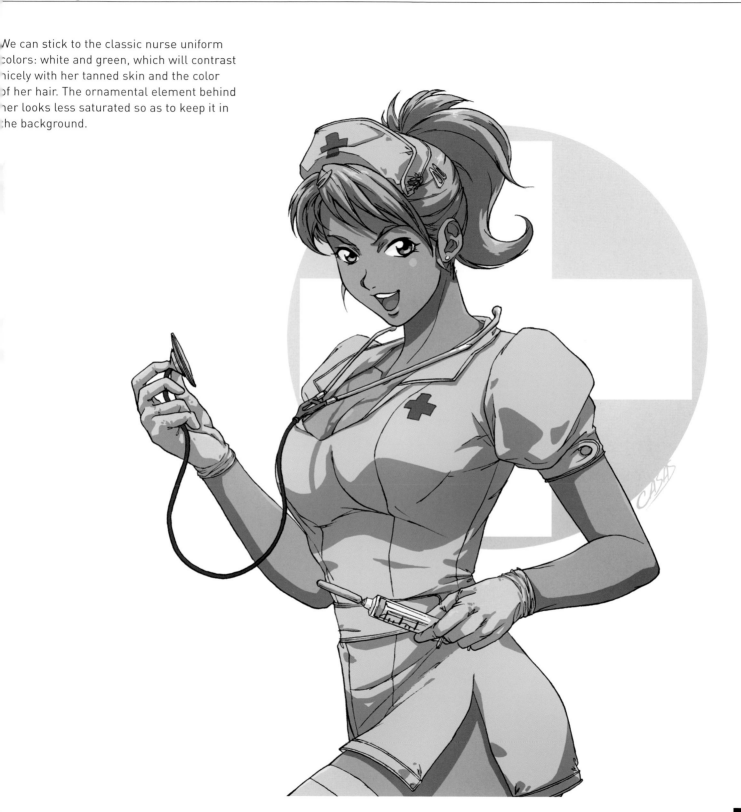

IDOL SINGER

In Japan the idol-singer phenomenon is something that is very unique. Many young Japanese dream of becoming famous, even if only in an ephemeral way. In lots of manga and anime series we find special episodes where some heroines test the waters of the music business. But this phenomenon doesn't just occur from time to time: there are dozens of series dedicated to it. Among those that focus on idol-singers, we can find classics like *Idol Densetsu Eriko*, *Idol Tenshi Youkoso Yoko* and *Idol Project*. Many are found in the *shojo* genre, since it is a topic that is usually more proximate to the female audience, while mixing fantasy genre and magical girls elements.

1. Shape

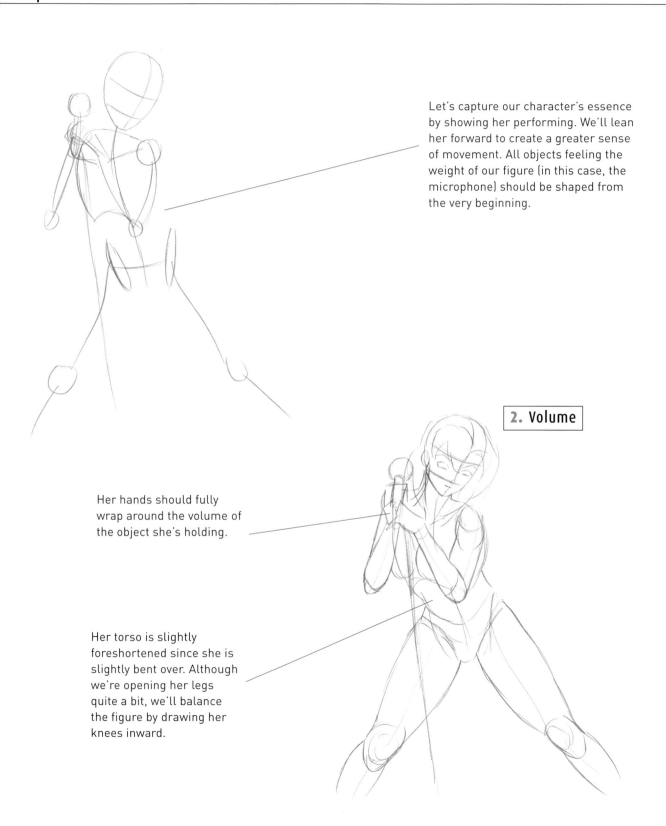

Let's capture our character's essence by showing her performing. We'll lean her forward to create a greater sense of movement. All objects feeling the weight of our figure (in this case, the microphone) should be shaped from the very beginning.

2. Volume

Her hands should fully wrap around the volume of the object she's holding.

Her torso is slightly foreshortened since she is slightly bent over. Although we're opening her legs quite a bit, we'll balance the figure by drawing her knees inward.

A star's look and personality are absolutely fundamental. We can achieve an interesting and attractive effect if we draw the singer with a seductive sideways gaze, a suggestive half-smile and a unique hairstyle.

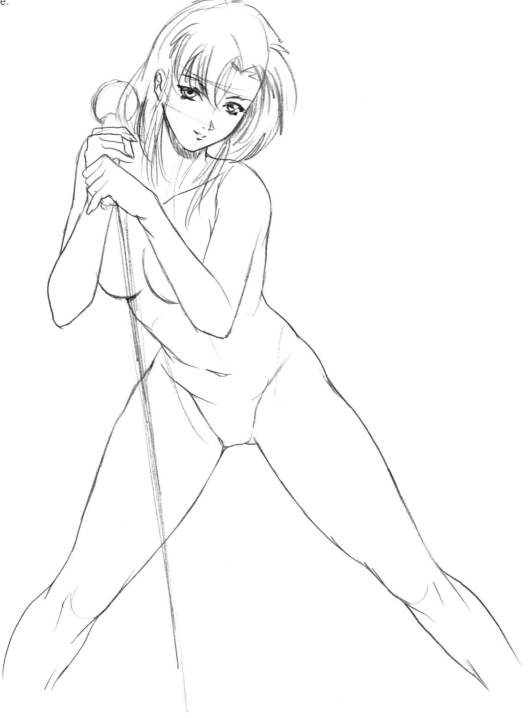

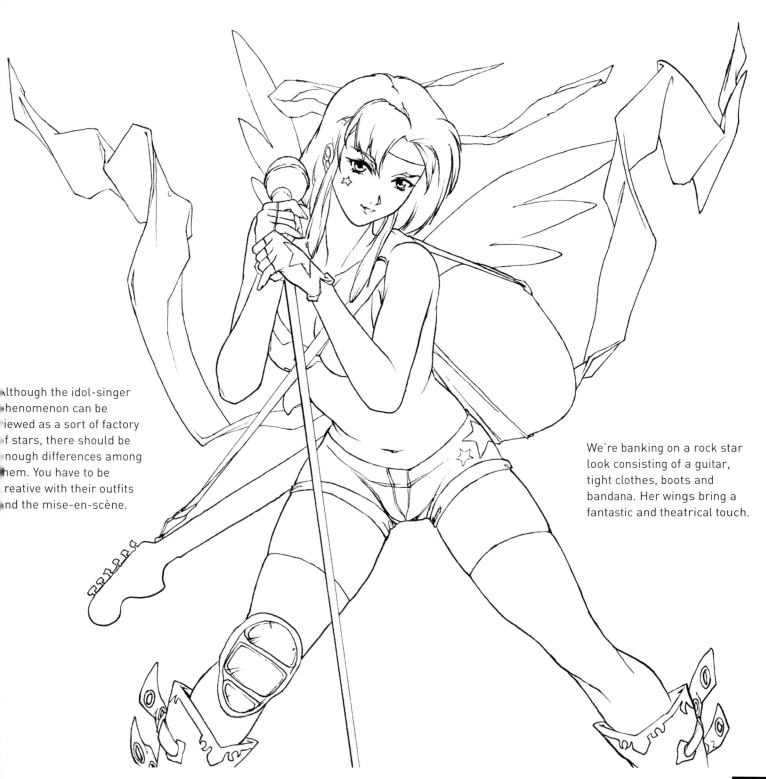

Although the idol-singer phenomenon can be viewed as a sort of factory of stars, there should be enough differences among them. You have to be creative with their outfits and the mise-en-scène.

We're banking on a rock star look consisting of a guitar, tight clothes, boots and bandana. Her wings bring a fantastic and theatrical touch.

Source of light

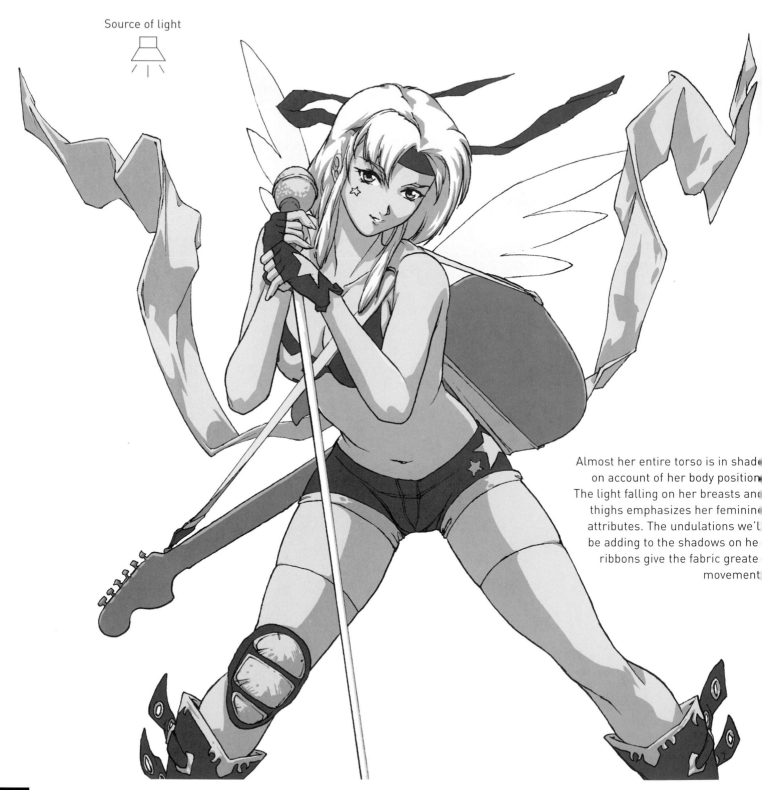

Almost her entire torso is in shad
on account of her body position
The light falling on her breasts and
thighs emphasizes her feminine
attributes. The undulations we'l
be adding to the shadows on he
ribbons give the fabric greate
movement

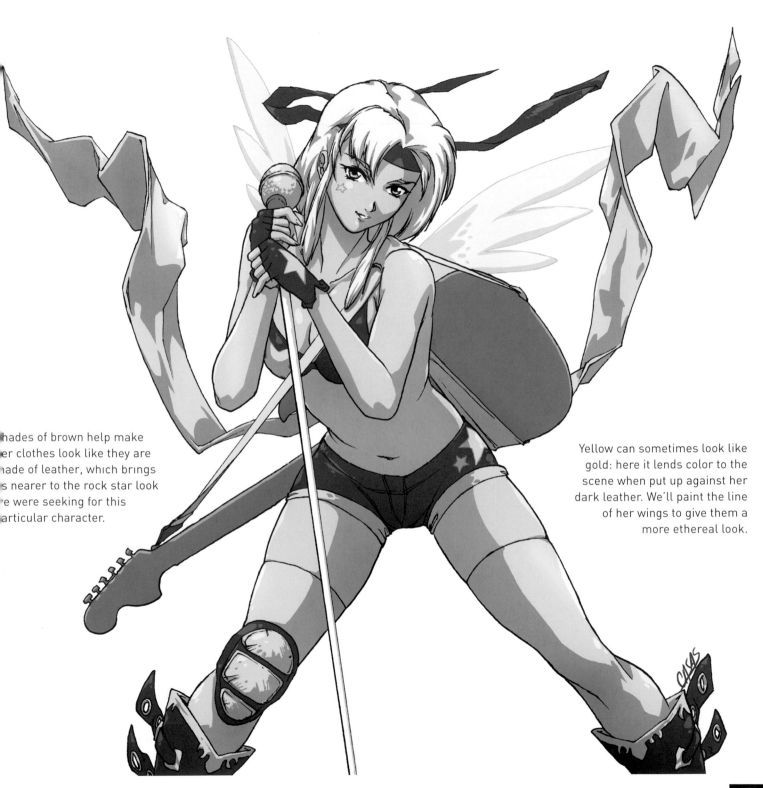

hades of brown help make
er clothes look like they are
ade of leather, which brings
s nearer to the rock star look
e were seeking for this
articular character.

Yellow can sometimes look like
gold: here it lends color to the
scene when put up against her
dark leather. We'll paint the line
of her wings to give them a
more ethereal look.

F1 RACE QUEEN

The Formula 1 girls and the majority of grid girls and paddock girls participating at the great sporting events serve as an added allure to these very special occasions. In the racing world, and especially in Japan, these women are known as race queens. The job of these promotional models is to hold a large umbrella over the drivers as they wait by their cars before the race begins. In the manga *Sena-chan Full Traction*, by Yuichi Takeda, the young protagonist, Sena Jyonouchi, begins as a race queen before getting the opportunity to prove to the whole world her extraordinary talent competing up on top of any motorcycle given her.

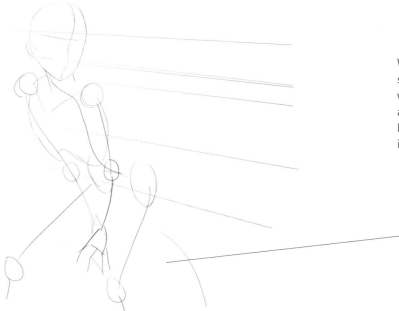

We're going to emphasize the sexy side of the races, so the first thing we're going to do is choose the appropriate point of view for showing both the girl and the car from an interesting perspective.

The car's gigantic tires can serve as a nice support for our figure. We'll draw some perspective lines to help us draw the car more accurately.

2. Volume

We'll begin by drawing the chassis of the Formula 1 car. Then it will be easier for us to position the girl resting on its tires.

Resting points should be drawn first and then used to construct a figure. By inclining her torso forward we achieve an attractive pose that accentuates her feminine shape.

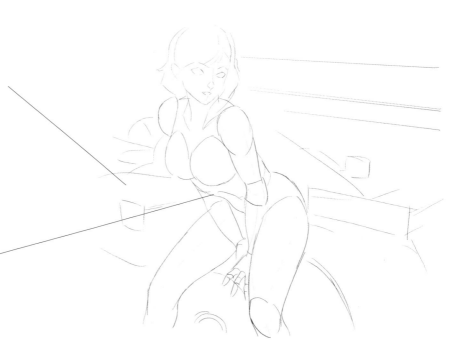

To draw the girl in a sensual way, it's a good idea to use open and rounded lines that define her smooth figure.

Cocking her head slightly and directing her gaze at the reader make her more sensuous. We can gather references in order to define the car and make sure we are giving it a realistic finish.

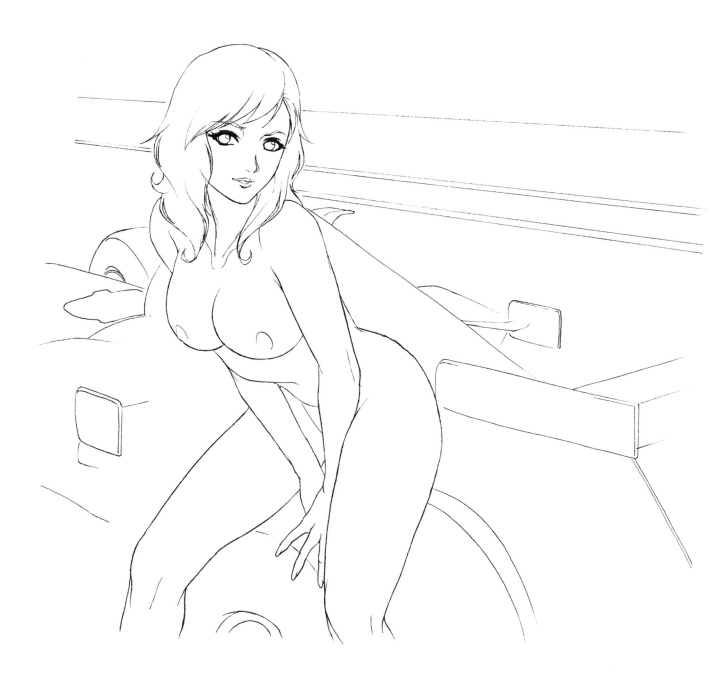

4. Clothes

Race queens usually dress up in scanty clothes, sometimes to the extreme, which has helped turn them into almost legendary characters. This is certainly reflected in manga, but you can't go overboard. What we mustn't forget is the omnipresent umbrella.

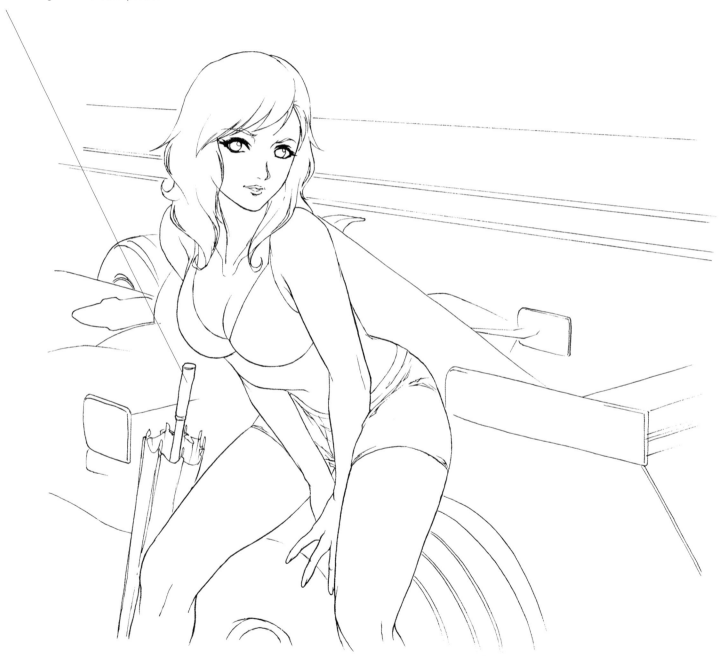

Different materials are distinguished by using contrast and by the shape of the shadows: soft and rounded on the girl's skin; harder and more angular on the car.

Source of light

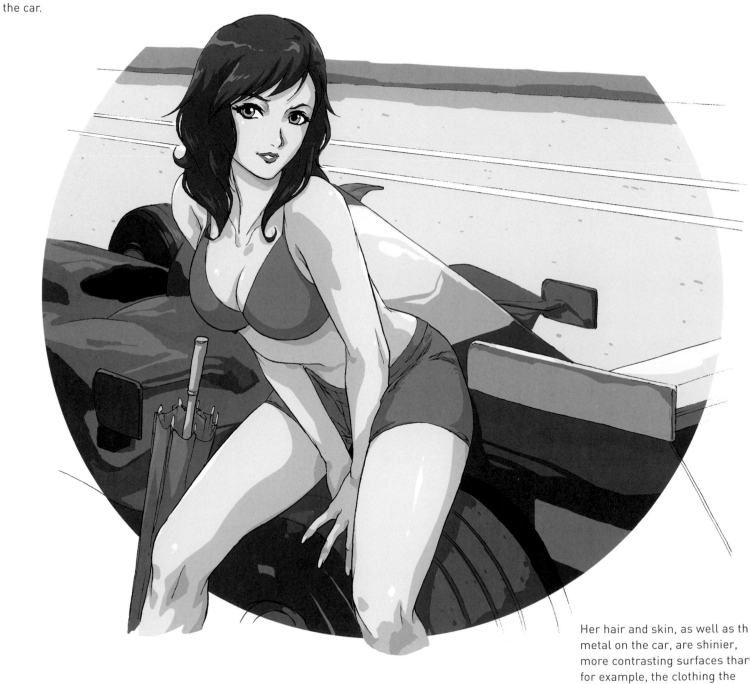

Her hair and skin, as well as th metal on the car, are shinier, more contrasting surfaces thar for example, the clothing the girl is wearing.

his time the added hint of color will be
n the sponsor labels and logotypes worn
y the girls and, especially, the drivers and
heir cars, and which must be adapted to
he surface they are placed on.

They must also follow the perspective
we've marked for the image and
project shadows the same way we
would throughout the rest of the
illustration.

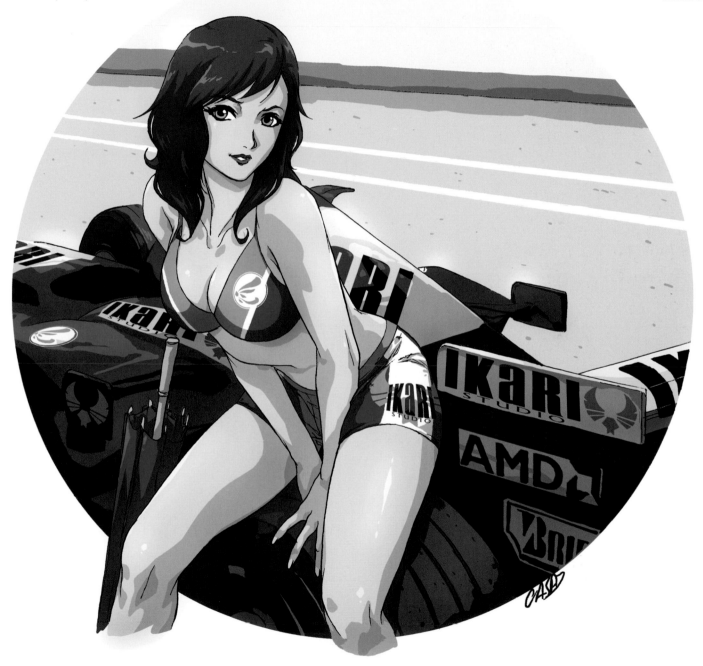

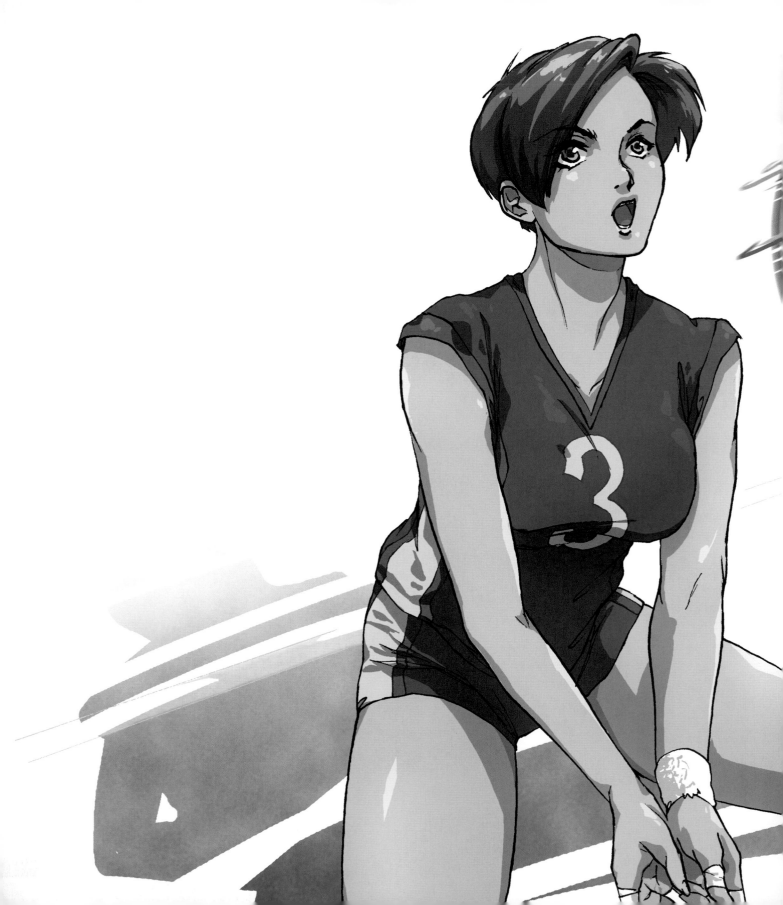

SPORTS

GYMNAST

In sport mangas, one of the most successful genres inside and outside of Japan, authors focus on the sports that are most in vogue and have the most fans, in addition to being their personal favorites. Artistic gymnastics are very important in Japan. In fact, it was in Japan that the new men's rhythmic gymnastics began in the late nineties.

We'll find characters who practice this sport in hundreds of animes and mangas such as Kodachi in *Ranma 1/2*, and Minami in *Touch*. Rhythmic gymnastics are also featured in works like *Hikari no Densetsu*, by Aso Izumi, where young Hikari is inspired by the promise of her idol and embarks on a career that takes her to the zenith of this sport.

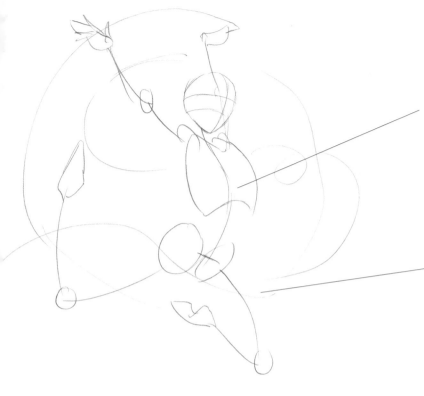

Turns, acrobatics and jumps are usually the most attractive and characteristic moments in this sport. In order to create a dynamic shape it's good to use ample curves when shaping her figure.

The dynamics of a figure begin with their spinal column's movement. One should avoid drawing extremities that are too rigid.

2. Volume

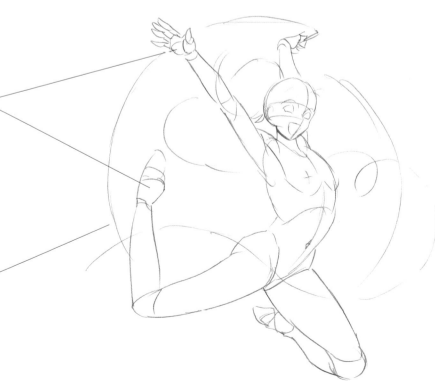

We can exaggerate the gymnast's pose by contrasting the position of her hands and feet with the rest of her body and making them more rigid and disciplined.

We'll also mark the path of the ribbon we've chosen for this scene, drawing it so as to enclose the composition within a circle.

The svelte gymnast body is characterized by the strength of her back, shoulders, glutes and legs, with a chest that is lighter when compared to the power of the rest of her thorax. A stylized neck can help reflect her disciplined nature.

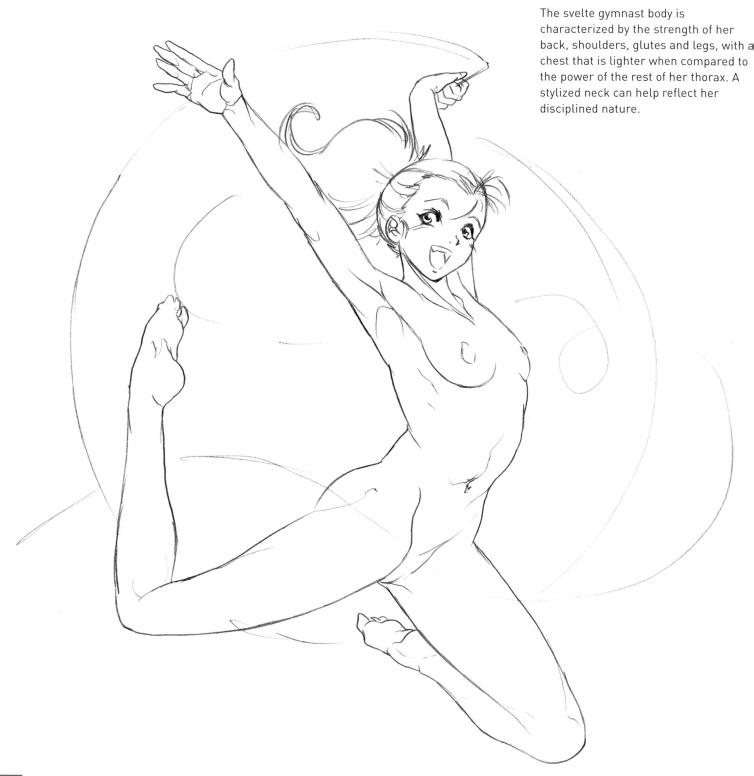

These athletes typically wear a maillot. Since it is a tight-fitting article of clothing, we'll only mark the ends of her sleeves and groin. It is very important to deform the clothing pattern so as to respect her body movement.

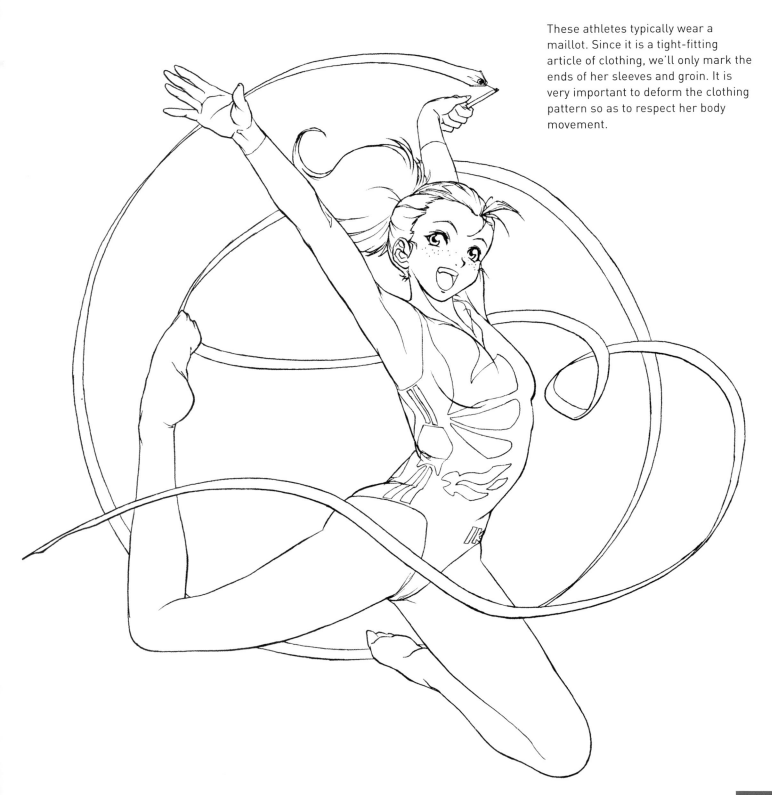

Source of light

The ribbon is probably one of the shiniest elements in the illustration. We'll achieve this effect by using highly contrasting color tones.

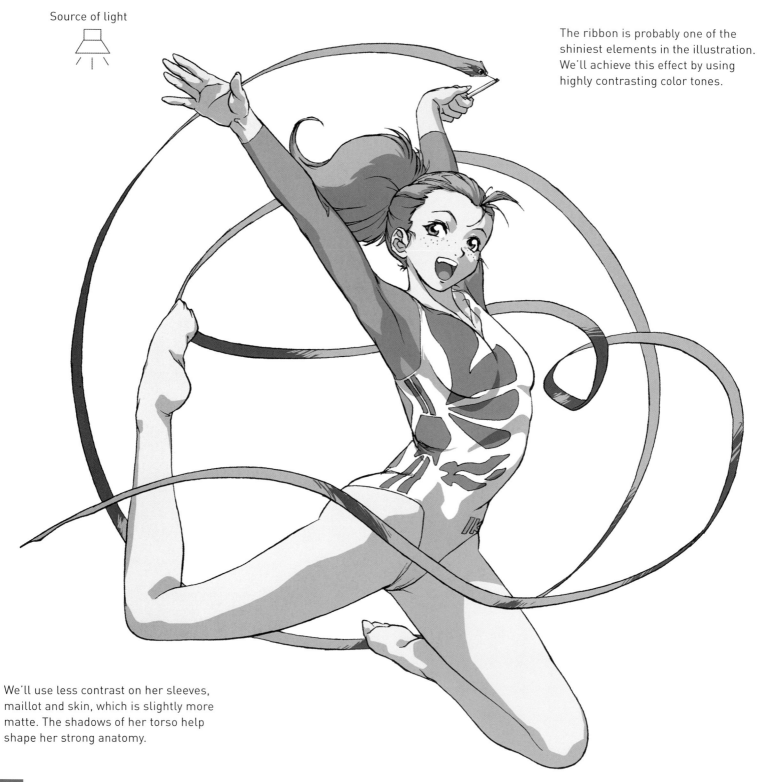

We'll use less contrast on her sleeves, maillot and skin, which is slightly more matte. The shadows of her torso help shape her strong anatomy.

We'll use the brightest colors for the shiniest surfaces. We'll place them on the uppermost parts of the volumes that interest us, respecting the general lighting, and then we'll integrate the maillot's pattern by painting its lines.

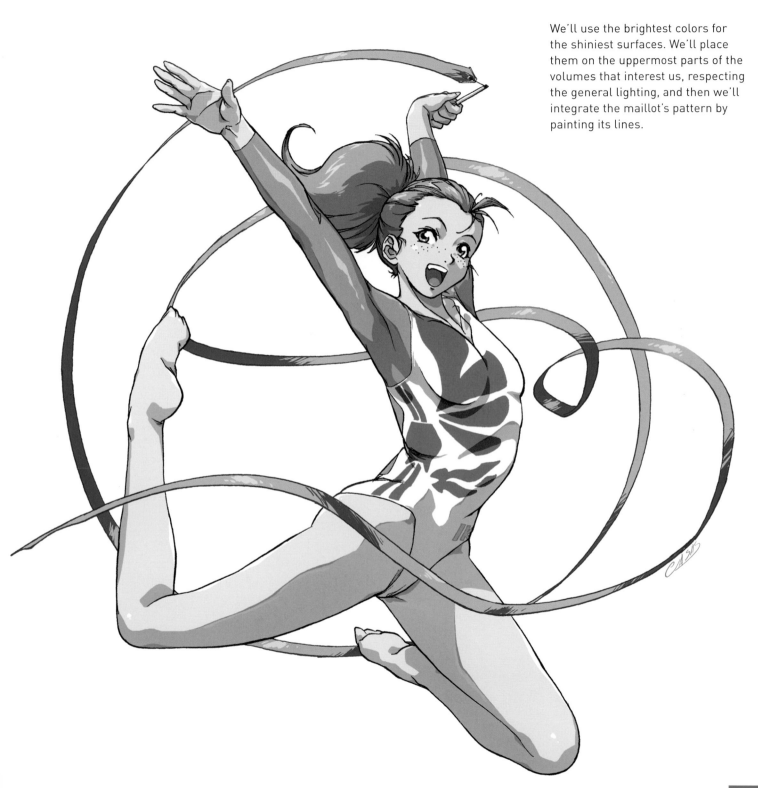

ATHLETE

Track and field, and running in particular, has become one of the most represented sports in manga and anime, generally as part of the academic activities many heroes in school stories engage in. Gym class usually has a strong aesthetic attraction for *mangakas* and their readers. Besides, it's a common activity at the kind of sporting events that usually pop up in young student stories. The thrill of the races and the young bodies burning on the track are filled with extraordinary dramatic power. They can also appear with a more fantastic character such as in the *Escaflowne ova*, where the protagonist actually enters another reality when on the track.

The best way of giving movement to a running figure is to incline them forward. We can also open her arms and legs to capture the moment of greatest intensity.

Since we chose a low-angle perspective, the foot in the foreground is much bigger than her head, which is further away.

2. Volume

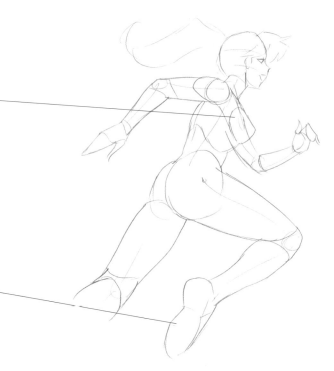

To correctly place her trunk and arms, we'll even draw the shoulder that gets hidden behind her torso. The shape of her facial elements must adapt to the profile view, so her eye ends up looking almost triangular.

We'll apply the basic laws of perspective to shape the volumes of the figure: elements that are nearer are drawn proportionately larger than the rest of the image.

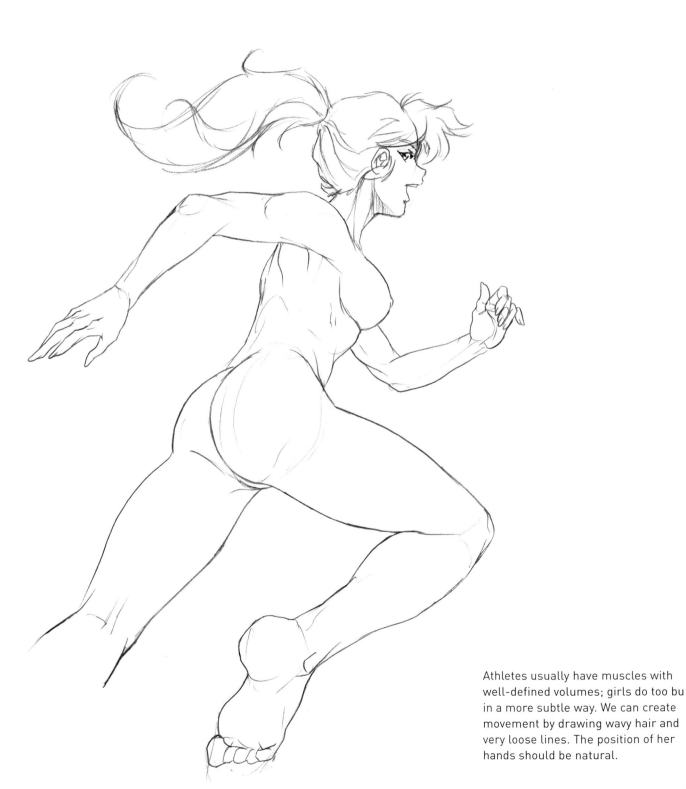

Athletes usually have muscles with well-defined volumes; girls do too bu in a more subtle way. We can create movement by drawing wavy hair and very loose lines. The position of her hands should be natural.

Her outfit is simple, but the wrinkles mark the lines of tension in her clothes and the direction the figure is moving in. Elements in the foreground, such as her sneakers, should be drawn with greater detail to make them look more realistic.

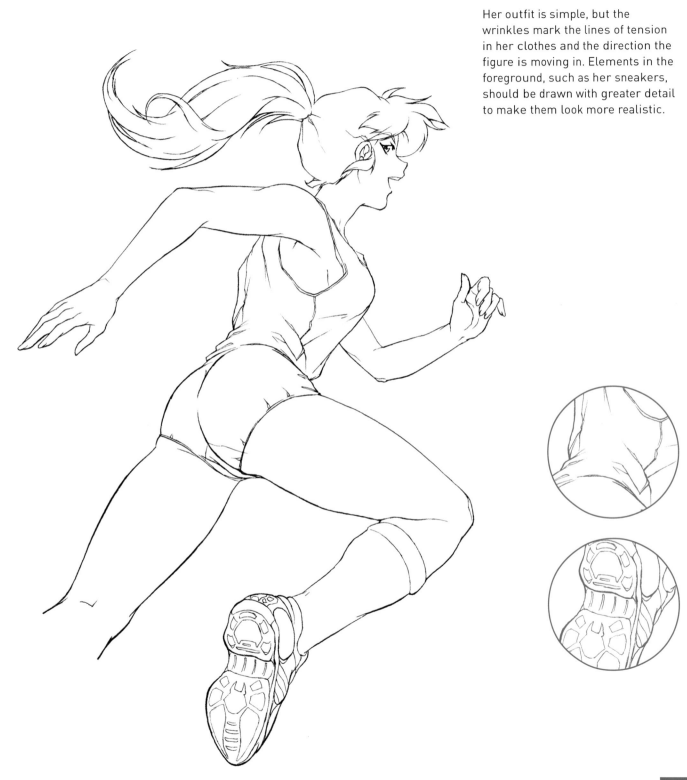

Once again, shadows help us to define a character's shape and muscles. We'll give the wrinkles on her clothes volume while following the direction of the drawing.

Source of light

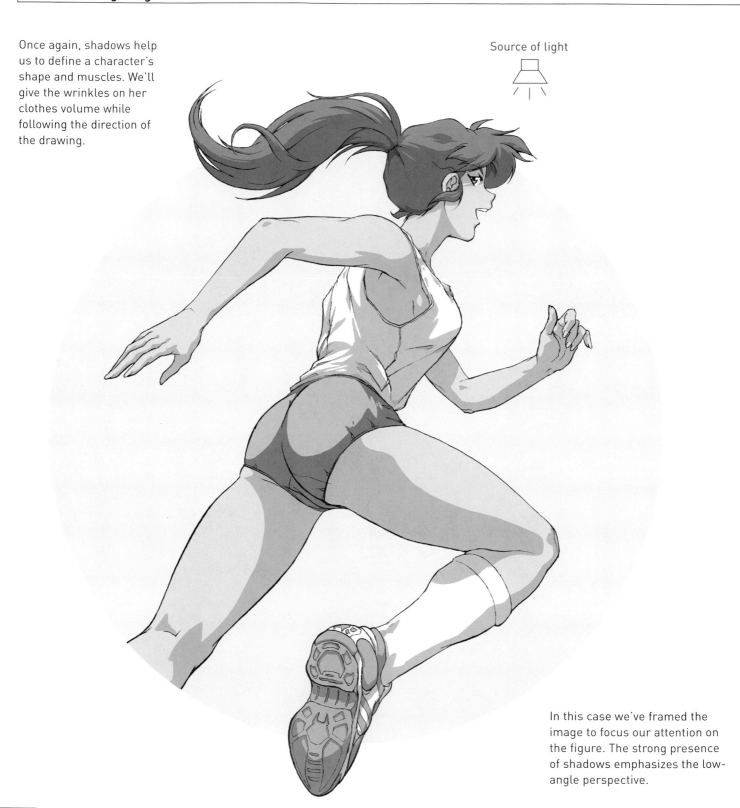

In this case we've framed the image to focus our attention on the figure. The strong presence of shadows emphasizes the low-angle perspective.

This simple background, using kinetic lines to fade elements (a resource used in manga) emphasizes the figure's movement. The strong contrast between her hair color and the rest of the illustration makes us focus on the character's face.

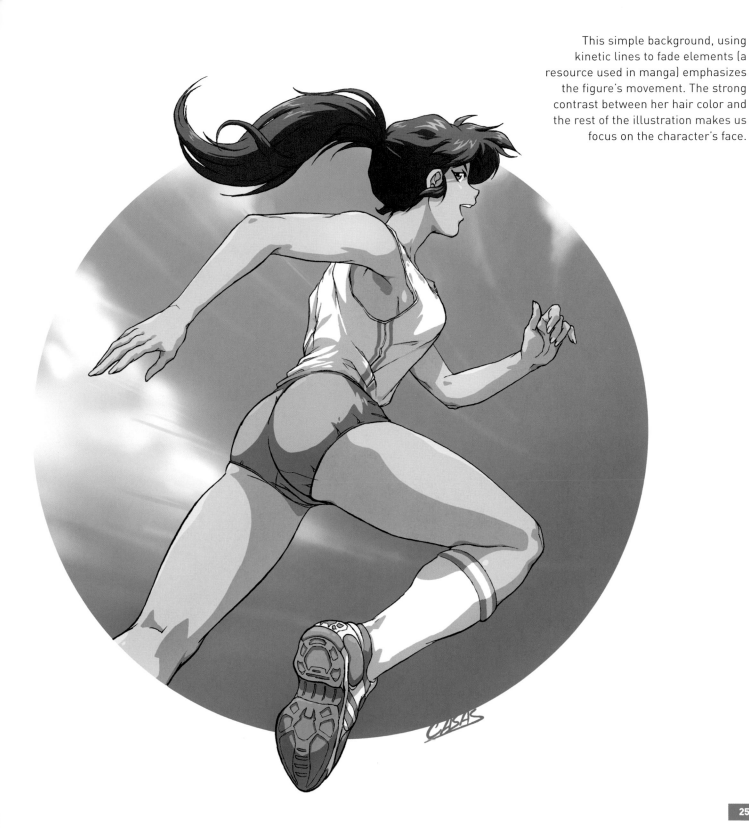

VOLLEYBALL PLAYER

Women's volleyball has been often depicted in manga and anime. Two series contributed most to spreading the sport on an international level: Attack N°1, from shojo renovator Chikako Urano, who in 1968 targeted a younger audience with a series that rode on the coattails of Japan's 1964 Olympic gold medal in women's volleyball; and Attacker You! by Jun Makimura and Shizuo Koizumi, published by Kodansha in 1984, which had great success in countries like Italy and France, where there was a sudden increase in school volleyball teams. Even today traces of these series live on in the hearts of many fans and mangakas; after all, they reinvented the genre by combining action, sport and romance.

1. Shape

It's very common to find illustrations of spikes or players setting up by the net. We can find more interesting points of view if we change the way we look at the sport. If we put ourselves in a position by the ball we'll see everything from a different perspective.

2. Volume

In this case we'll draw a low-angle perspective. The baseline helps us understand the position of the floor with respect to the figure we are going to draw.

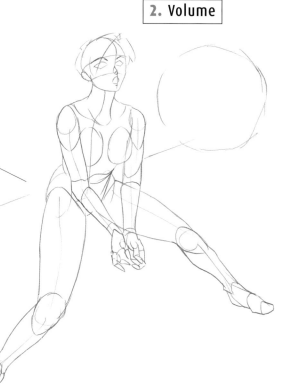

Let's stylize the figure and slightly shorten her extremities as we get nearer the floor. As with any other sport, it's important to rest one's feet properly in order to understand the action's movement.

This time we've chosen a slightly masculine look for our player. We can achieve this by widening her back slightly and making her body structure look more rigid.

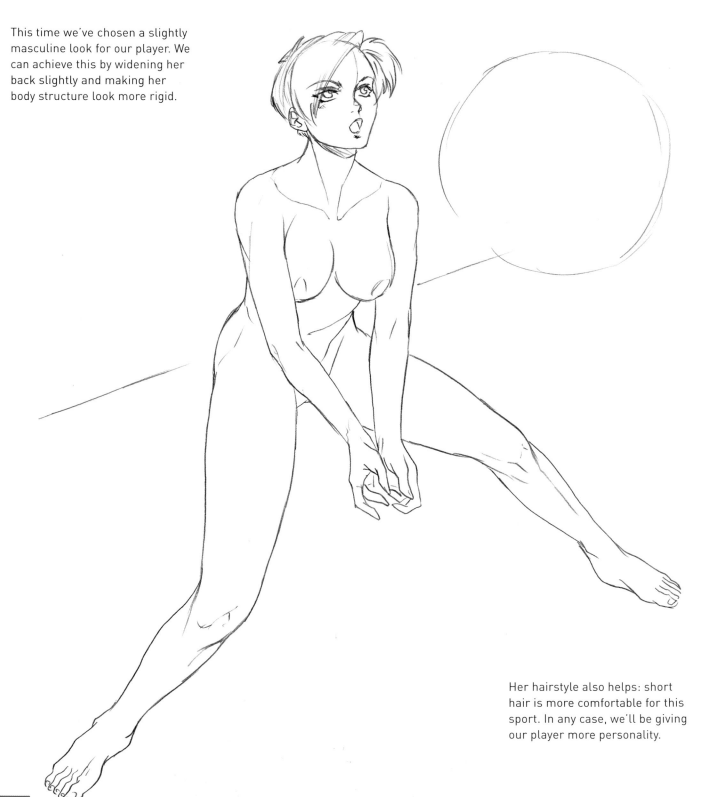

Her hairstyle also helps: short hair is more comfortable for this sport. In any case, we'll be giving our player more personality.

Over time sport uniforms change designs according to fashion, but shorts and a short top are always a good choice. What's more, there's a whole bunch of typical accessories that can aid us with our characterization.

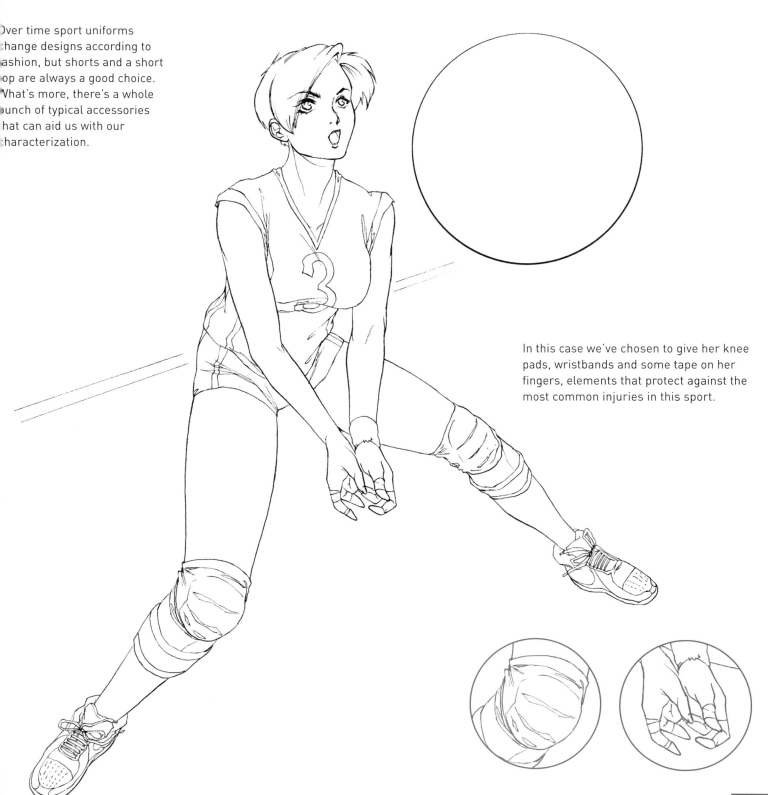

In this case we've chosen to give her knee pads, wristbands and some tape on her fingers, elements that protect against the most common injuries in this sport.

Lighting helps us give the figure and ball some volume. In this position her arms project shadows over her legs and torso.

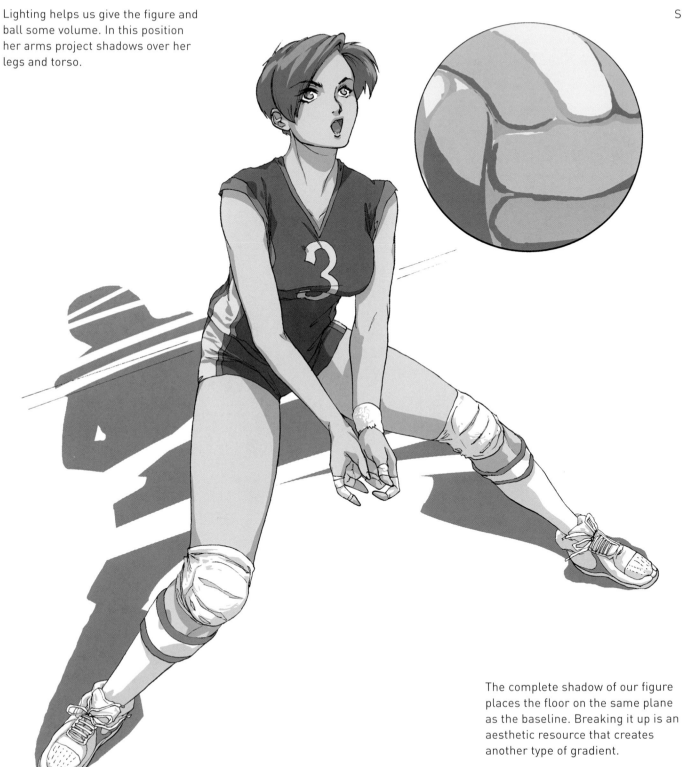

The complete shadow of our figure places the floor on the same plane as the baseline. Breaking it up is an aesthetic resource that creates another type of gradient.

Whenever drawing uniforms and sports equipment it's good to maintain the same tonal range or color combinations.

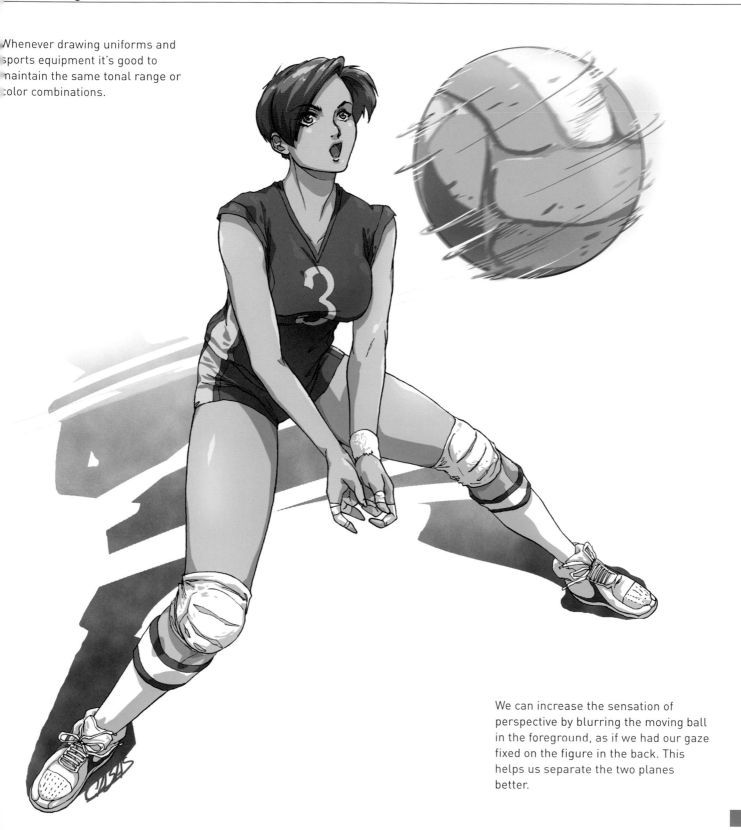

We can increase the sensation of perspective by blurring the moving ball in the foreground, as if we had our gaze fixed on the figure in the back. This helps us separate the two planes better.

CHEERLEADER

Cheerleaders are in charge of getting the crowd into a sports match by using dance, music and choreographies that are full of gymnastic and acrobatic movements. Cheerleading actually began as a men's activity in 1880 at Princeton University, but over time it became regarded as a women's activity. The legendary Dallas Cowboy cheerleaders were clearly the ones who popularized this phenomenon. As with many influences that are inherited from the United States, cheerleaders have also made room for themselves in the manga world, and more than one heroine has appeared in a mini-skirt with pompons in hand, a recent example being the series Lucky Star.

1. Shape

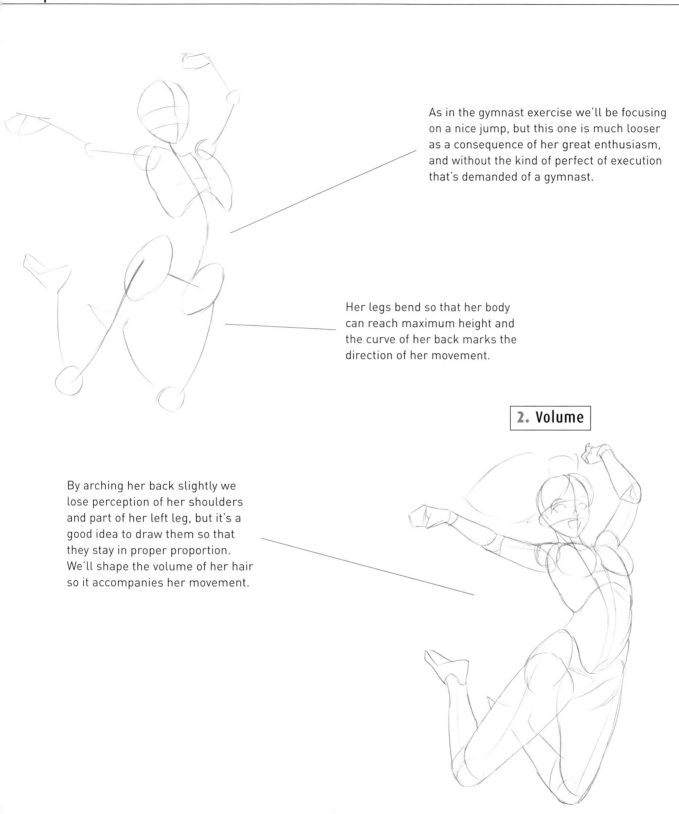

As in the gymnast exercise we'll be focusing on a nice jump, but this one is much looser as a consequence of her great enthusiasm, and without the kind of perfect of execution that's demanded of a gymnast.

Her legs bend so that her body can reach maximum height and the curve of her back marks the direction of her movement.

2. Volume

By arching her back slightly we lose perception of her shoulders and part of her left leg, but it's a good idea to draw them so that they stay in proper proportion. We'll shape the volume of her hair so it accompanies her movement.

Her breasts also follow the direction of her body. Cheerleaders are usually svelte and athletic thanks to the great physical effort that's required. Her expression should always be happy so as to transmit her passion.

The trick is to make their skirts lift in a suggestive way that accompanies their acrobatic movements and choreographies. All of the elements follow the body's inertia and action.

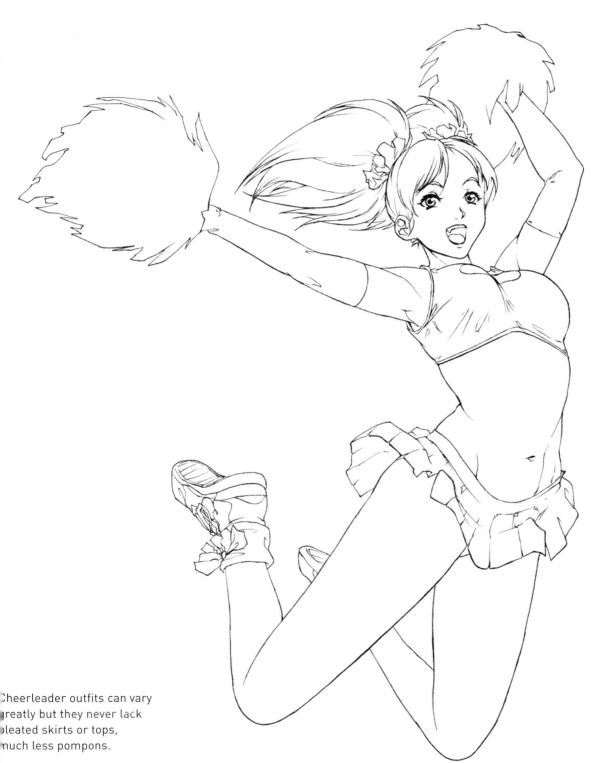

Cheerleader outfits can vary greatly but they never lack pleated skirts or tops, much less pompons.

Source of light

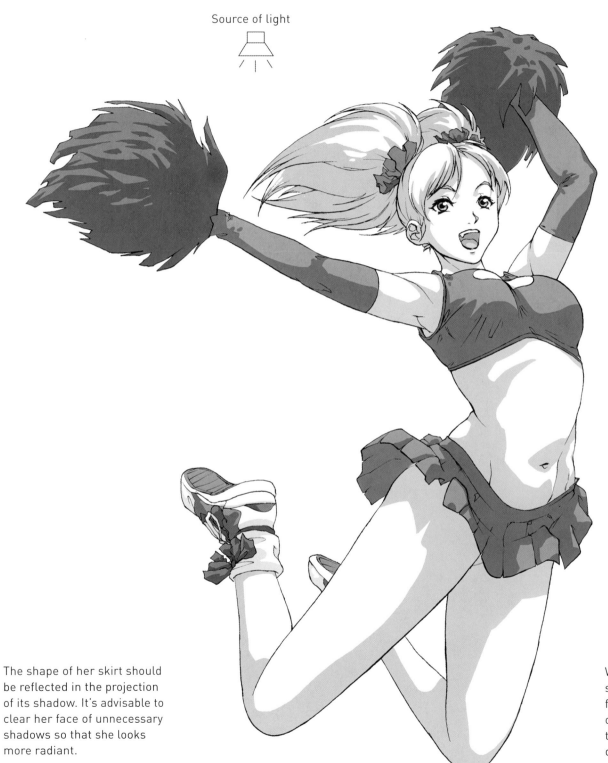

The shape of her skirt should be reflected in the projection of its shadow. It's advisable to clear her face of unnecessary shadows so that she looks more radiant.

We can play with light and shade to shape the ribbons forming the pompons. In order to achieve the proper texture, they should be drawn loosely and with a lot of movement.

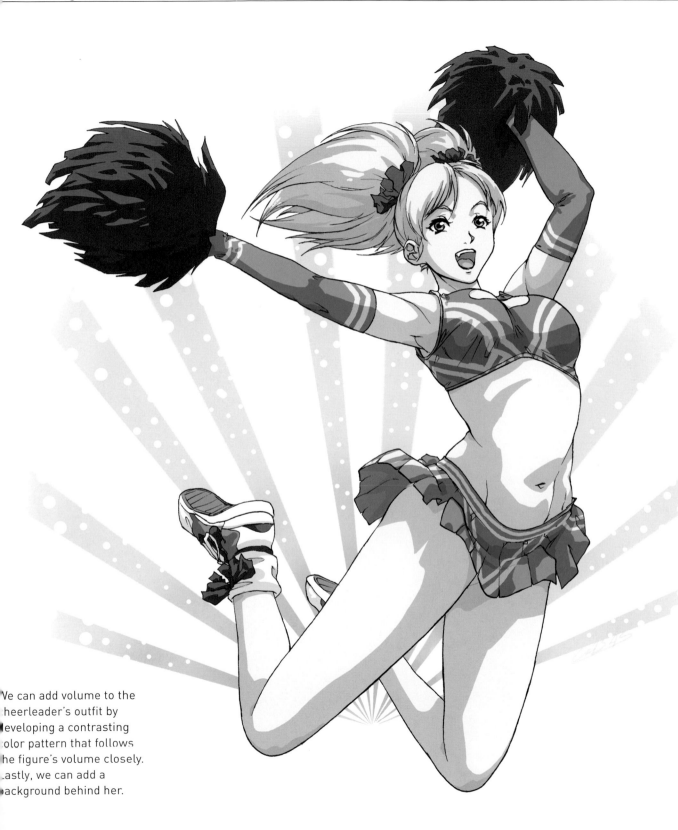

We can add volume to the cheerleader's outfit by developing a contrasting color pattern that follows the figure's volume closely. Lastly, we can add a background behind her.

TENNIS PLAYER

Tennis is yet another popular sport in manga. You can still feel the influence of Ace o Nerea, a seventies series that brought tennis to the animation forefront and is still currently one of the most famous within the category of shojo manga. In this series a smart combination of tennis and drama moved viewers from all around the world.

Today the shonen manga The Prince of Tennis is the one responsible for putting the sport back among the best sellers with its non-stop action and suspense. Tennis is quite respected in Japan, as are all sports where protagonists have the opportunity of transcending beyond that which is strictly related to the sport.

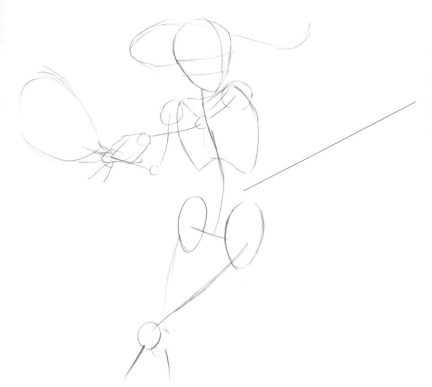

We can use sinuous lines to create dynamic compositions. In this case an S-shape serves to outline the tennis player's movement. We can exaggerate her pose better by breaking the line of balance and concentrating the figure's weight on one side.

2. Volume

Her left arm covers part of her torso and the other arm, but it's still a good idea to shape all these elements even though they won't be visible later on. To draw her grip on the racquet we must first shape the handle and then the hand that is holding it.

For this position we see that her torso is more compact and her arms help enclose it. The different body parts interact and, in this case, her breasts come together as well. We mustn't forget the kind of determined look that is typical of athletes in action.

Tennis outfits are comfortable and close-fitting on the body. We can find inspiration in the more audacious models that have been in style in recent times and fit well with the manga aesthetic, as well as including other elements like a visor.

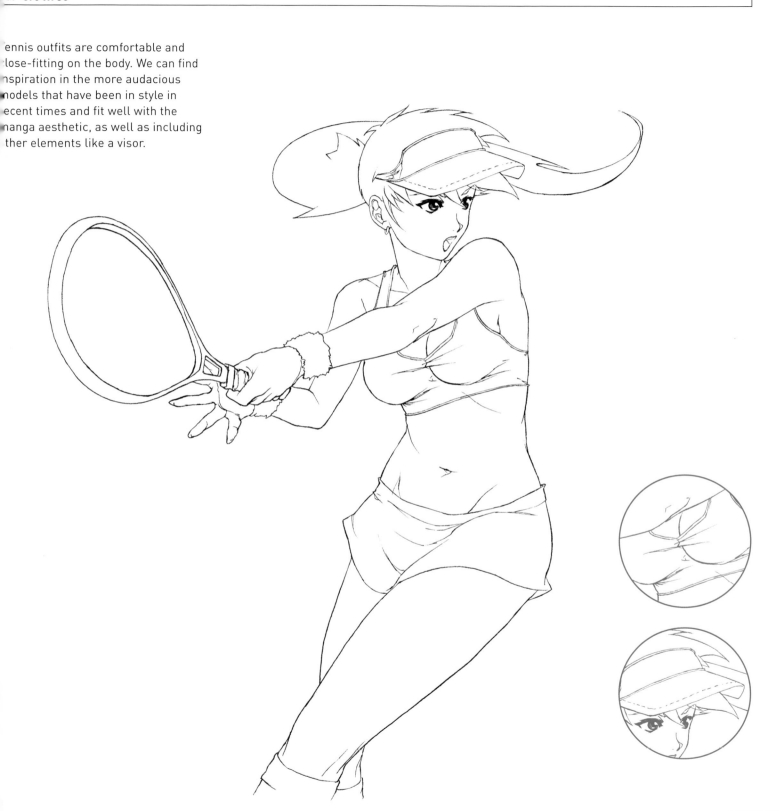

We'll leave her entire lower torso in shade to emphasize the position of her body. This makes her twisting motion more evident. The shadow projected by her visor lends some volume to her cranium.

Source of light

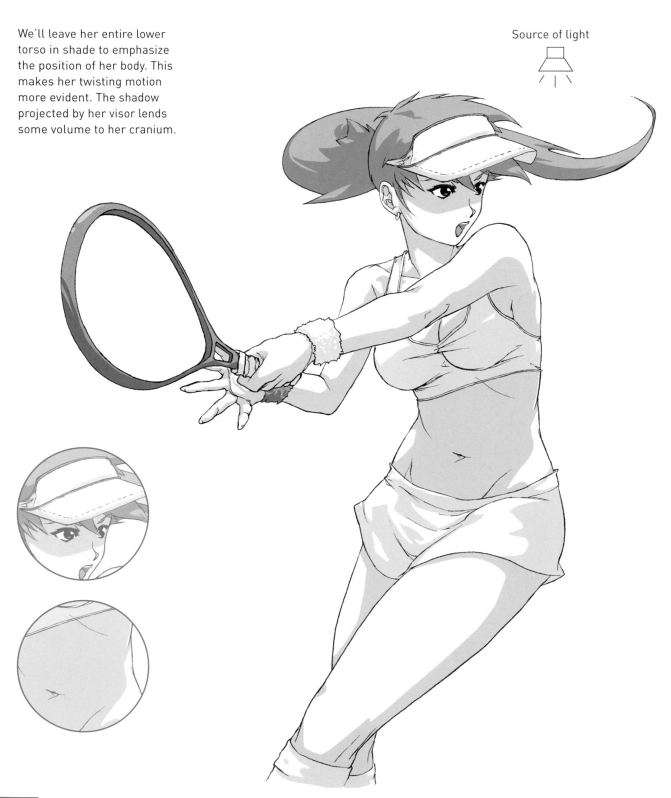

We can choose some kind of typical sports pattern such as color stripes to give her a more personal touch. White and pink make our character look quite feminine.

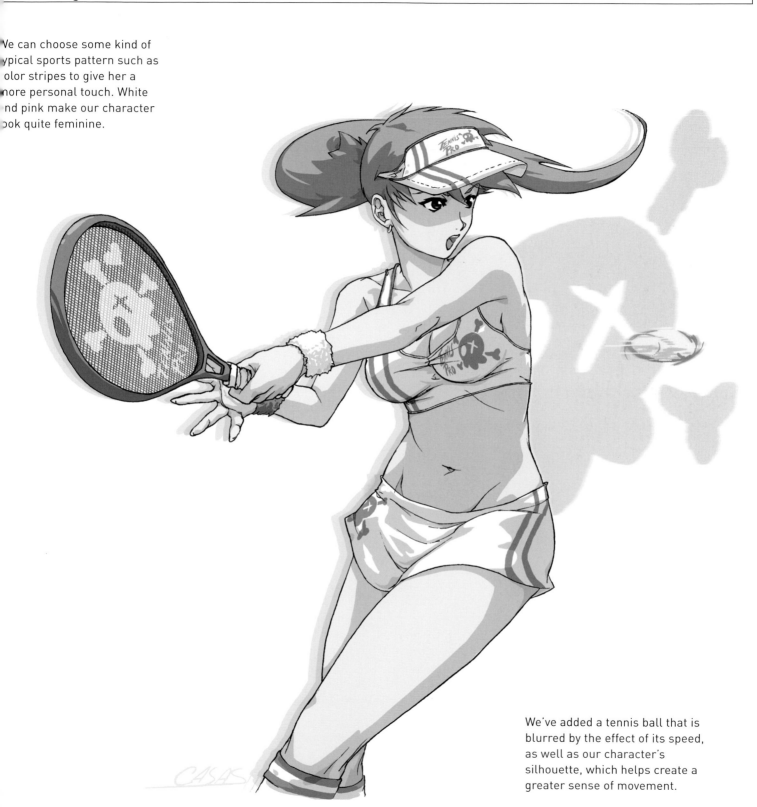

We've added a tennis ball that is blurred by the effect of its speed, as well as our character's silhouette, which helps create a greater sense of movement.

SWIMMER

The swimming pool is yet another favorite setting for mangakas. Aquatic activities set at the pool or the beach appear in special episodes of hundreds of series, especially those dealing with academic topics aimed at younger audiences. As with track and field competitions, often times these situations take place at high school sporting events. Other times, the action revolves around a character's clumsiness as they learn how to swim, and are generally rather comical.

Typically, authors like to show the more sensual side of their heroines. And to the delight of the male fan base, swimsuit specials gather characters and put them in swimsuit outfits.

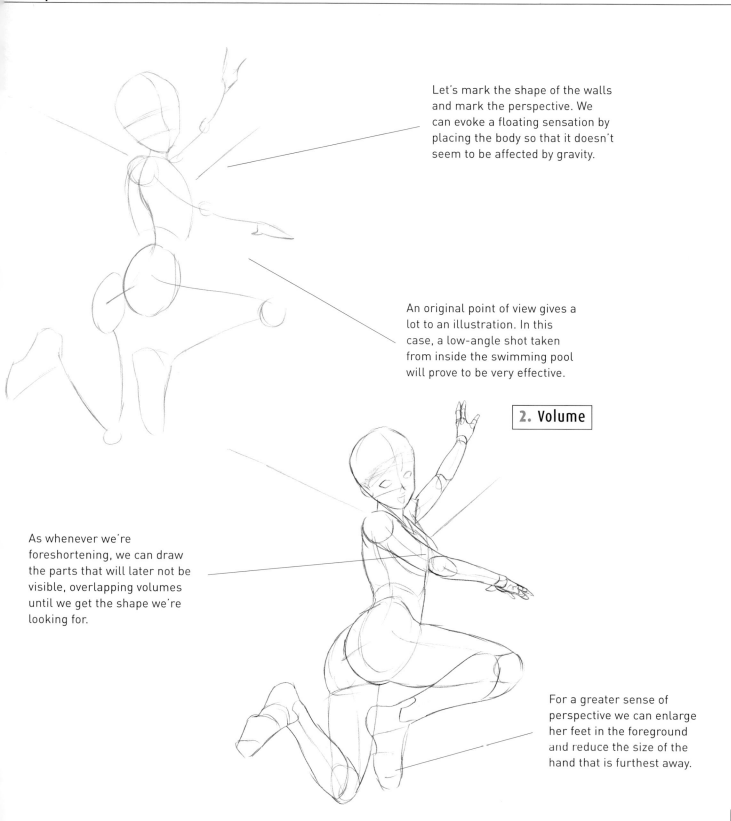

Let's mark the shape of the walls and mark the perspective. We can evoke a floating sensation by placing the body so that it doesn't seem to be affected by gravity.

An original point of view gives a lot to an illustration. In this case, a low-angle shot taken from inside the swimming pool will prove to be very effective.

2. Volume

As whenever we're foreshortening, we can draw the parts that will later not be visible, overlapping volumes until we get the shape we're looking for.

For a greater sense of perspective we can enlarge her feet in the foreground and reduce the size of the hand that is furthest away.

Sticking to the athletic character stereotype, we'll be drawing an athletic body that reflects the kind of strong backs and legs that swimmers have.

Twisting her body, and the position of her hips and arms, help create a sensual pose with a lot of movement.

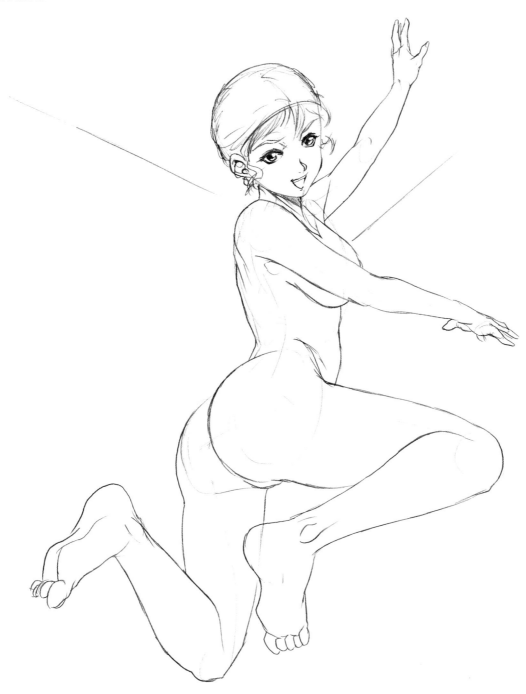

We'll draw a classic bathing suit, the kind you would find in swimming classes, and also give her the kind of swimming cap that is mandatory in most swimming pools.

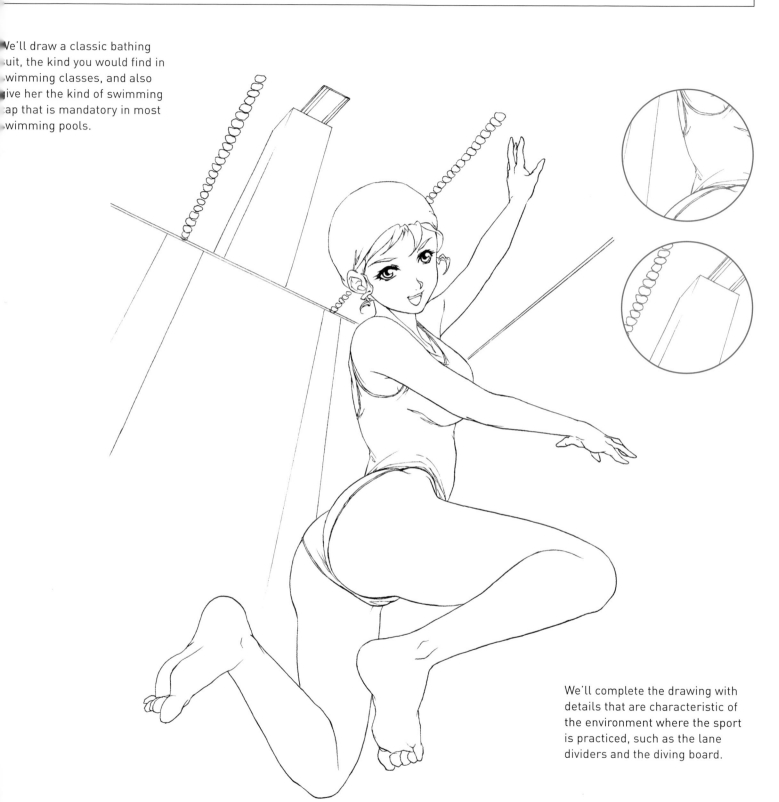

We'll complete the drawing with details that are characteristic of the environment where the sport is practiced, such as the lane dividers and the diving board.

The first thing we must do is shape our protagonist's figure and, since the main light source is outside the pool, the majority of her body will be shaded.

Source of light

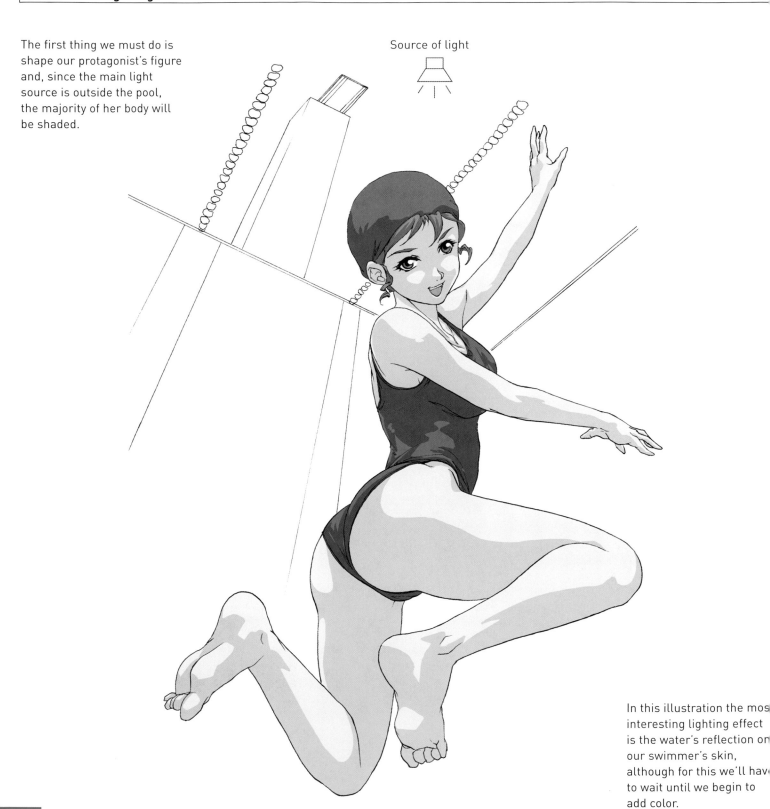

In this illustration the most interesting lighting effect is the water's reflection on our swimmer's skin, although for this we'll have to wait until we begin to add color.

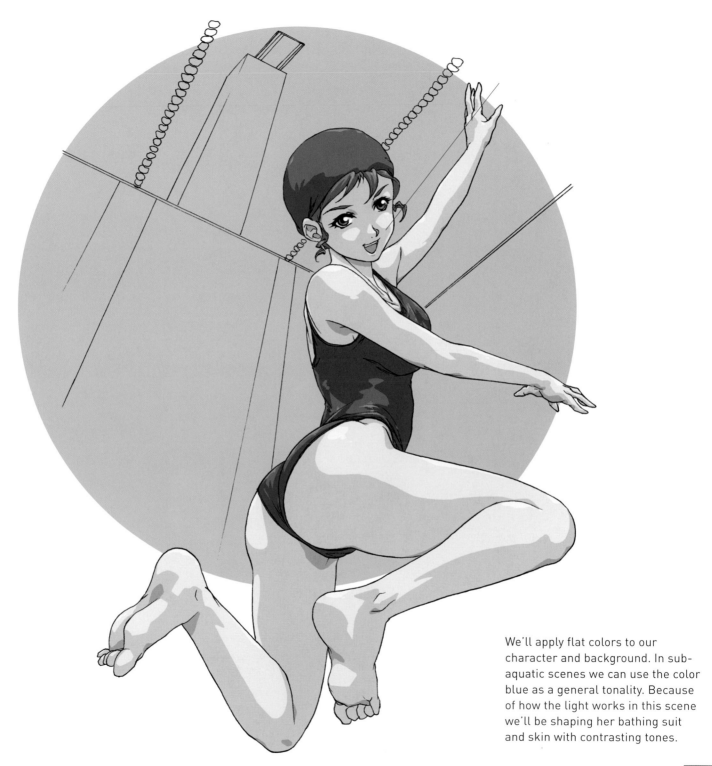

We'll apply flat colors to our character and background. In sub-aquatic scenes we can use the color blue as a general tonality. Because of how the light works in this scene we'll be shaping her bathing suit and skin with contrasting tones.

We'll finish giving all the elements their flat colors and then we'll tint the entire scene in the same color blue so that it looks like we are really underwater with our protagonist.

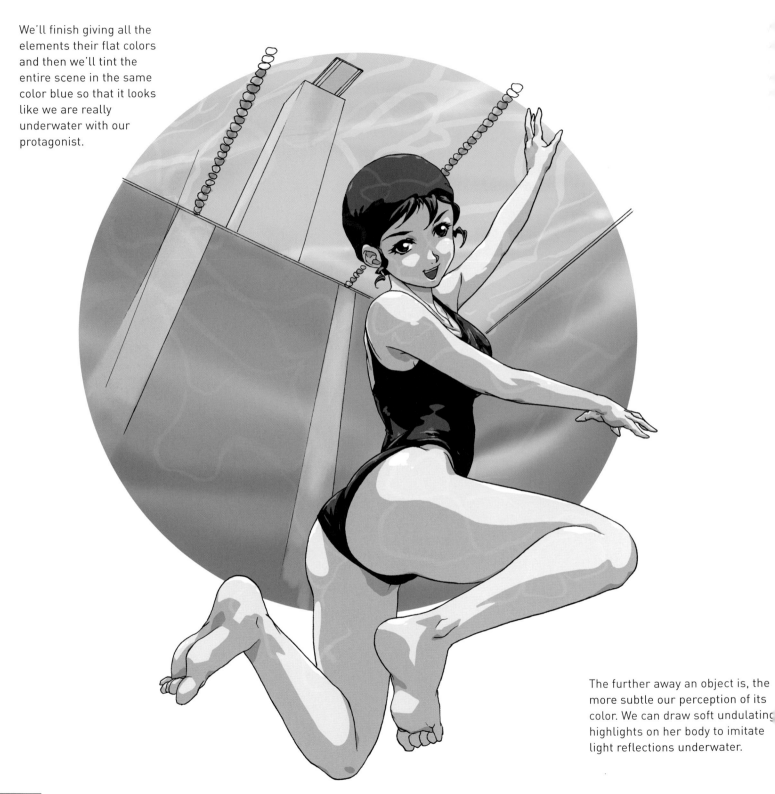

The further away an object is, the more subtle our perception of its color. We can draw soft undulating highlights on her body to imitate light reflections underwater.

We'll add the final touches. In sub-aquatic scenes that are well-lit we can add blue light reverberations that come from the bottom of the pool.

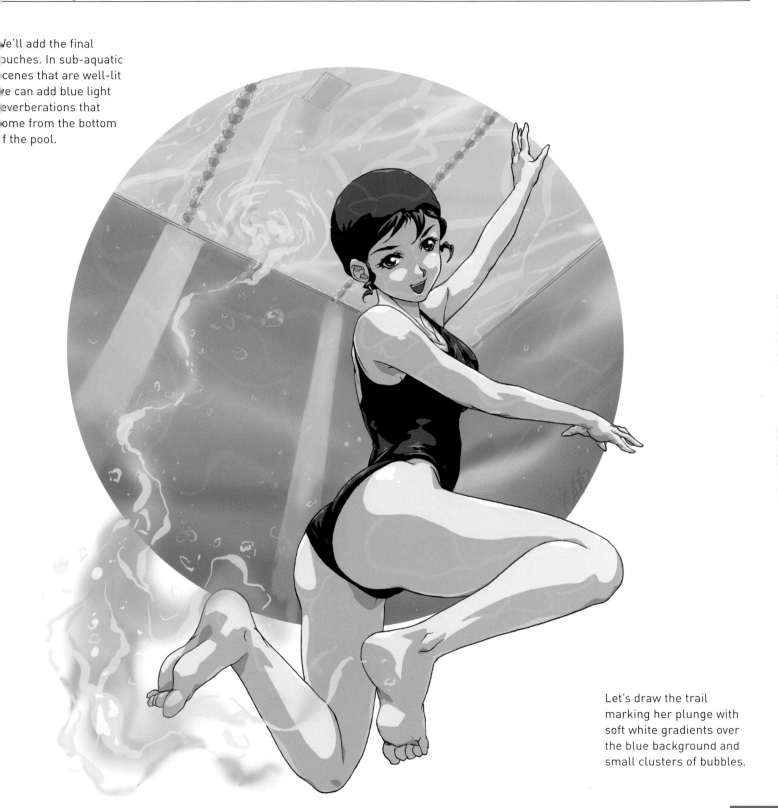

Let's draw the trail marking her plunge with soft white gradients over the blue background and small clusters of bubbles.

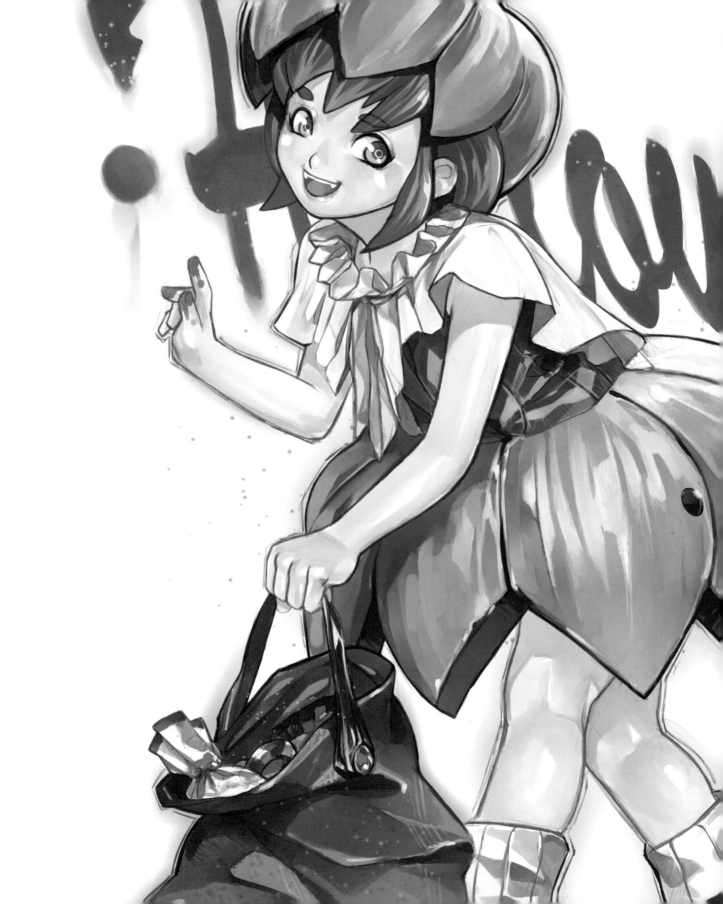

VanDrell

SEASONS AND FESTIVITIES

CHRISTMAS

Christmas is the perfect setting for a wide variety of stories. The winter season, and the snow that accompanies it, provide an interesting array of aesthetic landscapes, while Christmas celebration imagery uses a great deal of aesthetic resources as well. Among this imagery it's typical to find Santa Claus and his presents. A female version of this theme is constantly being reinvented in hundreds of manga stories and, especially, in promotional shots and illustrations.

In these kinds of illustrations characters usually appear beside the gifts, the Christmas tree and other typical holiday decorations in poses that clearly express either gratitude or the act of giving.

We've chosen a pose that depicts the act of giving. To make it much more evident, we'll use exaggerated foreshortening to place her hands in the foreground, as if she were handing something to the viewer.

2. Volume

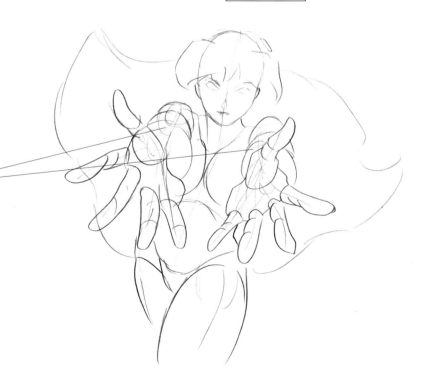

We can emphasize the action by exaggerating the pose with a slight low-angle perspective. When foreshortening her arms we must divide them in volumes drawn in perspective, overlapping them and increasing their size as they get nearer the viewer.

In these kinds of points of view it is very important to pay maximum attention to what's in the foreground, in this case her hands.

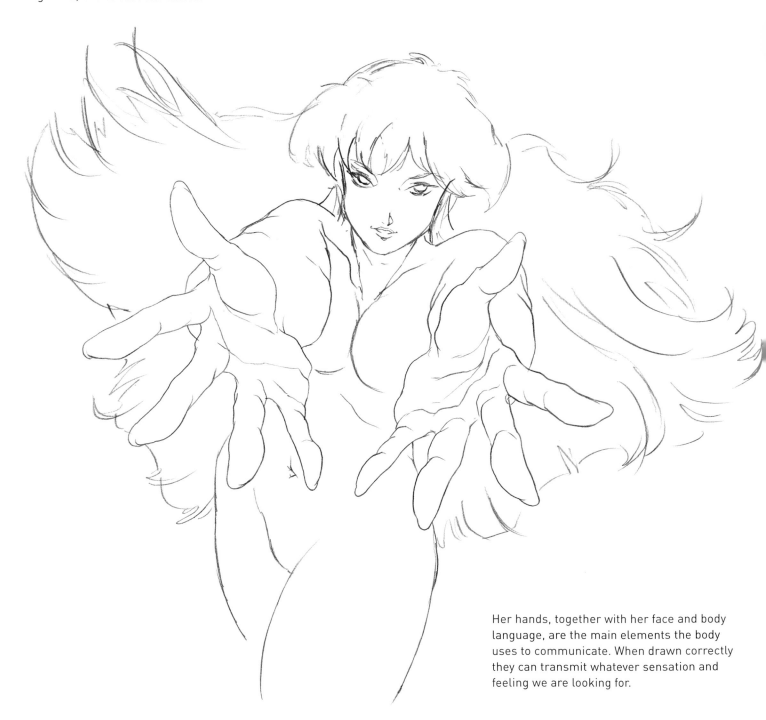

Her hands, together with her face and body language, are the main elements the body uses to communicate. When drawn correctly they can transmit whatever sensation and feeling we are looking for.

We've chosen to dress our girl in a Santa Claus outfit. This particular way of reinventing Saint Nick allows for fun improvisation and more aring and original outfits based on the traditional one we all know.

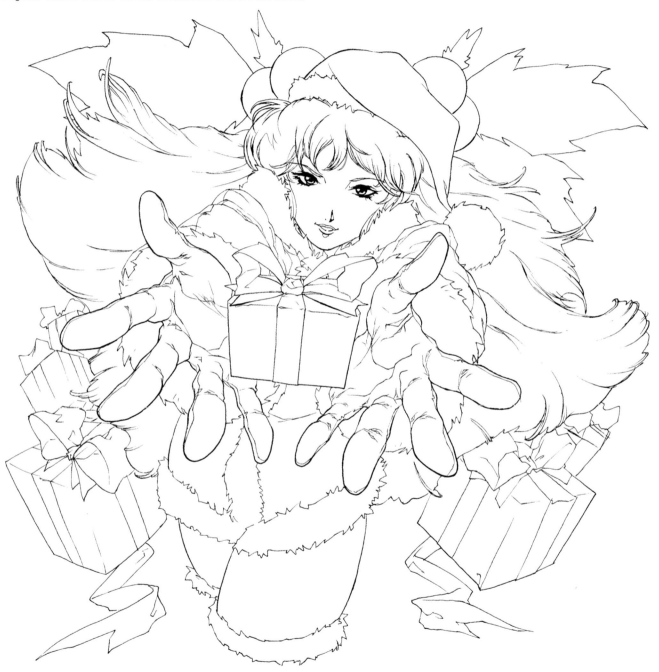

The rest of the elements, such as the gifts, form part of classical Christmas imagery, and we can use them to finish decorating the illustration.

In cases where we must deal with very pronounced foreshortening, we can use lighting as a resource that helps us separate the different planes.

Source of light

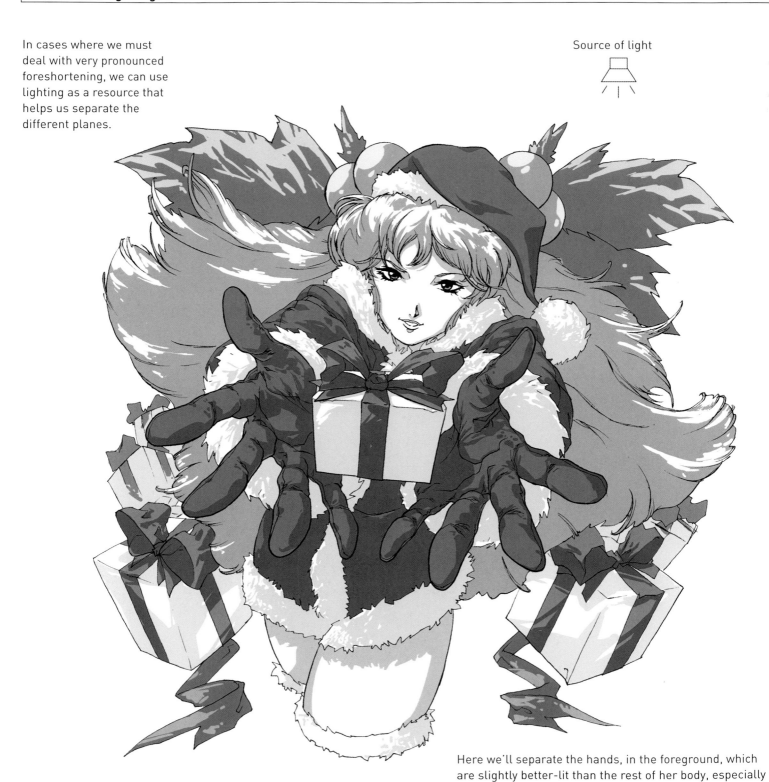

Here we'll separate the hands, in the foreground, which are slightly better-lit than the rest of her body, especially her trunk, which is left in shade. This helps make the sensation of perspective more evident.

ince we've decided to maintain the popular
olors for her clothing, it's a good idea to use
ther colors that lend a chromatic touch. Green is
omplementary of red, so the leaves provide
nough contrast to enrich the illustration.

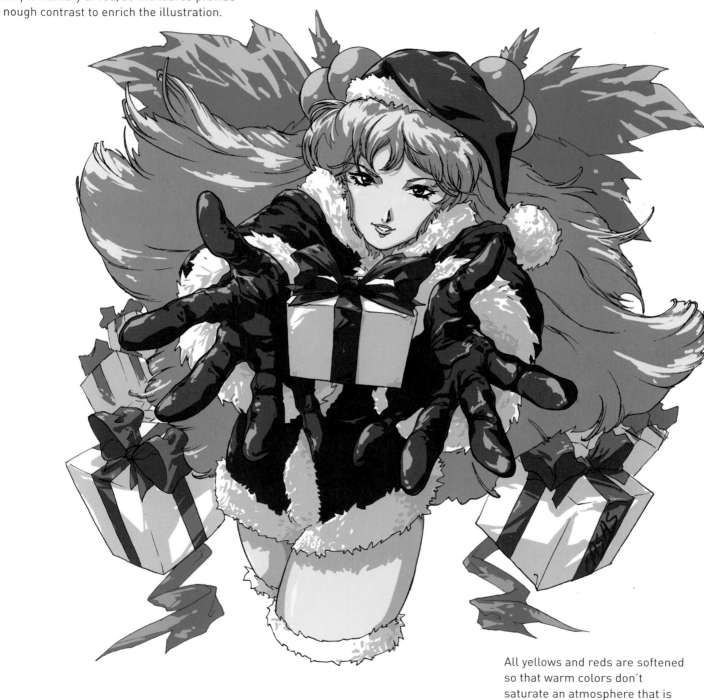

All yellows and reds are softened
so that warm colors don't
saturate an atmosphere that is
typically colder at Christmastime.

SPRING FESTIVAL

Spring is the season when the Japanese celebrate the festivals that are most widely known outside their country. One of them is Hinamatsuri (Doll Festival), which consists of a platform with various levels of dolls that are dressed in the traditional outfits of the Court from the Heian period. These are ordered from top to bottom, putting the emperor and empress up on the highest level and court ministers on the lowest level.

Perhaps the most widely known festival and most often represented in manga and anime is Ohanami, the tradition of sitting beneath the cherry trees at the end of March and beginning of April to eat, drink and watch the flowers blossom.

We'll sketch the character sitting beneath a cherry tree. To do this we must force the position of her legs, bringing them into the foreground. We'll also shorten her right arm, which is resting on the ground, since it is furthest away.

2. Volume

The exaggerated perspective created by the position of her legs gives the drawing greater depth. Part of our character's hips will be covered by her foreshortened legs, thus accentuating her volume.

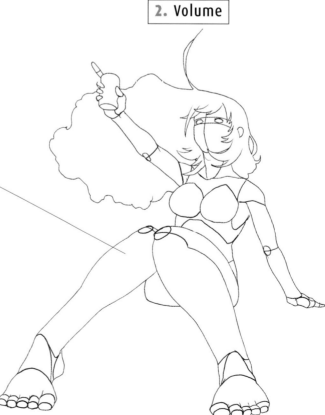

We can see that foreshortening her legs and body makes her trunk a little shorter. We've chosen a typical girl, so we'll use standard proportions rather than drawing her particularly athletic or boney.

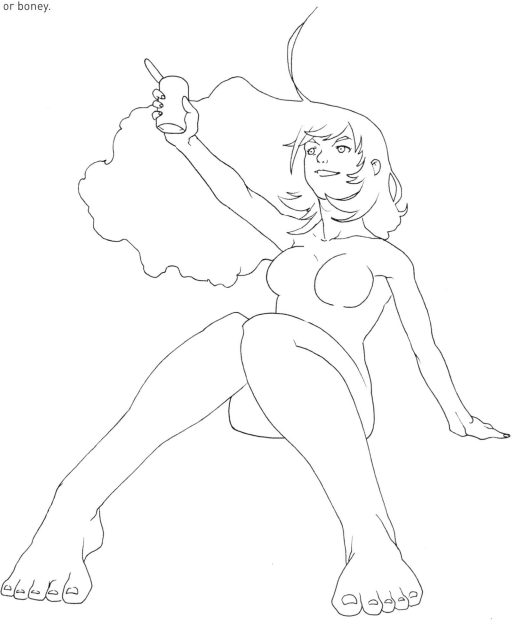

4. Clothes

For Ohanami, girls usually dress up in traditional outfits. We've chosen a simple yukata without many accessories. Her clothing, and the drink she has in her hands to toast for the cherry blossoms, indicates that warm weather is getting nearer.

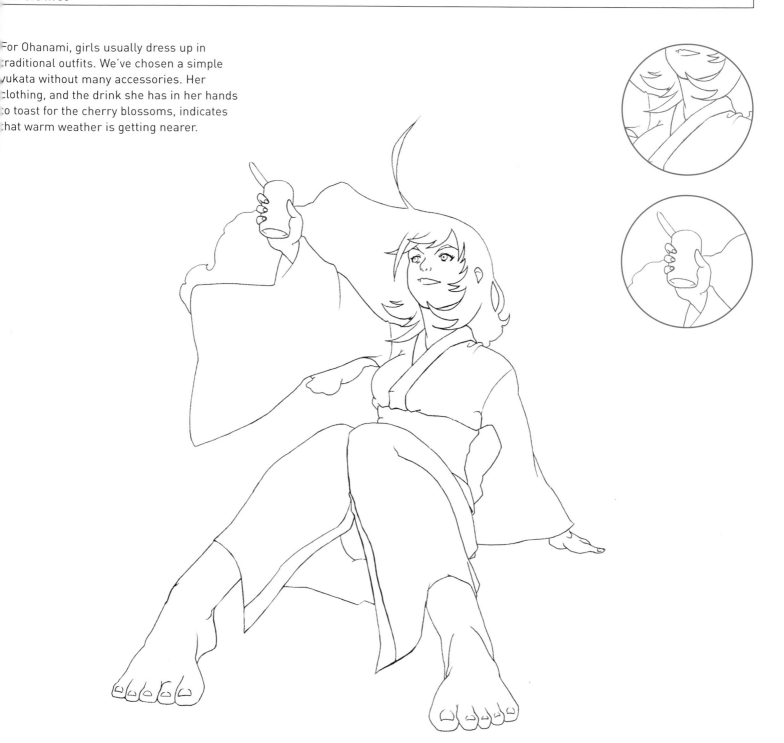

When drawing an open-air scene, it's typical to use the sun as our light source. This is no exception, so we'll be using zenithal lighting that marks the volume of her clothing while also accentuating that of our character.

Source of light

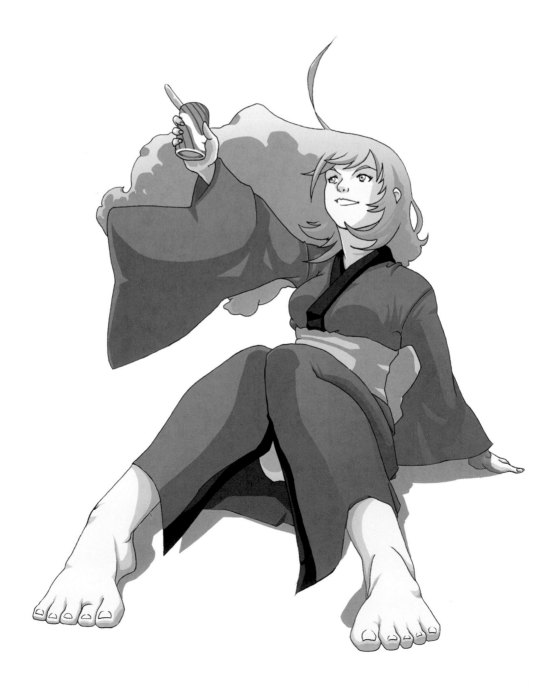

We'll use saturated colors on our character and her clothes in order to contrast with the background, which is softer. Then we'll achieve a more finished look by adding some simple floral motifs to her clothes (which match the drawing's theme).

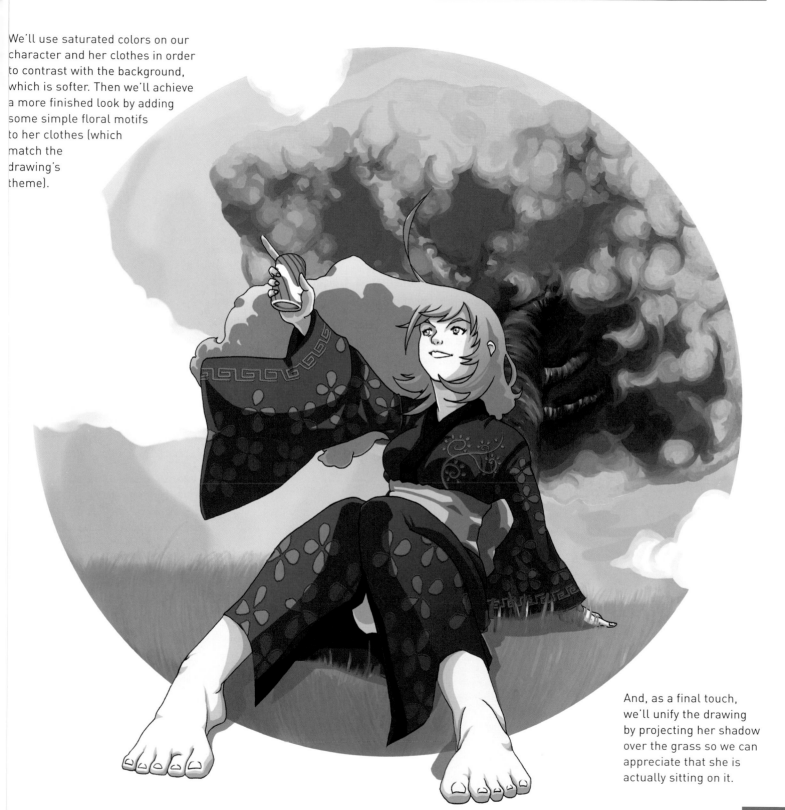

And, as a final touch, we'll unify the drawing by projecting her shadow over the grass so we can appreciate that she is actually sitting on it.

There are two important things in this step: first, the girl's delicate body, which is achieved with smooth, stylized lines, even when drawing her fingers.

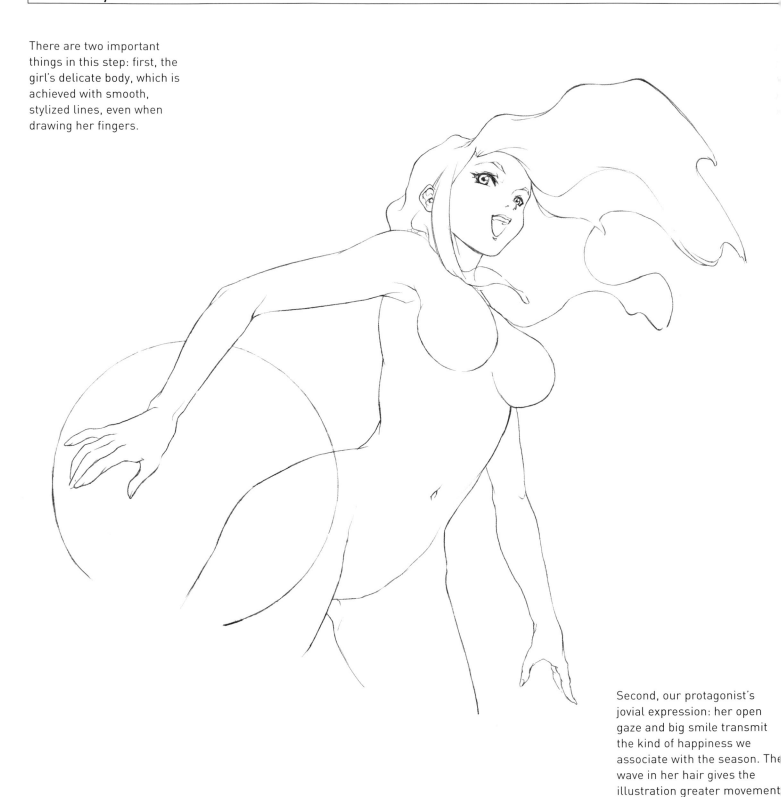

Second, our protagonist's jovial expression: her open gaze and big smile transmit the kind of happiness we associate with the season. The wave in her hair gives the illustration greater movement

In this particular case we must draw the sea and waves while respecting the inclined horizon we've chosen for our point of view.

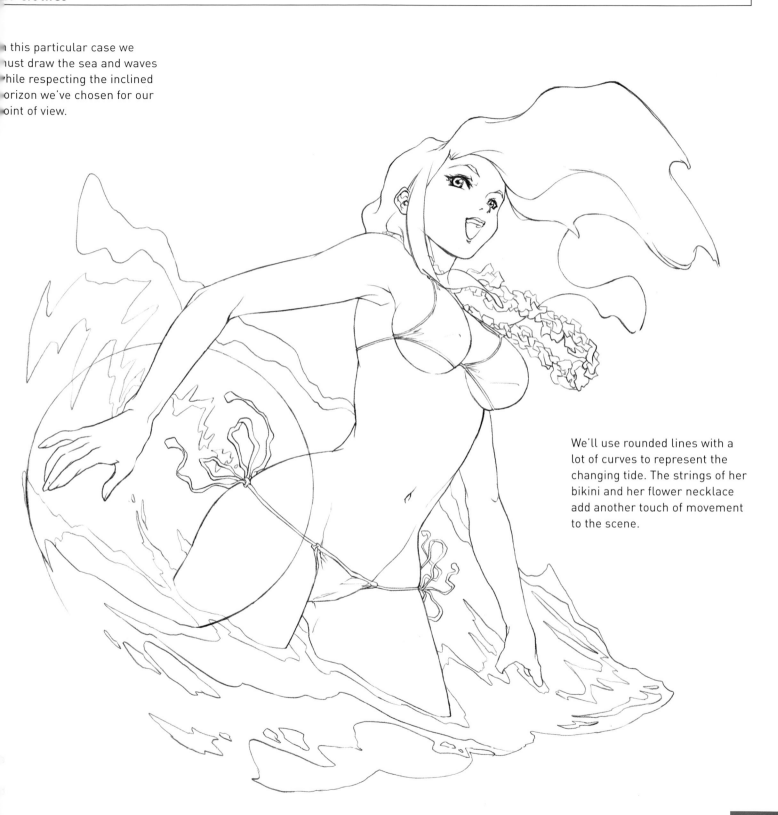

We'll use rounded lines with a lot of curves to represent the changing tide. The strings of her bikini and her flower necklace add another touch of movement to the scene.

Here we must study where to place the areas that will give the girl her volume. The lighting (which is zenithal since we are in broad daylight) can be strong and slightly contrasting. The shadow projected over her face emphasizes the volume of her hair.

Source of light

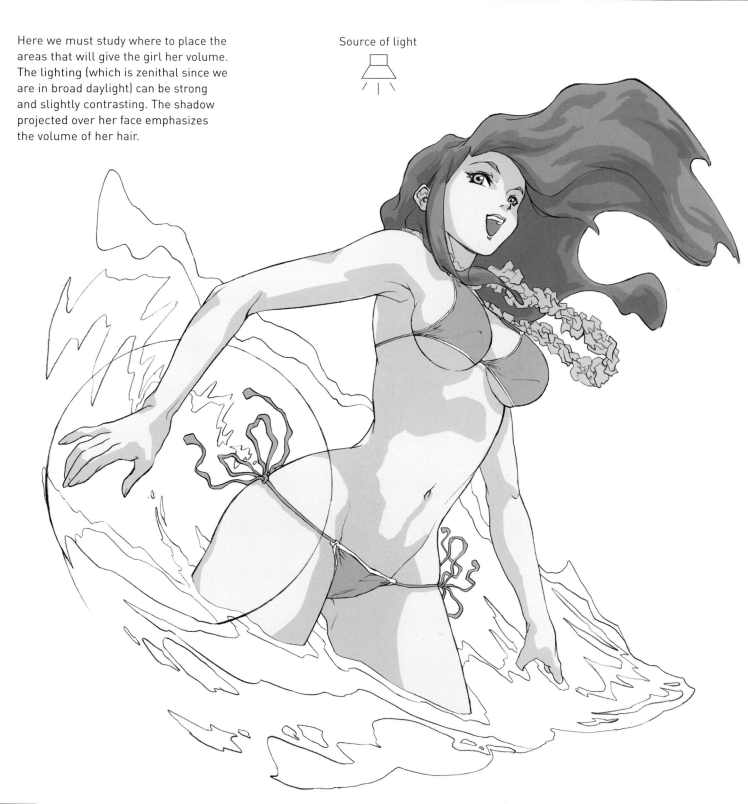

n accordance with our lighting
e must begin by bathing the
cene in light while making
ure to maintain the same tone
n all the elements. In this
ase blue is the base for the
ntire illustration.

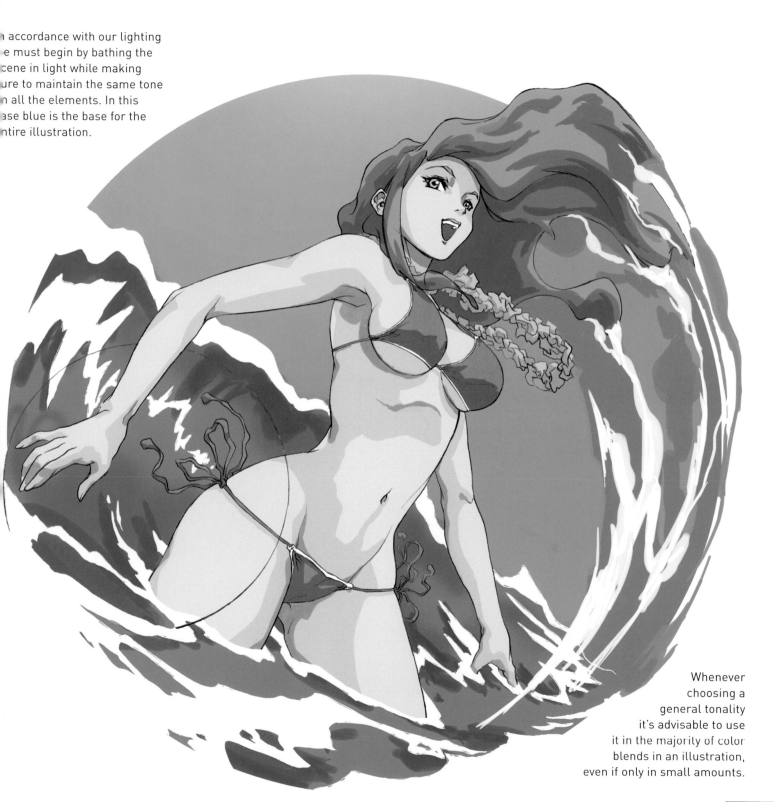

Whenever
choosing a
general tonality
it's advisable to use
it in the majority of color
blends in an illustration,
even if only in small amounts.

We'll shape the figure and the background by working the gradients with the flat colors we created previously and adding more contrasting ones for lit and shaded areas. We'll begin giving each material its corresponding texture.

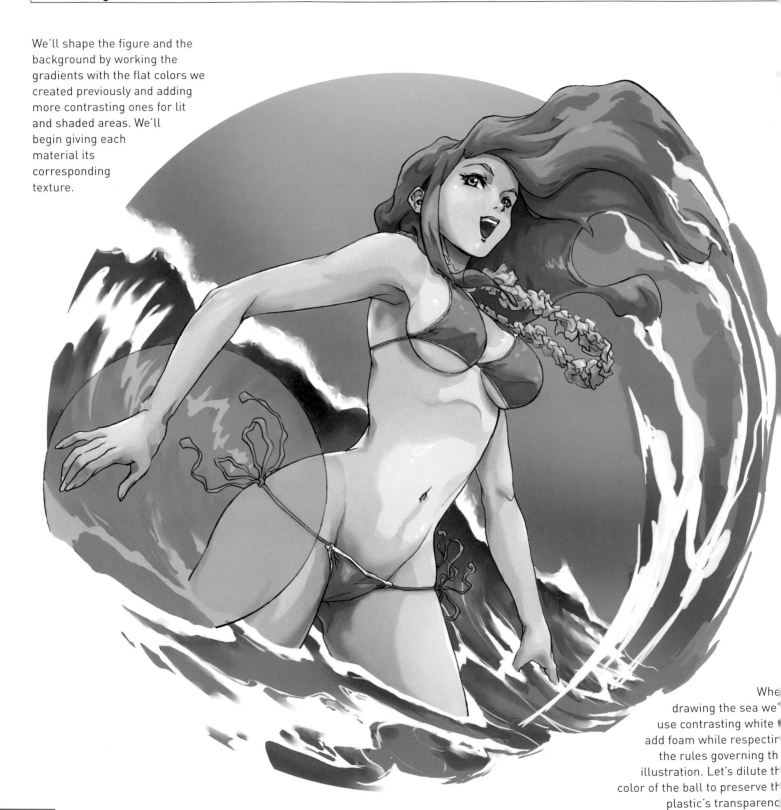

Whe[n] drawing the sea we'[ll] use contrasting white [to] add foam while respectin[g] the rules governing th[e] illustration. Let's dilute th[e] color of the ball to preserve th[e] plastic's transparenc[y]

After giving the ball volume and maintaining its transparency, we'll finish off the drawing with details that give it greater depth, such as highlights and the sun's effect on drops of water.

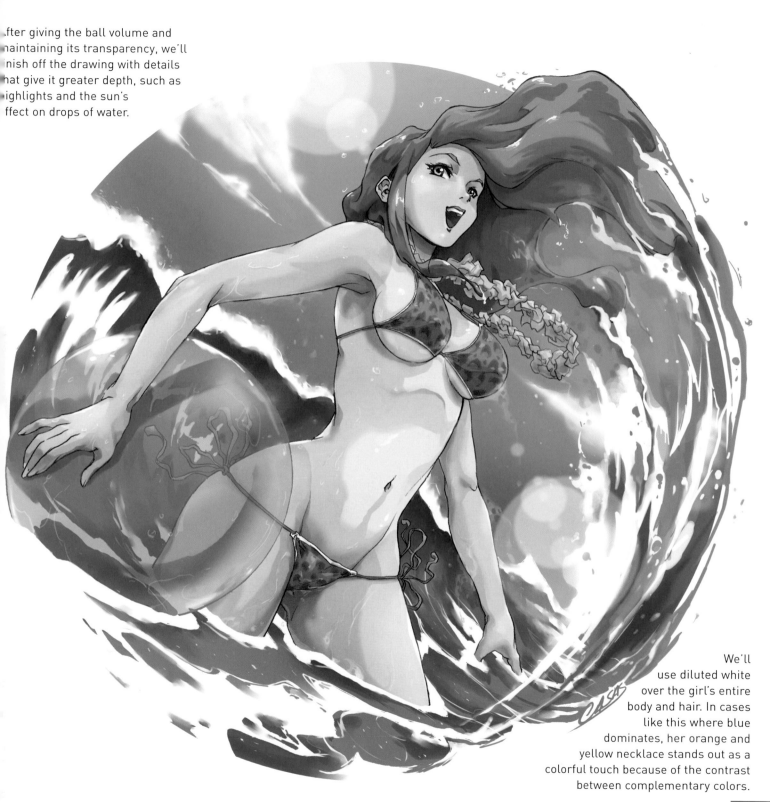

We'll use diluted white over the girl's entire body and hair. In cases like this where blue dominates, her orange and yellow necklace stands out as a colorful touch because of the contrast between complementary colors.

THERMAL BATHS

Thermal baths are another of the traditional Japanese places for leisure and relaxation that have been popularized by manga and anime. Onsen are the traditional Japanese hot springs, where people can enjoy a very special, peaceful atmosphere. Because Japan is a volcanic archipelago it has been blessed with lots of natural thermal baths. In series like Love Hina and Ranma, we've had the opportunity of seeing our favorite heroes takes advantage of moments of repose to bond with their friends in a perfectly relaxed atmosphere. Although there are usually conflicts between boys and girls, these typically stem from the boys' bad intentions.

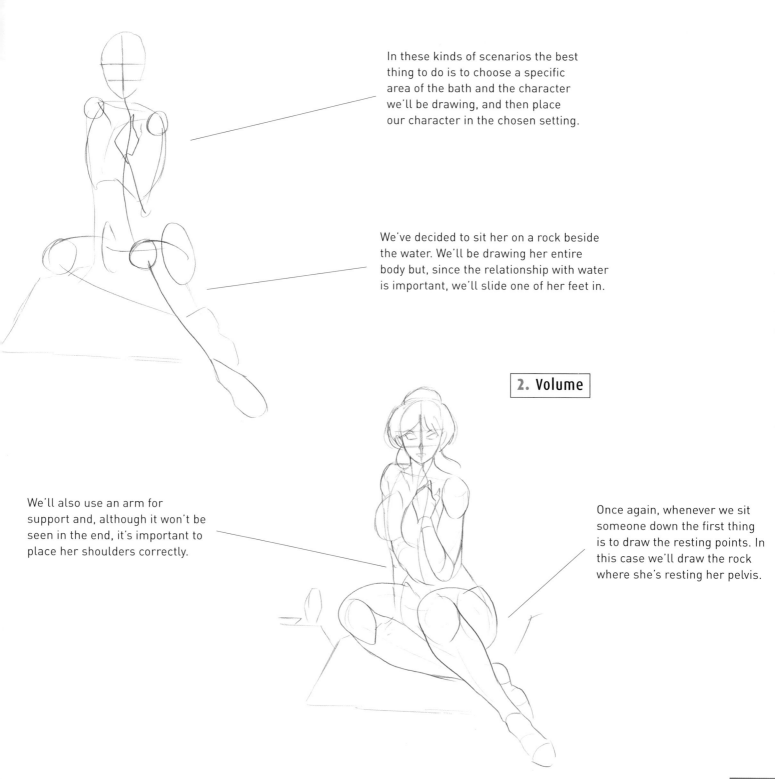

In these kinds of scenarios the best thing to do is to choose a specific area of the bath and the character we'll be drawing, and then place our character in the chosen setting.

We've decided to sit her on a rock beside the water. We'll be drawing her entire body but, since the relationship with water is important, we'll slide one of her feet in.

2. Volume

We'll also use an arm for support and, although it won't be seen in the end, it's important to place her shoulders correctly.

Once again, whenever we sit someone down the first thing is to draw the resting points. In this case we'll draw the rock where she's resting her pelvis.

Traditionally these kinds of illustrations are pretty sensual and suggestive because of the atmosphere itself and the fact that they are half-naked.

We must be delicate when drawing her body, using soft and rounded lines, making sure that every part of her body, even her feet, exudes femininity.

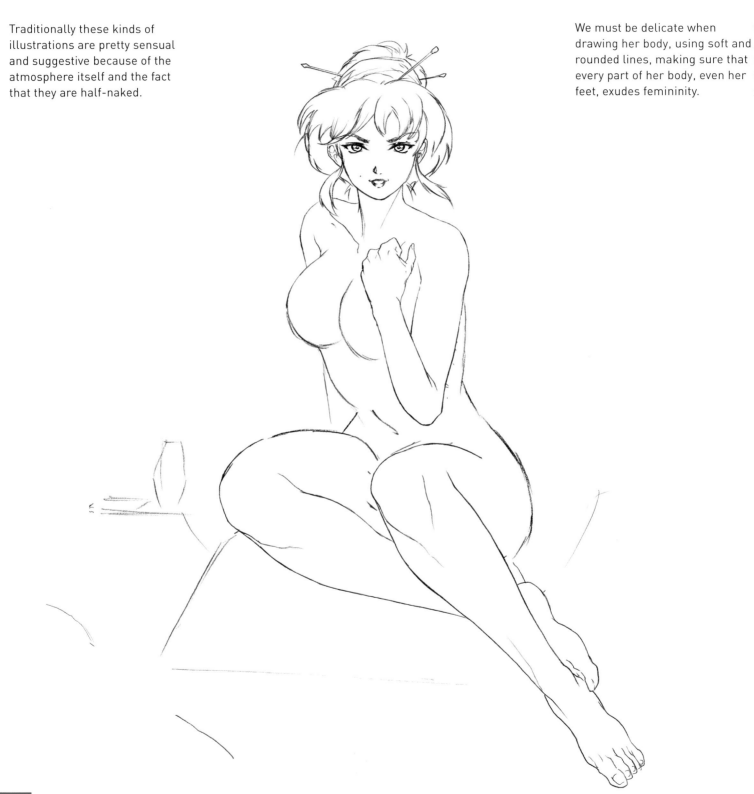

Normally two towels are used in baths: one is for the body and the other for the head, which girls tend to use to keep their hair up.

For decoration, we've added a traditional vessel and dish on a tray. When immersed in water, one of the finest pleasures is to relax while drinking something delicious.

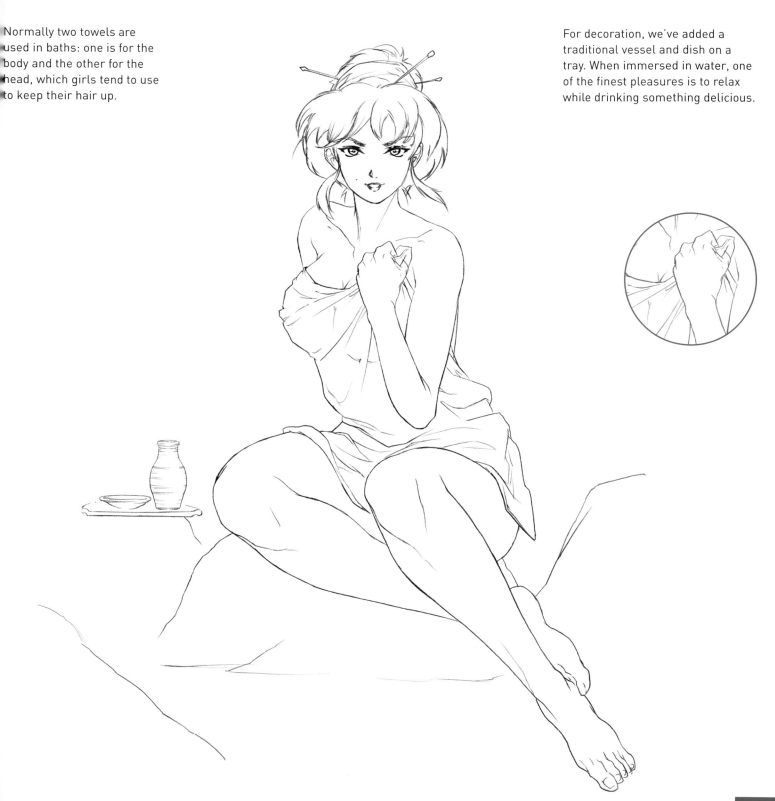

Light is essential for drawing the scene and the character's volume. Vapor makes her skin shinier, slightly increasing contrast in areas that are lit. Since the lighting is not natural but artificial, we must use softer lighting.

Source of light

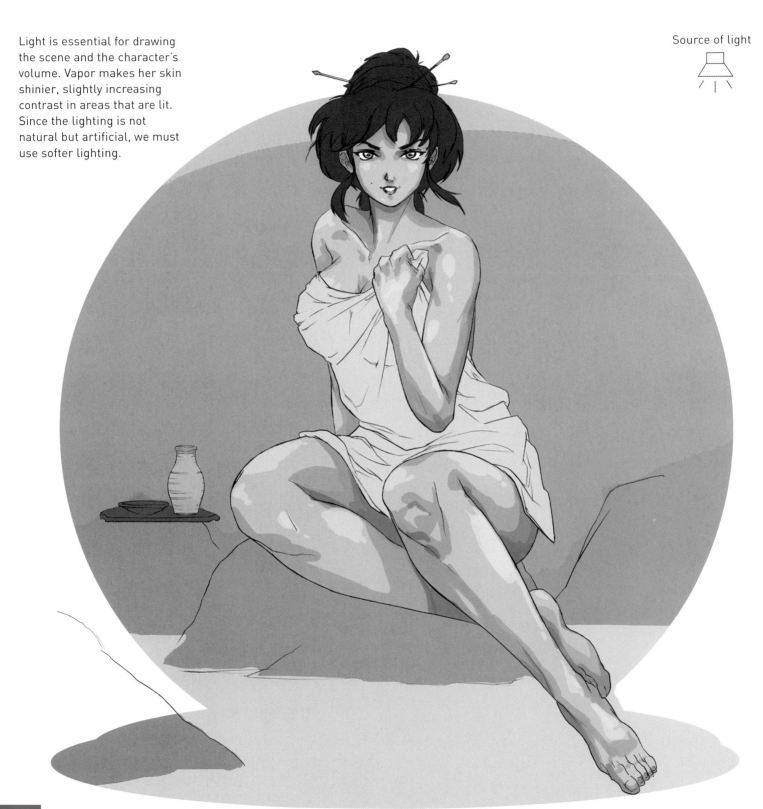

In this first step we'll give the illustration its tonality. We'll choose toasted colors, with a wide range of earthy tones, grays and browns to create a traditional atmosphere. Earth colors make an image look classical and traditional.

The water is slightly lighter in color since it is reflecting some of the light. Its cloudiness is appropriate for natural hot springs.

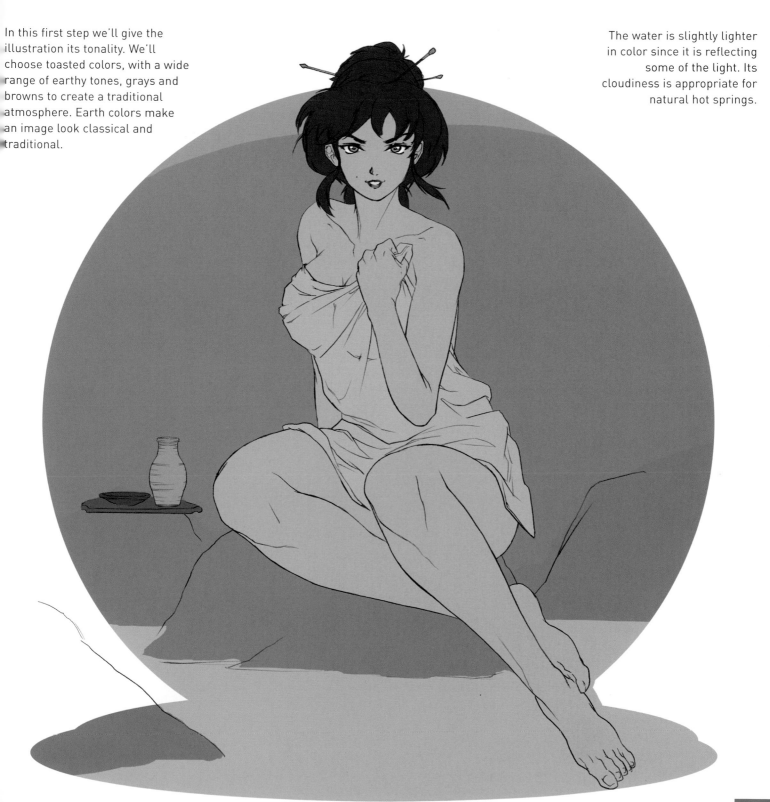

We must respect our lighting when shaping the character and other elements in the scene. By working contrasts between light and dark areas we can detail the volumes of the rocks and give them the right shape.

The rock has sharp contrast with clearly marked limits, because the shape is more angular than that of the girl's body, which is soft and rounded.

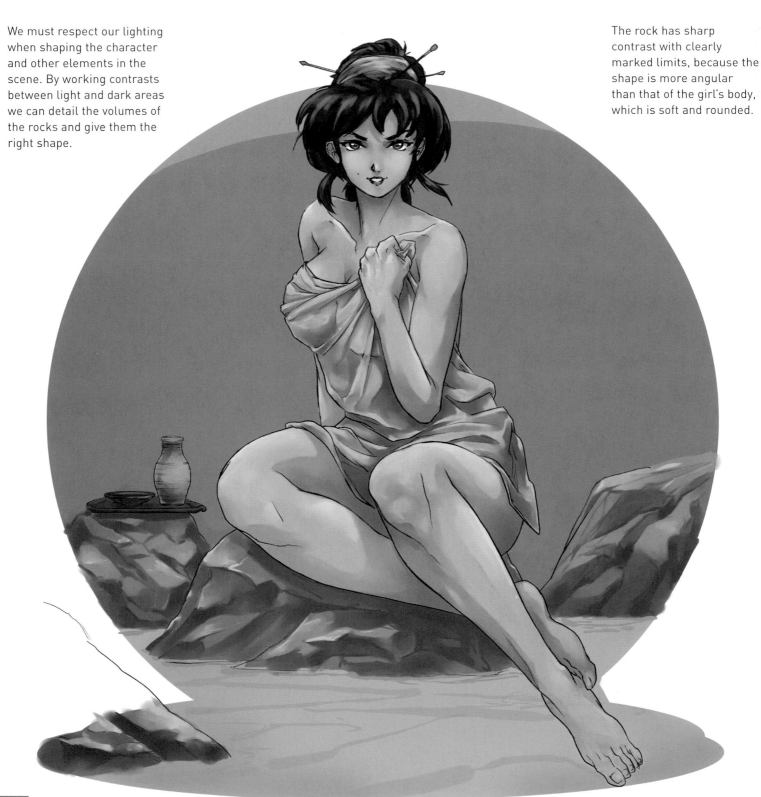

Next, we'll add the final lighting details and textures: highlights in the water, drops of sweat on her wet skin, etc.

We'll finish the illustration by drawing the vapor coming up from the hot water. By superimposing vapor on top of the various elements in the drawing we'll be giving the volumes in the image one last final touch.

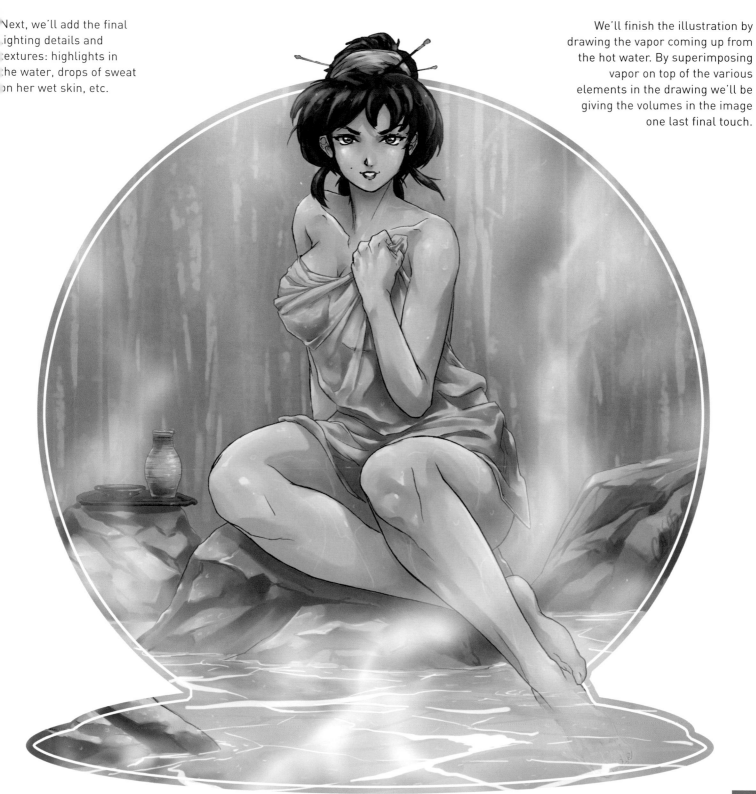

HALLOWEEN

Some people forget that Halloween has its roots in Northern Europe. It was a pagan feast for Celts commemorating their dead and celebrating the beginning of harvest. Years later the Catholics converted it into the holy holiday of All Saints Day.

As occurs with holidays like Christmas, the great many visual and graphic Halloween elements give us a lot to choose from when drawing illustrations related to the holiday.

It's hard to find a successful girl series that doesn't have one or more representations of Halloween. From the trick-or-treat to the pumpkin, it's easy to identify with the scene and flash a smile when seeing these kinds of images.

1. Shape

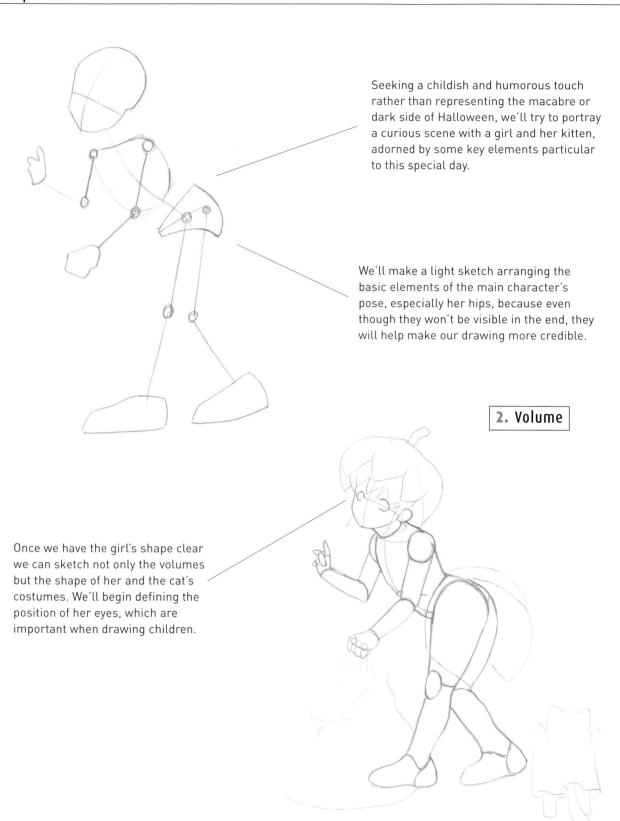

Seeking a childish and humorous touch rather than representing the macabre or dark side of Halloween, we'll try to portray a curious scene with a girl and her kitten, adorned by some key elements particular to this special day.

We'll make a light sketch arranging the basic elements of the main character's pose, especially her hips, because even though they won't be visible in the end, they will help make our drawing more credible.

2. Volume

Once we have the girl's shape clear we can sketch not only the volumes but the shape of her and the cat's costumes. We'll begin defining the position of her eyes, which are important when drawing children.

Our character is in a somewhat forced position so, although you can barely notice in the end, it's important to position her hips and legs correctly.

We'll give her extremities some more or less realistic proportions although we'll be covering her feet with large boots when we get to her clothing.

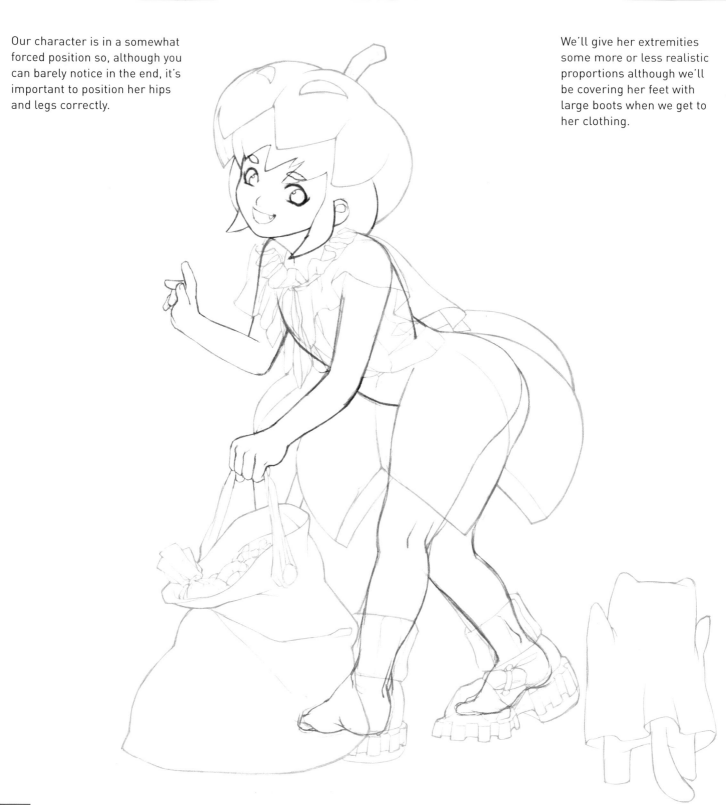

We'll pay attention to the wrinkles and volumes of the shawl covering her shoulders and exaggerate certain elements, such as the boots or the pumpkin-shaped skirt to reinforce the tone we're trying to give this illustration.

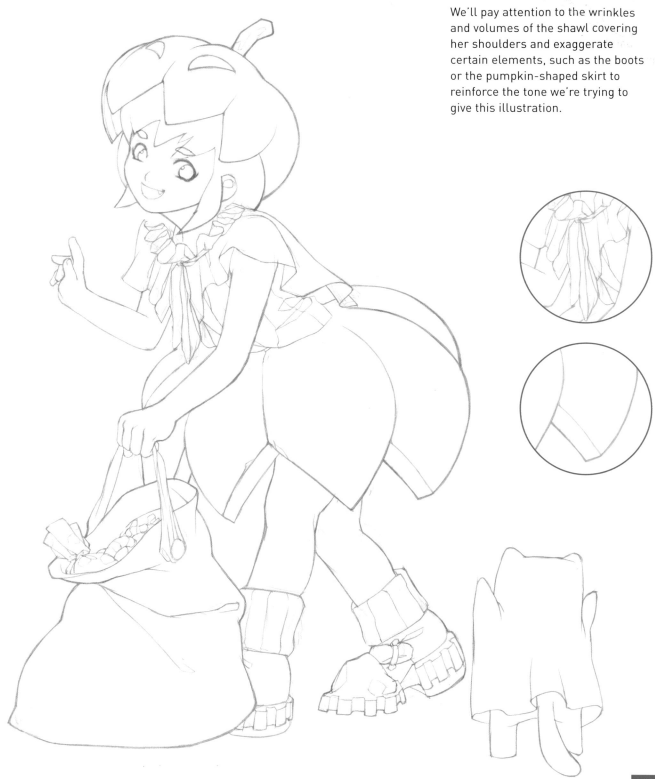

The lateral zenithal light source heightens the pumpkin's texture. We must consider the direction of the light when projecting the girl's shadows and the elements in her costume so as to make their lighting more uniform and believable.

Source of light

The flat colors should be showy and bright, and on this occasion, in tune with the pumpkin. We'll begin to mark the effect of the light on the pumpkin with white patches so we can later create texture.

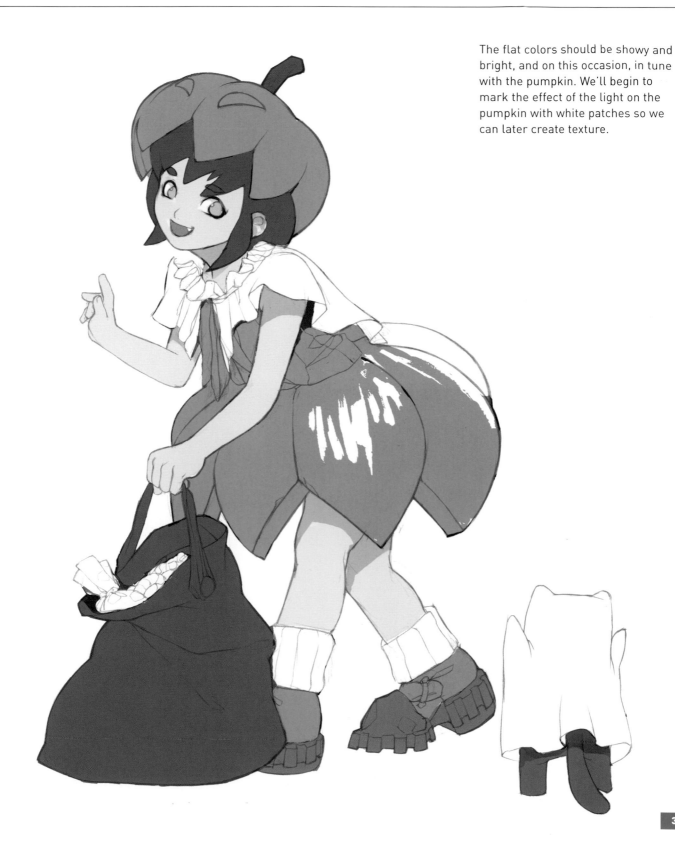

We have lots of pumpkin elements which will look more credible in ochre tones and shading that give them more volume. It's also very useful to add a bit of texture.

Another defining element is the sack, which we'll complete with lot of splashes of color and texture to give it a more worn look and to differentiate it from the girl's costume and the phantom kitten.

We'll use tools like the airbrush to frame our character's silhouette and strengthen it later with lines that help the figure stand out. The same resource applied to the typography will give it a colder, more artistic feel.

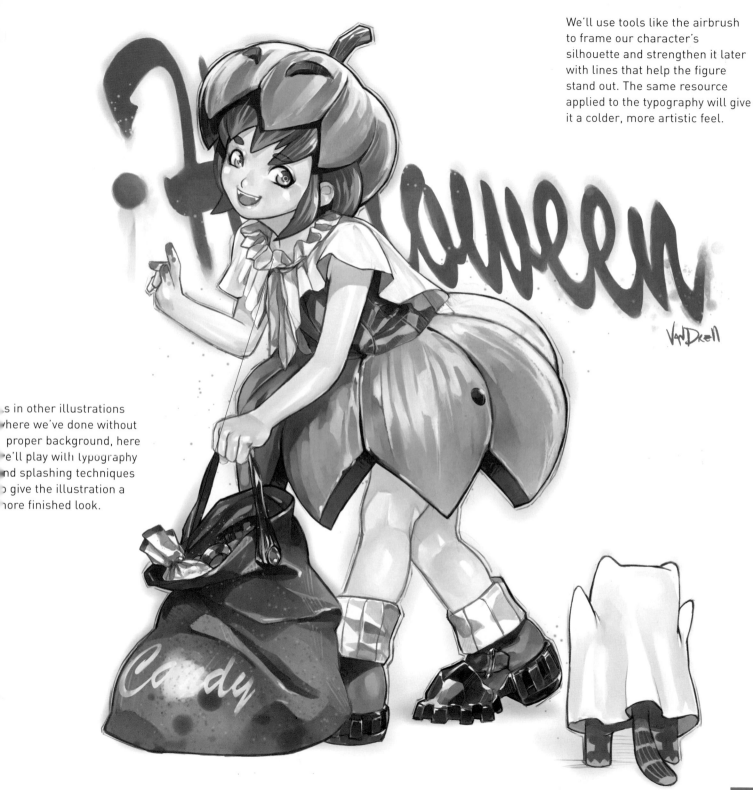

VanDrell

s in other illustrations
here we've done without
proper background, here
e'll play with typography
nd splashing techniques
 give the illustration a
ore finished look.

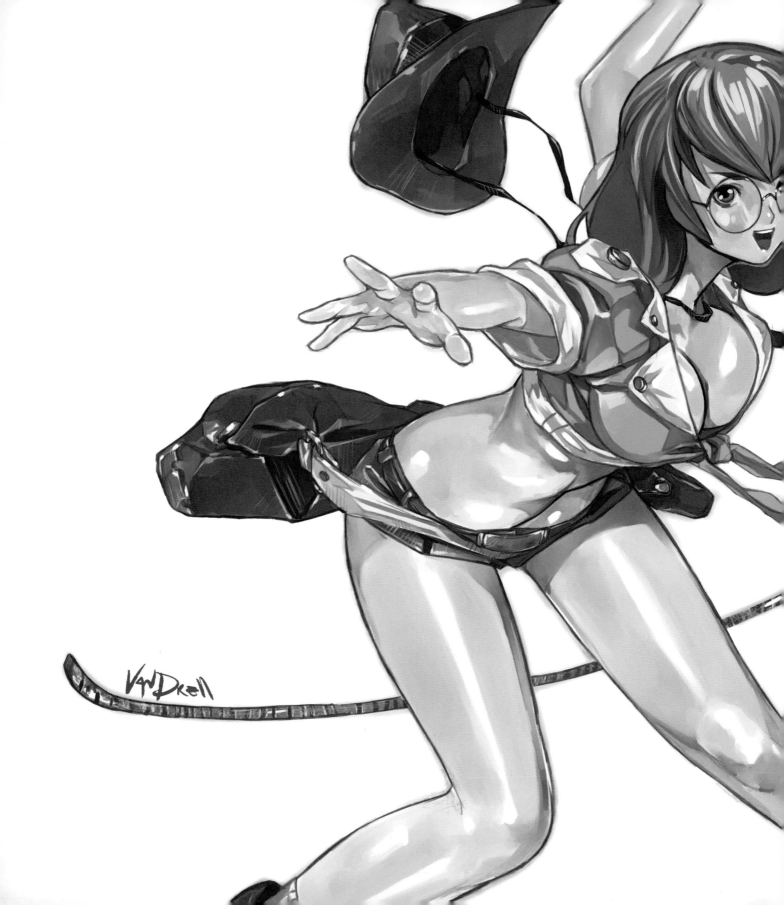

HEROINES

SCI-FI FUTURIST

Science fiction is yet another popular theme in manga. Hundreds of authors have opted to bet safe and choose to take their readers on journeys that explore new universes in futuristic settings. These stories are the perfect framework for depicting the kind of technological advances that are of great interest to the majority of manga readers. In this genre we may find space operas, gigantic robots, cyborgs, new dimensions, the exoticism of extraterrestrial beings and everything else that a mangaka can possibly think of. Girls play a major role in this genre, and in the future envisioned in manga, females are always beautiful and powerful.

1. Shape

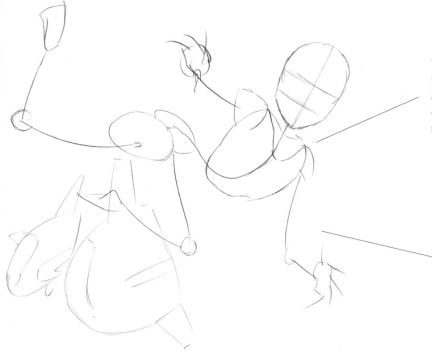

To create a scene that is truly different from our daily affairs, we should seek extraordinary moments, such as floating in space.

When a character is floating it is not necessary to worry about how we balance them or position them on the floor, which allows us to be a lot more creative with their body position.

2. Volume

To capture the sensation that our character is flying, we'll open her extremities slightly as if drawing a free-falling parachutist. We'll also sketch the basic geometric shapes of the ships appearing in the background.

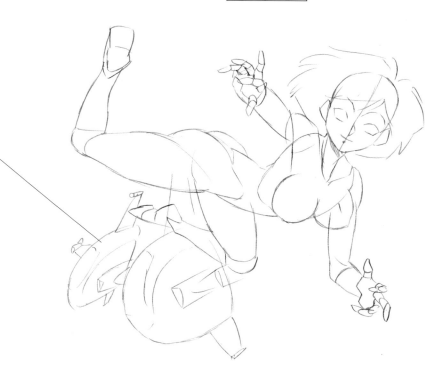

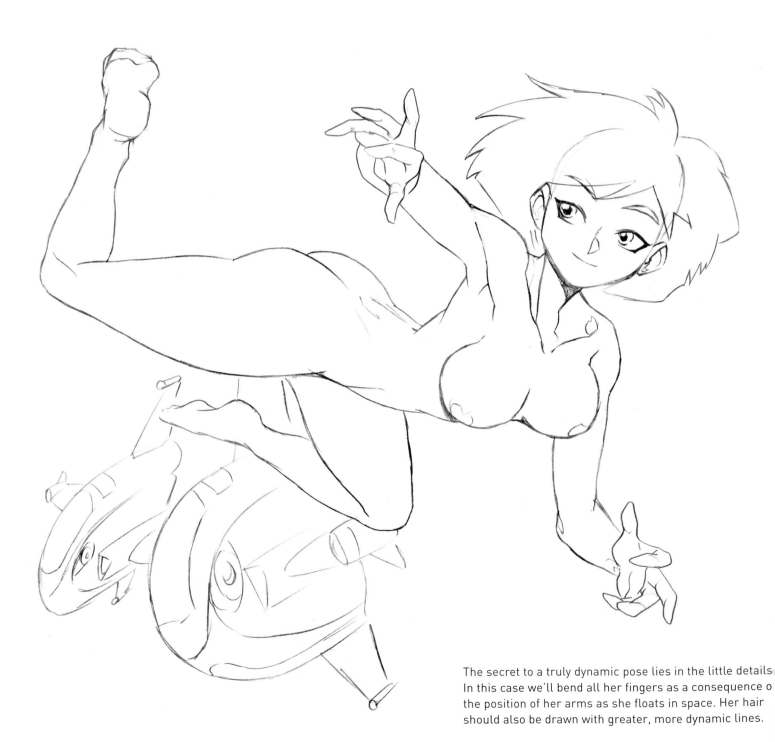

The secret to a truly dynamic pose lies in the little details
In this case we'll bend all her fingers as a consequence o
the position of her arms as she floats in space. Her hair
should also be drawn with greater, more dynamic lines.

It's time to bring our character to the future. Simple, tight-fitting clothes such as diving suits are usually a good place to begin when drawing space suits.

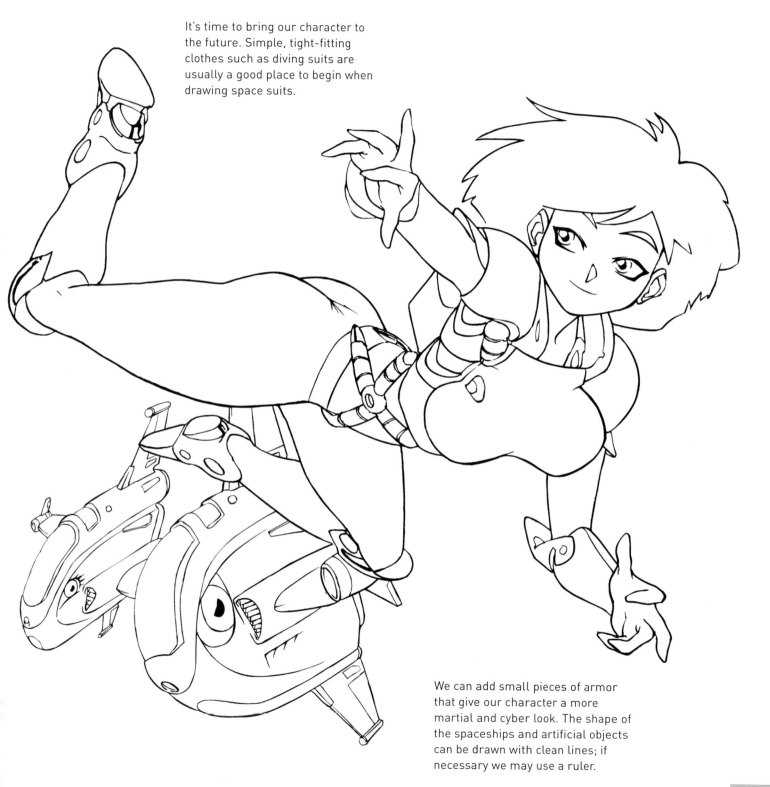

We can add small pieces of armor that give our character a more martial and cyber look. The shape of the spaceships and artificial objects can be drawn with clean lines; if necessary we may use a ruler.

Source of light

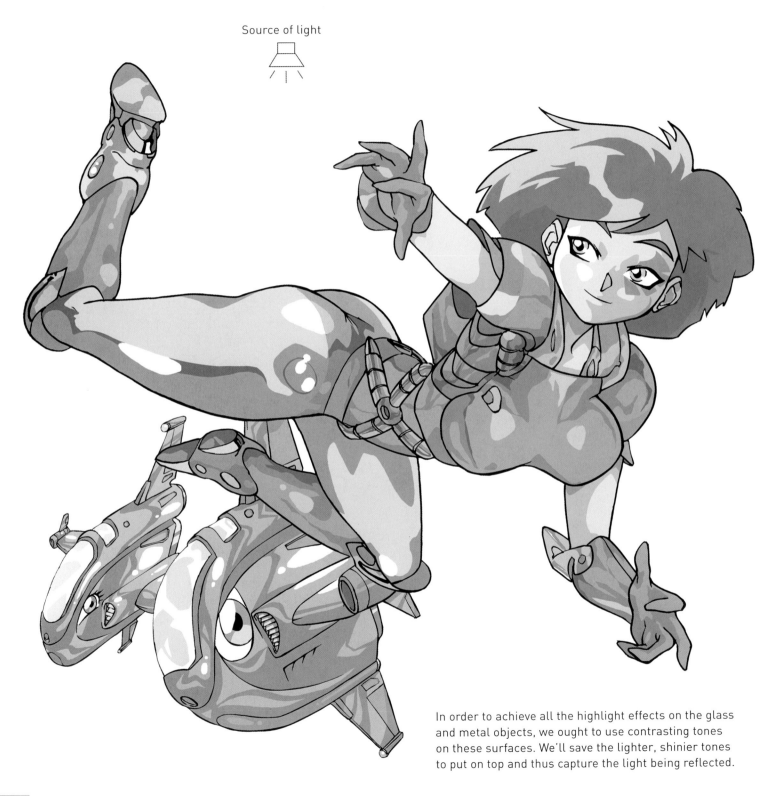

In order to achieve all the highlight effects on the glass and metal objects, we ought to use contrasting tones on these surfaces. We'll save the lighter, shinier tones to put on top and thus capture the light being reflected.

We can bring our character to the fantasy world with a fun and original chromatic combination. A realistic view of space, black and dark, can be unattractive or even dull for an illustration, so it's a good idea to add some color.

TSUNDERE

Tsundere is a Japanese term that is formed by the combination of two words: tsuntsun (cold, aggressive) and deredere (tender, affectionate). It is used to define people who at first glance seem very harsh and tough, but who later on prove to be friendly and perhaps even vulnerable. In manga the term is usually used to refer to female characters who assume a fighter or warrior-type role but, at the same time, are also adolescent girls coming to grips with the typical problems of their age. Thus, these are characters that a young female audience can relate to easily and really have no trouble sympathizing with.

A school girl beside her weapons, reading cell phone messages after a strange duel with a creature from another planet, makes for a nice tsundere image. We'll begin shaping her in a relaxed position, marking the various foreshortened areas.

2. Volume

Let's sketch the main elements that make up this illustration, such as the swords, pocketbook and cell phone. Let's also mark the volume of her hair and her facial features.

The most important anatomical elements in this drawing are her legs: robust but elegant, in a pose that is as natural as possible.

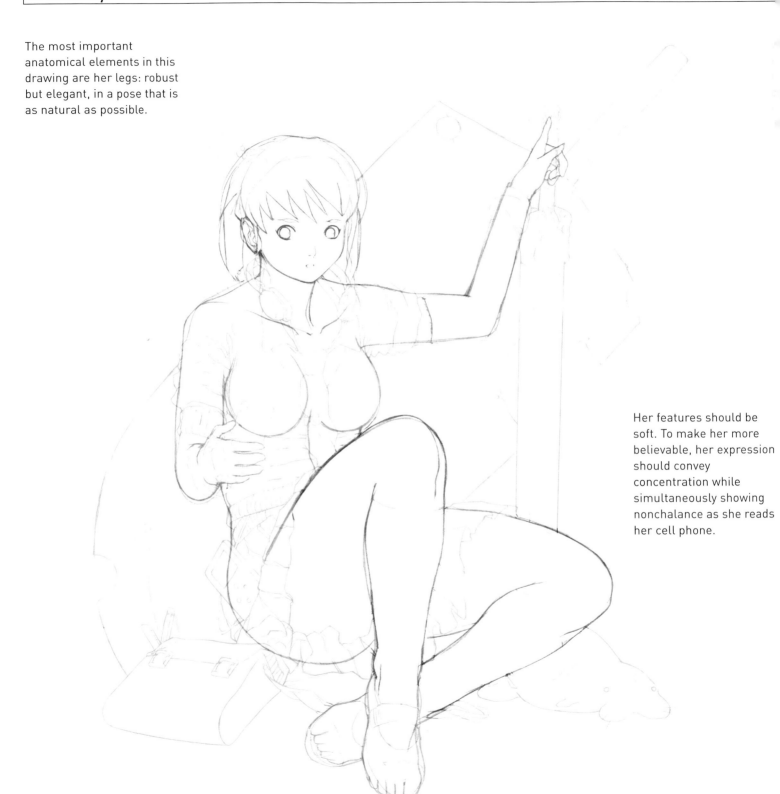

Her features should be soft. To make her more believable, her expression should convey concentration while simultaneously showing nonchalance as she reads her cell phone.

4. Clothes

We'll resort to all sorts of accessories, such as bracelets and a pocketbook to make her look more like an adolescent girl and contrast better with the weapons beside her.

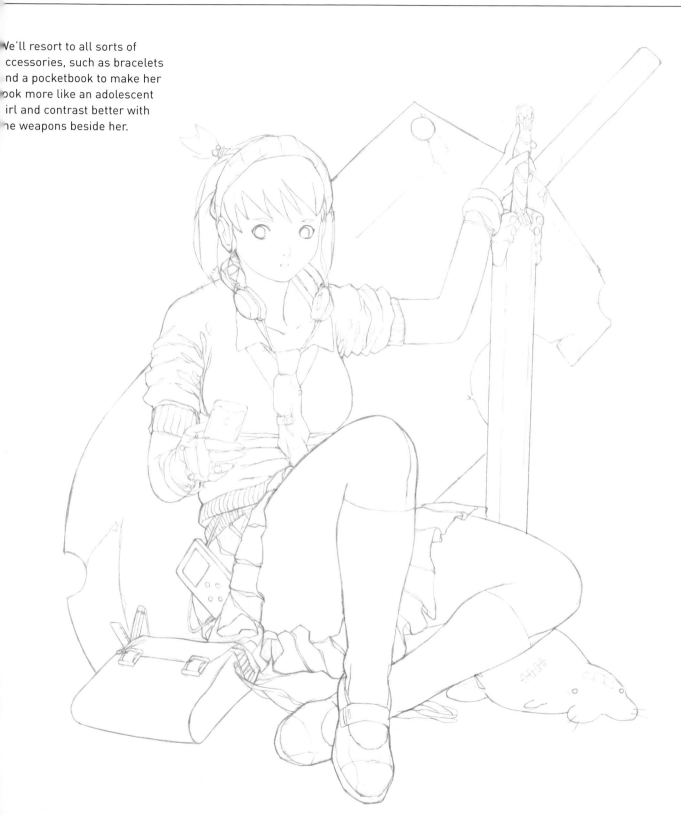

A relatively intense zenithal light will perfectly mark the volumes of the girl's body and her clothes.

Source of light

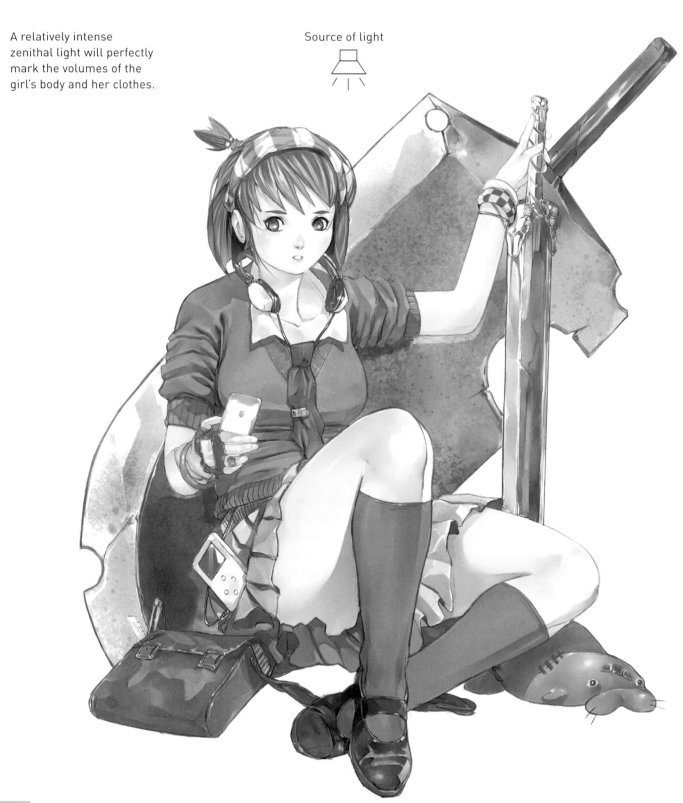

Realistic colors will make the image of the girl look more authentic. We'll use pastel colors to shape the various areas of the drawing.

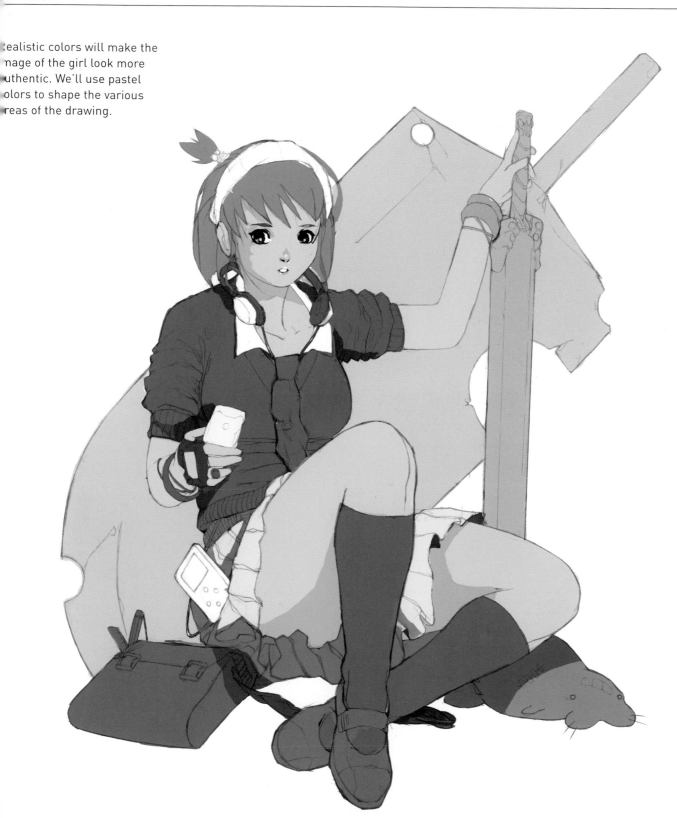

Let's go over the main shadows and wrinkles that form on her clothing. For the smaller sword we'll be using duller shades of the same color and add some light so it looks more like chrome.

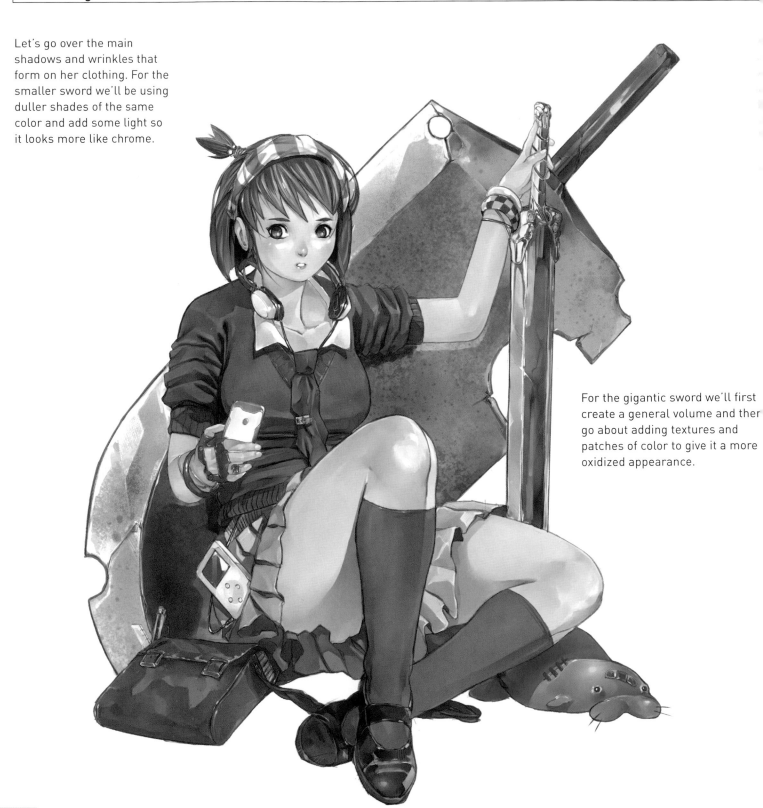

For the gigantic sword we'll first create a general volume and then go about adding textures and patches of color to give it a more oxidized appearance.

After supporting the scene with a shadow on the floor, we'll trim our heroine's silhouette and the elements in the foreground with soft lines in order to create layers of depth. Then we'll finish with some faded kanjis on the gigantic sword.

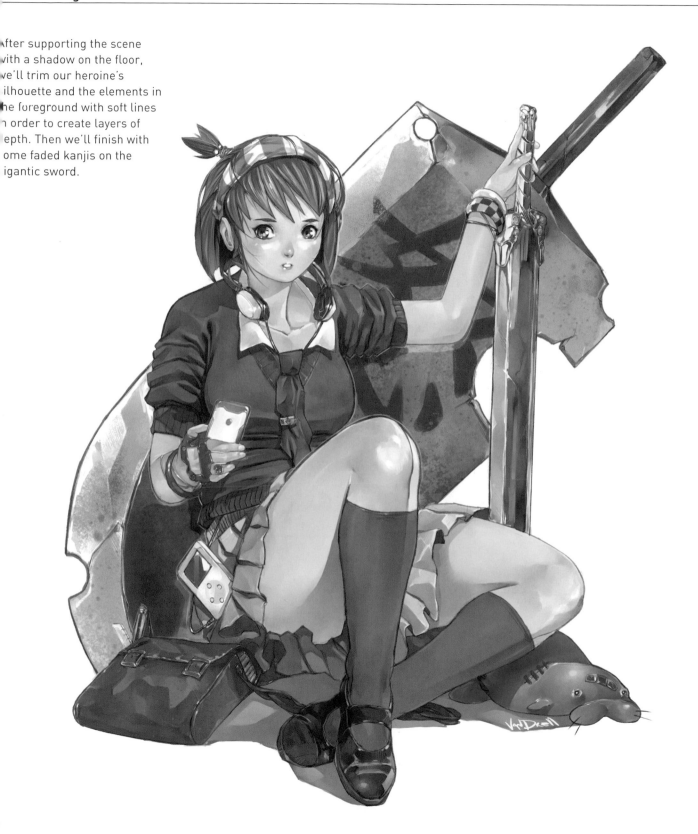

JOAN OF ARC

The samurai woman and what she represents for Oriental culture has its equivalent in the West in a character represented innumerable times in various mangas: the knight woman, in other words, the more or less trustworthy historical approximation of the Joan of Arc figure. Her indisputable beauty is somewhat overshadowed by the coarseness of her character and the mission this archetype engages in: fighting for ideals that are beyond everything, even her own image. So we'll distance ourselves from the idyllic mental picture that other characters might inspire us, and inch closer to the possible reality of a Middle Ages warrior, even if only in a manga context.

1. Shape

The important thing is to capture the character's movement and force, so we'll place her near the viewer. We'll carefully draw her foreshortened arms and legs to create a marked sensation of perspective and depth.

2. Volume

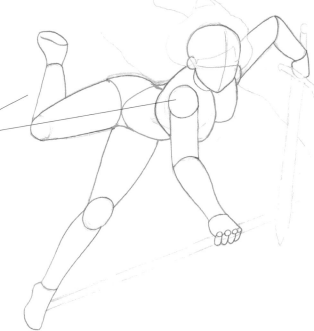

We'll give her arms and legs shape to create more depth in the illustration and begin to sketch elements that go along with the knight, such as the flag and weapons, as well as her hair.

In this illustration the previous steps are only for guidance. Now is when we should fully develop her pose (although her anatomy will later be hidden behind the armor).

Another elemental feature in this drawing is the heroine's face, which should have youthful but hard features as well as a serious and tenacious expression.

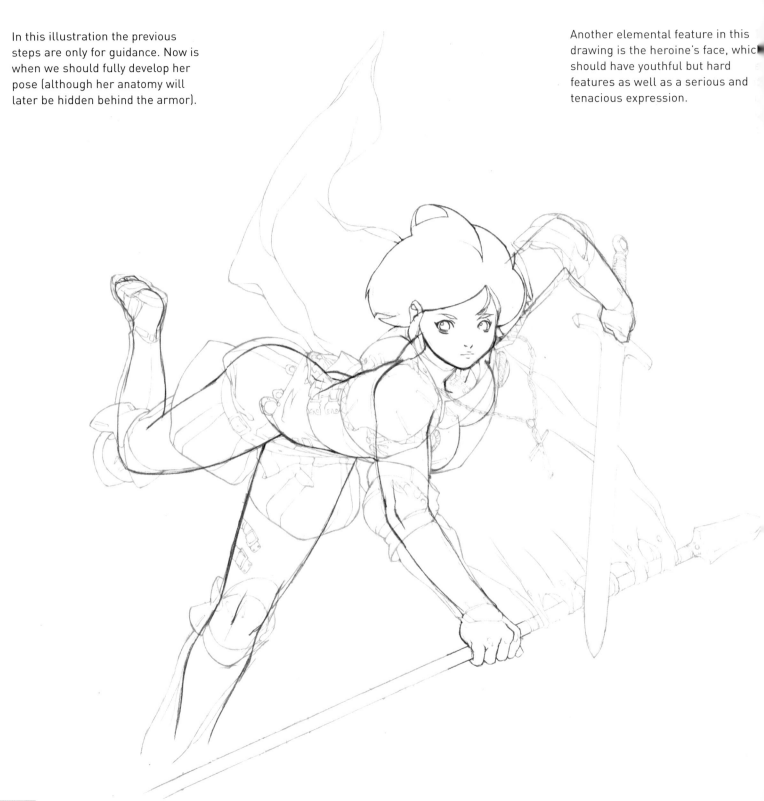

4. Clothes

This is the most interesting section since the warrior's armor should contain elements that identify her and make her unique. So we'll be giving her lots of details in the way of shoulder and elbow pads.

We can gather references to create more spectacular and fantastic armor or more realistic ones depending on what we intend on drawing.

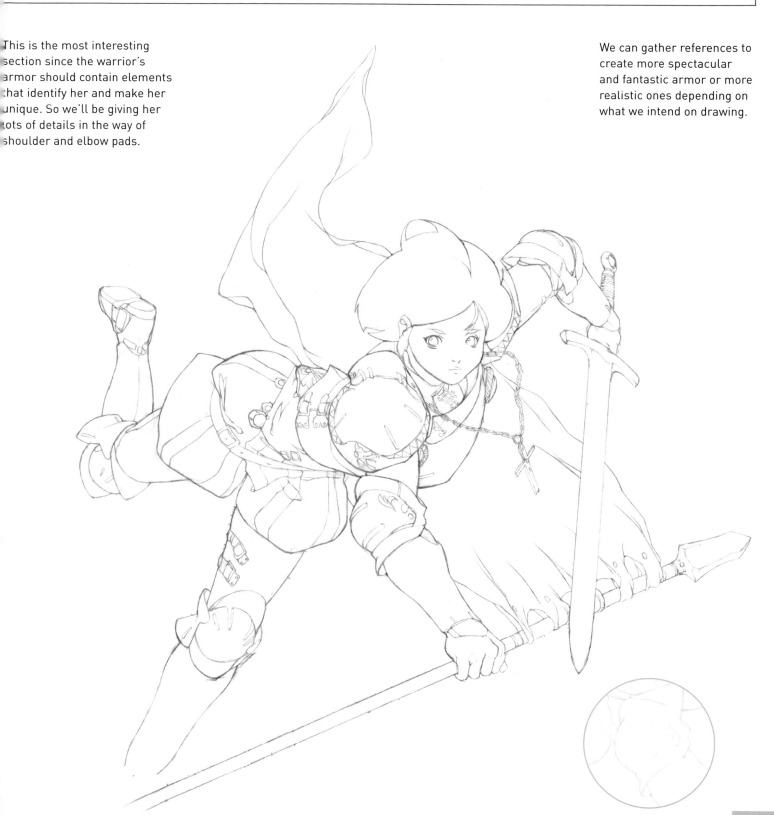

A frontal light source will be enough to amuse us. Lots of nuances in color allow us to create realistic armor and cape, and if we don't skimp on the variety of shades used we'll achieve, at the very least, attractive results.

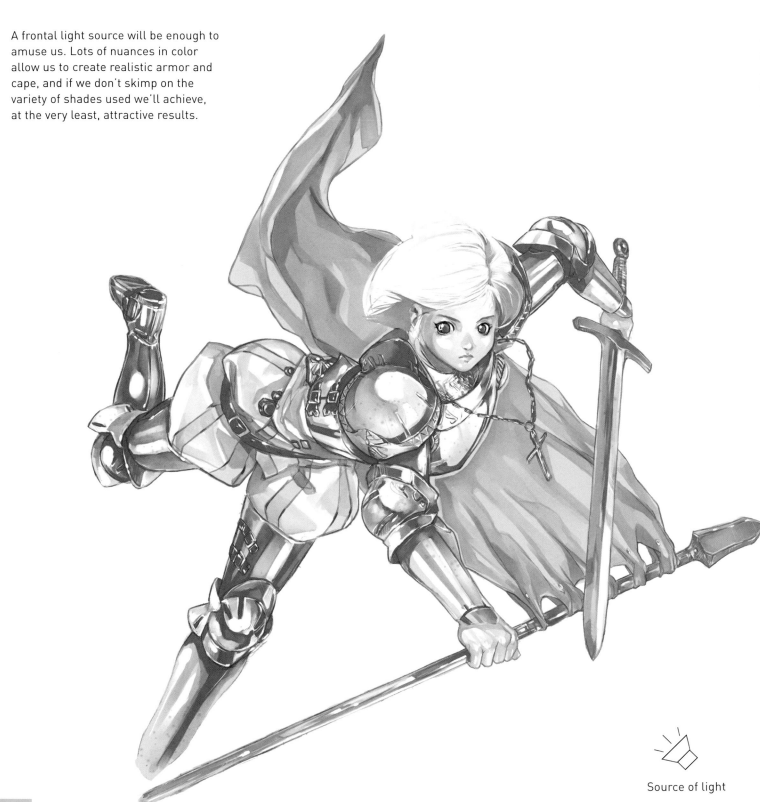

Source of light

6. Color

In this case we'll limit ourselves to establishing the flat colors for the majority of elements (we'll seek the lightest tones) and add the main lights on her armor to create a better metallic effect later on.

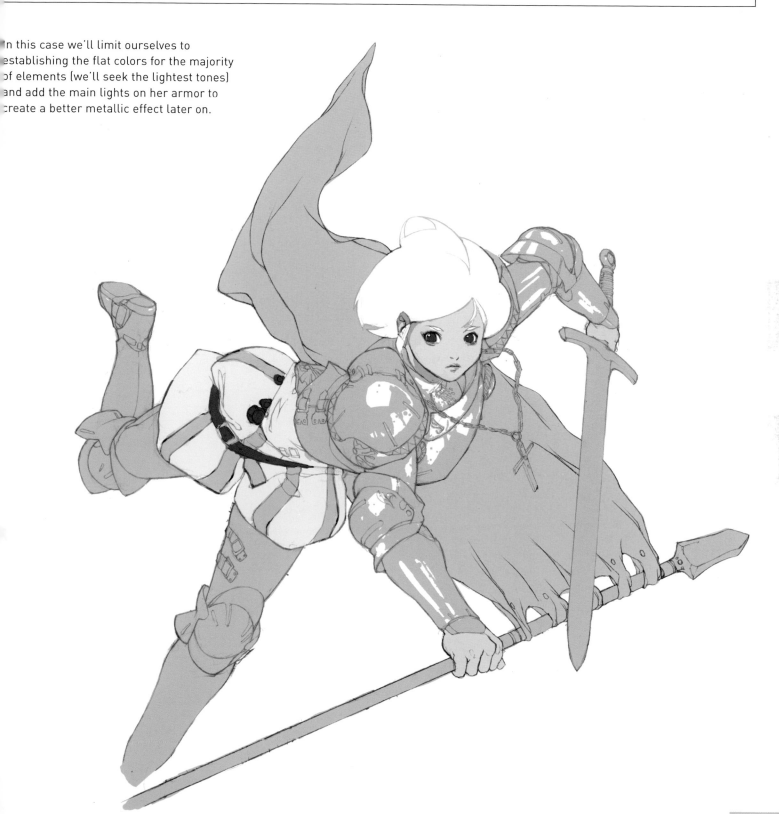

We'll combine the shaded tones of the armor without using colors that are too dark and we'll use lighter colors and white to go over the outlines of all the elements.

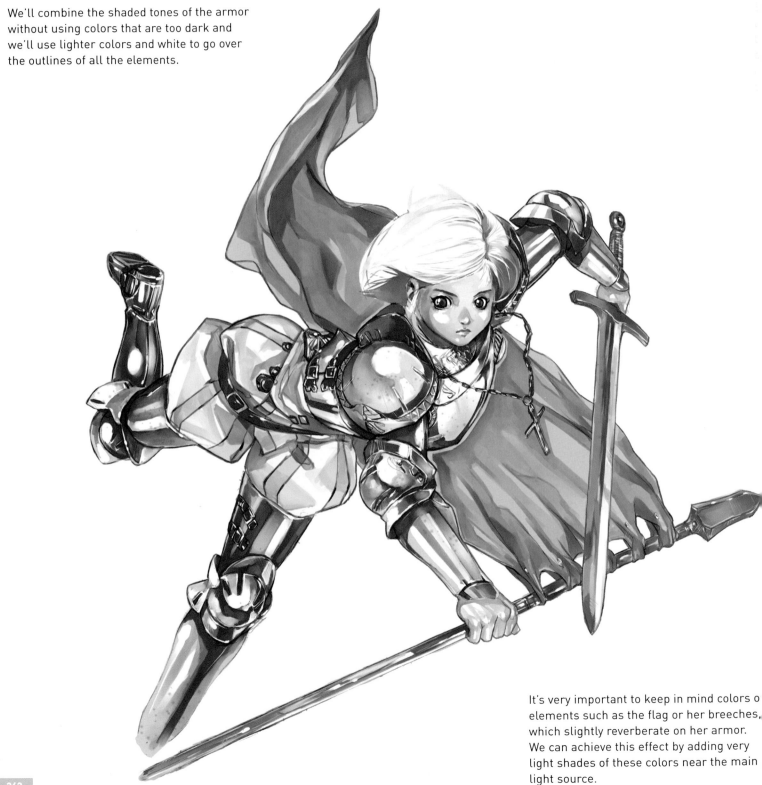

It's very important to keep in mind colors o elements such as the flag or her breeches, which slightly reverberate on her armor. We can achieve this effect by adding very light shades of these colors near the main light source.

Since the work we've done with the armor is quite complex already we'll do away with finishes such as backgrounds in favor of a more functional one that doesn't take protagonism away from our heroine.

We'll resort to a motif that alludes to the time of the warrior and strengthen some of the main elements such as her hair, face and front arm. In doing this we achieve the support necessary to create a proper sense of depth and volume.

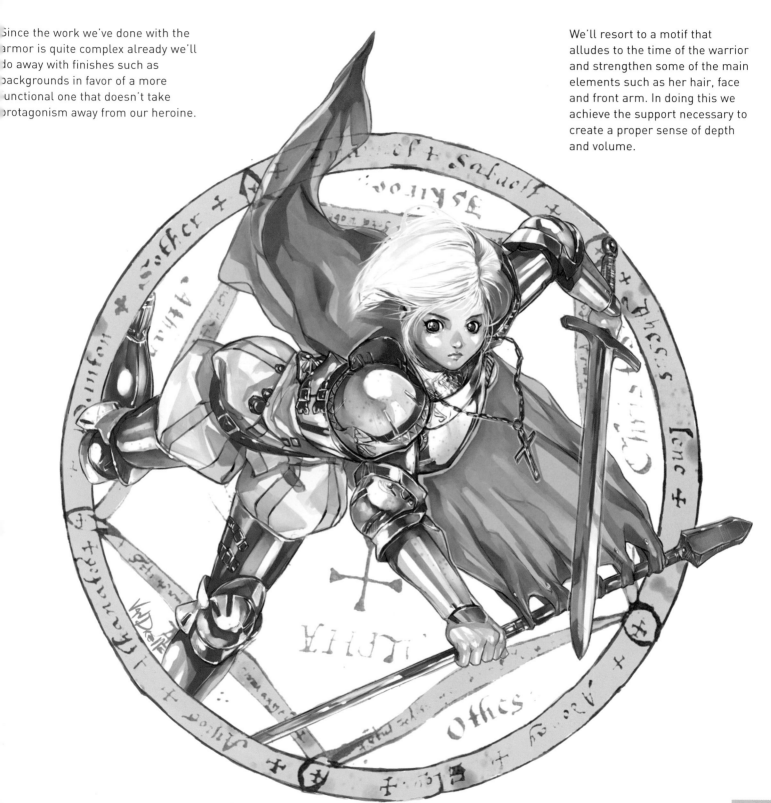

SAMURAI

Legends were born in the lands and forests of feudal Japan that still live on today. Some speak of real samurai warriors who fought in solitude against the warlords to defend just causes and raise the spirits of the people. People who spoke badly of them claimed they were traitors to society. Many assured that the most lethal samurais were women who, despite their frail appearance, were able to beat even the most hardened soldiers. Subtle and discreet, they brandished their swords with lightning speed. Neither manga nor popular Japanese story iconography can escape the influence of this charismatic character that is the foundation for the kind of corporate assassins that are in vogue today.

1. Shape

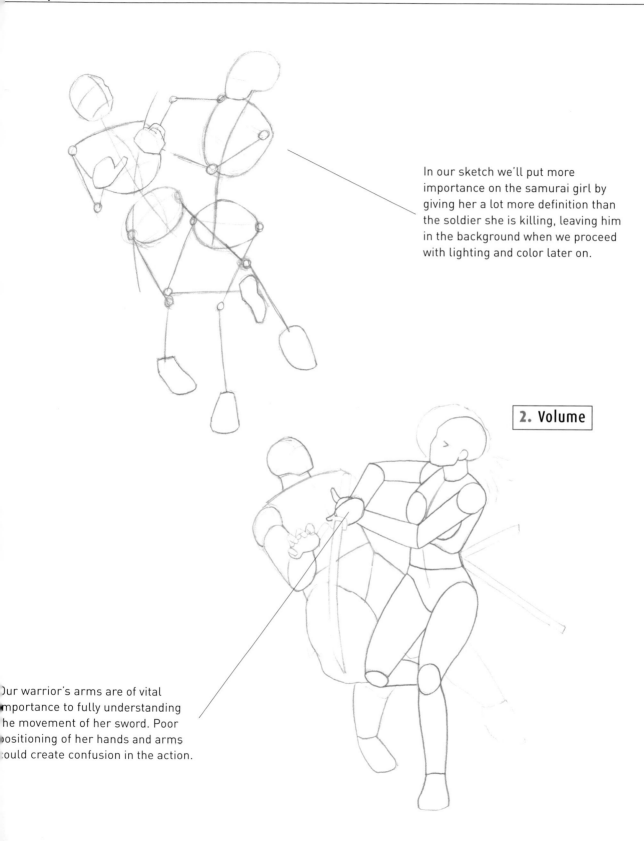

In our sketch we'll put more importance on the samurai girl by giving her a lot more definition than the soldier she is killing, leaving him in the background when we proceed with lighting and color later on.

2. Volume

Our warrior's arms are of vital importance to fully understanding the movement of her sword. Poor positioning of her hands and arms could create confusion in the action.

The girl's anatomy should indicate she is trained to kill. To achieve this we'll mark the muscles of her arms and give her an athletic look, as well as a tough, cold expression.

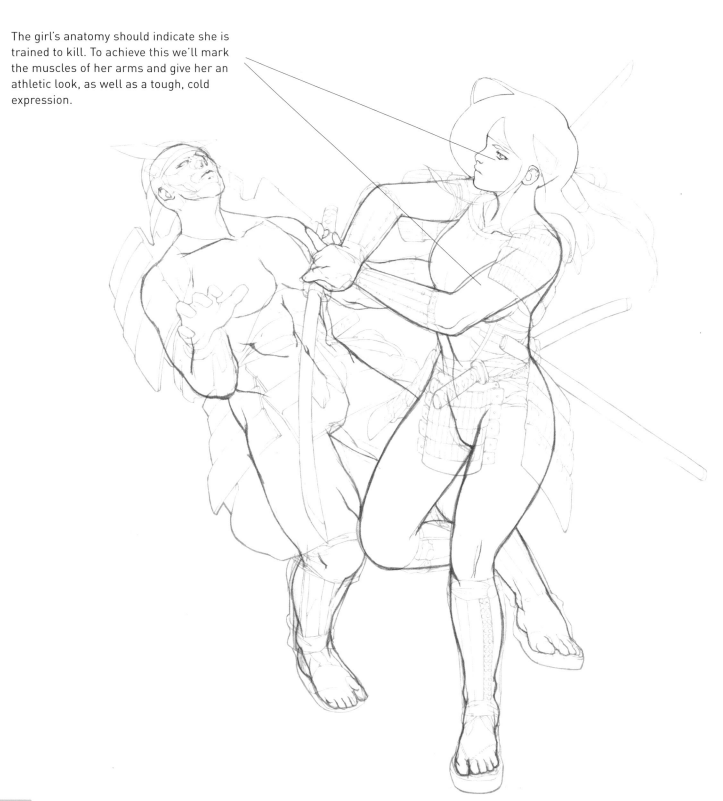

4. Clothes

We can guarantee the success of our
illustration by finding references from
the period for things like her armor,
clothing patterns and katana.

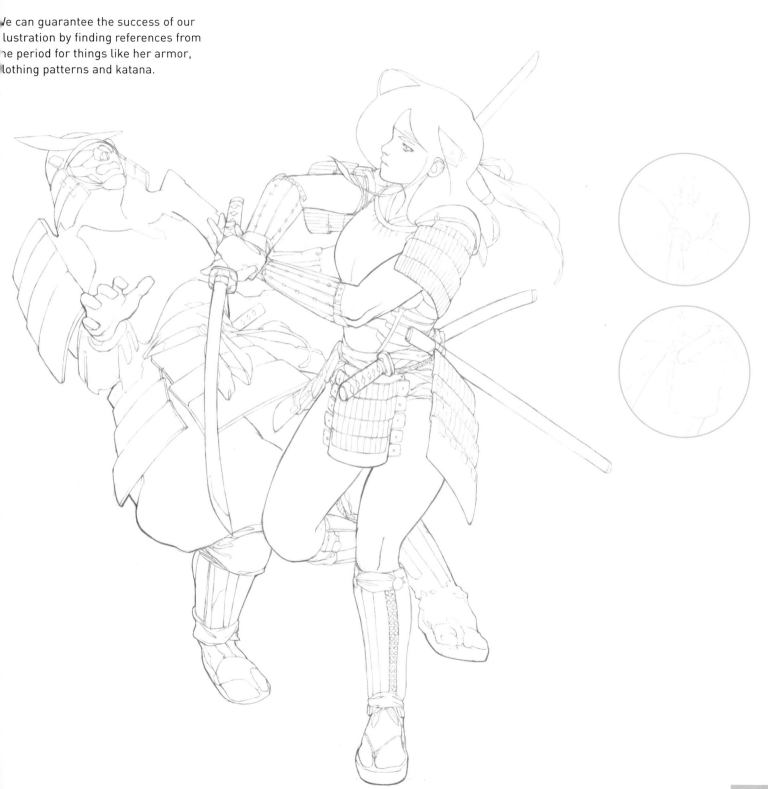

Source of light

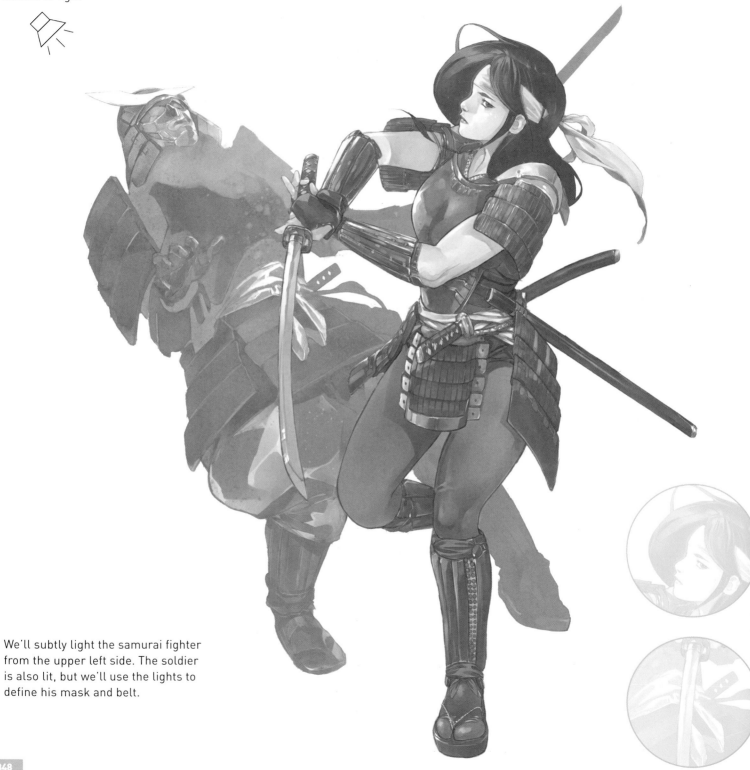

We'll subtly light the samurai fighter
from the upper left side. The soldier
is also lit, but we'll use the lights to
define his mask and belt.

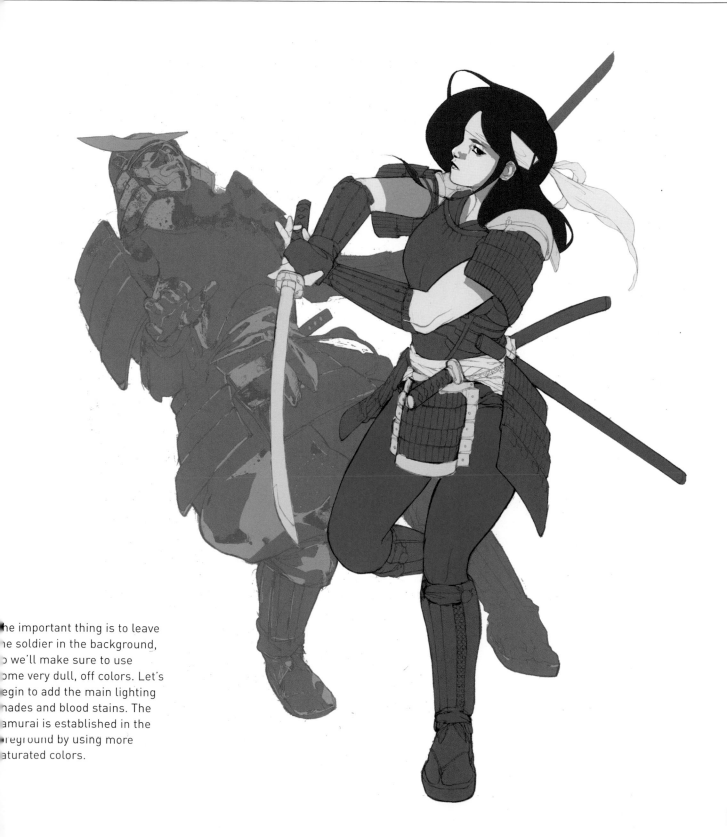

The important thing is to leave the soldier in the background, so we'll make sure to use some very dull, off colors. Let's begin to add the main lighting shades and blood stains. The samurai is established in the foreground by using more saturated colors.

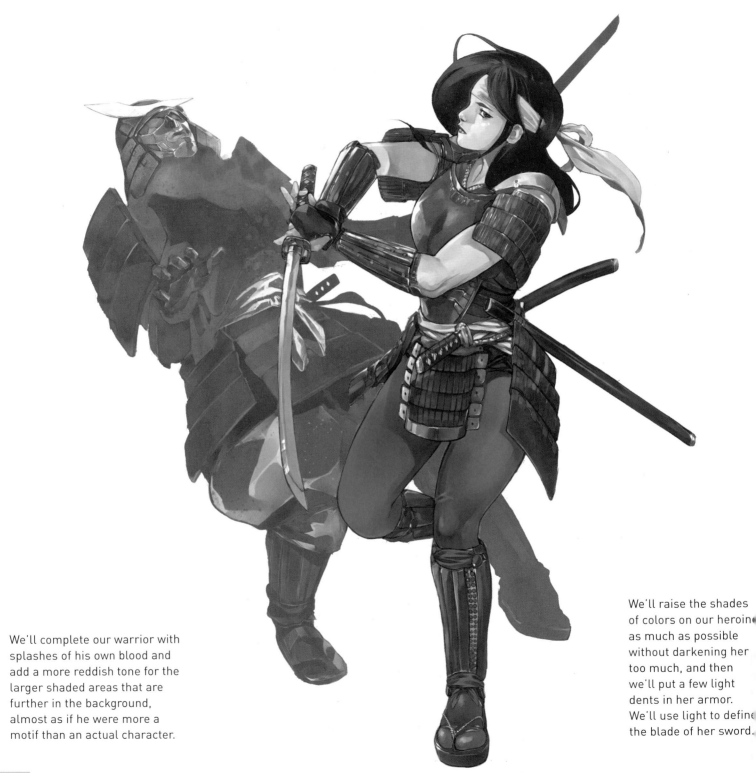

We'll complete our warrior with splashes of his own blood and add a more reddish tone for the larger shaded areas that are further in the background, almost as if he were more a motif than an actual character.

We'll raise the shades of colors on our heroine as much as possible without darkening her too much, and then we'll put a few light dents in her armor. We'll use light to define the blade of her sword.

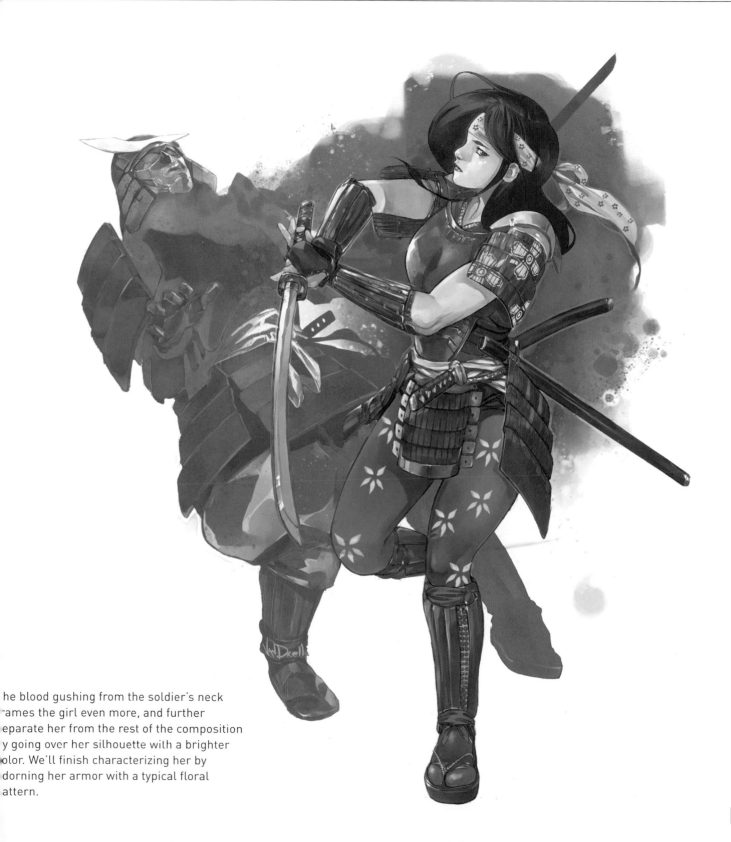

he blood gushing from the soldier's neck
ames the girl even more, and further
eparate her from the rest of the composition
y going over her silhouette with a brighter
olor. We'll finish characterizing her by
dorning her armor with a typical floral
attern.

COWGIRL

The wild west is a word ruled by men where you have to be quick on the draw; nonetheless, our character is without a doubt a top-notch heroine from head to toe. Unlike the Joan of Arc character, the cowgirl doesn't renounce her femininity. Quite the contrary, she uses it in her favor; she uses all the weapons within reach in order to achieve her objectives. She is of extraordinary beauty, and like any femme fatale, she's a woman with character who is always looking out for her best interests, although since she's a heroine, she doesn't believe in the Machiavelian dictum that the end justifies the means. In short, she's a hard woman prepared to face hard times.

1. Shape

This pose transmits the two-sided nature of our protagonist: on one side, her swaying hips bring out her more feminine side; on the other, we see her head's defiant gesture with revolver in hand. The lines marking her shoulders and hips are also important.

2. Volume

Next we'll define her anatomical attributes and sketch the elements that complete her clothing, such as her hat and bag.

We must make sure we capture the naturalness with which our character moves. When drawing her legs we should think about the heels on her boots and define her proportions correctly. The smooth lines of her neck and shoulders emphasize her sensual body.

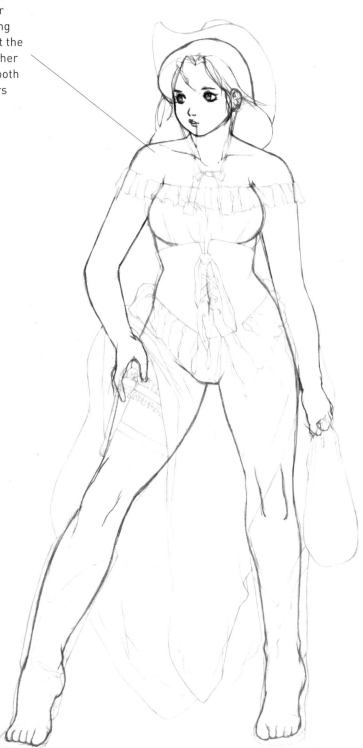

It's very important not to be skimpy when drawing details on her clothing. The wrinkles and folds give her more presence, and the boots and corset succeed in putting our heroine into an historical context.

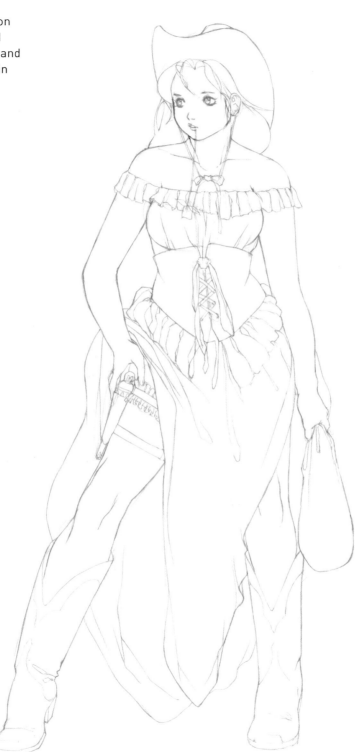

All shadows are projected from a single natural light source and are concentrated on the lower part of objects, particularly her clothes. The inner part will have its own range of colors to help establish a sense of greater depth.

Source of light

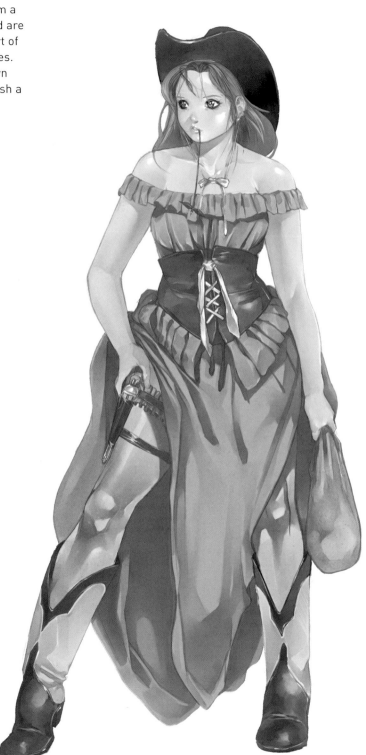

We'll use earth colors to give the illustration the dustiness that is typical of the wild west, and then go over her clothing and her tanned skin. We'll mark the primary shadows of the elements in the drawing, especially those on her skin and clothing.

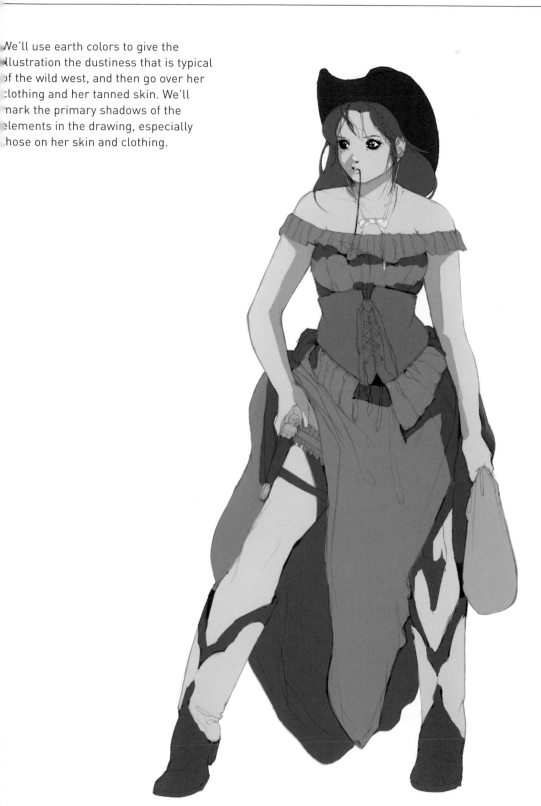

We'll add effects like splashes and the texture of her sack and then lend volume to her boots with patches of color, but without defining them too much so that they look worn. We'll also create the typography in the background which decorates our illustration.

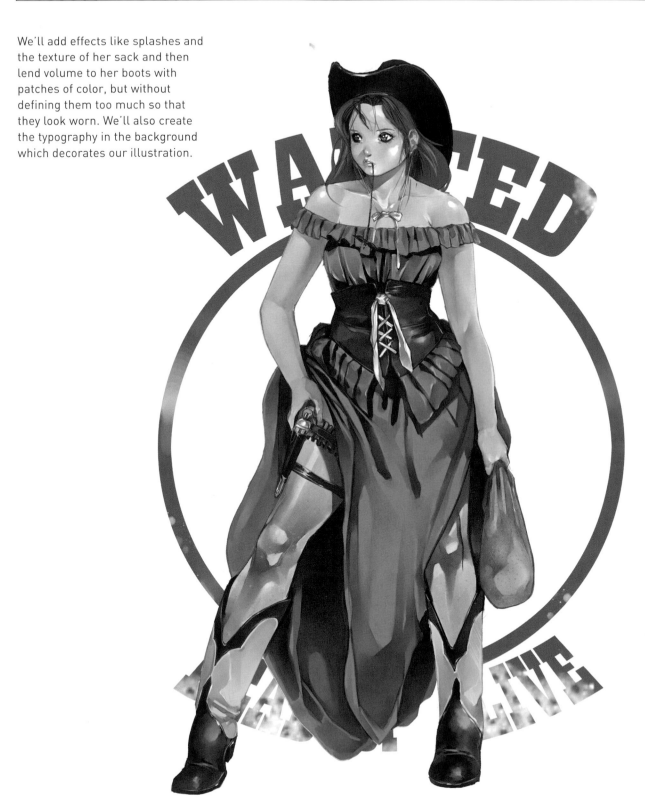

We'll draw decorative motifs on her corset and boots. We'll treat the background typography with splashes of color and textures, while adding some glare so it looks like it is behind our figure.

Lastly, we'll use patches of color to shape bullet holes. This little detail gives our illustration its final wild west touch.

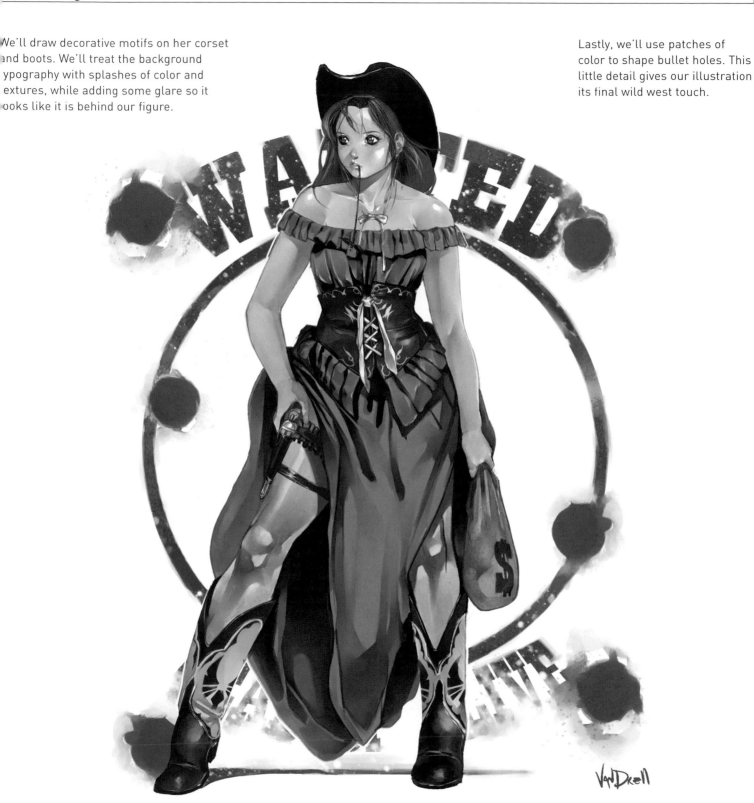

ADVENTURESS

It hasn't been long since the figure of the courageous contemporary adventurer woman reached the West. However, in manga this character has always enjoyed a special place. This highly sensual woman who is equally charismatic and able, capable of overcoming adversities and on many occasions with far more success than her male counterparts (who in these kinds of stories only serve as filler material), has known how to capture the attention of a broad area of the public: from boys who are anxious to see their heroine move her curves, to girls who see her as much more than just an object of desire, and view her as an icon they can identify with.

1. Shape

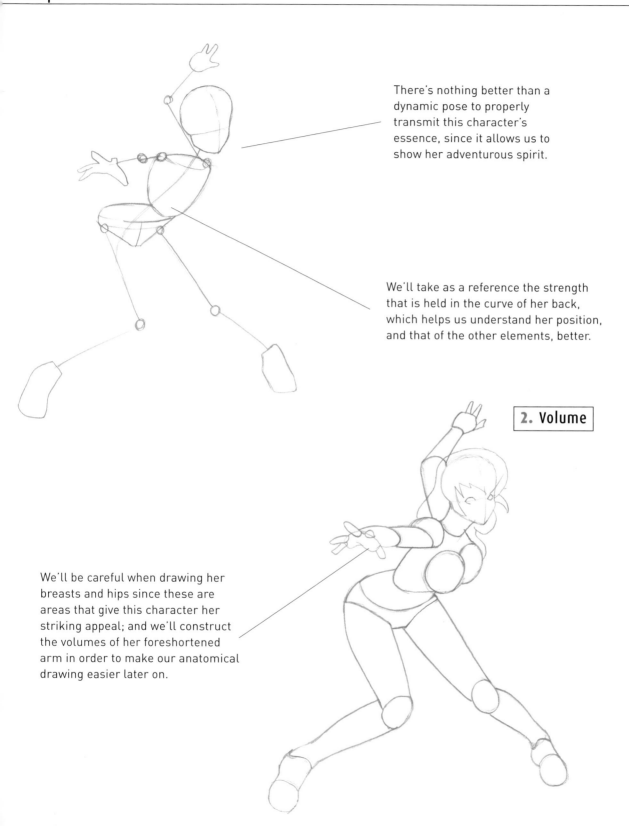

There's nothing better than a dynamic pose to properly transmit this character's essence, since it allows us to show her adventurous spirit.

We'll take as a reference the strength that is held in the curve of her back, which helps us understand her position, and that of the other elements, better.

2. Volume

We'll be careful when drawing her breasts and hips since these are areas that give this character her striking appeal; and we'll construct the volumes of her foreshortened arm in order to make our anatomical drawing easier later on.

This is perhaps the most relevant step. We'll define her body with clean, but dynamic, lines that help reinforce her movement without taking away from her attraction. Then we'll give her some rudimentary facial features.

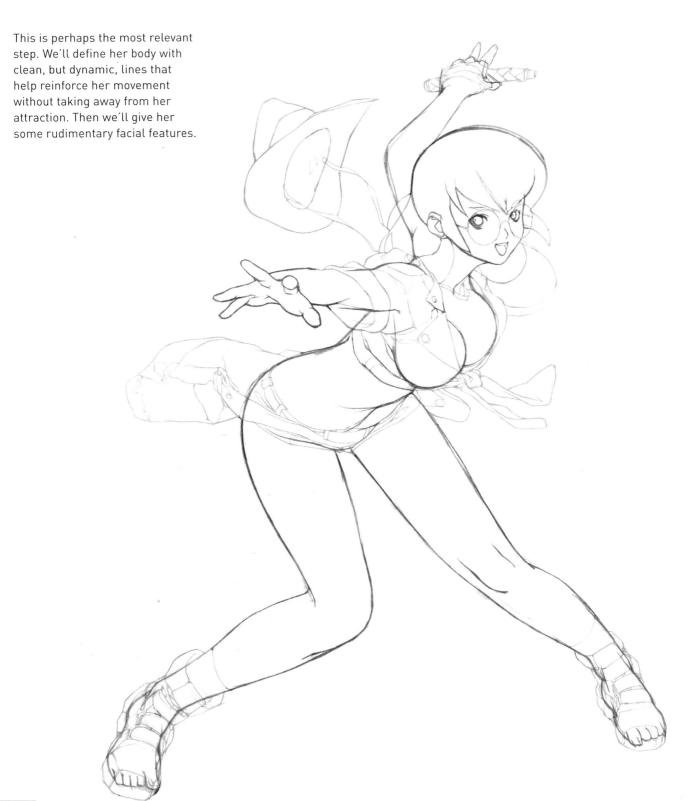

Her clothes depend on her gesture and the movement we are trying to capture. For this reason, other than the more rigid elements (such as her boots), the remaining accessories should emit strength and speed.

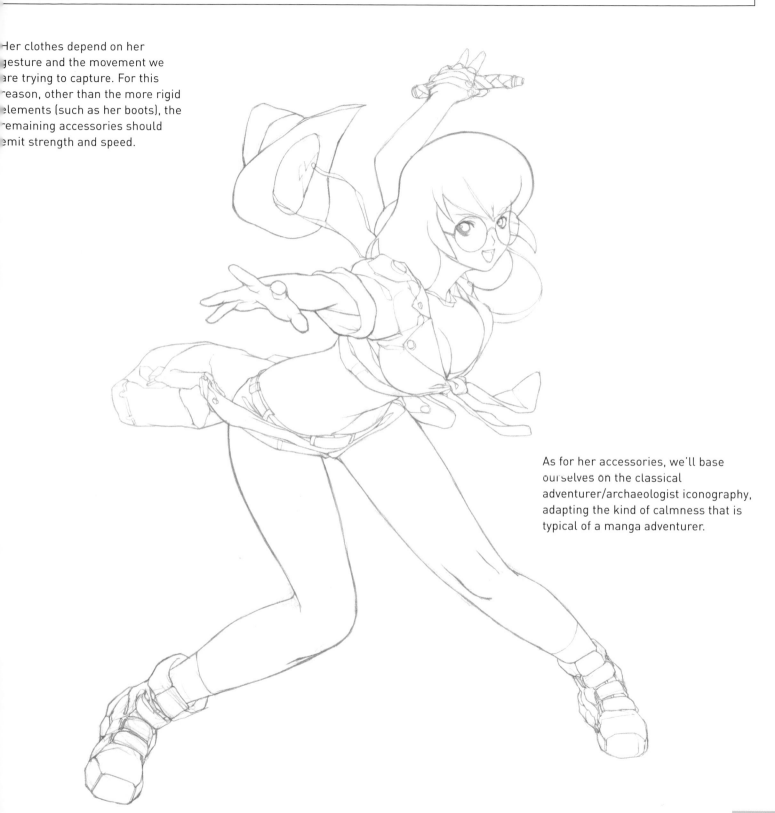

As for her accessories, we'll base ourselves on the classical adventurer/archaeologist iconography, adapting the kind of calmness that is typical of a manga adventurer.

The main light focus, located halfway between frontal and zenithal, allows us to focus on details such as her skin and the shadow she projects over herself, while helping to give her pose better depth.

Source of light

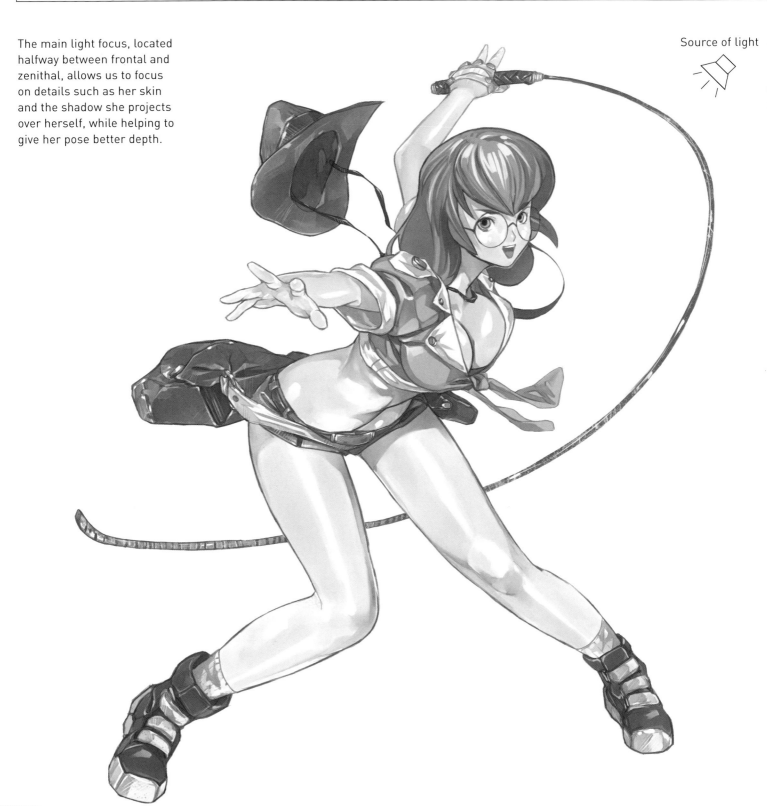

She's a manga adventurer and we can lend her her own special personality by selecting the color of her hair and jacket, which has nothing in common with your typical leather one. Continuing the lighting scheme, we'll then mark the main shaded areas.

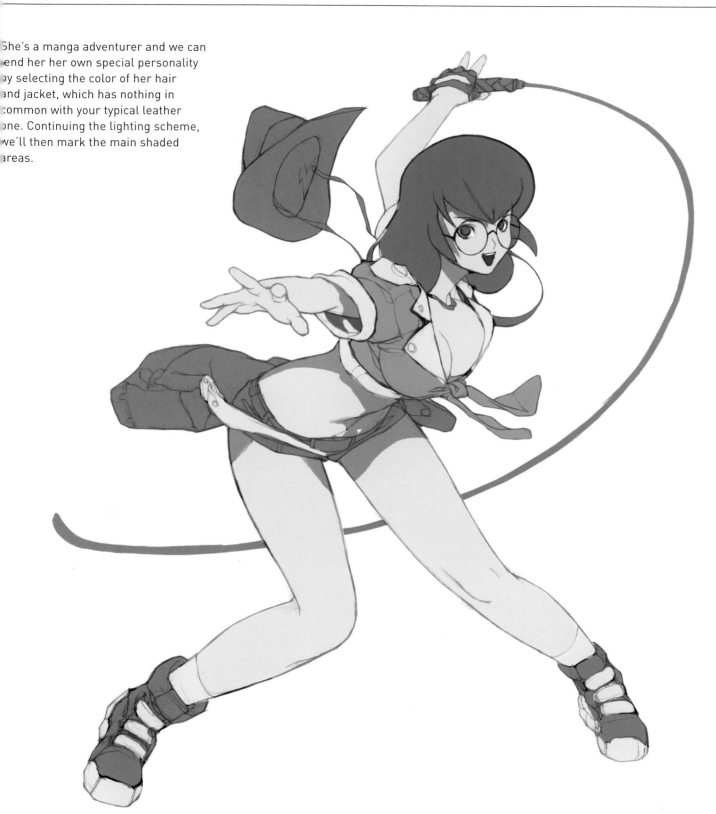

In this step we'll be completing the majority of the elements in the illustration. We'll leave some white areas for her legs and breasts to accentuate the action and create the sensation that she is sweating, and we'll create volume by adding darker shades to the various shaded areas.

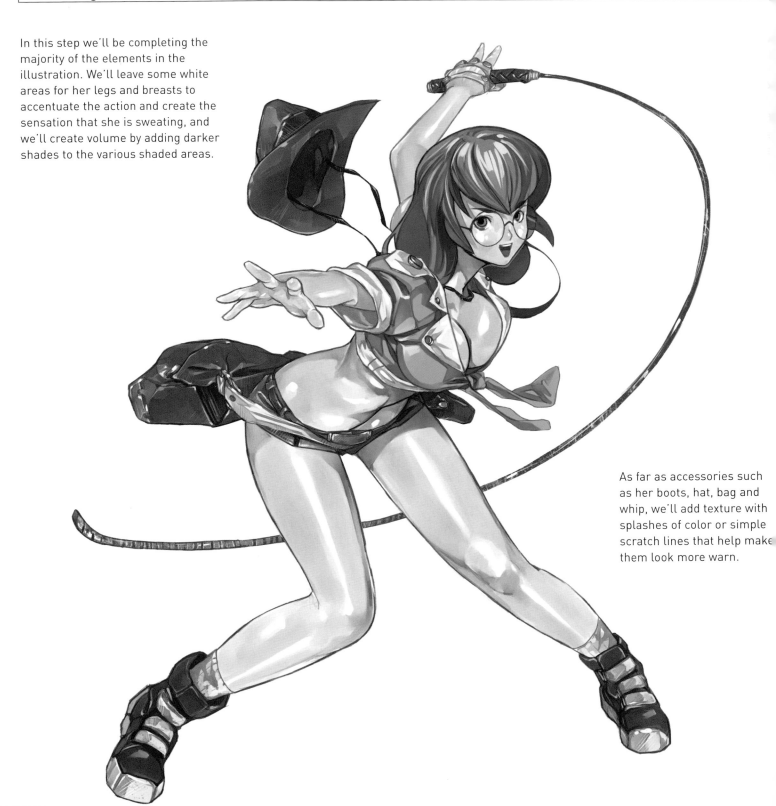

As far as accessories such as her boots, hat, bag and whip, we'll add texture with splashes of color or simple scratch lines that help make them look more warn.

We'll give the final touch to the lighting by using light colors on her glasses and face in general. Although this is a simple illustration, with a straight-forward presentation, it is strengthened by elements such as the shadow on the floor and the light orange halo.

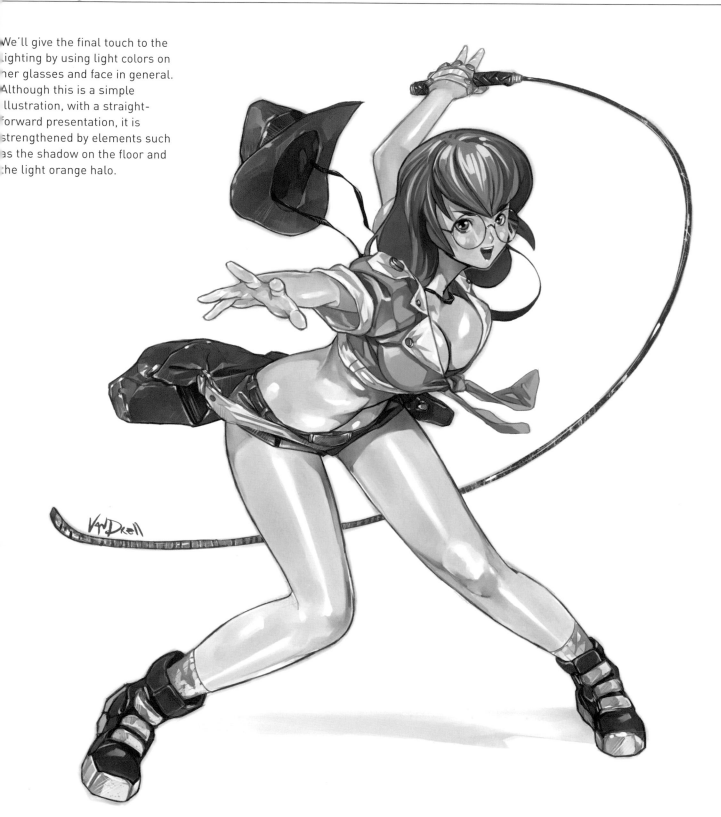

VALKYRIA

The perfect combination of almost divine beauty and strength make the Valkyria an easily recognizable character within the extensive gallery of heroines who inhabit the world of manga. Unlike the original Valkyrie who were mostly robust and not very feminine in their appearance, the image of the figure we've come to see and expect in manga has proved to be a true symbiosis of delicacy and heroism. With long platinum blonde hair that is as shiny as their shining armor, they are at the same time the most epic and romantic heroines around, and can represent a shonen as well as a shojo: they are our fantasy heroines par excellence.

1. Shape

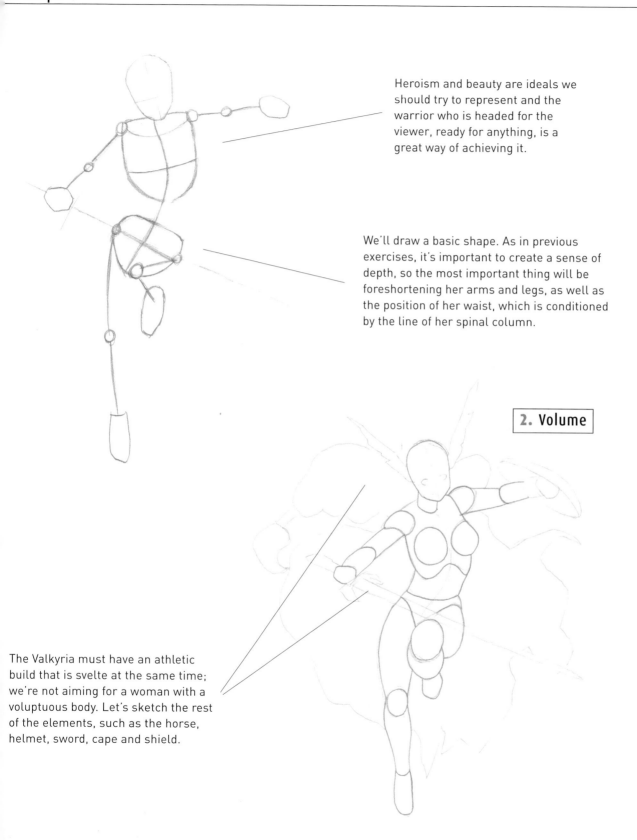

Heroism and beauty are ideals we should try to represent and the warrior who is headed for the viewer, ready for anything, is a great way of achieving it.

We'll draw a basic shape. As in previous exercises, it's important to create a sense of depth, so the most important thing will be foreshortening her arms and legs, as well as the position of her waist, which is conditioned by the line of her spinal column.

2. Volume

The Valkyria must have an athletic build that is svelte at the same time; we're not aiming for a woman with a voluptuous body. Let's sketch the rest of the elements, such as the horse, helmet, sword, cape and shield.

For her face we'll be seeking a middle ground with large, but not exaggerated, eyes, and with her hair flying in accord with her movement. We'll finish defining the visible parts of her anatomy without making her overly muscular.

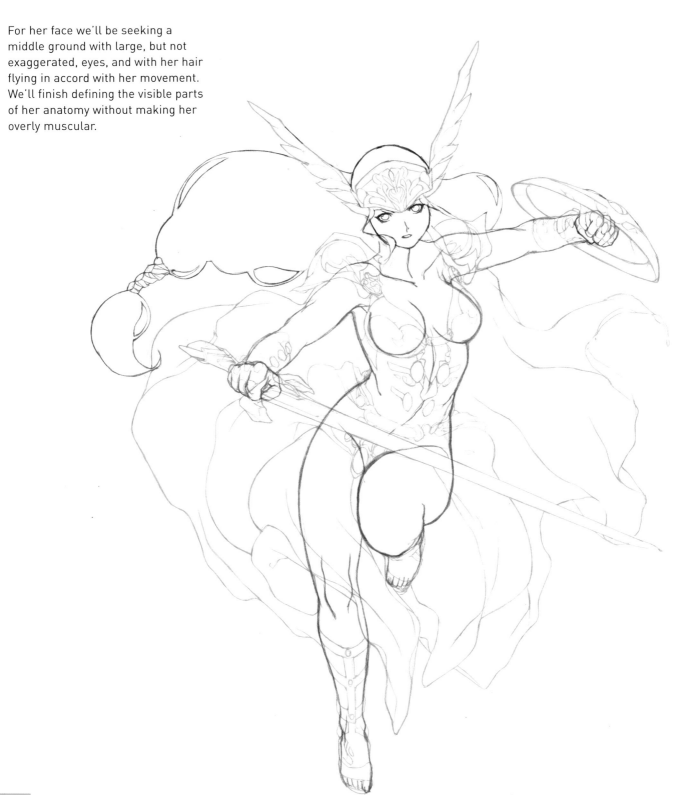

4. Clothes

She's a fantasy warrior with all her splendor, so it's not smart to skimp on the details when drawing her armor. We can look for motifs that allude to mythology.

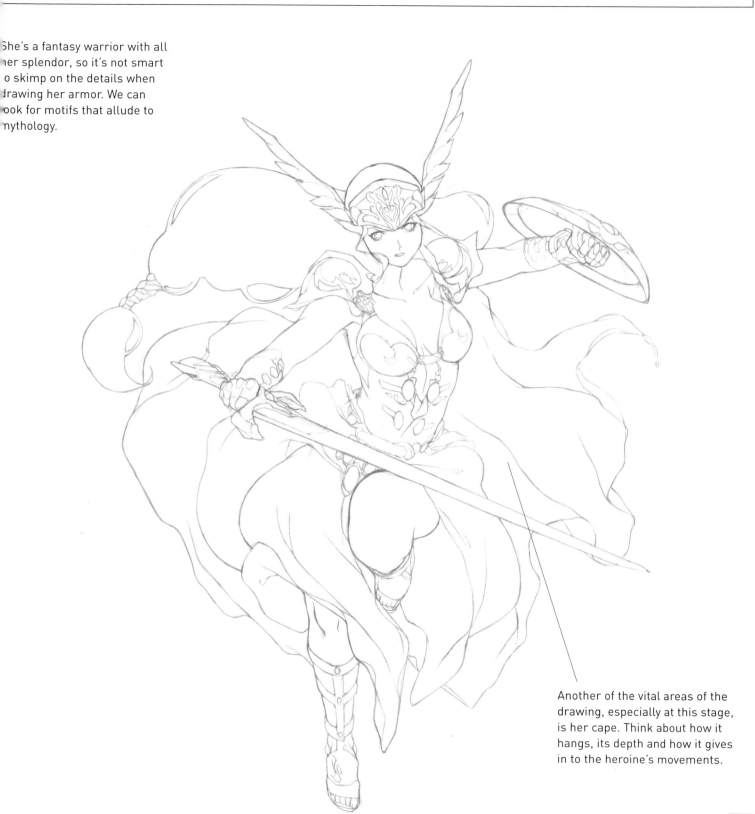

Another of the vital areas of the drawing, especially at this stage, is her cape. Think about how it hangs, its depth and how it gives in to the heroine's movements.

Here we have natural lighting
where the shadows are
projected on the lower areas of
objects. When painting we
should focus on the chrome
areas of her armor.

Source of light

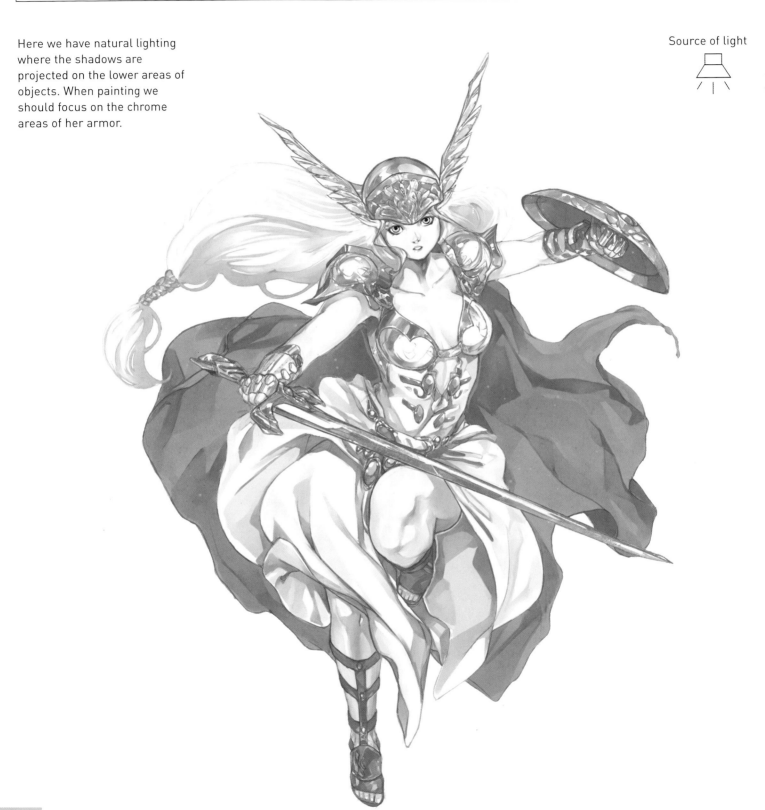

We'll color our protagonist with pastels that are not especially saturated, except for the cape which, as we increase the color of the other objects, will be left in the background without losing any of its impact.

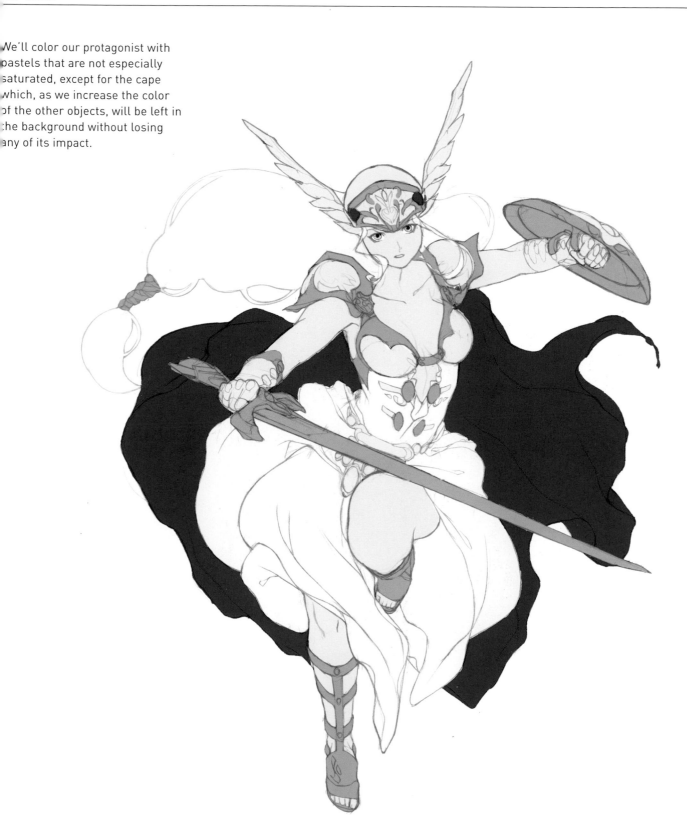

When painting her armor we must especially think about how it affects the other objects, how it reflects on her skin, hair and outfit.

We can keep the cape in the background by making sure not to add reflections of the cape on the metal. We can reinforce this sensation by using light red to mark the Valkyria's contours over her cape. Then we can use darker lines when shading her hair.

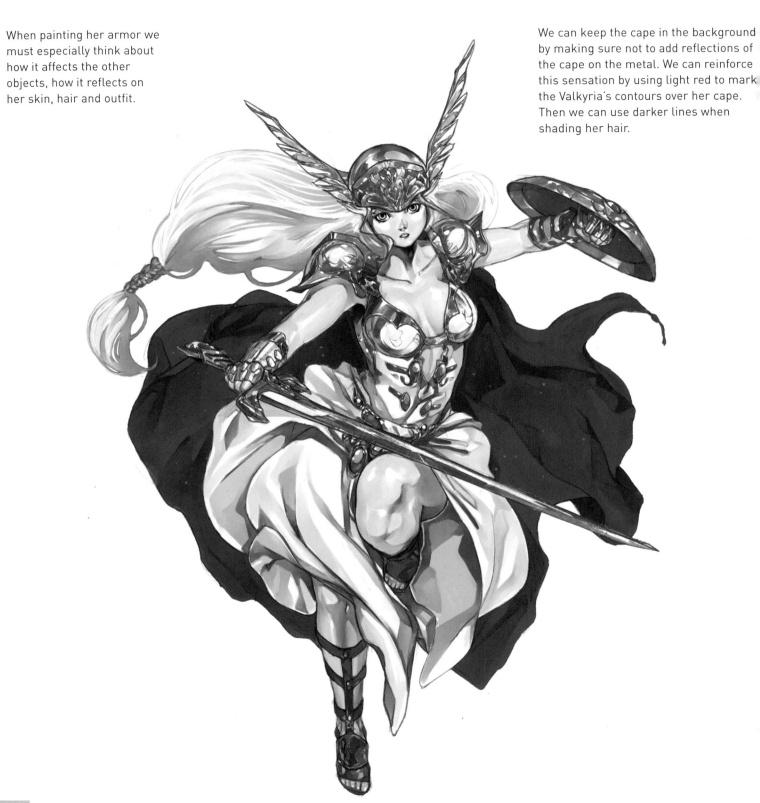

We can gain movement by painting a red border and then using a dappling effect around the Valkyria. Once again, we'll use contour lines for her arm and sword.

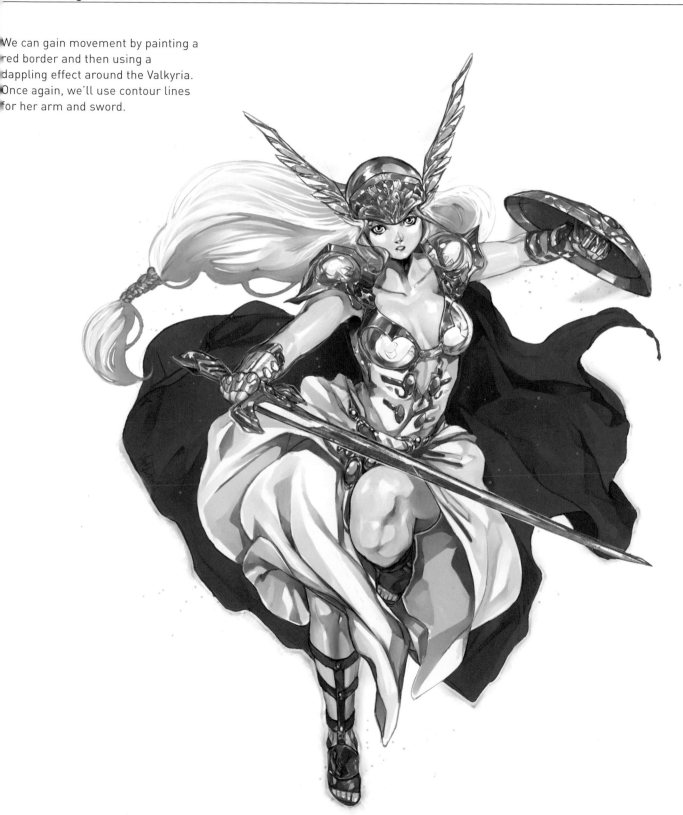

PREHISTORIC

The famous image of the sexy woman surrounded by dinosaurs is easily known by everyone thanks to their widespread portrayal in the world of cinema during the mid-seventies, when suggestive posters of cavewomen proliferated as advertisements for films all over the world. Manga is no stranger to the influence of this prehistoric female archetype, although in its pages this character is almost always joined by a distinct sense of humor. Brute dinosaurs, which are at the same time funny, and heroic feminine characters, which although simple and somewhat silly, always end up being amusing, and in this case also prove to be sensual and attractive.

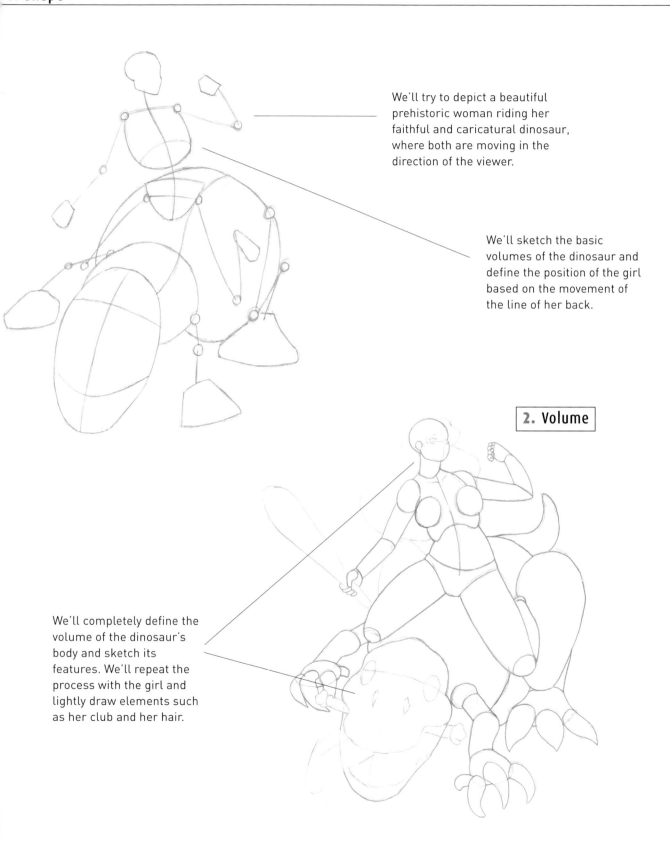

1. Shape

We'll try to depict a beautiful prehistoric woman riding her faithful and caricatural dinosaur, where both are moving in the direction of the viewer.

We'll sketch the basic volumes of the dinosaur and define the position of the girl based on the movement of the line of her back.

2. Volume

We'll completely define the volume of the dinosaur's body and sketch its features. We'll repeat the process with the girl and lightly draw elements such as her club and her hair.

This is one of the more revealing aspects of this drawing since both the girl and the dinosaur are characters who barely wear any accessories.

The girl should have a strong build while being extremely attractive, and her expression should simultaneously express surprise and ingenuousness. As for the dinosaur, its face is the most important thing, and it should be halfway between realistic and caricatural.

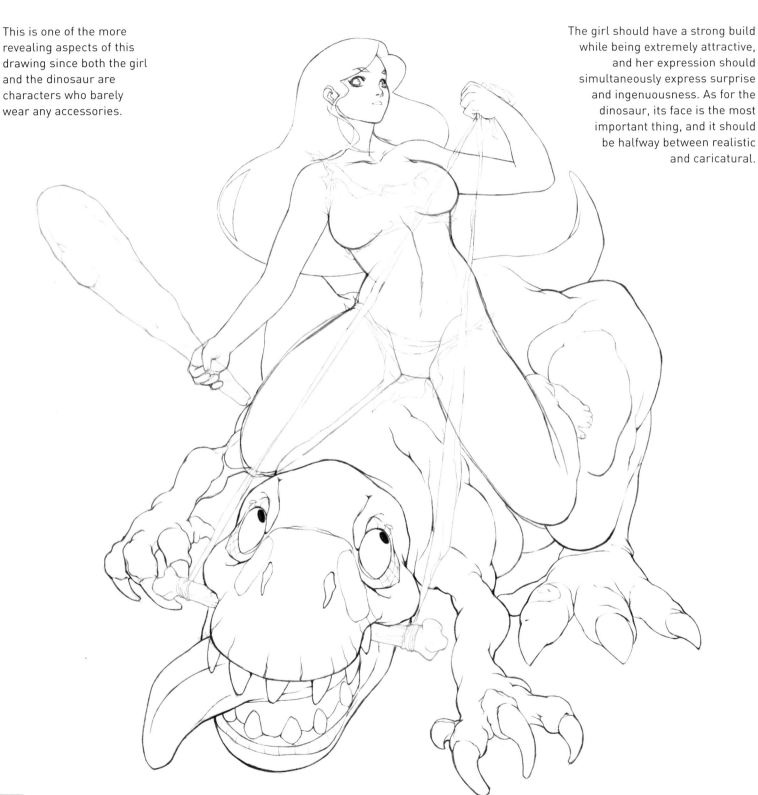

We'll use rougher strokes for her club and the bone the dinosaur is holding.

The other elements, such as the outfit worn by the prehistoric woman, should follow the direction of the line of her back.

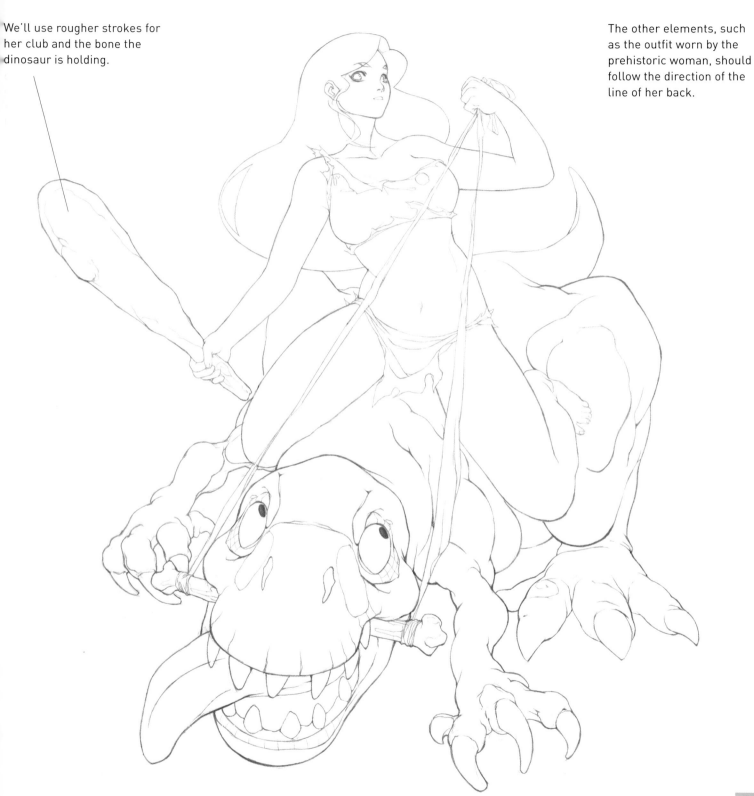

We'll use a zenithal light source to develop the basic volumes, keeping in mind the texture of the dinosaur's skin and how light might fall upon it.

Source of light

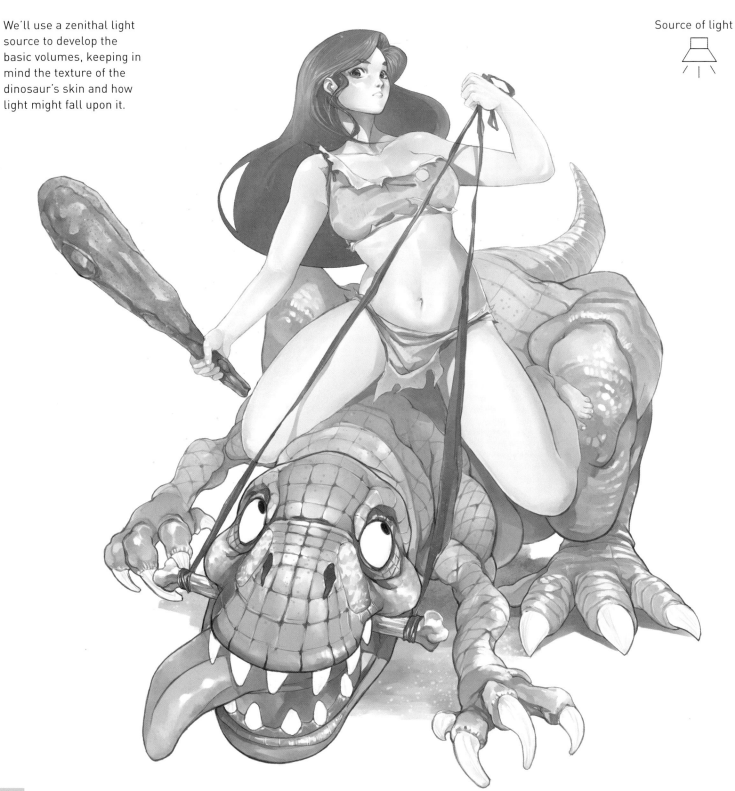

We'll use bright, pastel colors (especially on the girl) and mark the main shadows on the girl's skin as well as on the dinosaur's.

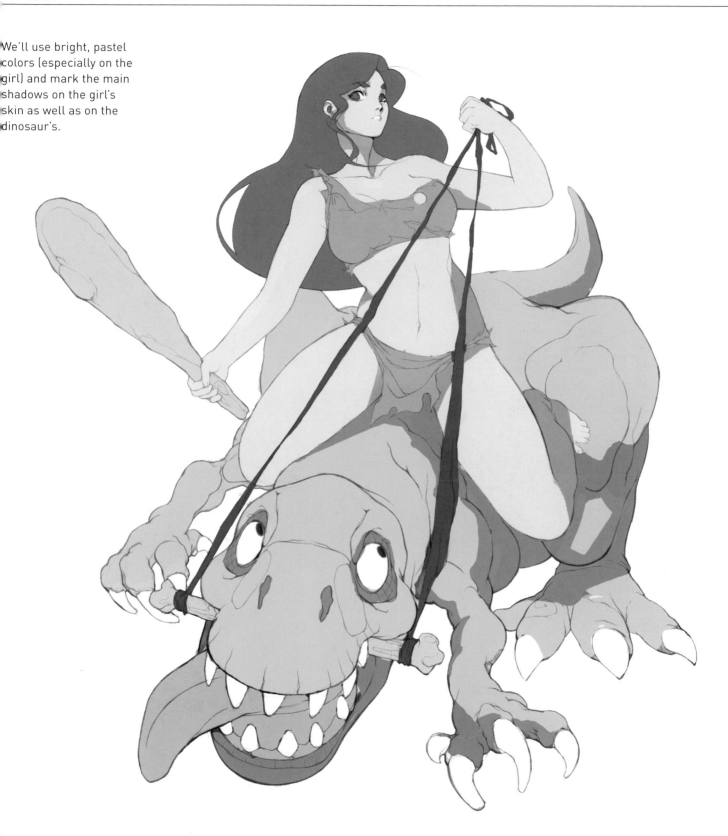

Here we'll seek warm colors for the girl's skin and then use highlights to simulate sweat. We'll create the texture of the dinosaur's skin by using patches of light as a base.

We'll add texture and splashes of color to her club and repeat the process with her clothes, without going overboard with the splashes.

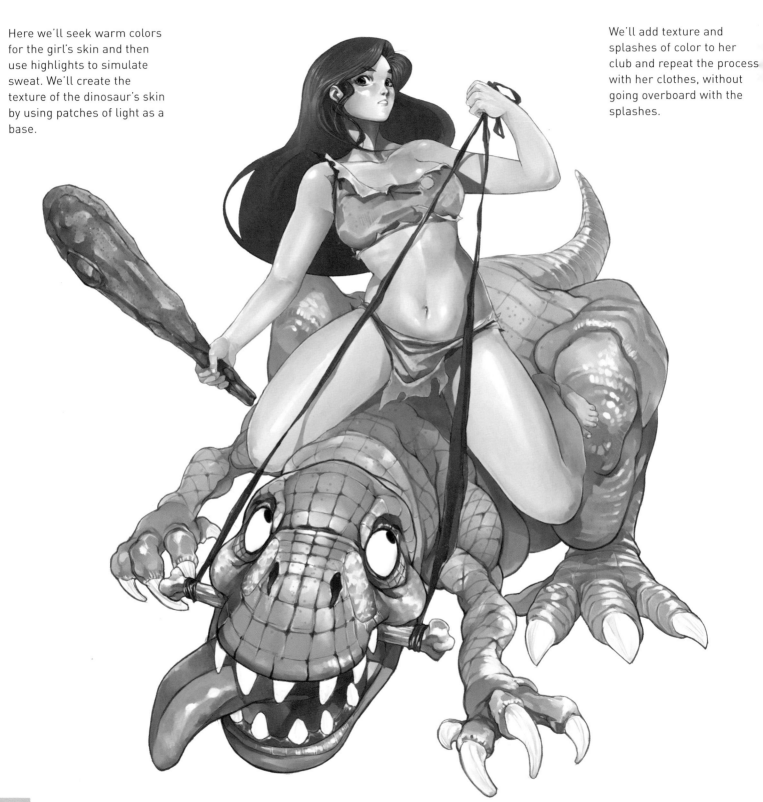

The speckles on her bikini, the dapples of color on the dinosaur's skin and the light shadow cast on the floor complete this illustration.

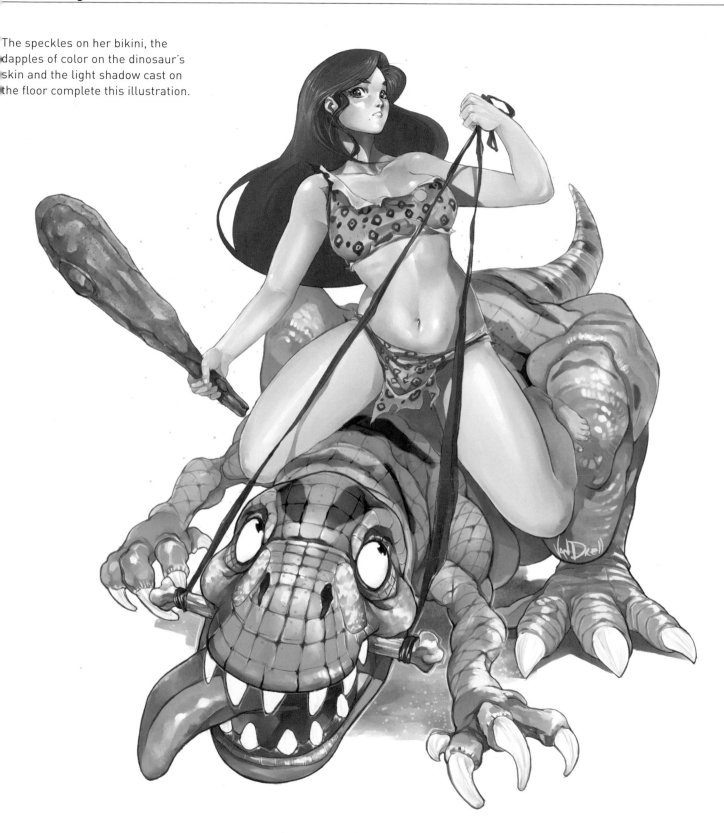

Thanks to
Ikari Studio would like to say thanks, once again, to all of those who have supported us
on our path, especially the ladies who have served as inspiration while making this book.